*D*

# Indian Art

# Oxford History of Art

Partha Mitter is Professor in Art History at the University of
Sussex. He was Fellow of Clare Hall, Cambridge, Mellon Fellow
at the Institute for Advanced Study, Princeton, Research Reader
of the British Academy, and Radhakrishnan Memorial Lecturer
at All Souls College, Oxford. He is the author of *Much Maligned
Monsters: History of European Reactions to Indian Art* (1977) and
*Art and Nationalism in Colonial India 1850–1922: Occidental
Orientations* (1994), as well as numerous articles on various
aspects of art, identity, and representation. He has also lectured
at many of the major universities around the world.

# Oxford History of Art

Titles in the Oxford History of Art series are up-to-date, fully-illustrated intro
wide variety of subjects written by leading experts in their field. They will app
building into an interlocking and comprehensive series. Published titles are in bol

Oxford History of Art

# Indian Art

Partha Mitter

OXFORD
UNIVERSITY PRESS

*To Ma, Babumama, Mamima, and remembering Baba, Sidhartha, and Raghubir*

# OXFORD
UNIVERSITY PRESS

Great Clarendon Street, Oxford OX2 6DP

Oxford New York

Athens Auckland Bangkok Bombay Calcutta
Cape Town Dar es Salaam Delhi Florence Hong Kong Istanbul
Karachi Kuala Lumpur Madras Madrid Melbourne Mexico City Mumbai
Nairobi Paris São Paulo Shanghai Singapore Taipei Tokyo Toronto Warsaw
and associated companies in Berlin Ibadan

Oxford is a registered trade mark of Oxford University Press
in the UK and in certain other countries

0-19-284221-8

10 9 8 7 6 5 4 3 2 1

British Library Cataloguing in Publication Data
Data available

Library of Congress Cataloguing in Publication Data
Data available

Picture research by Charlotte Morris
Typeset by Paul Manning
Design by Oxford Designers and Illustrators
Printed in Hong Kong on acid-free paper by C&C Offset Printing Co. Ltd

*The websites referred to in the list on pages 278–81 of this book are in the public domain
and the addresses are provided by Oxford University Press in good faith and for information
only. Oxford University Press disclaims any responsibility for their content.*

# Contents

# Preface

In 1977, I had argued in *Much Maligned Monsters: History of European Reactions to Indian Art* that colonial readings of ancient Indian art were in need of revising.[1] The last two decades have seen scholars questioning the dominant western canon, which treats Indian art as an adjunct of a universal art history. There is a need for a reassessment of the way in which we look at, and talk about, Indian art. The interesting question is not what Indian art shares with western art, but how it differs from it. One of the hidden assumptions of Indian art and architectural history has been the belief in the universal validity of artistic teleology, where all art is judged by whether or not it embodies notions of progress. While this has been the cornerstone of European art since Vasari, it is not the case for Indian art. This is not to say, however, that the evolution of artistic styles is irrelevant to India.

An insight into the unique qualities of Indian art is best achieved though a broad cultural history which places art production and patronage in its social and cultural contexts. Unlike the narrow western interpretation of fine art, the distinction between fine and decorative arts was not pronounced in India, which evolved, for example, a great tradition of decorated utensils. Any discussion of Indian art must encompass a wide range of different media: architecture, sculpture, illustrated manuscripts, painting, miniatures, textiles, and latterly photography and installation work.

It is inappropriate to attempt a purely stylistic analysis that uses categories and influences derived from the West as these do not take into account the very particular cultural and political developments of the Indian subcontinent. However, Indian art can be usefully separated into specific periods each reflecting certain religious, political, and cultural developments. These run as follows: Hinduism and Buddhism of the ancient period (*c.*300 BCE –1700 CE); the period of Islamic ascendancy (*c.*712–1757 CE); the colonial period (1757–1947); and finally Independence and the postcolonial period (post-1947). This book redresses the balance of previous discussions of Indian art by including analysis of the colonial and later periods as well as the arts of women and tribal peoples.

By remapping the chronology of ancient Indian art history we can better appreciate the achievements of ancient Indian art. The current dating of Buddhist, Hindu, and Jain art, largely based on James Fergusson's pioneering work, assumes that ancient Indian art, which began with 'simple' and elegant early Buddhist sculptures and monuments, attained perfection in the 'classical' Gupta period in the fifth century CE.[2] Then followed a period of continuous decay, represented by many-armed Hindu deities and florid Hindu temples. Such a judgement, grounded on the western classical ideal of simplicity as perfection, and on decoration as a sign of decadence, fails to appreciate the ornamentation of Hindu temples as an essential expression of Indian taste.[3] This perception has led not only to a serious imbalance in tracing the evolution of Indian art but also to the systematic neglect of great Hindu temples of the later period. When we accept that Indian taste, which blends simplicity with richness, does not necessarily conform to Winckelmann's ideal of 'noble simplicity and quiet grandeur', we begin to see these temples in a different light. Thus it was not in the Gupta period in the fifth century, hitherto regarded as the culmination of ancient Indian art, but much later in the tenth century and beyond that temple builders and sculptors gained the requisite experience to create the dazzling ornamented surfaces of Khajuraho, Konarak, Tanjavur, and Madurai, to name a few of the striking temple sites.

In short, we need to see the development of ancient Indian art not in terms of a 'classical age', nor in terms of a linear development, but rather as a series of paradigm shifts bringing to prominence different aims and objectives in different periods and regions. Thus, for each region, we should locate specific artistic and architectural objectives and their fulfilment in advanced edifices. In North India, for instance, only from the tenth century do these conditions attain fulfilment, but significantly, great temple building activity continues until the thirteenth century. After that period, Islam ushers in a different form of architecture in the region. In South India, a peak is reached in the Cola period in *c.*1000 CE, to be followed by different sets of objectives between the thirteenth and eighteenth centuries at Madurai, Srirangam, Rameswaram, and other late monuments. In the colonial era we again meet with a different set of rules, based on European architectural and artistic practices. While rejecting extraneous criteria such as a 'classical age' to judge ancient Indian art, we should not, in a fit of cultural relativism, renounce all notions of quality and of development. Ancient Indians knew the difference between outstanding and inferior examples of art. Thus in order to establish what was the summit of Indian artistic tradition, we must try and retrieve the aesthetic conditions that prevailed among Indian artists and patrons themselves.

Unlike that of Buddhist, Hindu, and Jain art, the historiography of Islamic and colonial/modern art is less contentious. This is partly because Islamic art was relatively easily assimilated into European aesthetics and did not raise the same issues of misrepresentation as Hindu art did. Nonetheless, if one were to detect a new development in Islamic art scholarship, this has been the move away from connoisseurship and stylistic analysis towards a more contextual approach that takes into account the political, social, and cultural implications of artistic production. The most significant development in this sphere has been the tracing of links between architecture and political ideology, especially in the Mughal empire. There have also been advances in another area of research that is of considerable significance. Contrary to earlier writings, we now know that Islamic architecture and painting were not simply imposed upon the indigenous population by the conquering powers. Indeed Islamic architecture was introduced into India long before the establishment of Muslim rule in the thirteenth century. Also, Ġujarati painters, working under Hindu and Jain rulers, steadily absorbed Persian and Mamluk elements in the wake of trade partnership between the Gujaratis and the Arabs. The focus in the Islamic section is on the social and cultural implications of Mughal painting and architecture as expressions of an urban milieu that was emerging in the Mughal empire, addressing in particular the ideological underpinning that culminated in the Mughal theory of kingship.

The final section covering colonial and contemporary art and architecture considers issues of globalization and modernization as they make their gradual appearance on the subcontinent. I focus in particular on the impact of westernization on Indian artists and patrons during the Raj and subsequent nationalist resistance to colonial academic art, a period documented in my work on colonial art and national identity.[4] An important aspect of the period is the self-image of Indian artists confronted with colonial rule. Moreover, during the nationalist period from the end of the nineteenth century onwards, western orientalist ideas of a national art were 'inverted' by the Indian artists in creating their own form of artistic resistance. International artistic modernism overtook the subcontinent in the 1920s and grew in strength in the postcolonial period. The works of Indian artists even today naturally reflect the tension between global modernism and national self-definition that goes back to the colonial era. A significant development since the last decades of the twentieth century has been the growing importance of contemporary women artists of South Asia, who offer us an alternative vision of art.

*Indian Art* seeks to highlight exciting new research in the field, while putting the material in a clear theoretical framework. This framework, which probes the interaction between artistic production

and patronage, and between individual creativity and dominant ideology, serves as a corrective to colonial art history. Perhaps more than any other non-European artistic tradition, the study of Indian art is soaked in western art historical concepts that reflect an obsession with the influence of the West on Indian art, ideas that neglect the role and function of art in the Indian society itself.

A key objective is to redress the imbalance that many general books on Indian art seem to suffer in that they tend to give undue importance to Hindu, Buddhist, and Jain artistic achievements to the detriment of Islamic and colonial/modern arts. As far as possible, I have tried to give equal importance to the three main periods of Indian history, bringing out the distinct flavour of each period. Hindu art in particular has suffered considerable misrepresentation in the West, a colonial legacy to which contemporary Indian scholars were not necessarily immune. *Much Maligned Monsters* belongs to an emerging intellectual revolution in the 1970s that questioned the claimed 'objectivity' of western knowledge of non-western cultures. *Indian Art* hopes to make a contribution to this continuing debate.

I would like to thank here friends and colleagues who read parts or whole of the manuscript, shared their expertise, and offered suggestions, advice and other forms of help: Jalaluddin Ahmed, Debashish Banerjee, Robert L. Brown, Craig Clunas, Debra Diamond, Madhuvanti Ghosh, Ebba Koch, Rachel McDermott, Vivek Nanda, Divya Patel, Rashmi Poddar, Raghubir Singh, Robert Skelton, and Deborah Swallow. My thanks go to Fiona Sewell for her help in the publication process, to Katharine Reeve for reading the manuscript with enthusiasm and offering valuable comments, and to Charlotte Morris and Karl Sharrock for, respectively, their thorough picture research and editing. As always, Swasti, Rana, and Pamina have been a tower of support in this enterprise. Finally, the work owes a great deal to Robert Skelton's awesome library of Indian art texts and to the encouragement and friendship of Simon Mason, the commissioning editor.

# Part I

# Buddhist and Hindu Art and Architecture
(*c*.300 BCE–1700 CE)

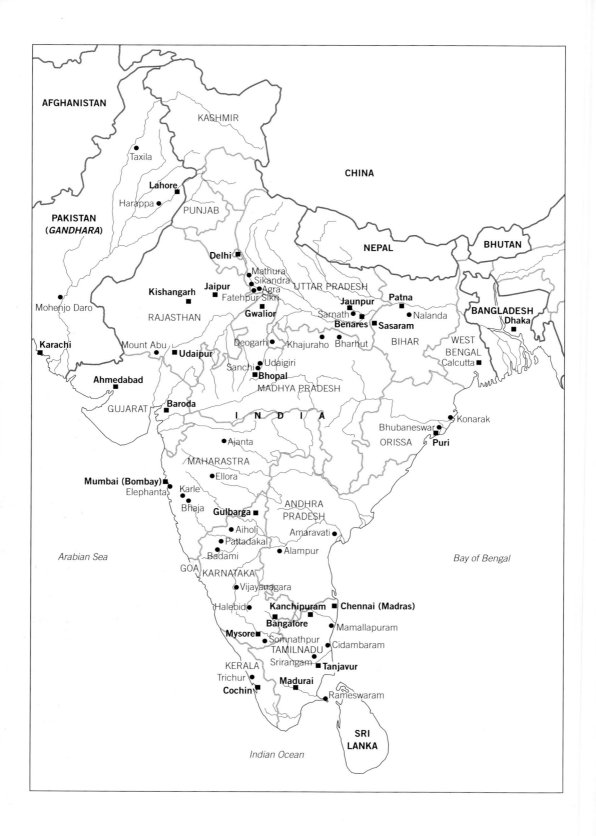

# Introduction

The Indian subcontinent may be divided into four broad swathes differentiated culturally and physically. The border regions of east and west have affinities with landscapes and societies beyond the subcontinent. For instance, if you fly into India from the Middle East, you see a wide sweep of brown and dusty terrain extending from west Asia, southern Iran, and Afghanistan down to Sind and the Punjab plains up to Delhi. This was the crossroads of Indian civilization, as wave after wave of invaders poured through the great passes into the subcontinent. Then, imagine you are flying from Bangkok to Calcutta during the monsoon season; the green paddy fields and rainforests that begin in South-East Asia and continue through Bangladesh right into West Bengal form the second region. The third consists of the alluvial Gangetic plains, the Aryavarta of Sanskrit literature, later called Hindustan, usually described as the heartland of ancient India. The fourth distinct area is the south Indian peninsula including the Deccan, the civilization of the Dravidian-speaking peoples.

## A cultural map of the Indian subcontinent

At the end of the British Raj in 1947, the Indian subcontinent was partitioned into the Republic of India and the Islamic Republic of Pakistan. In 1971 Pakistan's eastern wing became the independent state of Bangladesh. Though using *Indian Art* as the title of this book, I wish to remind readers of the shared culture of the subcontinent in which Islam has played a major role. This shared culture has a historical validity that transcends modern national boundaries. Thus no art history of the subcontinent can afford to exclude the arts of Pakistan and Bangladesh. As the Pakistani art historian Akbar Naqvi writes with some passion, the 'political destinies of Pakistan and India may be different, and the two may quarrel politically, but the cultural ties are too old and archetypal to be forgotten or severed for political expediencies'.[1] I have, however, excluded Sri Lanka and Nepal from this survey. While they have many features in common with India proper, their histories are so removed from that of India that they cannot be meaningfully included.

India is a multicultural subcontinent resulting from a history of migrations of diverse peoples and the establishment of new communities. They came from as far afield as Greece and Asia Minor in the west and the borders of China in the east. The newcomers, often arriving as invaders, carrying their cultural baggage with them, were gradually absorbed into Indian culture. These constant infusions enriched the culture, even as the settlers' own values were powerfully modified by India. Once assimilated, the heterogeneous strands melded into what was unmistakably Indian. Regional differences have led some authors to dismiss India as a modern invention. But there is no contradiction between the diversity of regions, religions, castes, and languages and the unity of shared experiences that at once separates India from the surrounding countries. One is forcefully reminded of the passage in the Bible that admirably captures Indian pluralism: 'In my Father's house are many mansions'.[2]

## Early art

Art generally means sculpture and painting, and often includes architecture, but human artefacts may embrace a wider category of material remains that includes the decorative and minor arts, such as jewellery, pottery, metal and wooden utensils, and even toys. The artefacts of the earliest inhabitants of India, the stone age societies, go back many millennia: rock paintings of central India used different pigments to depict humans and animals, neolithic pottery was ornamented with natural and geometric patterns, while terracotta figurines suggest the universal cult of the Great Mother. These arts, which continue to this day, have traditionally been regarded as elements of folk culture that have existed alongside 'high' art and enriched it.[3]

Around 2500 BCE, the urban culture of Harappa sprang up in the north-west of India along the Indus river, continuing down to the west coast. At its cultural hub were the centrally planned cities of Mohenjo Daro and Harappa, which boasted straight, wide roads and affluent private residences with bathrooms served by a drainage system. The poor, however, lived huddled in slums, the inevitable underclass in a

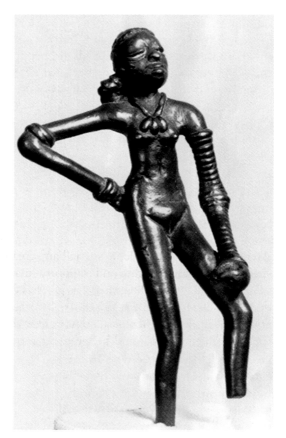

**1**

Dancing girl, bronze, Mohenjo Daro, 2300–1750 BCE.

There is something endearing about this bronze nude, which captures the artless pose of an awkward adolescent. Other Indus artefacts include decorated pottery, small human sculptures that evince a sure knowledge of anatomy, bulls and other animals, ornaments, and toys.

hierarchical system. Until the Indus script is deciphered, its people will remain an enigma to us, though the different skull types are found to be similar to those of present day Indians.[4] The Harappans traded with the Mesopotamians but did not share their fondness for colossal images [1]. Stone carvings of what appear to be genitalia at Indus suggest the prevalence of sexual cults. The image of a male with erect penis, apparently wearing a buffalo mask with horns, seated in a 'yogic' position, and surrounded by animals, recalls the later Hindu god Siva. However, scholarly opinion is divided on this.[5]

*From Vedic sacrifice to religions of salvation*
The Indus cities declined and were possibly abandoned around 1800 BCE. The earlier view that they were destroyed by the invading Indo-Aryans has lost favour, and ecological change has emerged as a strong contender. Rather than invading, Indo-Aryans were migrating to India in successive waves from around 2000 BCE.[6] A pastoral people, they lived on the banks of the five great rivers of the Punjab, requiring neither temples nor images but simply a square altar for the fire sacrifice (*yajna*) that invoked the gods of the elements. These invocations were collected as the four Vedas, the most sacred Hindu texts. The Vedas are the mainstay of our knowledge about the society, for very little material evidence of the culture exists. Vedic society revolved around the priest (*yajaka*), who performed *yajna* for the patron (*yajmana*). Gradually, through interactions between the indigenous population and the newcomers, the society evolved into four great classes (*varna*)—Brahmin, Ksatriya, Vaisya, and Sudra—said in one of the four texts, the *Rg Veda*, to emanate from the body of the Creator. These rankings laid the foundations of the caste (*jati*) system in India. Untouchables and those who led a life of renunciation were not included.

Apart from pottery we have little evidence of art until the third century BCE. Colonial art historians claimed to trace its origins in western classical art. However, art appears not because it is imposed from the outside but because of the internal needs of a society. Architecture, for example, a 'spatial' art, creates domestic and public spaces. Public architecture and sculpture in ancient India, as in many other pre-modern civilizations, was created to satisfy religious needs. Faith alone, without the material wherewithal, could not realize such ambitious projects. There is a complex interaction between patronage and social institutions, and between artistic tradition and individual creativity, a phenomenon which Bourdieu aptly calls 'the field of cultural production'.[7] One of the problems of studying ancient Indian artists is their relative anonymity, commensurate with their artisan status. Only exceptionally did artists publicly declare their authorship. Such an exception was Narasobba, an eighth-century artist, who

**Religious background**

Intellectual revolution followed the rapid urbanization of the second millennium BCE, as the fire sacrifice of the Vedic (Indo-Aryan) culture was challenged by thinkers who speculated on the nature of religion. In search of salvation, they confronted the profound mystery of death, their quest predicated on two cardinal principles: *samsara*, or reincarnation, and *karman* (karma), the individual's position in *samsara* as determined by his or her past actions. This ideology of moral force bearing the seeds of future good or bad fortune became the cornerstone of the Indian caste system. The Upanishadic texts (*c*.1000 BCE) proposed that our souls (*atman*) are part of the great universal consciousness (*brahman*). Delusion (*maya*) arising from worldly existence makes us forget this unity. The notion of unity, *advaita* (non-dualism), has dominated Indian thought, while the search for spiritual knowledge has involved meditation (*yoga*), austerity (*tapas*), and renunciation. Buddhism, the first world religion, and Jainism, which had a limited but enduring appeal, were the two major developments of this intellectual revolution. The prince Gautama (*c*.563–483 BCE) was named the Buddha ('Enlightened One') after attaining illumination. His message was that sorrow was unavoidable because one craved for things that perished. To Buddhists, only *nirvana*, the end of consciousness, could end the sorrow. Yet it was not the forbidding *nirvana* but the Middle Path—a life of good conduct and compassion through balancing extreme indulgence and painful renunciation—that became the Buddhist credo. Buddhism surged through India, as Brahmanical rituals failed to keep pace with change. Many of its first converts were Vaisyas (merchants), upwardly mobile, affluent urban groups, and women, both of whom wanted to overcome their low ritual status, but even Brahmin youths flocked to the order.

claimed that he had no rival in temple and house building.[8] Thus we are reduced to inferring individual creativity mainly from the works of art themselves. The danger here lies in making judgements beyond our own time and culture that can distort the original aims of those who produced these works and their patrons.

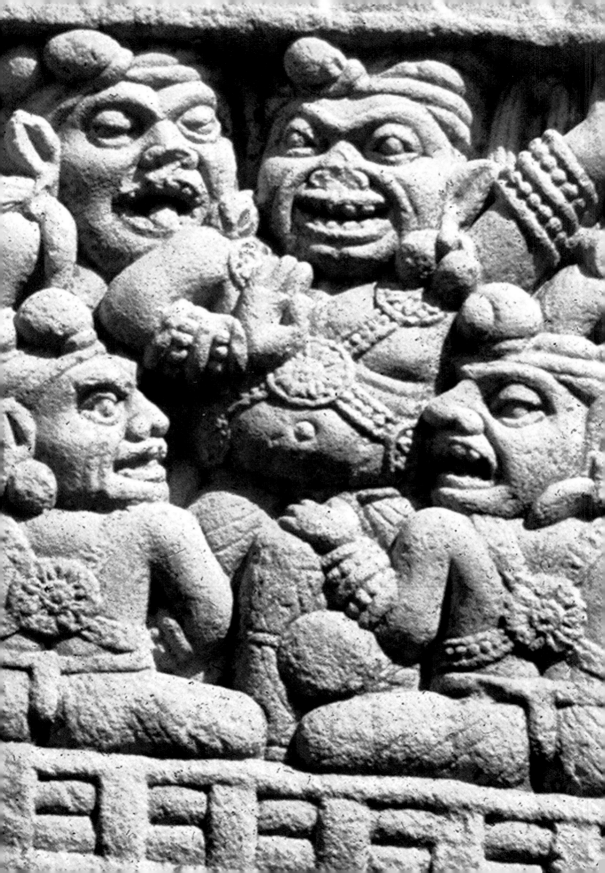

# Buddhist Art and Architecture

## Early Buddhist art

The earliest Indian religion to inspire major artistic monuments was Buddhism, the first creed to enjoy the patronage of a thriving community, express a clear ideology, and boast an efficient monastic organization. Buddhist monuments were great human endeavours inspired by faith and creative imagination. By the first millennium BCE, Vedic society in the Punjab was breaking up, as the population pushed east along the course of the Ganges, clearing forests and settling on the fertile land. Cities emerged as centres of trade and commerce, populated by prosperous merchants who were served by artisan guilds living close to urban centres. Money, as a form of exchange, and writing gradually made their appearance in this society.[1] The political map of India was changing, pastoral communities giving way to early states called *mahajanapadas* as tribal republics fell before ambitious monarchs competing for control over North India. The situation was aptly described in the epic *Mahabharata* as one 'where big fishes ate little fishes'. The state of Magadha in the north-east, controlling the river trade, forests, and rich deposits of minerals, ultimately emerged as the nucleus of the first Indian empire.[2]

### Asoka and the empire of compassion

The emperor Asoka (*c.*269–232 BCE) was the first major patron of Buddhist art. He succeeded his grandfather, Candragupta Maurya (322–297 BCE), who had brought the whole of North India under his control by overthrowing the unpopular Nanda dynasty. He created the cosmopolitan Mauryan empire, which was run by an efficient centralized bureaucracy. Asoka, who inherited the vast empire, made a dramatic conversion to Buddhism which led to an experiment unique in human history. Shocked at the carnage attending his conquest of Kalinga (present-day Orissa), Asoka became a Buddhist and a pacifist, admonishing his subjects to practise compassion and ethical behaviour. The code of behaviour (*dharma*) propounded by him also showed political astuteness in inculcating social responsibility in a heterogeneous empire where tensions between urban merchants and Brahmin orthodoxy threatened stability.[3] Asoka, who inscribed his

*anda*—ovum or egg, the hemisphere of the stupa

*ayaka*—decorated five-pillared projection at Amaravati

*Bodhisattva*—the 'Buddha to be', containing his essential characteristics

*caitya*—apsidal prayer hall

*citra*—picture or painting

*dana*—giving unreservedly to others as a form of religious merit

*gavaksa*—arched or horseshoe-shaped window in a *caitya*

*hinayana*—the 'doctrine of the Lesser Vehicle', a term used by Mahayanists for their opponents who venerate the Buddha

*jataka*—the stories of Buddha's previous human and animal lives

*mahayana*—the 'doctrine of the Greater Vehicle', which holds the Bodhisattva as greater than the Buddha

*mudra*—language of hand gestures in art and dance conveying meaning and mood (also Hindu)

*naga*—mythical many-hooded king cobra

*parinirvana (nirvana)*—end of cycles of suffering through the end of consciousness, symbolising the Buddha's demise

*pipal*—tree under which the Buddha attained illumination

*pradaksina*—ritual circumambulation of a sacred structure or image in a clockwise direction (also practised by the Hindus)

*sangha*—monastic order

*stupa*—memorial to the Buddha, shaped like the mound of earth containing his ashes

*tirtha*—holy pilgrim site associated with relics

*torana*—arched gateway

*triratna*—the three Buddhist jewels: the Buddha, the Doctrine, and the Order

*vihara*—a retreat for nuns and monks

*yaksa/yaksi*—male and female nature spirits with supernatural attributes in folklore

message on rock faces and stone pillars in public places throughout his empire, comes across as refreshingly human.

Mauryan artisan guilds, mentioned in literature, were engaged in Asoka's projects. The high polish of Asokan pillars, lotus bell capitals, and stylized lions [2] had suggested to scholars, such as Vincent Smith in 1930, that Iranian journeyman carvers came to Asoka's cosmopolitan empire in search of work after the fall of the Achaemenids. From this evidence Smith confidently ascribed Perso-Hellenistic origins to Indian art.[4] In 1973, John Irwin challenged this 'colonial' hypothesis.[5] He suggested firstly that not all 'Asokan pillars' belong to Asoka's reign: he might have simply adapted many of the existing pillars for his own imperial ends. Secondly, while the four lions are influenced by Persian art, bulls and elephants are treated with a lively observation that is unmistakably Indian. Again, the honeysuckle and acanthus motif, which at first sight seems adopted from Western classicism, was no more Greek than Indian. It belonged to the ancient west Asian artistic pool that nourished both ancient Greece and India. Finally, Irwin maintained that in order to discover the true origins of these pillars, it is more useful to look beyond their style to their function. In short, rather than initiating monumental art in India, Asoka made imaginative political use of a much older pillar cult symbolizing the

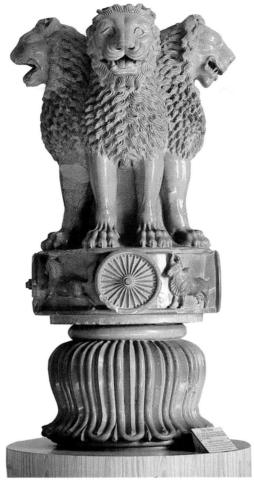

*axis mundi* (the pillar as the symbolic representation of the axis on which the world spins).

### Buddhist patronage and the monastic order

Asoka's astute marriage of politics and religion, as expressed in art, was an exception. In early Buddhism, which established close links between monasteries and the laity, communal patronage vied with royal patronage. In India, royal support of religious monuments is a rather complex issue. One reason may be that royal or Ksatriya claims to divinity were held in check by the competing claims of the Brahmins. Art historians have tended to use royal dynasties as convenient stylistic labels, since hard evidence for constructing a reliable chronology for Indian art has been scarce. While dynastic labelling rightly makes a virtue out of necessity, we should be careful not to confuse a monument's mention of a royal era with active patronage by that dynasty. Often such mentions are no more than royal

recognition of all the faiths within the kingdom.[6] Indeed, as we shall see, tensions arose where kings used royal temples as a form of political legitimization when the temples themselves belonged to communities rather than to monarchs. These tensions are reflected in the fact that sometimes members of a royal family were very active patrons although the ruler himself was not. Sacred buildings or images were often endowed in India by individuals to gain religious merit, and these included kings in their personal capacity as devotees.

Buddhism, the first Indian religion to require large communal spaces, inspired three major types of architecture: the stupa, the *vihara*, and the *caitya*. Between the first century BCE and the first century CE, major Buddhist projects were undertaken with subscriptions raised from the whole community. Generous donations were made by landowners, merchants, high officials, common artisans, and, above all, monks and nuns, many of them belonging to emerging social groups in search of an identity. It is remarkable that women from all walks of life, including courtesans, were drawn to Buddha's teaching. Did women and the lower *varnas* play a more active role in Buddhism because they were debarred from Brahmanic rituals?[7]

### The Great Stupa at Sanchi

The early stupas, which preserved the Buddha's relics, were the first monuments to symbolize the power and magnificence of the faith. Originally the focus of a popular cult of the dead, the stupa celebrates the Buddha's *parinirvana*, the central message of Buddhism, and also symbolizes his eternal 'body'. Unlike the early stupa at Bharhut and Stupa II at Sanchi, the Great Stupa at Sanchi has survived intact, offering us first-hand knowledge of the aims and achievements of early Buddhist architecture. Situated on a major trade route near the city of Vidisa (Madhya Pradesh), Sanchi came to be a great sacred site and was visited by Asoka, who is commemorated on the East Gate of the

**3**
*Vessantara Jataka* (story of Prince Vessantara), bottom architrave, front and back, north gate, the Great Stupa, Sanchi, first century BCE/CE.
The prince, who is the Buddha in his previous life, gives away all his material possessions, including the white elephant, auspicious emblem of the kingdom. Banished by his enraged subjects to the forest, he loses his family there. Eventually virtue is rewarded and everything is restored to him. Its prominent representation at Sanchi reminded the laity of the importance of giving to the Order.

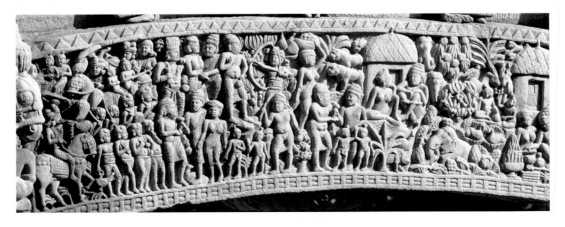

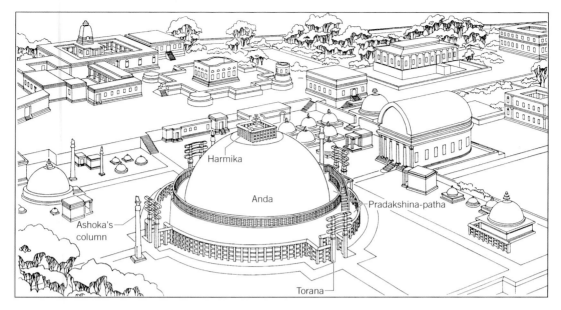

Harmika

Anda

Pradakshina-patha

Ashoka's
column

Torana

**4**

Reconstruction of Sanchi. In
the foreground is the Great
Stupa, first century BCE/CE.

The Great Stupa is replete with
cosmological symbolism, as
well as being the central
symbol of Buddha's
*parinirvana*. The svastika-
shaped ground plan, with four
gateways facing the cardinal
directions, is the spatial image
of the *dharma cakra
pravartana* (setting the wheel
of the Doctrine in motion), the
supreme principle of
Buddhism. Visiting pilgrims
performed circumambulation,
tracing clockwise the path of
the sun, which reminded
them of the Buddha's dazzling
spiritual power. The earth-
filled dome represents the
seed of life, *anda*. The three
parasols shade the reliquary
from the sun, the enclosing
railing further protecting its
sanctity. A shaft symbolizing
the world axis penetrates the
dome, fixing the stupa firmly
on the ground. Other
cosmological details include
the 120 uprights of the
monolithic balustrade
representing the 12 signs of
the zodiac.

Great Stupa. By the first century CE, the Great Stupa had been
enclosed in brick and stone slabs, plastered over, and possibly painted
white and its ornamental gateways were completed.[8]

Around a thousand small donors, including some 200 women
(among them the nun Buddhapalita), funded this remarkable stupa, its
scale and artistic richness bearing witness to the organizational
efficiency and considerable resources of the monastic order.[9] However,
the cost of the decoration of the gateways was borne by 11 major
donors. Generosity (*dana*) was raised to the level of a sacrament in
Buddhism, instilled through the popular story of Prince Vessantara
[**3**].[10] Among the donors at Sanchi were the ivory workers from the
nearby town of Vidisa who carved the details of the gateways as an act
of piety. But the overwhelming evidence is that in ancient India
architects (called *sutradhara*, literally builder-carpenter), masons,
stoneworkers, and sculptors were professionals who undertook
religious projects regardless of their own religion, a phenomenon seen
throughout Indian history. If ancient Indian art and architecture were
expressions of profound faith, this was mainly the faith of the patron,
not necessarily of the craftsman.

The stupa's crowning glory is the set of four sandstone gateways,
their festive sculptures providing a dramatic foil to the unadorned
hemisphere [**4**]. The sculptures remind us of wood or ivory carving, as
in the Indian ivory statuette found in the Roman town of Pompeii,
which was buried in lava in 79 CE. In each gateway of the stupa, three
uprights and architraves, with coiled ends resembling the unfurling of
scrolls, rest on thick rectangular pillars. *Triratna* motifs, the three
Buddhist jewels—Buddha, the Doctrine, and the Order—are placed

Yaksi (nature spirit), the Great Stupa, Sanchi, first century BCE/CE.

The nubile tree nymph, a support for the architrave, is often represented lovingly wrapping her leg around a tree to make it bloom. A Buddhist folk deity, her deep-set navel, rounded breasts, narrow waist, and 'full-moon' face anticipate the Indian canon of beauty. The links between women, fertility, and auspiciousness are well attested in literature.

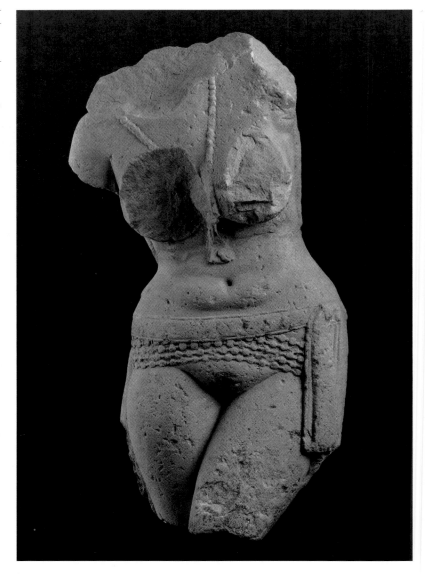

at the pinnacle of the gateways (*toranas*). The most significant decorations are the central narrative panels, surrounded with a host of human, animal, geometric, and plant motifs, among them the earliest female nudes—the schema embodying a hierarchy of meaning implicit in Indian sacred decoration [**5**]. Especially sensitive are the renderings of water buffaloes and elephants that mingle in a magic world with human-headed lions and many-hooded king cobras (*nagas*), reiterating the Buddhist belief in the unity of life. The Sanchi artists revel in forest scenes and towns with buildings containing balconies, vaulted roofs, and moats, offering us a wealth of information about contemporary life not found before.[11]

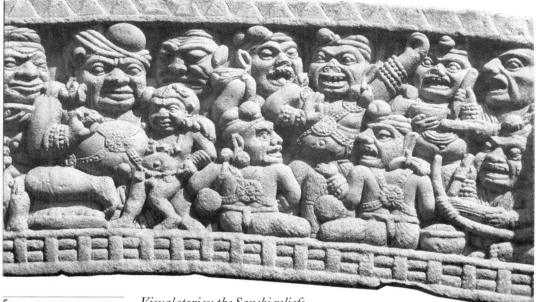

**6**

Buddha's victory over Mara's forces, his final tempters before illumination, the Great Stupa, Sanchi, first century BCE/CE.

The artists show off their versatility in caricature here in portraying the demons sent by Mara to frighten the Buddha. As opposed to the canon of beauty seen in **5** and **52**, these demons with bulging eyes, snub noses, and protruding teeth epitomize the 'ugly'— thus negatively reinforcing the aesthetic canon.

*Visual stories: the Sanchi reliefs*

If the actual construction of the stupa was left to professionals, the narrative programme shows a unifying vision that was almost certainly provided by the monastic order, the guardians of the Buddhist canon. The pilgrims were introduced to the basic tenets of their religion represented on the front and the rear of the gateways, the sculptures providing spiritual lessons in an age of limited literacy. Around 60 major themes chosen from the Buddhist canon can be reduced to two types: *jatakas*, the stories of the former animal and human lives of the Buddha, paradigms of the Buddhist pilgrim's progress towards an enlightened state, and the life of the historical Gautama who attained Buddhahood [**6**].

It is curious that at Sanchi and other early monuments the historical Buddha was never represented as a human being. As the French orientalist Alfred Foucher argued in 1911, early artists used a specific symbol to suggest each 'station' in Buddha's spiritual journey, the *pipal* tree standing for his Enlightenment, the wheel for his First Sermon, and the stupa for his final *parinirvana*. Yet Buddha images became a commonplace by the second century CE. This change from the 'aniconic' to the 'iconic' phase in Buddhist art has been one of the most contentious issues in Indian art history (see box). The late appearance of the Buddha image has been variously explained on stylistic and doctrinal grounds, firstly by Foucher. Recent research has discovered early literary references to Buddha images, thus fuelling a new controversy, led by Susan Huntington.[12]

The Sanchi reliefs offer us the first narrative devices employed in ancient Indian art [**3**]. On the three central panels of each gateway an

essentially 'pictorial' technique was adopted, for instance the suggestion of recession by placing distant figures above and behind the foreground ones. These panels anticipate the preference of Indian sculptors for relief carving, rather than making free-standing figures. Even fully rounded figures, such as the *yaksis* at Sanchi, are meant to be seen as 'three-dimensional' only from the front or from behind, but appear flat if they are seen from the side. The relief form gave artists an opportunity to create large narrative scenes full of movement and an overarching rhythm, the sculptural groups forming part of the monumental stonework. The sense of movement in Indian art, very different from the static notion of perfection in classical Greek and Roman art, is often lost in a museum, where Indian sculptures are displayed as isolated fragments divorced from their contexts.

Any artistic representation must resolve the problem of time. The well-known mode in art history, deriving from Greek sculpture, is the representation of the significant moment, in which a dramatic action is 'frozen'. At Sanchi, several narrative conventions were adopted. The story could be told either in a sequence within a single frame or in a continuous narrative. The famous *Vessantara Jataka* uses a continuous narrative that flows from the front through to the back. Another technique is a 'repetitive' device suggesting progression, seen in the *Battle for the Relics of The Buddha* (south gate, back, middle architrave), one of the most dramatic scenes at Sanchi. The central panel depicts the impending battle with chariots, elephants, and foot soldiers in readiness, the town serving as a backdrop. The tumult is captured by subordinating the individual figures to an overall rhythm; next to it is the scene of kings exchanging relics amicably among themselves. Vidya Dehejia identifies the *Monkey Jataka* at Sanchi as a further, 'synoptic'

mode: multiple episodes, presented within a frame, are held together by a single central representation of the main character in the plot.[13]

*Buddhist monasteries*

One of the three jewels of Buddhism, the Buddhist monastic order, which was organized on a large scale, required commensurate living quarters. From the time of the Enlightened One, the order and the lay followers developed a relationship of mutual dependence. Monks and nuns, shunning worldly possessions, survived on the generosity of the laity. They repaid this by offering religious lessons to the faithful, who gained merit through materially supporting the order. Monasteries were founded as centres of Buddhist learning near prosperous towns and on sites hallowed by association with the Buddha. They grew into vast establishments, as at Sirkap in Gandhara or at Nalanda in Bihar. By 100 BCE, *viharas* and *caityas*, hewn out of the living rock, began competing with constructed ones, partly on account of their durability.

Between 120 BCE and 400 CE, over a thousand *viharas* and *caityas* were built in the Buddhist monastic complexes along ancient trade routes in the Western Ghat mountains. These sites evolved from the haphazard placing of buildings to their systematic planning.[14] The *vihara* was a dwelling of one or two storeys, fronted by a pillared veranda. The monks' or nuns' cells were arranged around a central meeting hall, each cell containing a stone bed and pillow and a niche for a lamp. In contrast to such austerity, *caityas*, or halls for congregational worship, were second in splendour only to stupas. Merchants and members of the monastic order endowed the *caityas* generously, though small donations soon dried up in favour of fewer, larger endowments.[15] The focus of veneration within the *caitya* was a replica stupa, placed at the end of the prayer hall. Later, at Ajanta for instance, a Buddha image embellished the front of the stupa. Circumambulation, hitherto performed in the open air at stupas, was incorporated into the U-shaped plan of the *caitya*: two rows of pillars separated the narrow corridors on either side of the main hall, thus creating a path which continued behind the replica stupa.

As with much ancient Indian art and architecture, most of the *caityas* cannot be firmly dated and thus pose problems for the study of their evolution. In an attempt at a solution, the pioneering historian James Fergusson applied the concept of evolution from the simple to the complex to these monuments. However, Fergusson's own classical taste led him also to conclude that the earlier and simpler the architecture, the better it was. Fergusson's chronology, which is still in use, seriously distorts our understanding of Indian architecture. But if we take early Buddhist architecture as technically, if not 'aesthetically', simple, we can then trace evolution in terms of greater complexity and sophistication, as builders became more experienced. (However, the

**7**

*Caitya*, Bhaja, *c.*100–70 BCE.
The open façade, which allows a full view of the interior, is as yet without the distinctive stone window (*gavaksa*). In the interior, the pillars are plain octagons having neither a base nor a capital, all of which indicate its rudimentary character. The imitation of wooden beams and other elements in stone suggests the human tendency to retain forms that have lost their function, a phenomenon best described as 'the persistence of memory'.

**8**

Interior of *caitya*, Karle, *c.*50–70 CE.
A handsome stupa rises at the curved end of a spacious hall. Rows of robust pillars with capitals that support couples riding on animals on either side separate the main hall from the low ambulatory corridor. The slight gap between the pillars and the 46-foot-high curved ceiling reinforces the impression of the lofty vault of heaven. However, the grandeur of the interior is created less by size or height than by the proportions of the architectural parts, a distinct feature of Indian architecture.

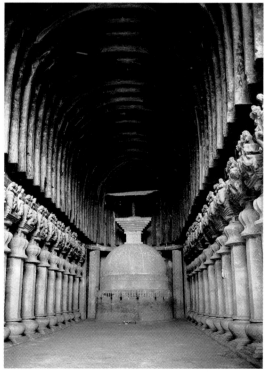

persistence of wooden elements in rock-cut *caityas*, which seem to hark back to the past, creates its own difficulties.)[16]

A comparison of an early example from Bhaja with one of the most ambitious ones at Karle highlights the significant features of the fully formed style [**7, 8**]. In successive sites new elements were added and forms refined. The dimensions increased, while pillar capitals were richly embellished with figures as the bases emulated auspicious water-filled vases. Karle (*c.*50–70 CE), built with subscriptions from Buddhists from different walks of life, and measuring 124 feet by 45 feet, was the summit of *caitya* architecture, not because it was the latest but because it was the most elegant. A massive four-lion pillar at the entrance proclaims the majesty of the Doctrine. The crowning feature of the façade, set in a recess carved out of the surrounding rocks, is an elegant horseshoe-shaped *gavaksa* window derived from secular wooden buildings, which bathes the interior in a mellow light. The height of the ceiling is only 46 feet; the grandeur of the interior is created less by size or height than by the careful proportions of the architectural parts, a distinct feature of Indian architecture.[17]

## Later Buddhist art

*Buddhist icons*
The representation of the human form of the Buddha, one of the most enigmatic developments in Buddhism, changed the course of narrative art in India. When European archaeologists found the first classically inspired Buddha images at Gandhara in north-western India in the 1830s, they associated them with the Indo-Greeks who ruled the region in the first century BCE. The discovery led Foucher to conclude that the Buddha image was invented by the Greeks, thus prompting an artistic revolution in India. His conclusion followed from his argument that at Sanchi and other early sites the Buddha was represented symbolically. This assertion was challenged in 1926 by the nationalist art historian Ananda Coomaraswamy, who cited a different set of Buddha images produced in the same period at Mathura. As he showed, these were inspired by the indigenous *yaksa* cult that owed little to western classical art. However, modern research has overtaken such purely stylistical explanations of the Buddha image, although the date of its origin continues to be hotly debated.[18]

To follow the implications of the latest research, we need to examine the history of the period. After the break-up of Asoka's empire in the second century BCE, regional dynasties came to prominence, while the different centres of Buddhism gained in importance, notably Gandhara in the north-west. Since the time of the Persian conquest Gandhara's fortunes had been interlocked with those of Bactria (the region between present-day Afghanistan and

Tadzhikistan), a cosmopolitan area populated by Persians, Greeks, Scythians, and Parthians. After the fall of the Mauryas, Alexander's successors ruled Gandhara for a while. The Indo-Greek king Menander (140–110 BCE) was almost certainly a Buddhist, as suggested by the famous *Discourses of Menander*.

Hellenistic art followed Alexander's footsteps from Asia Minor through Iran to central Asia, reaching Gandhara under the Indo-Greek rulers. Not only were classical orders deployed in the buildings of Taxila, the capital of Gandhara, but examples of the minor arts of the classical world—stone palettes, gold coins, jewellery, engraved gems, glass goblets, and figurines—poured into the region in the wake of Roman trade. The region imported Chinese lacquer and South Indian ivory with equal enthusiasm. Furthermore, the ivory figure from Pompeii shows that trade also flowed westwards.[19] The Roman historian Pliny the Elder complained bitterly of Rome's being drained of gold because of an unfavourable balance of trade with India.

In the first century CE, the region came under the sway of the Kushan empire. The far-flung territory of Kanishka (*c*.78–101 CE), covering an area from Mathura in north-central India through Gandhara-Bactria up to the borders of China, helped to disseminate Buddhism. Kanishka, its greatest champion since Asoka, became renowned as the patron of the Buddhist intellectual Asvaghosha. Kanishka convened the fourth Buddhist Council at Kashmir and was associated with one of the largest stupas in Afghanistan.[20]

Kanishka's reputation as a Buddhist and his trade with Rome led scholars to believe that Gandhara Buddhas originated in the Kushan empire and were of Roman inspiration. Although some revisionist scholars now believe that Hellenistic Gandhara Buddhas were the first to be created, as early as the first century BCE, it was only in Kanishka's empire in the first century CE that one finds large numbers of Buddha icons [**9**]. During Kanishka's reign, an alternative Buddhist tradition arose at Mathura, a great religious centre. One of the earliest Buddha images found here was that dedicated by the monk Bala [**10**]. Gandhara and Mathura Buddhas, hitherto regarded as culturally inimical to one another, appeared within the same empire.

If both Gandhara and Mathura Buddha images were created in the Kushan empire, how then can we explain the shift from the aniconic to the iconic phase? Some scholars see the appearance of the Buddha icon in the doctrinal changes that followed the rise of Mahayana Buddhism (the doctrine of the Greater Vehicle) during Kanishka's reign. The reverence for the Buddha as having shown the way to salvation was rejected by the Mahayanists in favour of the Bodhisattva (Buddha-to-be), who postponed his own *nirvana* for the sake of suffering humanity. There are, however, objections to the hypothesis that this doctrine of the saviour figure gave rise to the Buddha icon. The Buddha was

**9**

*Bodhisattva Maitreya,* Gandhara, second century CE. Bodhisattva ('the Buddha to be') is represented with elaborate coiffeur, moustache, and personal jewellery, worthy of a prince. But his attributes—*usnisha* (literally turban, the topknot of an ascetic's hair), *urna* (the spot on his forehead), and elongated ears—show him to be superhuman. The Greek sun god Apollo provided the model for Bodhisattva, who appeared like the young sun come down to earth, according to the Buddhist philosopher Asvaghosha. As a great teacher, the Buddha also dons the Greek philosopher's *palliatus* (robe).

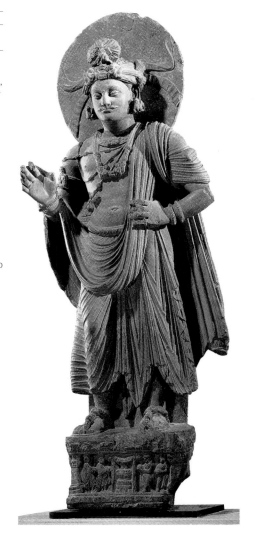

worshipped almost from his lifetime. Furthermore, Bala, mentioned above, was a Hinayana monk, a sect hitherto believed to be hostile to image worship. Even more interesting is the fact that the majority of early monks and nuns were sponsors of images.[21] However, the fact remains that Buddha images became ubiquitous only during Kanishka's rule, when Mahayana had transformed the Buddha ideal. Also, the spread of devotionalism (Bhakti) in around the first century CE, with its emphasis on personal salvation, must have encouraged the use of icons. Finally, the concept of divine kingship prevalent among the Kushans may have encouraged the image of the Bodhisattva as a princely figure.[22]

The Kushan sculptors established clear iconographic conventions for the Buddha and the Bodhisattva and for their *mudras* (language of hand gestures), one of the central ones being the *dharmacakra*

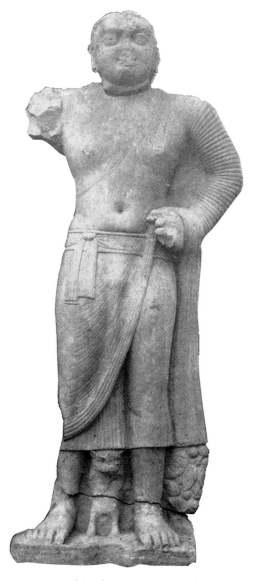

*pravartana* (the first sermon, symbolized by the turning of the wheel of the Law). Gandhara also initiated a new narrative mode, employing 'the frozen moment' of western art that relied on anatomical accuracy, spatial depth, and foreshortening. A rather striking use of western anatomy is to be found in the representation of the skeletal Buddha, whose emaciation was the outcome of his asceticism before his illumination. One must remember, however, that Gandhara made only selective use of western illusionism, melding Hellenistic, Roman, Indian, and Parthian elements.[23] As opposed to Gandharan illusionism, Mathura developed an alternative 'shorthand' narrative mode for depicting Buddha's life.[24]

## The Great Stupa at Amaravati

While Buddha images were being fashioned in North India, the Great Stupa at Amaravati, founded in the Asokan period, was reaching its culminating phase. Amaravati was situated near the capital of the kingdom of Satavahana (in present-day Andhra Pradesh), whose prosperity was based on overseas trade, especially with Rome. The stupa owed its final splendour to the Mahayana monks, wealthy merchants, and a Satavahana queen.[25] Rediscovered by British officials in the nineteenth century on the eve of its demolition, today it survives only in fragments. A happy accident, however, enables us to marvel at the stupa even now. The surviving panels show different versions of the monument, offering a glimpse of what the stupa may have looked like. This 'self-imaging' process has always been an integral part of Indian architecture (see chapter 3). Even though we can never gain a totally accurate picture of the stupa, which evolved over a long period of time, we can at least form a clear impression of its basic design.

Its most noticeable difference from the Great Stupa at Sanchi is in the use of limestone sculptural reliefs to cover the entire dome, creating a shimmering, marble-like effect [11]. We can retrace the pilgrims' path as they entered the stupa through one of the gateways, after gazing in admiration at the roundels of the outer railing decorated with lotus motifs. Once inside the gate, the pilgrims read the sacred tales of Buddhism on the inner face of the railing as well as on the drum during their circumambulation [12] Amaravati contains both early narratives without the human Buddha and those with his human form in the final stages of the stupa, allowing us to observe clearly the transition to the new mode. The drum allowed the creation of long narrative friezes, such as that depicting the Great Departure, now showing the Buddha as a human being.

**11**

The Great Stupa at Amaravati (reconstruction), second century CE.

The face of the drum of the monument and the projecting *ayaka* platform on the west side can be seen through the cutaway section of railing. The decoration of the upper dome is speculative and is based upon contemporary renditions from the drum slabs.

The solid hemisphere, estimated to have been 60 feet in height, was raised on a cylindrical platform 6 feet high and 140 feet in diameter. The stupa was protected by a three-part outer railing, 192 feet in diameter, consisting of 136 lofty pillars and 348 robust crossbars that held up 800 feet of coping stone decorated with flowing garlands borne aloft by humans and animals. Two pairs of lions guarded a 26-foot-wide gateway at each cardinal point. The narrow ambulatory was placed between the outer railing and the drum, with profusely decorated *ayakas* at the cardinal points.

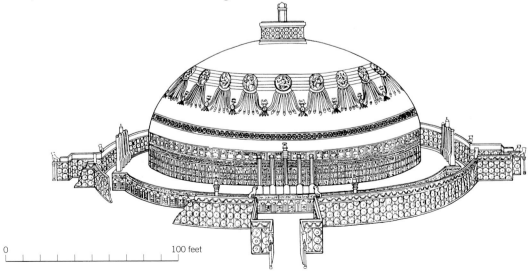

0                           100 feet

*Mandhata Jataka*, inner face of outer railing, the Great Stupa, Amaravati, second century CE.

The treatment of musicians and dancers demonstrates a new complexity in the deployment of figures and composition. Amaravati reliefs exude energy, their composition held together by a flowing narrative, realized through softly modelled figures. At Sanchi we only glimpse the sense of movement that is so characteristic of Indian sculpture, but that here is achieved with greater virtuosity, as expressive possibilities expanded.

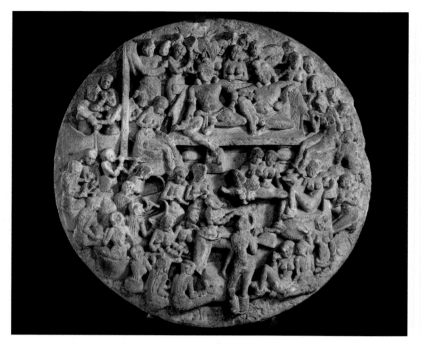

### The Gupta court

The period of the Gupta court (*c.*320–467 CE) is generally regarded as the pinnacle of ancient Indian civilization. Founded by Candragupta I in 320 CE in Bihar, the empire reached its zenith in the reign of Samudragupta (*c.*335–76). The so-called Allahabad inscription details the emperor's conquest of North India and his humiliation of the southern rulers. Some of his gold coins, which portray him as a musician, offer us a glimpse of his personal taste. The Chinese pilgrim Faxian, who visited the empire in *c.*405 CE, was impressed by the Pax Gupta: its stable regime, light taxes, and general sense of well-being.[26]

The Gupta court in the fifth century was adorned by the legendary 'nine gems', including the astronomer and mathematician Aryabhatta, who was the first human known to have calculated the solar year accurately, and Kalidasa, ancient India's greatest poet and playwright. Another contemporary, Vatsyayana, who composed the *Kama Sutra* for the young man about town (*nagaraka*), attests to the urbane way of life in the Gupta empire. A treatise on sexual pleasure, the *Kama Sutra* considers sex as only one aspect, though an essential aspect, of gracious living. Vatsyayana advises that the well-appointed leisure chamber for the cultivated should include not only musical instruments but also 'a painting board and box of colours'.[27] Even more interesting is Yasodharman's commentary on Vatsyayana, the *Sadanga* (*Six Limbs of Painting*), dealing with proportion, expression, representation, colour, and other aspects of the art. A contemporary reference to Gupta images as being 'made beautiful by the science of *citra*' suggests the

existence of aesthetic manuals.[28] Drama and lyrical poetry, written in courtly Sanskrit, reached unprecedented heights. Indian ideas of beauty, especially of female beauty, received their canonical expression in literature and subsequently influenced the visual arts. Ambitious stupas, *viharas*, and *caityas* continued to be raised all over India and beyond, as a complex network of Buddhist patronage stretched from

**13**

Seated Buddha, fifth century CE.

During the Gupta period the Buddha icon became a synthesis of Gandhara and Mathura styles. It is easily recognizable by its perfect oval face, serene smile, dreamy lotus eyes, elongated ears, close-cropped ascetic's hair, slim body, clinging light robe, and elegantly carved halo. The sculptors paid close attention to the fingers (important for the language of gestures or *mudra*), which were rendered with great delicacy. Monks and nuns were in the forefront of those who commissioned Buddha icons for the spiritual benefit of their friends and relations.

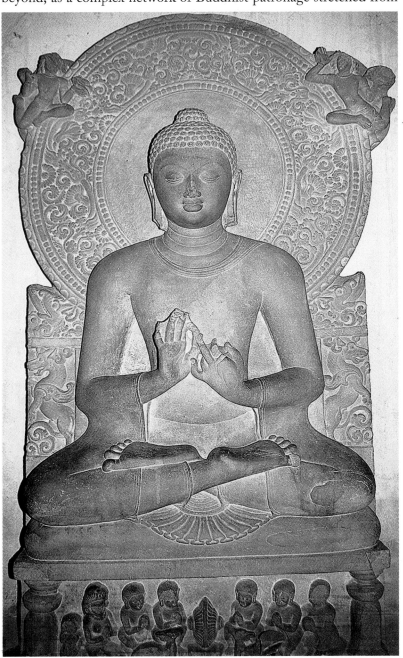

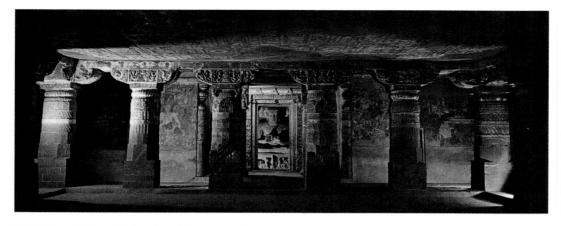

**14**

Cave I, Ajanta, interior, fifth century CE.

The lavish square central hall where monks probably socialized is dominated by the sculpture of a meditative Buddha set in a shrine against the back wall. The other walls are embellished with the Buddhist narrative cycle, including two paintings of the princely Bodhisattva of arresting nobility, their themes of kingship suggesting links with the reign of Harisena.

**15**

*Bodhisattva Padmapani,* Cave I, Ajanta, fifth century CE.

Ajanta painters used chiaroscuro and foreshortening, creating uniform natural light with tonal browns and yellows. Light yellow and white are used to highlight faces, figures, and architectural details and to create 'sheens' on surfaces. These techniques, together with Greek decorative borders, have led some scholars to suggest links with western classical illusionism.

Asia Minor to China along the well-trodden Silk Route, nourished by a thriving international trade [13].

*The Ajanta cave paintings*

In the rock-cut monasteries at Ajanta in the Deccan, narrative painting had been developing over centuries, its most intense and final flowering occurring in the reign of Harisena of the Vakataka dynasty (*c.*460–77 CE). His officials and vassals and Buddhist monks commissioned 20 of the finest Mahayana Buddhist caves. After the collapse of the Vakataka kingdom following Harisena's death, the caves were abandoned until they were rediscovered by the British in the nineteenth century. Literary evidence on Indian painting exists from the ancient period. In addition to the *Sadanga*, one notable work is the sixth-century iconographic text *Visnudharmottaram*, which gives details of landscape and other genres of painting. Fragmentary paintings have also survived at many sites including Ellora, Bagh, Badami, and later southern monuments. But only at Ajanta has enough evidence survived to give us an idea of the scope of ancient Indian painting.[29] The walls of the *viharas* were utilized for large-scale paintings that were harmonized with surrounding polychrome sculptures and ceiling decorations [14, 15].

The artists at Ajanta revel in action, drama, and human emotions. The *jatakas* and the Buddha's life, hitherto realized only in sculpture, are now invested with a new freshness and wealth of detail. One notices the evolution of narrative art from Sanchi to Ajanta, its growing complexity and its deeper exploration of human emotions (as, for example, in the moving story of Nanda's renunciation in Cave XVI), as well as its lively engagement with contemporary subjects and natural phenomena. Cave XVII is one of the most spectacular. The artists paint a storm at sea and a shipwreck in their treatment of the romantic tale *Simhala Avadana*. They also paint a panoramic battle scene, the only one known from ancient India.[30] At Ajanta, even though whole walls are taken as the

painting surface, the painters prefer to develop a series of illusionistic episodes within self-contained areas, each unit presenting a 'frozen' moment. Finally, in the light of such ambitious and carefully planned frescoes, it would be interesting to learn more about artists' workshops and guilds at Ajanta. Varahamihira, for instance, the author of *Brhatsamhita*, a compendium of various subjects including art and architecture, tells us that in social rank artists were placed with lowly musicians and dancing girls.[31] But apart from a general knowledge of ancient Indian guilds we know disappointingly little.

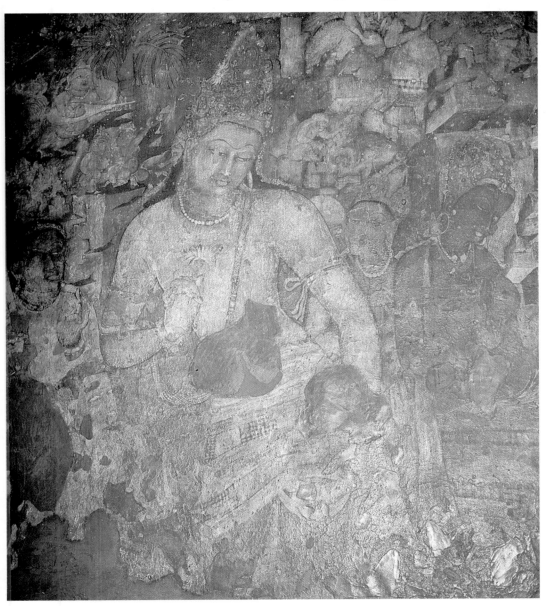

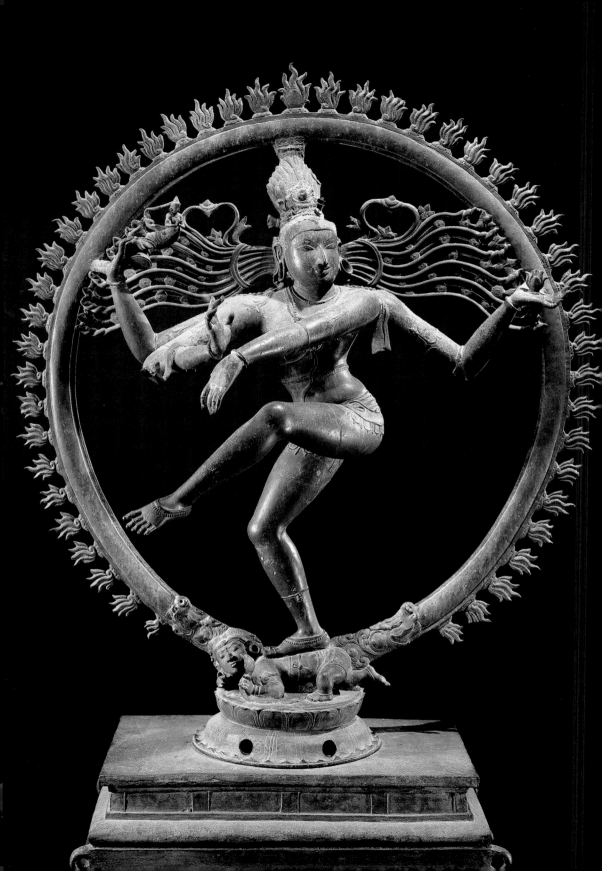

# Hindu Art and Architecture

## The rise of devotional Hinduism

While the Gupta period marked a high point in Buddhist art and architecture, the most innovative ideas were connected with the rise of the Hindu temple, a product of Bhakti or devotional Hinduism. Not only Buddhism, but orthodox Brahmanism too faced a new challenge from Bhakti, which swept across India in about the first century CE. The new Bhakti deities, such as Krsna, an incarnation of Vishnu, made their appearance in the two epics *Ramayana* and *Mahabharata* in around the first century CE, even as their images were being fashioned. The ascendancy of Vishnu, Siva, and Devi, the Great Goddess, heralded the fall of the Vedic gods, who were now reduced to the level of mythological figures. From now on, the three great deities of Hinduism would be solely responsible for human redemption.

A striking feature of Hinduism is the aesthetic vision of the divine as embodied by Siva, the first dancer who sets the universe in motion by dancing [16].[1] Indian classical dance, a form of offering to the gods based on Bharata's *Natyasastra* (second century BCE–second century CE), the key treatise on dance, music, and drama, closely corresponds to Siva's iconography, from the graceful *lalita* dance to the ecstatic *catura*, and ultimately to Siva's dance of death (*tandava*). The temple dancers (*devadasi*) enjoyed a central but ambivalent position in society.[2] In contrast to the social subordination of women in ancient India, the feminine principle embodied in Devi, the Great Goddess, has enjoyed primacy in Hinduism [17]. The subversive undercurrent in the cult of Siva/Sakti will be discussed later.

The sheer numbers and names of Hindu deities are confusing, a reflection of the fact that this dense pantheon is the product of a long evolution, accommodating an enormous variety of religions, cults, and sects. Thus bloody animal sacrifices exist side by side with extreme vegetarianism. The Hindu process of assimilation is a form of syncretism: whenever a local folk or popular deity was politically powerful enough to threaten Brahmanism, it was accommodated within the high pantheon. The syncretic process named the particular deity as an aspect of Vishnu or of Siva/Sakti according to its character [18].[3]

**16**

Siva Nataraja, bronze, Cola period, tenth century CE.

Siva's upper right hand holds an hour-glass-shaped drum, the lower one offers reassurance, the upper left hand displays a flame, the lower left one points gracefully to his raised left foot, while the right foot tramples the demon of ignorance. His elegant locks of hair stream to his sides, while a ring of fire surrounds him. In this image, Siva's cosmic play of creation, preservation, and destruction is visualized as an extended metaphor of the dance.

Devi as Kali, Bengal, late nineteenth century.

Devi, the universal mother, celebrates the feminine in its most emotionally overpowering. Alone among the Hindu goddesses Devi's images range from the graceful beauty of Durga or Parvati [see **33**] to the terrifying hideousness of Kali. In images from Bengal she is naked in her fierce form, standing on the prostrate figure of her consort, Siva.

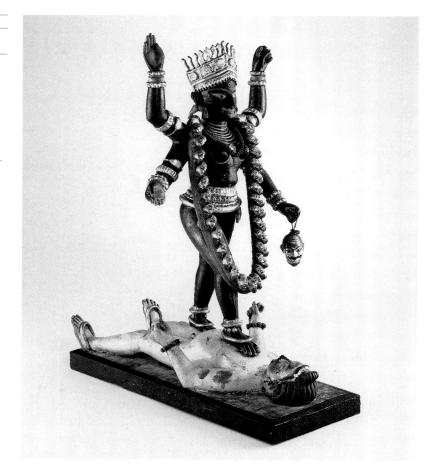

**18**

Five-headed Ganesa with his Sakti, Orissa, tenth century CE.

The elephant-headed god presides over the success of temporal and spiritual projects. The process of incorporating local deities into the high pantheon was not always smooth, as we know from the myth of Siva in which he cut off his baby son Ganesa's head in a fit of jealousy; later in remorse he placed an elephant's head on him. The myth points to the conflicts and ambiguities in the syncretic process.

## The Hindu temple

The Hindu temple is a public institution like a Buddhist *caitya*, but the different priorities of the new Hindu patrons—who did not form a coherent body as did the Buddhists—demanded a different organization of the sacred space, in keeping with the Hindu belief in mystical kinship with God. The temple is literally the beloved deity's dwelling (*devalaya*), a resplendent palace (*prasada*) where his or her needs are faithfully catered to by temple priests. Hindus are not obliged to attend temple services. Nonetheless, the temple is a holy site (*tirtha*), where they can perform circumambulation (*pradaksina*). They also perform the pious act of gazing at the deity (*darsan*) and offer prayers, flowers, and food (*puja*).[4] Even though the temple is never a meeting place for a congregation, in the south especially it came to be a focal point of the community, publicly maintained by land grants, which were often furnished by the ruling powers.

The heart of the temple is the dark, mysterious *garbha grha* (literally 'embryo chamber'), evoking the mother's womb, where one is meant to

feel the 'unmanifest' presence of the deity. From this numinous source flow streams of energy outwards in all directions, a dynamic concept that is central to temple design, as we shall see. The further one moves away from this centre, the less sacred does the space become. Thus depictions of the deity on temple walls are his/her 'manifest' forms

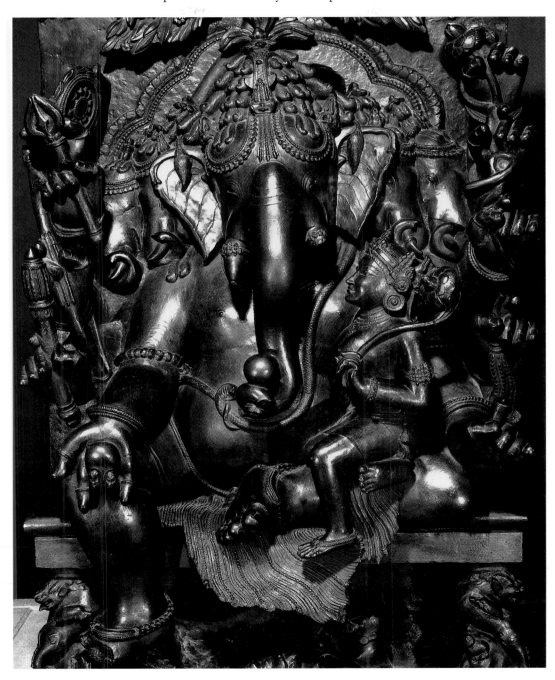

## Glossary of Hindu artistic and architectural terms

*alasa kanya*—'languid maiden', a decorative female figure

*amalaka*—fluted, disc-shaped capstone of a Nagara tower, shaped like the Indian fruit *amla* or *myrobalan*

*antarala*—antechamber to sanctum

*ardhamandapa*—portico of a temple

*bho*—decorative motif in Orissan temples with two dwarfs flanking medallion with monster regurgitating garlands as a front projection on towers

*bhoga mandapa*—hall reserved for the preparation and distribution of consecrated food in Orissan temples

*candrasala*—complex decoration based on the *gavaksa* motif

*darsan*—the auspicious act of viewing a deity or superior personage

*devalaya*—the deity's dwelling, temple

*dikpala*—guardian deities of the cardinal directions

*Dravida*—South Indian, as in Dravida temple type

*garbha grha* ('embryo chamber')—sanctum or shrine

*ghana dvara*—blind symbolic door often containing niche-deity

*ghanta*—bell-shaped finial

*gopura*—high pyramidal gate towers of Dravida temples

*jagamohana*—the *mandapa* in Orissan temples

*kirttimukha* ('face of glory')—lion's head with missing lower jaw as a decorative motif placed mainly over door jambs of temples or on the front part of the tower

*kuta*—an architectural motif in a Dravida temple in the form of a square, domed shrine

*linga*—emblem; Siva's sexual organ

*mahamandapa*—great pillared hall following the *mandapa*

*makara*—decorative motif based on a mythical sea monster

*mandapa*—closed or open pillared hall preceding the sanctum

*mukhamandapa*—main hall of temple

*Nagara*—North Indian, as in Nagara temple type

*nandi mandapa*—a pavilion containing a sculpture of Siva's bull (Nandi), usually fronting a Dravida temple

*nasi*—*gavaksa* motif in Dravida temples

*nata mandapa*—dance hall in Orissan temples

*nataraja*—the 'Lord of the Dance', a Siva image

*pada*—square unit of the *vastu-purusa-mandala*

*pancayatana*—five-shrined temple

*panjara*—vaulted apsidal motif in Dravida temples

*pidha*—roof tier of Orissan temples

*prakara*—high wall enclosing a temple

*prasada*—the deity's palace, temple

*puja*—ritual of worship with flowers, fruits, and food

*ratha*—wall division or projection in the elevation of a Nagara temple

*rekha deul*—sanctum

*sala*—a Dravida architectural motif in the shape of a barrel-vaulted roof

*sikhara*—tower of a Nagara temple (but name for the finial in Dravida temples)

*srikovil*—Keralan form of main shrine

*sukanasa* ('parrot's beak')—a front projection of a tower comprising an image within a medallion, it is a widely used decorative motif based on the *gavaksa* that provides aesthetic relief to the tower's symmetry

*tala*—storey, tier of the *vimana*

*vastu-purusa-mandala*—symbolic ground plan determining architectural proportions

*vastusastra*—architectural text

*Vesara*—mixed temple style combining northern and southern elements

*vimana*—tower and sanctum in Dravida temples

*vyala*—decorative lion monster

Hindus are divided into two rival, but not necessarily hostile, sects. The followers of Vishnu (the Vaishnava branch) consider him as a life-affirming, solar god. The earliest expression of Bhakti is Vishnu's epiphany in the *Bhagavad Gita* where Krsna, Vishnu's incarnation, assures his devotee, Arjuna, of the power of devotion in attaining salvation without the need for Vedic rituals. Later, Krsna becomes associated with the cult of Radha/Krsna and the love between Radha (human soul) and Krsna (God). Vishnu's icons show his consorts, Lakshmi and Bhudevi, on a smaller scale in comparison with him, reflecting Vishnu's origin in the Vedic patriarchal pantheon. By contrast, the Saiva branch is centred on the Siva/Sakti dualism of two equal partners represented by their sacred coitus. Unlike Vishnu, Siva is almost totally faithful to his wife, Sakti, the Great Goddess. She is the active one, *sakti* meaning energy. Siva, the god of paradoxes, is phallus incarnate, but also its opposite, the fiery celibate, underlining the binary opposition between 'indulgence' and 'renunciation'. Siva's sexuality represents life's energy but he is also the lord of death (not lord of the dead, who is Yama, a lesser god). Siva and Sakti are often represented by the *linga* and *yoni*, symbolizing their respective sexual organs; the *linga* and *yoni* together represent their sacred coitus.

The relationship between these three supreme deities and the devotee is mystical. Unlike the Judaeo-Christian God, who is the absolute 'Other' in relationship to humans, these deities, even though transcendental, manifest themselves in human (and animal) forms, a paradox that enables us to relate to them. As arbiters of salvation, they are legitimized by the following formula in the Puranas (sacred texts): the Vedic gods, Indra, Brahma, and others, are periodically threatened by their wicked cousins, the demons (*asuras*). In desperation they seek the help of either Vishnu, Siva, or Devi according to the particular Purana. The saviour deity restores righteousness in the world by crushing that particular demon.

(human and animal), his/her cosmic play (*lila*), less potent than the main icon in the *garbha grha*, and usually combined with other deities. The concept of the 'unmanifest' complements the doctrine of the 'non-dual' in Indian thought. As 'unmanifest' godhead, the central image is invariably either abstract or 'unbeautiful', revealing the otherness of divinity. The installation rituals of Hindu deities go back to the late Gupta text the *Brhatsamhita*. The development of the *Agamas*, ritual texts, and especially the *Pancaratra* (Tantric) system in the fifth century CE, led to elaborate rituals with metaphysical interpretations, which went hand in hand with the rise of Tantric esotericism, a major movement that rivalled Bhakti (see chapter 4).[5]

Gradually, more functional buildings such as pillared halls (*mandapa*) and porticos (*ardhamandapa*) were added to the *garbha grha*, which was surmounted with a tower (*sikhara*). Hindu temples are broadly classified into northern and southern types. The earlier racial classification, Aryan for northern and Dravidian for southern, has now been discarded in favour of indigenous labels, Nagara and Dravida respectively.[6] The distinction rests on the main features: the tower surmounting the sanctum, the ground plan, and the elevation or external walls. The Nagara tower (*sikhara*) has a gently sloping curve,

| | Vishnu | Siva/Sakti |
|---|---|---|
| **Standard image** | **Human** frontal figure holding four weapons or emblems (discus, lotus, mace, and conch shell). (Later *Pancaratra* texts elaborate icons such as four-headed (man, boar, lion, and horse) Vishnu as Vaikuntha, and a horse-headed incarnation, Hayagriva.) **Aniconic** *saligrama* (pebble-like formless stone) | **Human** form holds the trident (*trisula*) or occasionally a battleaxe or bow and arrow <br>• Ardhanarisvara (androgynous image) <br>• Kalyanasundara or *anugraha murti* (benign, graceful image) <br>• Samhara murti (fierce forms such as Bhairava) <br>**Aniconic** *linga* (either a phallus with 1–5 faces carved on it or the sacred coitus of Siva/Sakti (*linga–yoni*) as in the Siva temple at the holy city of Benares) |
| **Emblematic animal** | Garuda, a vulture-like eagle | Nandin, a bull |
| **As saviour god** | Ten incarnations in ascending order: **1** Matsya (fish); **2** Kurma (tortoise); **3** Varaha (boar); **4** Narasimha (man–lion); **5** Vamana (dwarf); **6** Parasurama (Rama of the Axe); **7** Rama (hero of the epic *Ramyana*); **8** Krsna (of the *Bhagavad Gita,* regarded as the only full incarnation or God on earth); **9** Buddha; **10** Kalkin (the future equestrian incarnation before the world's dissolution) | • Siva Andhakasuramurti/Gajasuramurti (destroyer of the demons Andhaka and Gaja) <br>• Siva Tripurantakamurti (destroyer of the Demon of the Three Cities) <br>• Siva Ravananurgahamurti (Siva forgives Ravan) <br>• The Descent of the Goddess Gaga (Ganges) <br>• Lingodvaha (a southern form in which Siva emerges out of a massive *linga* whose extent cannot be fathomed by Vishnu's bear incarnation or Brahma in the form of a goose |
| **Other forms** | **As creator** sleeps, shaded by the serpent of time (*sesa/Ananta* = 'end/endless') on the waters of oblivion after the universal flood. Brahma, the first man, who springs from his navel, is actually the creator with Vishnu's permission | **Dancing forms** <br>• Nataraja (King of the Dance) as creator dances to the end of time as the world collapses in a conflagration before its renewal <br>• Dancer of Katisama and Lalita, measured dances <br>• Tandava dancer (violent dance) <br><br>**Sakti, the Goddess, or Devi, Siva's partner as saviour deity** <br>• The Goddess as Durga Mahisasuramardini, the destroyer of the Buffalo Demon, rides on a lion <br>• The Goddess as Parvati, the beautiful daughter of Himalaya <br>• The Goddess as Kali, the fierce black one <br>• Devi has the hideous Seven Mothers as her companions |
| **Family** | *Two wives:* Laksmi (goddess of wealth) and Sarasvati (goddess of learning) or sometimes Bhudevi (earth goddess). The smaller human size of the wives in relation to Vishnu indicates their lesser importance. The most famous legend is the love between Vishnu's incarnation Krsna and Radha (human soul) | Siva and Parvati are a faithfully married couple; scenes of their marriage and gambling are often depicted in art <br><br>**Siva and Devi's children** Laksmi (goddess of wealth), emblematic animal: owl <br>• Sarasvati (goddess of learning), emblematic animal: white Himalayan goose <br>• Karttikeya (general of the gods, called Subhramania in the south), emblematic animal: peacock <br>• Ganesa (the elephant-headed god), emblematic animal: rat |

**19**

Bhakti deities and their genealogies

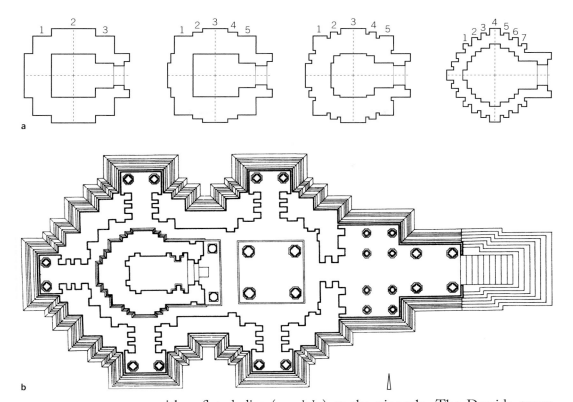

**20**

Nagara or North Indian temple type.

**(a)** Evolution of the North Indian ground plan of the *garbha grha* from the simple square with three projections (*tri-ratha*) to seven projections (*sapta-ratha*), ultimately forming star-pattern ground plans.

**(b)** The highly developed and complex Kandariya Mahadeva temple at Khajuraho, based on a *sapta-ratha* plan [see also **45**]. In Nagara temples, if we take the simplest elevation of a triptych of projections and recesses (*tri-ratha*), the locus of the deity would be the niche in the middle projection. Dravida elevations, on the other hand [**21**], consist of niche deities framed by entablatures that break the wall surface at regular intervals. The ornamentation essentially follows the contours of the temple walls.

with a fluted disc (*amalaka*) at the pinnacle. The Dravida tower (*vimana*) follows a dome and cornice pattern like a pyramid with diminishing tiers (*tala*), crowned by a square, polygonal, or round dome. The Nagara elevation consists of a series of projections (*ratha*) and recesses, whereas the walls of Dravida temples are superficially similar to European buildings in being broken up by images within entablatures at regular intervals [**20, 21**]. However, temples in a number of culturally distinct regions, such as Kashmir, Bengal, and Kerala, evolved their own variations on the canonical form. The temple is oriented in eight cardinal directions, each direction presided over by a deity (*dikpala*), though this is not always depicted. It is separated from the mundane world by a high, often richly moulded plinth. In South India, the temple is enclosed by protective walls with gate towers (*gopura*) marking the entrances. The architectural texts (*vastusastra*) from the fifth century onwards tend to use the metaphor of the body for the temple, while the tower is imagined as the cosmic mountain Meru or, in temples to Siva, as his mountain fastness, Kailasa.

### Architectural materials

Among the appealing aspects of Indian architecture is the use of a wide variety of materials, such as wood, brick (many examples of both being

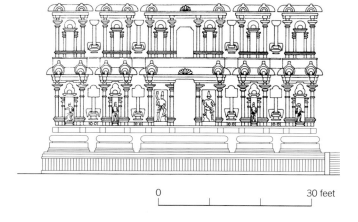

A  Sanctuary (*garbha grha*)
B  Ard hamandapa
C  Mahamandapa
D  Nandi mandapa
E  Gopura
F  Shrine of Subrahmanya

0 ⊢————————⊣ 30 feet

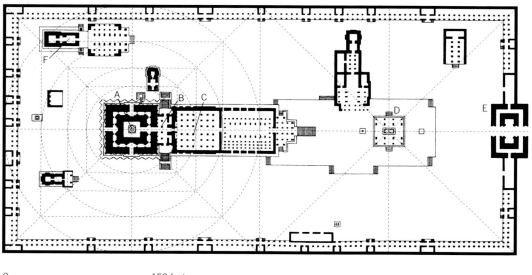

0 ⊢————⊣ 150 feet

**21**

Dravida or South Indian temple type.

As the ground plan and elevation of the great Brhadisvara temple at Tanjavur demonstrate, South Indian temple walls do not project outwards like North Indian ones but contain a series of niches placed at regular intervals along the walls, cf. **20**.

now lost), terracotta, and a variety of stone, ranging from pale yellow to red sandstone to grey granite, black schist, soft green chlorite, and brilliant white marble. Also distinctive, and unique to India, was the method of building by placing dressed stone horizontally. Since mortar was rarely used, the stonemason's art of cutting stone slabs with precision assumed major importance, as it did also in the long tradition of rock-cut architecture. These methods are sometimes seen as 'primitive' because they do not conform to European criteria, but their achievements are evident in the vast range of magnificent edifices they have produced.

## Principles of architecture

Canons of Hindu architecture came to maturity around the tenth century in the great temples of the north and the south. Western norms are so deeply entrenched in art history that they are taken to be universally applicable and any deviations from them are regarded as aberrations. Hence we need to be clear about the actual principles governing the design and construction of Hindu temples, so that we can appreciate their aims and achievements based on their own criteria, rather than on extraneous ones. The Indian outlook on architecture was so different from the European that art historians have found difficulty in categorizing its forms. When scholars complain that Indian architecture is uninventive, they tend to confuse the 'language' of Indian architecture with its application. In western architecture, the language is often a given, as for instance, the Graeco-Roman language of orders, which hardly changed over millennia. Yet much rich architecture came out of this vocabulary in the West. Similarly, within the conventions adopted by Indian architects, there was a great deal of novelty and development even though a conscious ideology of progress did not inform their work.

As the use of western art historical terms is inappropriate to Indian architecture, scholars have begun using Indian terms derived from indigenous texts.[7] However, some western terms remain in use in the face of difficulties, partly because Indian terms differ according to the region. Secondly, discrepancies between theory and practice in indigenous texts may escape our notice. One architectural treatise classifies the soil on which houses should be built: white soil for Brahmins, red for Ksatriyas, yellow for Vaisyas, and black for Sudras.[8] Such impractical advice was given not by architects but by Brahmanical theoreticians, as part of social control.

In Hindu architecture, the beauty and complexity of geometric design, whose underlying principle is harmony, comes into play. Buddhists prefer the circle, but in Hindu temples the square is the perfect shape for the ground plan. The *Brhatsamhita* mentions rare cases of circular and octagonal temples [22]. This compendium, which dates from the sixth century CE and is the earliest text on temples and images, selects two ideal ground plans, based on the grid systems of 64 (8 x 8) and 81 (9 x 9) squares.[9] However, the ultimate choice of auspicious proportions for the Hindu temple depended upon further astrological calculations that left a remainder of a fraction. Finally, the underlying connection between sexual rites and fertility in Hindu architecture is emphasized during the consecration of South Indian temples.

## The role of ornament

The most striking feature of the Hindu temple is its external ornamentation, which is mainly confined to towers and elevations. In

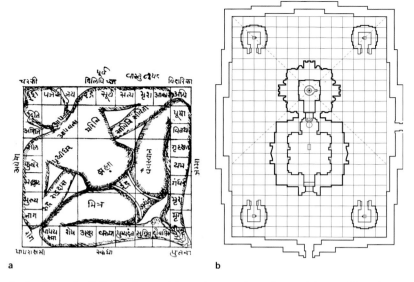

**22**

**(a)** The *vastu-purusa-mandala*.

**(b)** Ground plan of a Hindu temple built on a square grid. A myth explains the symbolic diagram (*mandala*): the gods, in seeking to impose order on chaos, forced the primeval man, Purusa, into a square grid, the *vastu-purusa-mandala*, whose basic unit is the square *pada*. The concept is similar to the theory of proportion in Renaissance architecture: the harmonic proportion resulting from a repetition of the essential parts of a building, of the same geometric pattern.

a          b

designing a building, the architect has to face the problem of breaking up the wall surface, usually with windows and decorations. In a Hindu temple, the three walls other than on the entrance side are decorated as part of an integral plan, the architect being guided by the Hindu texts, which describe these three sides as blind doors (*ghana dvara*), symbolic exits marking emanations of the deity. The *ghana dvara* is often visualized as a niche shrine containing a deity.[10]

Ornament plays a central role in Indian civilization. Classical Sanskrit delighted in similes, metaphors, puns, ironies, alliterations, and other literary effects. The Sanskrit verb *alamkar*, to decorate, literally means 'to make enough'. Ornament was a *sine qua non* of beauty in India, and things lacking in ornament were considered imperfect or, more precisely, incomplete.[11]

Temple ornamentation ranges from narrative reliefs to animal, floral, foliate, and geometric designs, all forming a coherent part of the relief stonework. And none is more germane to temple design than repetitive motifs based on architectural details, particularly the myriad patterns derived from the Buddhist *caitya* window (*gavaksa*). In the north, the *gavaksa* was transmuted into intricate honeycomb patterns, creating a rich lace-like surface texture. The south used variations on the *gavaksa* known as *kuta*, *nasi*, and *panjara* as well as profiles of barrel-vaulted *caityas* (*sala*). In the north, two further motifs, derived from the *sikhara* and the *amalaka* capstone, were used to considerable effect.

These repetitive motifs, be they *kutas* and *salas* in the south or *sikharas* and *amalakas* in the north, obey clear geometric rules. Western classical architecture's emphasis on the façade contrasts directly with the Hindu temple, which is conceived three-dimensionally. It is a curious paradox that temples such as the Kandariya Mahadeva at

Khajuraho [**20b**] can only be fully appreciated today by being viewed from the air. Also, the Hindu decorative motifs are not merely surface configurations, but are themselves conceived three-dimensionally, so that they emerge out of the very core of the sanctum in a series of cascading forms [**23**]. The symbolism behind the Hindu temple is

**23**

Visva Brahma temple, Alampur, seventh century CE. As the axonometric diagram shows here, the *amalaka*-topped shrine in each corner, which reproduces in miniature the main *sikhara* form of this Nagara temple, represents symbolic three-dimensional emanations of the core form of the temple on its four façades.

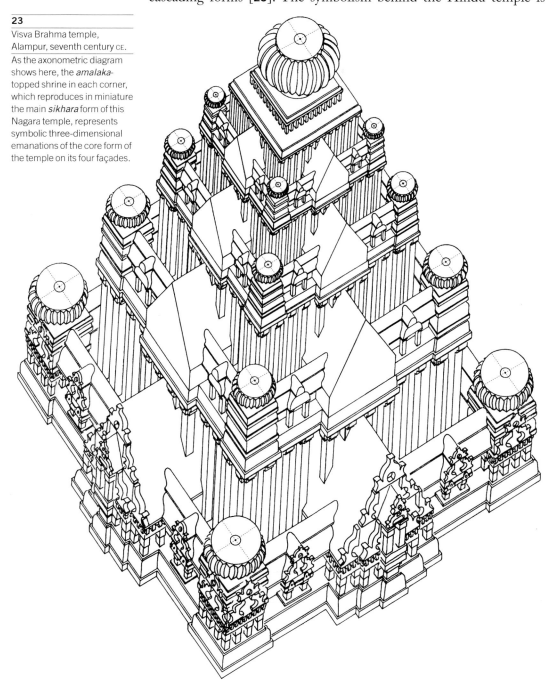

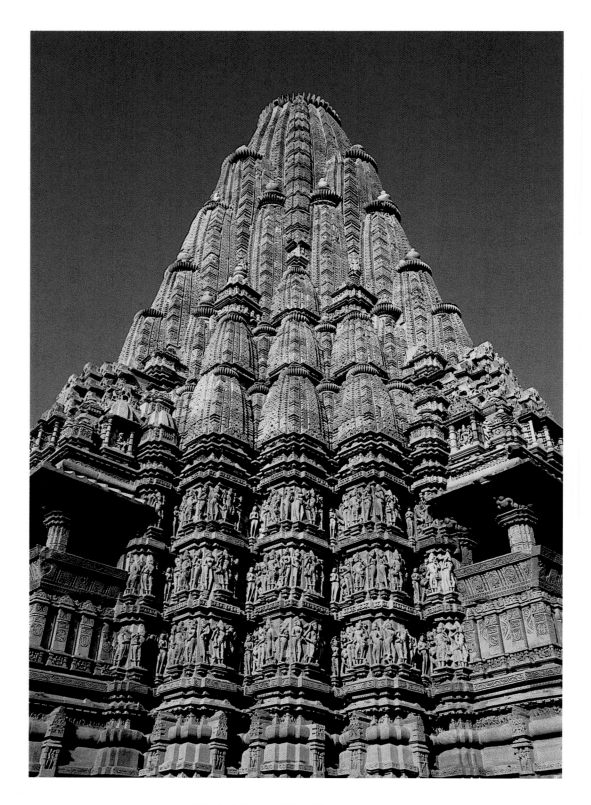

The *sikhara* of Kandariya
Mahadeva (Siva) temple,
Khajuraho, eleventh century
CE.

The *sikhara* incorporates a
clustering group of 84 smaller
towers, embedded at the
bases of projections, providing
a summit for each of the wall
projections beneath. Sharp
projections and deep recesses
create a dazzling interplay of
light and shadow under the
strong Indian sun. The
Kandariya represents the
apogee of architectural 'self-
imaging' in an orderly interplay
of fractals.

explained by Stella Kramrisch, who argues that it is a manifestation of the deity in which divine energy radiates in different directions from the *garbha grha*. The fragmentation and proliferation of motifs on the elevation may be characterized as the external expressions of this emanation, embodied in the niche shrine mentioned above.[12]

Hindu designers developed a system which can best be explained by the concept of 'self-imaging' developed by modern chaos theory. To offer an analogy, if one slices a cauliflower into two, the cross-section of the florets will resemble a series of miniature cauliflowers. These so-called fractals are 'self-same' in that they will look the same on every scale. Many of the greatest Hindu architects develop this geometric principle of nature with remarkable virtuosity [**24**].[13] Hindu temples were products of invention and experiment, of conscious choices, problem solving, and accumulated technical experience. They were the collaborative work of many individuals, led by chief architects and master sculptors who ran workshops and were well versed in the different arts and in the *vastusastras* and *silpasastras*, and under whom there were numerous non-literate assistants and ordinary labourers.

Full-blown Hindu temples, incorporating the principles described above, took many centuries to evolve. The process can be divided into two conceptually self-contained periods: an experimental period from the fifth to the eighth centuries CE, when there was an absence of consensus about the canon, and when rock-cut temples vied with structural ones, the former developing complex narrative sculptures; and a period of consolidation from the eighth to the eighteenth centuries, when the widely disseminated canon became the essential template for builders and patrons. This was when narrative art gave way to cult icons, as structural temples totally superseded excavated ones. Within this broad framework, architecture developed differently in different regions, each producing its own chronology of temple development, each providing different bits of the great chronological jigsaw.

## The age of experimentation (fifth to eighth centuries CE)

### The Gupta beginnings

The Gupta period (320–467 CE) stood at the intersection of two traditions: the maturity of Buddhist art and the genesis of the Hindu temple. Professional builders, assigned the new task of creating Hindu edifices, turned their knowledge of Buddhist architecture to advantage. Not only the *caitya* window motif (*gavaksa*) but the rock-cut shrines themselves inspired some of the finest Hindu excavated temples and narrative art as late as the eighth century, even though structural temples were assuming increasing importance. The first

Hindu monument was discovered at Besnagar, a pillar dedicated to Vishnu by the Greek Heliodorus in *c.*120 BCE, while the phallic Siva at Gudimallam in South India was carved in *c.*80 BCE. By the second century CE, flourishing workshops at the Kushan religious centre of Mathura were fashioning Hindu images. However, the most striking account of a sculpture of a Hindu god comes from a foreigner, the fifth-century Christian author Bardesanes:

They [Indian ambassadors] told me further that there was a large natural cave in a very high mountain … where there is a statue 10 to 12 cubits high … the right half of its face was that of a man and the left that of a woman … in short the whole right side was male and the left female … the two dissimilar sides coalesced in an indissoluble union … though not wood it most resembled wood, quite free from rot.[14]

The description leaves no room for doubt that the great androgynous deity is Siva, while the natural cave described here confirms the existence of rock-cut temples (see below).

The germ of the Hindu temple is taken to be the rudimentary flat-roofed temple No. 17 at Sanchi consisting of only a shrine, ascribed to the Gupta period. Yet another Gupta edifice, the Bhitargaon temple, shows great advances: it had a high northern tower, the three-part projections on its walls contain niches with images, while its terracotta *makara* and *candrasala* decorations faithfully follow the *Brhatsamhita*, the late Gupta text.[15] The identification of these two temples displaying extremes of technical knowledge as being in the Gupta style has raised the question of how meaningful this label is. Although the dynastic label is useful in the absence of dated temples, the frequent equation of the Gupta 'golden age' with artistic perfection is problematic as we know very little about direct royal patronage. Few

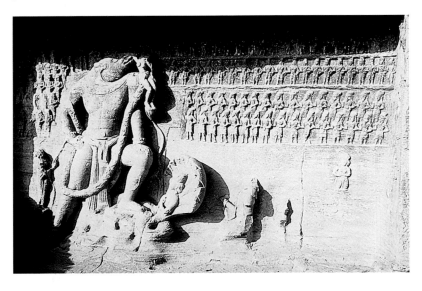

**25**

Vishnu's boar incarnation, Udaigiri, fifth century CE.

This monumental vision of Vishnu's boar incarnation, one of 10 incarnations, was inspired by the sacred text the *Matsya Purana*, which describes him as full of lustre like the sun, lightning, and fire, raising up the earth goddess on his tusk from the nether regions underneath the ocean. The artist captures with great skill this cosmic drama of Vishnu saving the earth, as witnessed by spellbound sages, his devotee Sesha the serpent, and other mythical creatures.

**26**

Vishnu Anantasayana panel, south side, Dasavatara temple, Deogarh, sixth century CE.

Sleeping Vishnu floats on the waters of oblivion, cradled by the serpent Sesha/Ananta (literally 'end/endless'), the paradox being emblematic of time. Brahma, who sits on a lotus sprouting from Vishnu's navel, creates the universe on his behalf. Vishnu's wife Lakshmi massages his right foot, flanked on her left by Vishnu's emblematic animal, Garuda. Personifications of Vishnu's weapons give battle to the demons Madhu and Kaitabha below, while his other wife, Bhudevi, stands on the far right. This cosmic spectacle is watched by other gods.

monuments, if any, bear any dedication by the emperors. Nor do 'Gupta temples' coincide with the lifespan of the dynasty. The label 'Gupta style' is thus less helpful in tracing the evolution of temple architecture than other clues, such as the development of architectural parts, notably doorways, pillars, and bases. The transmission of styles from the second-century workshops in the Kushan centres of Gandhara and Mathura to regional workshops has been proposed as a more fruitful tool in tracing the evolution of the Hindu temple as a continuous process.[16]

One of the most impressive Hindu shrines of the Gupta period, to Vishnu's boar incarnation, was carved out of the rock face at Udaigiri in Malwa [**25**]. Vishnu as the cosmic boar saving the earth from the ocean was possibly a political allegory of the conquest by the Gupta emperor Candragupta II (376–415 CE) of the Scythian kingdom of Malwa on the west coast. Not only did the conquest complete Gupta control of northern India but it also gave them access to the lucrative Mediterranean trade.[17]

The elegant, though damaged, sixth-century Dasavatara temple at Deogarh, built at the end of the imperium, illustrates the achievements of Gupta art and architecture. A west-facing, five-shrined (*pancayatana*) temple, its main shrine is placed on a sculptured plinth, reached by a flight of steps on each of its four sides. The recognizable Gupta feature is the 'T-shaped doorway', which provided inspiration for later Hindu temples. An unusual aspect of Deogarh is the set of three framed niches, one on each of three sides, each containing a relief of Vishnu as a saviour god. These niches were used to narrate Puranic stories for the pilgrim's benefit. The south niche, which depicts Vishnu dreaming a new aeon into existence after its cyclical dissolution, is the most striking, its importance emphasized by the Ganesa on its left side [**26**]. The image of Ganesa, whose blessing is essential for success in all

temporal and spiritual undertakings, marks the commencement of the pilgrim's ritual circumambulation in a Hindu temple. In this unconventional west-facing temple, however, Ganesa is on the south side, which suggests that pilgrims would circumambulate in an anticlockwise direction.[18]

*Regional art after the Guptas (sixth to eighth centuries)*
The Gupta empire, which had offered temporary political cohesion to North India, rapidly disintegrated in the wake of inroads made into the subcontinent by the Hunas from Central Asia, although Harsha (606–47 CE), the last North Indian emperor, maintained some semblance of unity during his lifetime. The political fortunes of North and South India diverged, bringing to the fore the regions and their art. While Buddhism was shrinking elsewhere, it remained important in Bihar and Bengal, where enormous monasteries thrived until the thirteenth century.

The next stage in the evolution of the Hindu temple took place in what was the south of the Gupta empire, namely the Deccan plateau, where four rival dynasties competed for hegemony in the seventh century, but none could maintain a permanent hold over the region. The Kalacuri dynasty dominated the coast around Maharastra, the 'Early Western' Calukyas of Vatapi controlled Karnataka and the Deccan, while the Pallavas from Tamilnadu in the south-east periodically threatened their more northerly neighbours, the Calukyas. Finally, in the eighth century, the Rashtrakuta kings enjoyed a brief supremacy over the region.

During this period, monuments to Vishnu gave way to Saiva ones (dedicated to Siva) in large parts of India, partly because of the influence of the saint Lakulisa, founder of the Pasupata sect. Born in Gujarat in around the first century CE, Lakulisa soon emerged as the most important Saiva saint.[19] Pasupata iconography drew upon stories of Siva as the saviour god in the *Linga Purana*, a major Saiva text. Craftsmen who had worked at Ajanta during the Vakataka ascendancy emigrated southwards as the demand for Hindu art and architecture expanded there. Rock-cut monuments continued to hold their own alongside structural temples.

Ambitious temples built in these different kingdoms in the Deccan and Tamilnadu have many common features as well as differences, which raises questions of transmission of styles. The prevalent explanation is that the rulers adopted each other's styles, sometimes in admiration, but often the appropriation of a style symbolized victory over an adversary. However, the diffusion of styles through interactions between rulers has been challenged as being simplistic. The suggested alternative is the spread of styles via craftsmen who moved from one regional workshop to another in search of work.[20]

**27**

Durga temple, Aiholi, eighth century CE.

Commissioned by a private individual named Komarasengama, its apsidal form was identified as Buddhist by earlier historians, though the form is now known also to have been used by Jains and Hindus. The *garbha grha* is surrounded by two ambulatory passages, including an outer colonnaded one. The temple rests on a high moulded plinth. The damaged three-projection Nagara tower, previously interpreted as an afterthought, is now accepted as part of the original structure.

## The Early Western Calukyas of Vatapi

The first temples in the Deccan were built in the four capitals of the Early Western Calukya dynasty, founded in 543 CE. Aiholi, Vatapi (modern Badami, in Karnataka), Pattadakal, and Alampur were all embellished with sacred buildings and bathing tanks made of locally quarried sandstone. The setting of the Badami temples on an artificial lake and with a massive bare boulder as a backdrop is particularly arresting. The very earliest temples were the excavated royal shrines at Aiholi and Badami, which can be linked to earlier rock-cut monuments in the Deccan. In the seventh century, a large group of Calukya structural temples were built with a wide variety of tentative ground plans, revealing the designers' uncertainty as to where to place the *garbha grha*. At Aiholi, the first capital, for instance, the experimental Lad Khan temple (*c.* seventh century) is a square pavilion resembling a thatched village hall, with the sanctum added as an afterthought. Although attractively decorated, it conveys the overall impression of heaviness, its massive walls carrying the weight of the stone roof [**27**].[21]

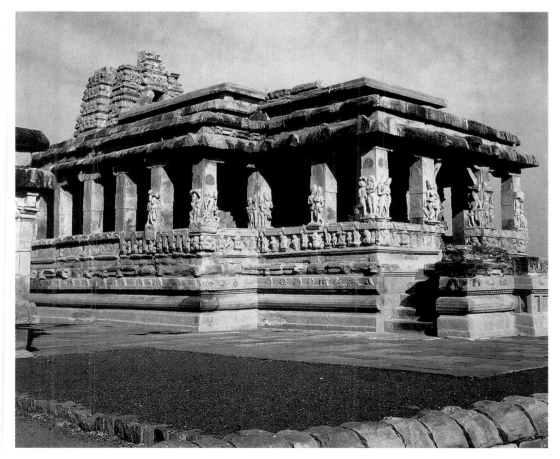

The final Calukya capital, Pattadakal, exhibits the maturity of this style. Despite seven temples out of a hundred being lavishly endowed by members of the royal family, no ruling monarch directly commissioned a temple. The Calukya kings seem to have been reluctant to declare such public institutions as their personal property. Two major temples, Sangamesvara and Virupaksha, express architectural self-confidence, by now clearly enunciating the main features of a Hindu temple, namely the sanctum and the front hall preceded by a portico. They were commissioned as thanksgivings by the queens of Vikramaditya II, the two Kalacuri princesses, on the occasion of the king's victory over the Pallavas. The grandest, Virupaksha, was dedicated by Queen Lokamahadevi in *c.*740 CE in celebration of Vikramaditya's third conquest of the Pallavas. Not only do we know the name of the architect, but even the sculptor signs his work, a rare expression of artistic individualism in ancient India [**28**].[22]

Virupaksha's portal shows how temple entrances had undergone further elaboration since the Gupta period, giving a new prominence to the door guardians. The crowning beauty of its southern, tiered tower is a *sukanasa* with a dancing Siva, which serves as a crest in front of the tower and provides aesthetic relief to the symmetry of the tower. The exterior walls of the temple contain 35 niches with sculptures based on myths of Siva. It is finally enclosed by a high wall in the southern fashion, with 30 sub-shrines and an incipient *gopura*. The *nandi mandapa*, an elegant pillared pavilion which shelters a sculpture of Siva's bull, Nandi, was yet another southern invention.[23]

## The Pasupata rock sanctuaries at Ellora and Elephanta

By far the greatest Hindu narrative sculptures of the experimental period were completed in the rock sanctuaries of Ellora and Elephanta

**28**

Virupaksha (Siva) temple, Pattadakal, eighth century CE. Of red sandstone, it is served by an internal ambulatory. The 16-pillared front hall (*mandapa*) is noticeably wider than the sanctum (*vimana*), this being emphasized by pillared porches projecting from the hall. Because of the temple's importance to the community, its inscriptions set out the rights and obligations of the individuals involved in maintaining it. Inscriptions on durable material such as stone or metal served as legal documents in India.

in Maharastra. A major pilgrim site since the early Buddhist period, Ellora shared the same artistic tradition as Ajanta, as is suggested by its pillar capitals and figure sculptures.[24] From the seventh century onwards, the same artisans were employed by Hindu patrons at Ellora. Although some outstanding Vaishnava art exists at Ellora, the greatest narrative projects were inspired by the Pasupata worshippers of Siva from the surrounding regions. Stories of Siva the redeemer, chiefly based on the *Linga Purana*, gave rise to a highly dramatic form of sculpture.

An outline of the evolving themes in Kalacuri, Calukya, and Pallava monuments might help us grasp the underlying structure of early Hindu narrative art as well as throw light on Pasupata patronage. These were, first, Siva's four saviour personae, as seen in his destruction of the demons Andhaka and Gaja and the demon of the Three Cities; his granting of grace to the demon Ravana; and his assisting the descent of Ganga (the river Ganges). Secondly, there were scenes from Siva and Parvati's domestic life, namely their marriage and the game of dice. Thirdly, there were Siva's dancing forms, which are the most ubiquitous in India, and can be found in Caves, 14, 15, 16, and 21 at Ellora. The myth that tested the artist's skill and imagination to the utmost was Siva's destruction of Andhaka. In Cave 15, the power and frenzy of the eight-armed Siva, who impales the demon on his trident, is evident even in its damaged state.

In 540–55 CE, on the island off the coast of Mumbai (Bombay) named Elephanta by the Portuguese in the sixteenth century, a Siva temple, displaying a remarkable unity of artistic conception and execution, was completed. The Kalacuris, the reigning dynasty, were Pasupatas but there is no direct evidence of their involvement in Elephanta. This ancient site may have originally contained images of perishable material but because of its great sanctity this ambitious and durable temple complex was eventually built.[25] The temple adapts the Buddhist *vihara* of the Ajanta type, with a central hall and a shrine placed against the rear wall. Unlike Ellora, where the sculptural panels are treated individually in the caves, here at Elephanta the temple and its iconographic programme form part of a coherent whole [**29, 30, 31**]. There is a strong suggestion that the plan was provided by a Pasupata patron.[26]

If Elephanta offered a compelling vision of Saiva mythology, the Kailasanatha temple (known as Cave 16) at Ellora was an edifice of great power and nobility, an architectural wonder. The designers fashioned an entire temple out of the living rock, in emulation of Siva's mountain fortress, Kailasa. To sustain the Kailasa illusion, they even carved under the temple the scene of Ravana being trapped by Siva under his mountain seat.

A project that necessitated the organization of resources on such a

0 — 75 feet

Key to the sculptures at Elephanta

**Main hall**

| | | | |
|---|---|---|---|
| 1 | Ravana | 6 | Marriage |
| 2 | Gambling Scene | 7 | Andhaka |
| 3 | Androgyne | 8 | Siva Dancing |
| 4 | Eternal Siva | 9 | Lord of Yogis |
| 5 | Ganges | | |

**West wing shrine**

10 Lord of Yogis
11 Siva Dancing

**Main hall shrine**

12 Linga

grand scale was intended by the short-lived Rashtrakuta dynasty to be a political statement, as an inscription on the temple makes clear. In 753–4 CE, Dantidurga made Ellora his capital soon after asserting his supremacy over the Calukyas. His successor, Krsna, who humiliated the other great power, the Pallavas, celebrated his triumph by commissioning this Siva temple, an undertaking that took 15 years and was completed just before his death. Craftsmen from neighbouring Calukya and Pallava regions enriched Kailasa with their expertise.[27]

The interplay of the temple's massive yet simple forms and delicate reliefs is remarkably effective [**32**]. The architects carved the temple out of a huge boulder, first separating it from the surrounding rocks and then possibly working from the top downwards, thus avoiding the need for enormous scaffolding. Its unusual design was prompted by the desire to create a powerful visual effect within a confined space. In order to prevent the temple from being perceived all at once, a lofty and solid front screen conceals it from view, forcing one to enter

**29**

Plan of Siva temple at Elephanta, sixth century CE.

The unique plan of this temple shows close links between architectural design and iconographic programme. The temple's east–west path leads to the non-manifest *linga* in the sanctum, while the north–south route ends in the great Eternal Siva image on the rear wall [**30**]. Nine prominent narrative panels on key themes, based on the *Linga Purana*, are placed along the ambulatory path to remind the pilgrim of Siva's play (*lila*) in his human forms. His dual nature— male/female, tranquil/fierce, dancing/reposeful, creator/destroyer—is expressed in contrasting pairs of images: the north wall displays Siva's dancing and ascetic forms; the west and east walls have his saviour figures, granting grace to Ravana and slaying Andhaka [**31**]. The domestic themes of Siva and Parvati's marriage and the gambling scene also face each other. Finally, Siva androgyne and the descent of Ganga (Ganges) are placed on either side of the great three-faced Siva image.

**30**

The Mahesamurti, Elephanta, sixth century CE.

The Eternal Siva's central impassive face is a sculpture of great nobility and expressive power. It is complemented by the feminine (*vama*) on the left and the fierce (*aghora*) on the right. The image has been known in the West since the sixteenth century as the 'Indian Trinity'.

through its modest central opening. Once inside, pilgrims found themselves in an excavated area shut in by sheer rock faces and cave temples. To enhance the effect of grandeur, the whole temple is placed on a 27-foot-high base with the actual temple laid out on the upper level. The king personally engaged a sculptor named Baladeva to contribute to the project, though his work cannot be isolated from that of other sculptors. Among the wealth of sculptures, one in particular engages our attention: the myth of the goddess Durga destroying the Buffalo Demon is one of the most animated treatments of the theme [**33**].

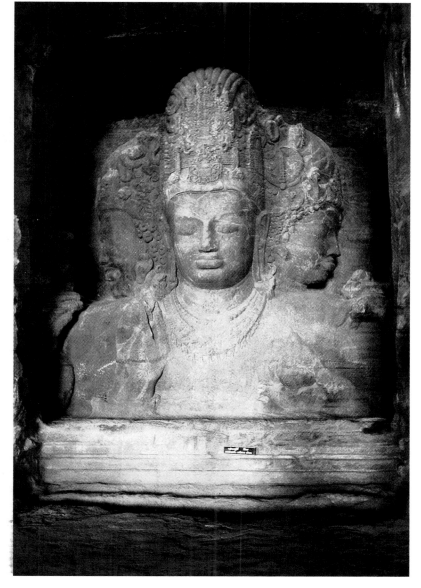

**31**

Siva, slayer of the demon Andhaka, Elephanta, sixth century CE.

This sculptural group is arresting in its restrained ferocity. In the myth, the demon Andhaka was virtually invincible, for thousands of Andhakas sprang up the moment a drop of his blood fell on the ground. Siva destroyed him by lifting him up and placing a bowl under him to collect the blood from his wounds before it fell to the ground. In this cosmic act, Siva was aided by the frightening Seven Mothers. The iconography alludes to an additional myth: the slain elephant demon's skin acting as Siva's veil behind him.

### The Pallava temples of Tamilnadu

The earliest temples in Tamilnadu in South India were built by the Pallava kings, who originated in Andhradesa. They sent expeditions to Sri Lanka and traded with China and South-East Asia. Their capital, Kanchipuram, a major cultural centre, was visited by the Chinese pilgrim Xuanzang in the seventh century.[28] Royal patronage in Tamilnadu was systematic and ideologically oriented. Pallava monarchs sought to legitimize their rule by naming specific royal temples after themselves and declared their allegiance to Siva by adopting the Somaskanda iconographic type (showing Siva with his wife Sakti and son Karttikeya) as their dynastic emblem.[29] Gradually, a complex relationship grew up between temple, king, and community.

The first Pallava temples were cave shrines near the seaport of Mamallapuram, which had been a centre of trade since Roman times. Among them, the 'Durga and the Buffalo Demon' cave is one of the most accomplished. The first structural temple, known as the Shore Temple, was built by Narasimhavarman II Rajasimha in c.700 CE [**34**].

In contrast to this tentative building, in his capital at Kanchipuram Rajasimha built the majestic Rajasimhesvara temple, popularly known as Kailasanatha. The royal temple was not only named after him in accordance with a growing practice, but the legitimizing process can be discerned in temple inscriptions that made public pronouncements on the ruler's interests and personality. The most ambitious temple of its time, it so charmed the monarch's Calukya enemy that he spared it and may even have introduced its advanced style into his own capital [**35**]. The temple's base is granite, but the superstructure is of sandstone and brick covered in plaster. It is difficult to imagine today what the temple

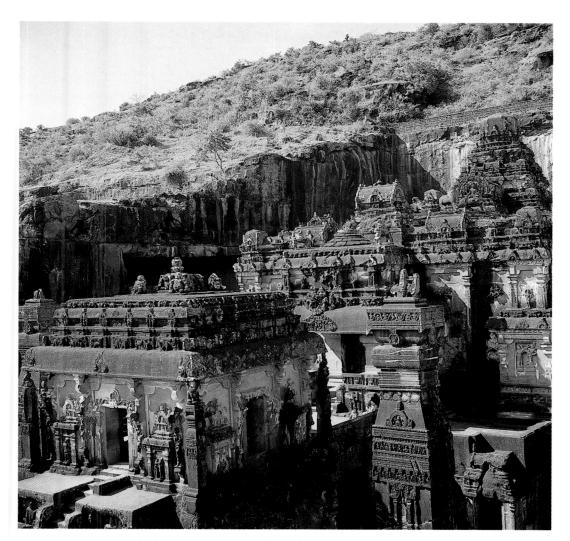

Kailasanatha (Siva) temple,
Ellora, eighth century CE.

A *pancayatana* (five-shrined)
temple in Karnata-Dravida
style, bearing marked
similarities to the Virupaksha at
Pattadakal [**28**] and the
Kailasanatha at Kanchipuram
[see **35**]. The sanctum,
crowned by a receding four-tier
Dravida tower, is surrounded
by an open-air ambulatory. The
hall (*mandapa*) is held up by
16 pillars in groups of four
forming a cross, with three
porticoed projections in front
and at the sides.

looked like originally, when it was richly painted and contained a
wealth of frescoes. The arrangement of the subsidiary deities and the
guardians of the directions shows the spread in the south by this time
of architectural treatises and iconographic texts, their importance
endorsed in this royal edifice.[30]

## The canonical period (eighth to eighteenth centuries CE)

The final phase in the development of the Hindu temple, that of
structural temples, occurred between the eighth and eighteenth
centuries in North and South India, with the tenth century providing
the defining moment. Now a perfect balance was struck between scale
and aesthetics at three of the greatest temple sites, Tanjavur in the
south, Bhubaneswar in the east, and Khajuraho in central India. In
temple decoration, icons incorporated within an overall conception of

**33**

Durga, slayer of Mahisa, Kailasanatha temple, Ellora, eighth century CE.

The youthful goddess rides into battle on her mount, the lion, bearing the weapons given to her by the gods who had created her. Artists interpreted the myth in two different ways: the common one shows the vanquished Buffalo Demon lying prostrate at Durga's feet. The more dramatic approach presents the actual battle scene when the outcome is as yet uncertain. No relief matches the dramatic intensity of this scene with bodies strewn about in the battlefield while the young goddess confronts her proud adversary.

**34**

The Shore Temple, Mamallapuram, c.700 CE.

The shrine, containing a *linga*, faces east in the direction of the Indian ocean. The unusually elongated tower and the visibility of the *linga* from the ocean suggest that it was seen from the ships that sailed to South-East Asia. Facing west are two additional shrines, one to Siva and another to Vishnu. The model for the temple was probably the Dharmaraja Ratha, one of the 'experimental' monoliths adjacent to it, because its proportions conformed to the *vastu-purusa-mandala*.

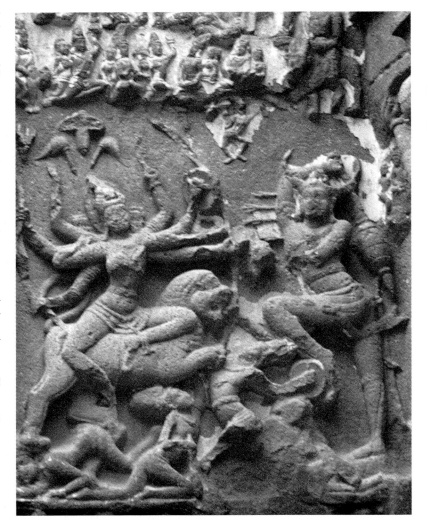

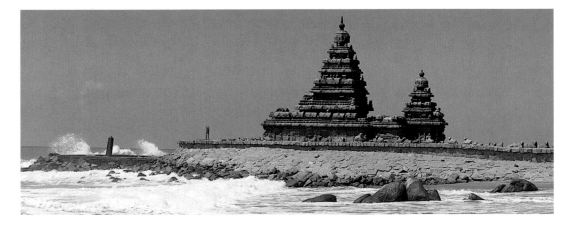

Rajasimhesvara/Kailasanatha
(Siva) temple, Kanchipuram,
eighth century CE.

Built on a developed Dravida
plan, the rectangular walled
enclosure contains other
typical southern features: a
water tank, *nandi mandapa*,
early gate towers (*gopura*),
and numerous sub-shrines
along the enclosing walls. The
tower of the sanctum is made
up of closely layered tiers
(*talas*). It shelters a basalt
*linga*, behind which are
sculptural reliefs, marking the
birth of a southern tradition.
The southern elevation is
elaborated here with
pilastered entablatures
containing monumental
sculptures, including over life-
size graceful and ferocious
Siva figures and rampant
lions.

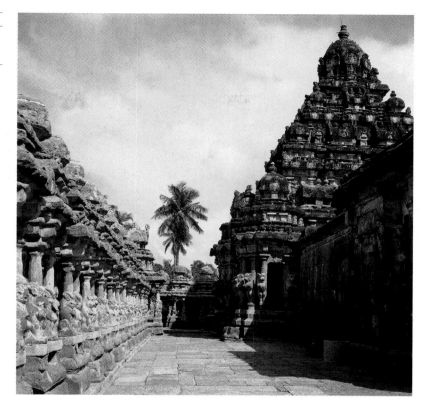

the sacred space replaced the narrative mode of the experimental period. This may reflect the greater use of ritual texts, such as the *Agamas*, and possibly the decline of outdoor ambulatories. In the early period, pilgrims read the sculptures as they circumambulated outside, rather than inside, the temple. Finally, the *Agama* texts themselves are proof of the widespread influence of esoteric Tantric cults from Kashmir in the north to Tamilnadu in the south.

### Southern temples (eighth to eighteenth centuries)
#### THE IMPERIAL COLAS AND THEIR SUCCESSORS

Few Indian rulers matched the Cola kings in their political use of art. Not only did they ritually desecrate their rivals' temples but they used their own temples to make unequivocal statements about political hegemony. The greatest imperial power in South India, by the tenth century the Colas had reached the borders of the Rashtrakuta kingdom in the north, replacing brick temples with grander stone ones as they went. Rows of temples were built on both banks of the Kaveri river to mark their growing power.[31] Crowned in 985 CE, Rajaraja I ('King of Kings') was the only Indian monarch to carve out an overseas empire, establishing his second capital at Pollonaruva in Sri Lanka. Cola art and architecture in South India was the product of a prosperous,

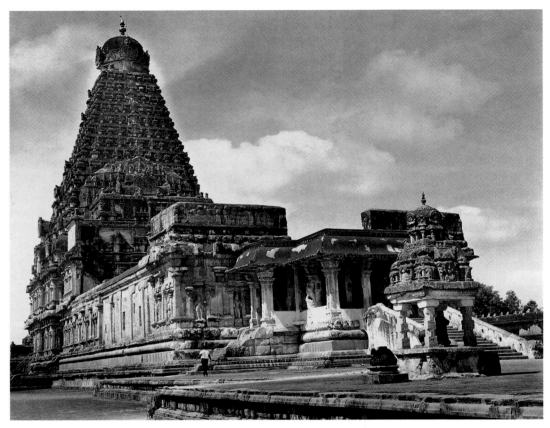

**36**

Rajarajesvara/Brhadisvara
(Siva) temple, Tanjavur,
eleventh century CE.

This 216-foot-high Pasupata
temple towers above the Cola
capital. One of the tallest
temples, its every part was
designed for maximum effect.
The conspicuous tower
consists of 15 closely stacked,
diminishing tiers ending with a
massive capstone of a single
block of granite above a gilded
base. The *kuta* and *sala*
ornaments are on a grand
scale, with elaborate fan
shapes in the middle portion
(all three decorative motifs
playing on the *gavaksa* form),
and are accompanied by
forbidding *kirttimukhas*.

highly efficient empire during the period of its greatest territorial
expansion.

Rajaraja I built the royal Rajarajesvara temple, known today as the
Brhadisvara temple, in his capital at Tanjavur. Its many inscriptions
make clear the triumphalist nature of the edifice [21, **36**, **37**]. It was
recently identified as a royal funerary monument but the weight of
evidence seems to go against this hypothesis.[32] The temple took 15 years
to build (995–1010 CE) though Rajaraja did not live to see its
completion. Its construction was partly funded by war booty and
tributes from Sri Lanka. It also received gifts from the emperor, his
queen, and officials. The numbers of architects, accountants, guards,
and functionaries and the names of numerous temple dancers, as well
as details of the land revenue allocated towards its maintenance, were
engraved meticulously on the temple walls and formed a public record
of the affairs of this institution central to the Cola capital.[33] As in
Pallava architecture, the richly moulded granite base of the *vimana*
holds up brick upper storeys to reduce the overall weight. The
elevations of the handsome two-storeyed, corniced sanctum contain
six deep niches flanked by pilasters, within which are heroic Siva
figures. The interior is equally imposing. The two-storeyed sanctum,

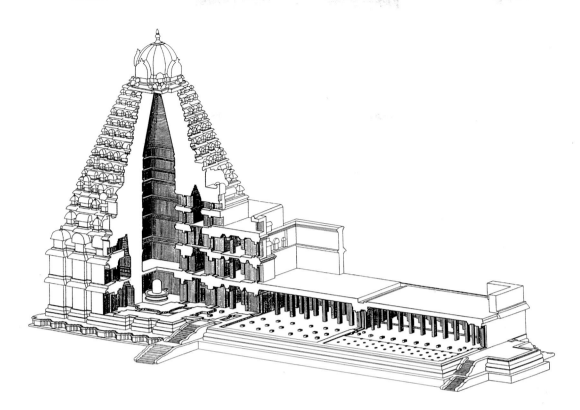

**37**

Rajarajesvara temple, Tanjavur, isometric drawing showing section.

The temple, laid out as a Dravida *padmagarbha-mandala* of 16 x 16 squares, contains all the southern elements—sanctum (*vimana*), great hall (*mahamandapa*), front hall (*mukhamandapa*), and antechamber (*ardhamandapa*)—inside a fortified and moated rectangle. The sanctum is approached by a majestic staircase. The temple contains multiple shrines and a *nandi mandapa* at the temple entrance while over life-size door guardians in inner *gopuras* anticipate later Nayak versions.

lit up by central openings, shelters a massive *linga*, surrounded by a profusion of sculptures and murals—the earliest depictions of classical dance poses (*karanas*).[34]

By common consent, the finest Cola masterpieces are the bronze images of Siva Nataraja (Lord of the Dance), admired by the French sculptor Auguste Rodin, among others, as epitomizing Hindu civilization.[35] They were carried in procession during festivals as surrogates for the fixed image in the sanctum, reflecting the importance of festivals in South India from as early as the second century BCE, the 'golden age' of the Sangam period [**38**, see also **16**].[36]

After the Colas three tendencies dominated South Indian temple building until the modern period. First, temples increasingly turned into sacred cities, demonstrating the growing importance of the temple as the pivot of the Tamil rural community. These vast precincts are worth studying as much for their spatial organization as for their social and economic roles in society. The temple-cities had a powerful impact on rural hinterlands, with money and land being donated to priests, who as large landholders invested in village irrigation works centring on tanks.[37] Secondly, dance assumed an even greater importance in temple sculpture, underlining the importance of temple dancers. Finally, *gopuras* overtook actual temples in size and importance. The sacred city of Cidambaram, a complex of multiple

**38**

Parvati, bronze, Cola period, *c.* eleventh century CE.
Dravida culture created a recognizable ideal of beauty, which consisted of slender bodies and narrow elegant faces, as exemplified by Siva's consort Parvati. Although this ideal appeared in stone sculptures early on, it reached perfection in the free-standing Cola bronzes. These portable metal icons, cast by the 'lost wax process' in conformity with art manuals and ritual texts, belonged to temples.

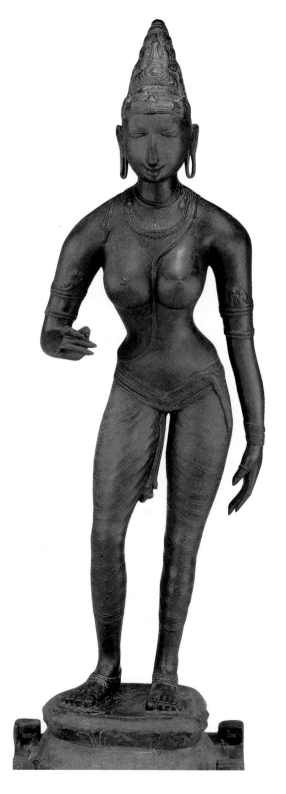

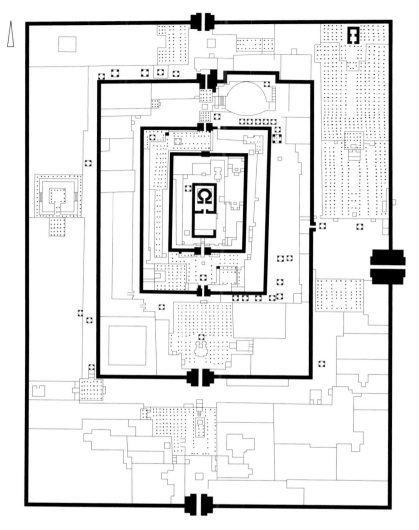

Plan of four inner enclosures,
Vaisnavite temple city,
Srirangam, thirteenth to
seventeenth centuries.
Srirangam is one of the more
developed temple cities in the
South of India.

shrines and halls, sanctified by the legend that Siva danced there, attained its present form in the thirteenth century. The temple compound expanded greatly to become a 55-acre rectangle enclosing four precincts, their streets oriented towards the temple as the symbolic heart of the universe. The reliefs at Cidambaram offer an encyclopedia of dance poses accompanied by literary quotations.[38]

Although Siva seems to have inspired the finest art and architecture in South India, the Ranganatha at Srirangam—the largest temple complex in the south, which was completed in the seventeenth century—aptly reminds us of the importance of Vishnu worship in Tamilnadu. The sacred city, built on a north–south axis and occupying three times the area of Cidambaram, was designed in seven concentric rectangles as prescribed in the texts. It is dotted with 21 *gopuras*, including the four incomplete ones, which would have been the largest [**39**].[39]

*Gopura*, Minaksi-
Sundaresvara (Siva-Sakti)
temple, Madurai, seventeenth
century CE.

These gaily painted, multi-
storeyed brick and stucco gate
towers, crowned by barrel
roofs, rise to great heights,
dwarfing the main shrine.
Emerging as shrines within
Dravidian temples, the
*gopuras* originally had
ambulatories as in *garbha
grhas*. This temple enclosure
also boasts a large, stepped
'tank of the golden lilies',
multi-pillared pavilions, and
long, covered corridors in
addition to the cluster of 11
*gopuras*, the four outer ones
being the tallest.

## THE NAYAK PERIOD

The last major temple-building activity took place during the rule of
the Nayaks, who enjoyed primacy in the south after the fall of
Vijayanagara in 1565. (Vijayanagara is discussed later, in chapter 5,
because although late Hindu its architecture cannot be fully
appreciated without taking note of Islamic forms.) Temple complexes
on an ever grander scale were built under Tirumalai Nayak (1623–59),
familiar to us from his life-like portrait sculptures. The most elaborate
Nayak temple was the twin-temple complex at Madurai; the better-
known one, dedicated to Minaksi, the Great Goddess, is known for its
*gopuras* [**40**].[40]

The outcome of advanced technical skill, these majestic towers are
the considerable achievements of a civilization whose artistic taste is so
different from the European that colonial historians, led by James
Fergusson, have felt impelled to condemn them as products of cultural
decadence.[41] The unanswered question is, why do *gopuras* increase in
size the further they are from the sanctum, completely dwarfing it?

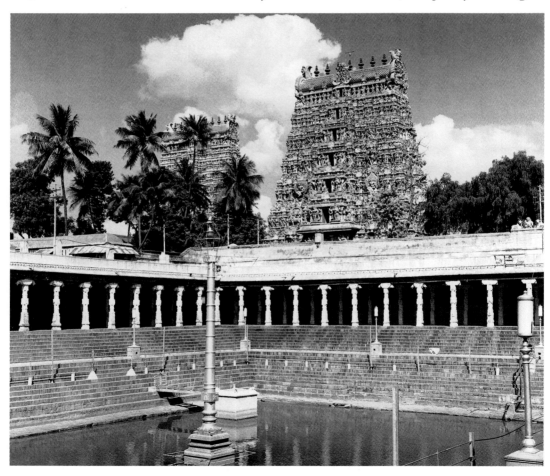

A tentative explanation, based on the notion of purity versus pollution that is central to the Brahmanical religion, may be offered here. In a temple, the cult image in the *garbha grha* is surrounded by a hierarchy of deities, with minor ones at the outer periphery, all arranged according to a scale of purity. The aim is to protect the sanctum from worldly pollution. If these gateways, which are accompanied by high walls, are to serve as symbolic barriers to pollution, the higher they are, the greater the chance they have of being effective.[42] The other characteristic Nayak structure was the gallery of 'a thousand pillars', first introduced in Vijayanagara, whose most opulent instance is the seventeenth-century corridor at Rameswaram at the southern tip of the subcontinent, decorated with royal donors in poses of supplication.

### Northern temples (eighth to thirteenth centuries)
#### ORISSA

From the eighth century CE, Nagara styles in the north began evolving in parallel to the Dravida styles in the south. Orissa on the east coast and an area covering Gujarat/Rajasthan and central India represent two related but distinct styles. We know virtually nothing about Orissa until the seventh century CE, except for Asoka's conquest of the area, followed by the exploits of the legendary king Kharavela. Gupta temple art arrived there in the wake of a dynastic marriage between Orissan and Western Calukya rulers in the eighth century.[43] The Pasupata sect, which had inspired Karnata-Dravida monuments, had spread to Orissa by this time, inspiring major temples.[44] Unlike those of much of the north, Orissan temples have largely survived, so that their evolution can be clearly mapped, especially in terms of the progressive richness of architectural divisions, mouldings, and sculptures.

While working with northern elements, Orissan architecture developed its own typical features: *gavaksa* nets, languid female figures (*alasa kanyas*), love-making couples, *vyalas* (decorative 'lion-monsters' trampling elephants), and, above all, the *bho*. Two unique additions to the Orissan temple design, dating from around the tenth century, were dictated by social needs: the hall for dispensing consecrated food (*bhoga mandapa*), and the hall for temple dancers (*nata mandapa*), the latter becoming an integral part of temple ritual and sacred sexuality.[45] Even today, Orissan temple dancers at the Jagannatha temple in Puri, who are called 'slaves of god' (*devadasis*), are ritually married to the deity and to his living incarnation, the god-king of Puri.[46] This social practice, which made *devadasis* sexually available to kings and priests, came under the disapproval of the British Raj, which sought to save them from their 'depraved' lives.

Bhubaneswar was the major site of the Pasupata temples. The eighth-century Parasuramesvara temple introduces typical Orissan

**41**

Rajarani temple, Bhubaneswar, eleventh century CE.

The contrast between the elaborate sanctum (*rekha deul*) and the plain front hall (*jagamohana*) with a pyramidal roof of diminishing horizontal bands is dramatic. The *rekha deul*'s finial is an 'Orissan' fluted *amalaka* capstone but its multiple projections are closer to the Gujarat-Rajasthan style [see **24**]. The temple is enriched with two bands of elegant figure sculptures, including erotic ones, and a complete set of guardians of the eight quarters, a rare feature. The sanctum and its central image niches are now empty.

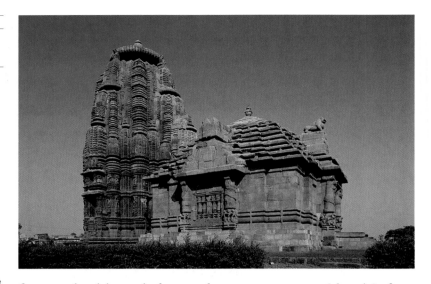

**42**

Detail of tower, Lingaraja (Siva) temple, Bhubaneswar, twelfth century CE.

Despite the generous use of horizontal bands, replica towers, and corner *amalakas* on the *sikhara* in a self-imaging process, the designer forces us to pay attention to the sheer verticality of its plain, slightly curving profile. The *bho* ornamental medallions on the tower act as a light relief to its stern demeanour. They are an ornate *gavaksa* design with a *kirttimukha* regurgitating garlands flanked by a pair of dwarfs, an Orissan invention with some affinities with the *sukanasa*.

features: the elaborately decorated sanctum contrasts with a plain front hall; horizontal bands (*pidha*) decorate the roofs; and *amalakas* and *gavaksa* segments at the corners of the *sikhara* do not disturb its plain sloping contours. Orissan temples attain self-confidence in around the eleventh century CE. An intimate style informs the gem-like, red sandstone Rajarani temple (1000 CE) [**41**]. With the twelfth-century Lingaraja temple the Orissan style acquires a solemn grandeur. The use of grey stone, rather than the more common red sandstone, emphasizes the austerity of the Pasupata shrine [**42**]. Unlike other major temples, the surprisingly sparse embellishments of the sanctum's outer walls make the tower all the more imposing. The roof of the front hall (*jagamohana*) has now evolved into two levels of *pidha* tiers with a recess in the middle, while its fluted, bell-shaped finial (*ghanta*) has acquired considerable elegance. The temple, originally containing only the sanctum and the pillared hall, gradually incorporated two more structures, the hall for consecrated food and the dancing hall, indicating the growing complexity of temple rituals. The Lingaraja's importance is reflected in the numerous shrines within a walled enclosure, in the southern fashion.[47]

Although Orissan style reached its pinnacle in the twelfth-century Lingaraja temple, our study of the style cannot be complete without considering the thirteenth-century temple to the sun at Konarak, situated near the coast, the late, stunning achievement of the Nagara style.[48] Young Nrsimhadeva I (1238–64 CE), who undertook the project at his mother's behest, decided to surpass all previous achievements. According to the Mughal historian Abu'l Fazl, many thousands of workers were engaged on the construction of the temple, which took 12 years. Although Surya is not one of the great saviour gods, the continuing strength of his cult since Vedic times is demonstrated by

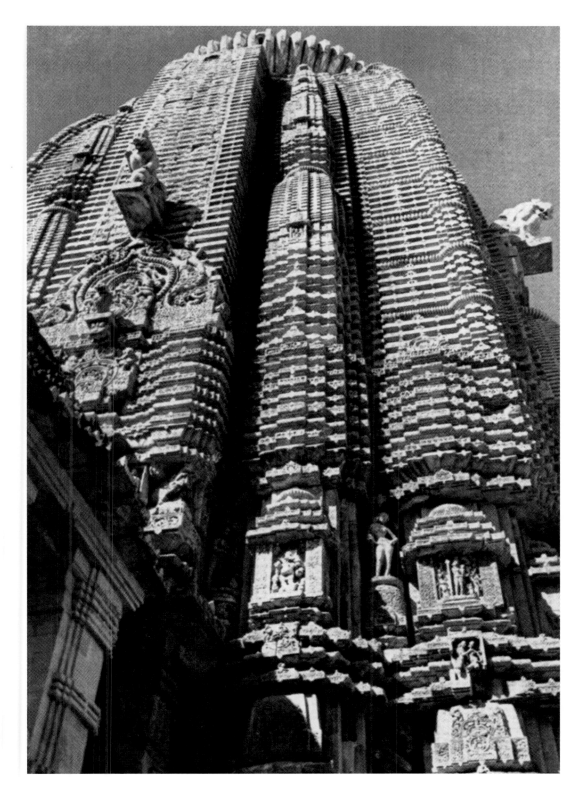

the spectacular temples built in his honour. It is intriguing that he is the only god to wear boots, high ones made of leather, a polluting substance in the eyes of Hindus (southern versions are barefooted). Perhaps his cult had a Parthian or Kushan connection?

One may infer Konarak's political importance in the extensive portrayals of Nrsimhadeva in the temple, including that of his spiritual initiation, which hints at the legitimizing function of such a temple. The increased use of the dance hall for spiritual discussions, as well as the growing importance of the temple dancers themselves, was turning Orissan temples into the focal point of communal life.[49] However, tensions between royal ambitions and the temple's role in society were often just below the surface. It is significant that the king never speaks of his great project at Konarak; we know it only from his descendants.[50]

As with other examples of Indian architecture we have encountered so far, the temple's actual scale is less important than the monumental conception realized by means of proportions. In fact, from a distance, the five-projection *jagamohana* looks rather squat. But as one gets closer, the building slowly unfolds itself at each stage until we reach the entrance doorway [**43**]. Above the austere portal is a panel representing the nine planets. The three diminishing tiers of the roof pyramid consist of separate and elaborately developed horizontal bands (*pidhas*). It is significant that the recesses between them have now been enlarged into wide terraces, where over life-size, free-standing sculptures of women musicians and dancers have been placed at regular intervals. These, some of the most powerful in Indian art, celebrate the temple dancers. Three Surya icons are housed in the central niches of the damaged sanctum, enabling us to guess what the bronze deity in the *garbha grha* looked like. The profusion and variety of sex acts on the 'Black Pagoda' shocked Victorian sensibility.

## KHAJURAHO

Some 25 temples in the remote village of Khajuraho, known to tourists for their erotic sculptures, constitute the crowning achievement of the western and central Indian style. After the emperor Harsha's demise in 647 CE, North India splintered into numerous small kingdoms, as the three great powers, the Rashtrakutas of the Deccan, the Palas of Bengal (*c.*760–1142), and the Gurjara-Pratiharas (710–1027) of north-central India, began to cast a covetous eye towards his capital at Kanauj. The Gurjara-Pratiharas, whose dominance was brought to an end in the eleventh century by the Turko-Afghan invader Mahmud of Ghazni, are known for their open pavilion temples. However, the greatest development of the Gurjara-Pratihara style took place not in their territory, but at Khajuraho, the capital of the small Candella kingdom of Bundelkhand. Khajuraho was a flourishing cultural centre where poets, grammarians, and playwrights rubbed shoulders with

**43**

Temple to the Sun (Surya), Konarak, thirteenth century CE. This was imagined as the chariot of the god drawn by seven horses across the horizon. Today only the *jagamohana* remains fairly intact, its height at 100 feet greater than the *garbha grhas* of earlier temples. Its 12 pairs of giant wheels, representing the 12 months, are set in bold relief with decorations ordered hierarchically. Even the spokes of the wheels include images of love play, and the bottom of the plinth carries a narrow frieze of marching elephants.

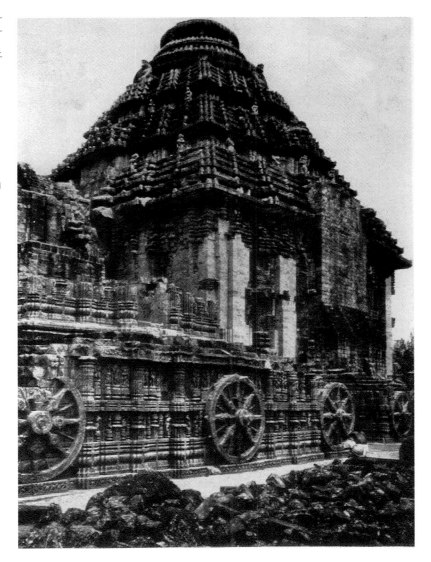

affluent Jain merchants and court officials. Extensive monastic establishments exercised considerable social power, encouraging lavish spending on temples.[51]

Between 900 and 1150 CE, some of the finest Nagara temples were constructed in Khajuraho. The first major royal edifice, the Laksmana temple (954 CE), was built by Yasovarman to celebrate Candella's independence from its Gurjara-Pratihara overlords [**44**]. The image installed by him in the *garbha grha*, and consecrated by his son Dhanga Deva, was a metal four-faced Vishnu (Vaikuntha) image brought from Kashmir, which was later replaced by a stone one. Khajuraho was a centre of various Tantric sects, and the icon in Laksmana suggests the spread of the *Pancaratra* Tantric rites, which influenced the placement

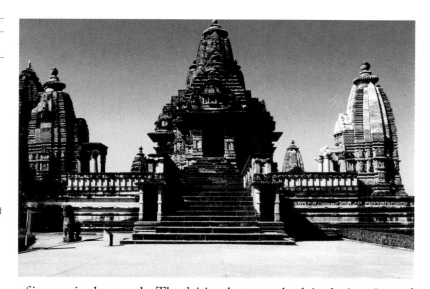

**44**

Laksmana (Vishnu) temple, Khajuraho, tenth century CE.

The five-shrined (*pancayatana*) temple, designed by the architect Chhichchha, contains the main features of the style: entrance porch (*ardhamandapa*), hall (*mandapa*), great hall (*mahamandapa*), antechamber (*antarala*) and towered sanctum. Khajuraho temples stand on a high terrace, their height enhanced by a steep decorated plinth. The roof over each building goes up in stages, enhancing a sense of cascading verticality. An ambulatory in the Gujarat-Rajasthan style, with open balconies, surrounds the temple. An inscription imagines that the temple rivals the Himalayan peaks.

of images in the temple. The deities that occur both in the interior and the exterior of the temples were interpreted, we know, as emanations of the main icon. Khajuraho developed a symmetrical iconographic programme that arranged the emanating deities in different hierarchical orders as well as in complementary pairs in conformity with ritual texts.[52] The temple testifies to the primacy of the new iconographic imperative over monumental narrative throughout India by this period. The *Agamas*, which endorse Tantric rituals, give a new gloss to the sectarian Puranas. In this system, Vishnu and Siva/Sakti clusters of deities often coexist in pairs. But at the same time, in a Vishnu temple such as this, although there is a plethora of Saiva deities, they would ultimately be subordinate to Vishnu, the final arbiter of redemption here. Siva in his turn will be supreme in a temple dedicated to him. The temple interior is sumptuously sculptured and the doorway attains a great richness here. The two main registers between the tower and the base contain the main figure sculptures, among them scenes of everyday life, 'languid women' disrobing or admiring themselves in the mirror and, finally, erotic scenes.[53]

The Kandariya Mahadeva temple, built nearly a century after Laksmana in the reign of Vidyadhara (1017–29 CE), has many similar but more developed features [**24, 45**]. Where this Siva temple differs is in its tower, which rises above a seven-projection (*sapta-ratha*) shrine. The interior contains over 200 figures, their iconography conforming to the *Saiva Siddhanta*, the more orthodox Tantric sect, as compared with the Kaula Kapalika cult (see chapter 4). In contrast to the unmanifest *linga* in the sanctum, the 'manifest' forms of Siva and other gods are arranged hierarchically on its three interior walls along the ambulatory. The most enigmatic of the images is a phallic form of Siva with six heads and four legs.[54] Outside, the sculptures in the middle

associated with a particular idiom within the wider Hoysala style. The uniformity of the Hoysala style was the result of a long training that included learning by heart basic designs drawn on stone. The artist's status was predictably low, but some of them who lived in well-known centres managed to acquire social respect and status, moving around the empire to work on the public projects that were in high demand. K. Collyer suggests that by designating themselves *acaryas*, a term usually associated with Brahmanical teachers, the lower-caste workshop masters were seeking to improve their status in what is known as the process of 'Sanskritization'. In accordance with Brahmanical values, education was a criterion of higher status. The apprentice spent time in the master artist's household much like the Vedic student under a Brahmanical guru. However, the status of the sculptor was subsumed within the hierarchical system consisting of the temple, the king, and the priest [46].³

*Kashmir (eighth to fourteenth centuries CE)*

The vale of Kashmir, sheltered by the Himalayas, belonged to the cosmopolitan milieu that stretched as far as Gandhara and Bactria.

**46**

Kesava (Vishnu) temple, Somanathpur, thirteenth century CE.

This finest example of the Hoysala style was built for a king's general in the greatest period of the empire. The Hoysala dual shrine expands here to a triple-shrine structure, each shrine with an antechamber, but all sharing one spacious front hall. The star-pattern ground plan (a development of the northern elevation) is repeated from the base right through to the low towers of the sanctum. Mimicking this pattern the monumental figures are arranged like folding screens with six bands of friezes depicting humans and animals at the bottom.

# 4

# Minority Traditions, Ideal Beauty, and Eroticism

The three artistic traditions outlined in the first part of this chapter illustrate how the dominant canon was radically modified in response to religion, culture, and environment. Their peripheral position may have contributed to their relative neglect among scholars. The chronology in each case is specific to that region since each follows its own historical trajectory.

## *The Hoysalas of the Deccan (eleventh to fourteenth centuries CE)*

The mixed (Vesara) temple styles of the Deccan were a reflection of their exposure to northern ideas. Among them, the Hoysala temples are arresting in their exquisitely carved grey-green steatite exteriors, their towers of modest height, and their star-patterned ground plans. During the ascendancy of the Hoysala empire in the twelfth to fourteenth centuries, kings, queens, the court, merchants, lower officials, and the affluent Vaishnava community were all active patrons. Vishnuvardhana (c.1108–42), who was converted to Vaishavism by the saint Ramanuja, built a fine Vishnu temple after defeating the Colas. However, out of over a thousand temples, royal involvement has been identified in only 35.

Partly because of its late period, Hoysala art offers us information about the social position and aspirations of Indian artists not available anywhere else. Although Hoysala sculptors worked collectively as members of guilds, the profusion of signed sculptures in Hoysala temples raises important questions about artistic individualism. The topos of artistic rivalry, a reflection of higher social aspirations, is suggested by inscriptions in which artists boast about their work and about surpassing other artists.[1] The work of Mallitamma, a leading sculptor, is so well documented that we have a clear idea of the style and quality of his output within the constraints of local guild conventions. His was a curious case, for he was not the most talented sculptor, but he was celebrated for having participated in all the major projects of the time, identifying every single work produced by himself over 60 years in all the regions.[2]

Why did Hoysala artists sign their works? First, the name, Mallitamma for instance, was probably that of the workshop master,

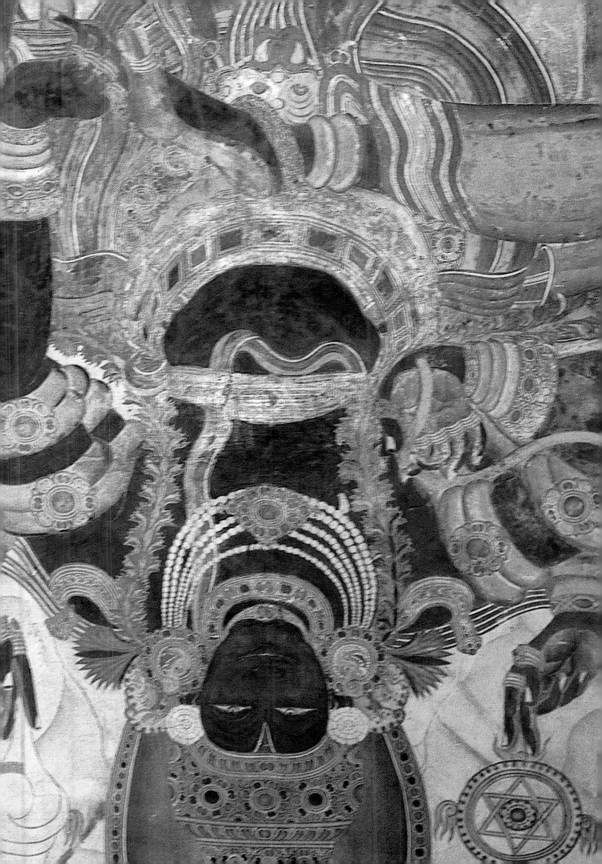

registers are of women in various poses and scenes ranging from love-making couples to group sex and bestiality. Scholars disagree over the significance of the erotic scenes, since many of them cannot be identified as Tantric.

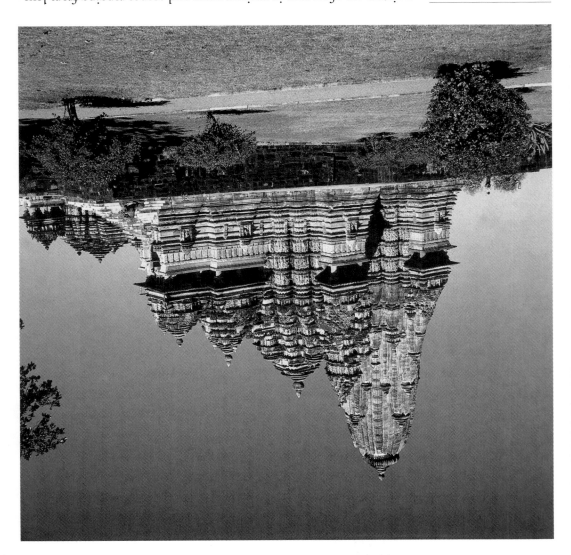

**45**

Kandariya Mahadeva (Siva) temple, Khajuraho, eleventh century CE.

This seven-projection temple is the culmination of the style. Here verticality is even more striking than in Lakshmana and each part more elegantly realized and details of sculptures and other decorations more refined, expressing a sense of grandeur and nobility. [See 24 for its remarkable tower.]

Temple to the Sun, Martand, Kashmir, eighth century CE.
This temple was conceived on a vast scale, with 81 small shrines emanating from the central image in the sanctum. Its entrance, which rests on a high plinth, is through a towering double gateway. The sanctum is preceded by a pillared hall, flanked in turn by double shrines on either side. The pitched roof tradition in Kashmir was dictated by climatic conditions, while the Roman-style fluted columns and pilasters continued the Gandharan-Bactrian heritage.

48
Vishnu's Vaikuntha image, Kashmir, eighth century CE.
The *Pancaratra* tradition produced the four-faced Vishnu Vaikuntha image. This is based on the four emanations (*vyuhas*): the frontal human form, Vasudeva, is flanked on the left by the boar, Pradyumna, and on the right by the lion, Sankarsana, while the rear represents the demon Aniruddha.

Even though Hinduism gained prominence by the eighth century, Kashmir, the site of the fourth Buddhist council, continued to be a centre of Buddhism until its conversion to Islam in 1339 CE. Politically and culturally its finest period was the eighth-century reign of Lalitaditya Muktapida. His lavish patronage, funded by military expeditions into northern India, was recounted by the great twelfth-century historian Kalhana. Lalitaditya not only built impressive monuments such as the massive *caitya* at Parihasapura, but, according to Kalhana, he erected the 'wonderful shrine of Martanda, with its massive walls of stone within a lofty enclosure' [47].4

By Lalitaditya's time Kashmir had become a stronghold of Tantric practices. Tantric Buddhism produced angry deities, such as Vajrapani, representing the mysterious powers of transcendent knowledge. Hindu Tantric systems, the *Saiva Siddhanta*, and the Vaisnava *Pancaratra* cults also flourished here. The *Pancaratra* tradition produced the four-faced Vishnu Vaikuntha image characteristic of Kashmir [48].5 Both the Buddhists and the Hindus of Kashmir commissioned bronzes, including colossal ones, during Lalitaditya's reign.6

### Kerala (sixteenth to eighteenth centuries CE)

Kerala, on the south-west coast of India, was renowned for its overseas trade with East and South-East Asia and with the West. The heavy pitched roofs of Keralan temples can give the impression of Chinese architecture. This, along with the fact that Keralans had trade contacts with China, has led scholars to suggest a Chinese influence on its art and architecture, but this is doubtful. It can be argued that the roofs had a protective function in a region known for its torrential rains. What is clear is that Keralan art shows contacts with Tamilnadu and Karnataka.7 The temples usually consist of several buildings within a walled enclosure. The main shrine, the *srikovil*, can be square, rectangular, apsidal, or circular. While the base is often of stone in the

southern tradition, the superstructure is of wood or brick, covered with a tiled roof. Temples are sometimes double-roofed, as is the case at Vettikkavalla. The Dravida tradition is evident in the walls of the Siva temple at Ponmeri with its rows of pilastered niches for elevations. A particularly distinctive type in Kerala is the circular temple. The Vatakkunnathan temple to the syncretic Hari-Hara (Vishnu-Siva) at Trichur, although founded in the eleventh century, was rebuilt many times [**49**].[8]

In Kerala wooden sculpture is preferred to stone. The paintings on the outside and inside walls of the *srikovils* are full of vitality and power, notably in the Padmanabhanswami temple at Padmanabhapura and later ones in the Mattancheri Palace in Cochin. The Vishnu from the palace shows the Keralan style at its most vivid [**50**].[9]

*Jain art and architecture (third to thirteenth centuries CE)*
The patronage of Jain merchants rivalled that of royalty. These powerful urban merchants often acted as bankers to monarchs. Like the Buddhists, they embraced an anti-Brahmanical faith. Jainism was founded by the Ksatriya Mahavira (*c*.599–27 BCE), the last of the 24 Jain saints, who were named *jina* (conqueror) for having broken the chain of *karma*. Once an important force in the subcontinent, today Jains are mainly confined to Gujarat, Rajasthan, and Karnataka. The sect steadfastly maintains its belief in the sanctity of life through vegetarianism, while its strict moral code includes the denial of sensual pleasures. Paradoxically, this very austere religion was embraced by a community renowned for its affluence.[10]

**49**

Vatakkunnathan temple to Hari-Hara (Vishnu-Siva), Trichur, eleventh century CE.
The temple consists of three *srikovils*, two circular and one square, with square interiors, a common Keralan feature. The two sets of overhanging, 'hat-shaped' plain-pitched roofs act as a protection against the rain.

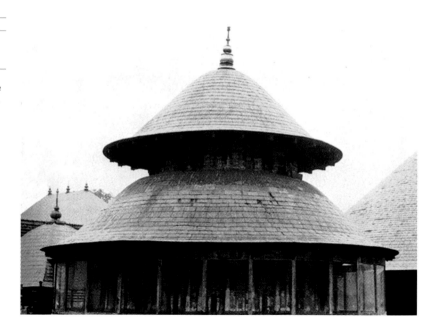

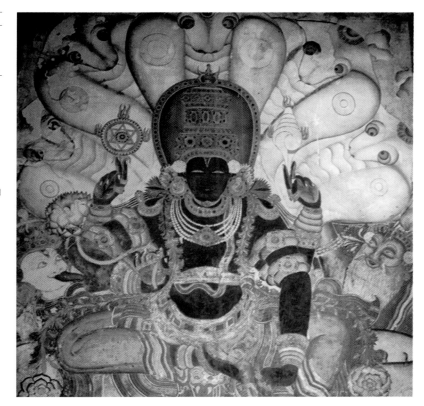

**50**

Vishnu, wall painting, Mattancheri Palace, Cochin, sixteenth/seventeenth century CE.

The three-quarter and frontal faces are painted with wide open eyes; bright reds, emerald greens, and oranges are the dominant colours. Light shading of the outlines lends solidity to the figures. Dressed in the attire of the Keralan Kathakali dance drama, the figures are pressed together within confined spaces, their elaborate ornaments filling the gaps. The paintings are reminiscent of the kalamkari fabrics from the neighbouring Kalahasti region.

Unlike Buddhists, Jains adopted the Hindu temple form but put it to different usage. Rather than being the dwelling of a deity, it was the temporal representation of the heavenly hall where the 24 Jain 'conquerors' assembled. Although the Jains erected sumptuous temples at Khajuraho, their most striking temples are of white marble and belong to the Solanki period in Gujarat-Rajasthan (950–1304 CE), when they became kingmakers.[11] The finest examples are from the Jain temple city on Mount Abu in Rajasthan, sanctified by its association with the Jain teacher, Mahavira. Exquisite carvings in these near-translucent white marble temples appear inside, their plain exterior a protection against Turko-Afghan attacks [**51**]. Apart from temples, other striking structures unique to the area are the complexes of step-wells elaborately decorated with sacred sculptures.[12]

Images of Jain saints resemble the Buddha, except that they are totally naked, the only completely nude male figures in Indian art, as for instance the colossal image of Bahubali at Sravana Belgola in Karnataka. The Jains adopted several Hindu gods, more as aids to meditation than as objects of worship: Sarasvati, the goddess of learning, and Ambika, the Tantric deity, are the most popular. In the later period, Jains specialized in sacred topographical paintings (see below for Jain painting).[13]

**51**

Luna Vasahi temple, Mount Abu, *c.* thirteenth century CE. Dedicated to one of the 24 Jain saints, it was built by Tejahpala, a wealthy minister to the Bhagela dynasty in Gujarat. Particularly remarkable are the delicate decorations, especially those representing the 16 slender goddesses of knowledge, on the domed ceilings.

## Notions of beauty

There are two central issues to be addressed here: the canon of beauty and the role of the erotic in ancient Indian art. Few aspects of non-European art have posed greater problems for the western art historian, raised on the universalist canon. Confronting very different standards of beauty in Indian art, the art historical response has often been to claim that Indian religious art is not concerned with 'carnal' beauty as such but with 'higher' spirituality. In fact, this is belied by numerous religious hymns which graphically describe the physical beauty of the goddesses. Apart from the fact that the western canon, which purports to be universal, is culturally determined, the interesting question is not what Indian art shares with western art, but in what ways it is a unique tradition with its own cultural rules. The aesthetics that art historians take to be ancient Indian is actually that of a male high culture that influenced art and literature and streamlined diversity by ignoring marginal traditions. Likewise, it has been the classical canon that has been dominant in the West and that has had such a profound influence on art criticism.

## Ideals of beauty

Classical and Indian aesthetics share certain ideas, which, for instance, Far Eastern art does not. In ancient India, as in Greece, the idealized human body was the measure of all things, inspiring, above all, architectural proportions.[14] Both societies imagined gods to be the bearers of sexuality, beauty, grace, and power. But whereas the Greek gods were utterly human, the many-armed Siva Nataraja inhabited a very different world of thought, at once human and transcendental (see chapter 3). So what were their respective ideals? The Greeks extolled athleticism, the young Kouros embodying the divine ideal. Even the nude goddess Aphrodite, a latecomer to the scene, turned to the male figure for inspiration.[15] However, if Greece was more homoerotic in its ideal, it was female sexuality that was obsessively celebrated in Indian literature and art. Part of the reason may lie in the different religious outlooks of these two essentially male-dominated societies. But neither in Greece nor in India did women have a decisive say in aesthetic matters, as they were largely confined to the home. One of the interesting aspects of Indian culture is that women are represented both as an object of the gaze and as part of the sacred—so are feminist critiques applicable here, since women are central to sacred art as the focus of sexuality and auspiciousness?[16] It is interesting that the opulent *Venus Naturalis* was a threatening form of sexuality in the West. Ancient Indian poets such as Kalidasa delighted in describing such

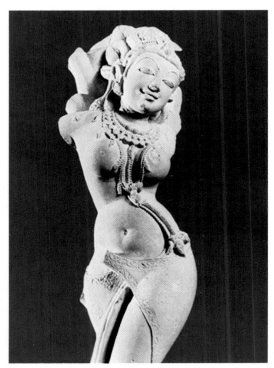

**52**

*Vriksaka* (tree goddess), Gyaraspur, twelfth century CE.

In India, the nude originated in nature deities, the *yaksis*, bearers of fertility magic. The literary trope of trees needing the touch of a nubile girl to blossom connects sexuality with auspiciousness. However, sculpture went far beyond fertility, creating a feminine ideal that mediated between literature and art, though both probably reflected Indian norms.

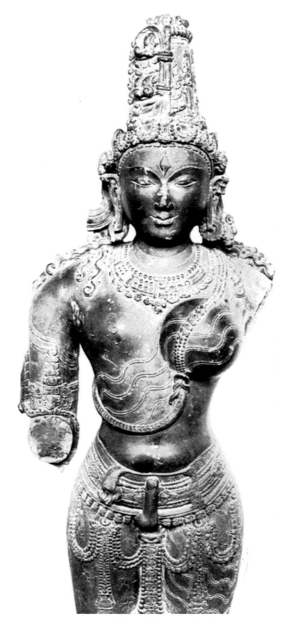

**53**

Siva Ardhanarisvara,
Vikrampur, *c.* twelfth
century CE.

In this androgynous image of
Siva, the male–female
difference is emphasized by
partitioning the figure into two
halves, with the
characteristics of each sex
carefully highlighted,
including the gender
differences in personal
ornaments.

nubile beauties: 'Slim, youthful, with the eyes of a frightened doe, fine teeth and red lips like the *bimba* fruit, slim waisted, deep-navelled, slowed down by the weight of the hips and bent by her full breasts, she is the best of her gender created by god' [**52**].¹⁷ This voluptuous ideal underwent substantial modification, however, in different parts of India, especially in the south.

The contrast between the western classical and the Indian ideal is perhaps best demonstrated in their notions of bisexuality. In the

classical hermaphrodite, the sexual differences were blended in a 'unisex' image.[18] In the Siva Ardhanarisvara image, on the other hand, the male/female difference was in fact emphasized by partitioning the figure into two halves, with the characteristics of each gender meticulously highlighted [53].

## Erotic art

In the case of the erotic sculptures in Hindu temples, art historical interpretations reveal a basis in Christian thinking on sexuality. Faced with public displays of private acts, including oral sex, group sex, and bestiality, above all in a temple, scholars felt obliged to search for their 'hidden' meaning. This is because such images could not be reconciled with an essentially modern, western outlook. But this search for meaning stems from our assumption that sex is a 'natural' act, whereas no human activity could be more culturally conditioned.[19] To answer libertarians, for instance, who admire Hindu erotic art as an expression of a 'natural' society, ancient Indians were no more liberated than we are. It is simply that their notions of 'decency' differed from ours. So instead of starting with our views of what is 'sexually' acceptable, we need to rediscover the specific normative boundaries of ancient Indian civilization, and the boundaries between the sacred and the profane. For, even phallic cults such as that of the Siva *linga* were never taken entirely literally by Indians, who responded to them on multiple levels of meaning.[20]

The obsessively erotic art of Khajuraho and Konarak gave these sites their notoriety in colonial and modern times. Yet, what is forgotten is that loving couples first appeared as early as the first century BCE in Buddhist monuments at Bhaja and Bedsa. Couples routinely adorned temple doorways from the Gupta period onwards [54]. However, sexual scenes began to proliferate only from the tenth century, as Hindu art and architecture reached their peak.[21] Earlier interpretations, that erotic sculptures were allegories of higher spiritual ideas, were simply transposing Christian interpretations onto Hinduism. It is not that a cult like that of Radha-Krsna did not represent love allegorically; it is simply that sacred coitus on temple walls cannot be explained allegorically. The view that it was a product of social decadence simply endorsed colonial prejudice against Hinduism.[22] Some of these sculptures had a clear protective function. Links between fertility, sexuality, and the auspicious are strong in Hindu society.[23] A study of the dancers at the temple of Jagannatha at Puri, one of the most sacred sites of Hinduism, shows convincingly their 'auspicious' sexual role within the religious context.[24] According to a recent work, erotic figures in Khajuraho are placed at meeting points of buildings as a protective device, playing on a visual pun between juncture and copulation. Another work claims that they

**54**

The Kiss, Kailasa temple,
Ellora, eighth century CE.
This delicate erotic image
forms part of the decoration,
possibly as an auspicious sign,
though until the tenth century
erotic figures did not
proliferate in temples.

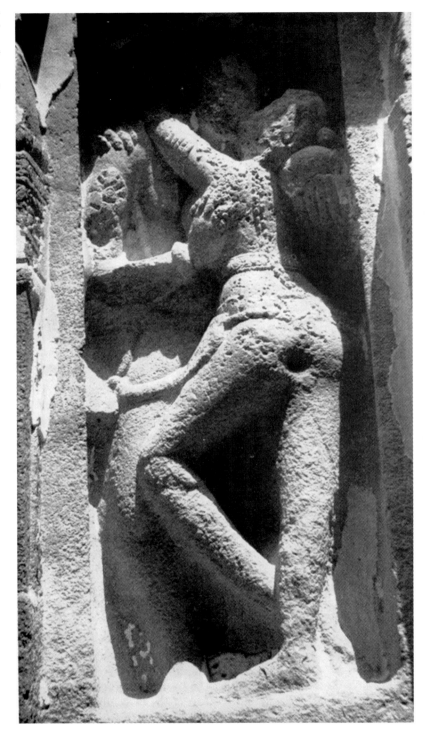

celebrate the marriage of Siva and Parvati. This hypothesis cannot, however, apply to the majority of these sculptures.[25]

A serious contender in this respect is the esoteric Tantric creed, which rivalled Bhakti in its powerful hold on Indian society, irrespective of whether one was a Buddhist or a Hindu, or even a Jain. Tantrics sought to gain spiritual fulfilment by acquiring power through social transgressions, including ritual sex. However, apart from some clearly identified Tantric images—symbolic images such as the *yantra* and *sri cakra*—many of the erotic sculptures in temples are too general to be representations of precise Tantric rituals. Perhaps one should abandon the search for a grand theory and interpret these erotic scenes in the contexts in which they occur.

There are, however, interesting connections between Tantra and sacred eroticism. Brahmanism faced two major challenges from within the Hindu religion: Bhakti and Tantra. Bhakti offered direct access to God without the intervention of Vedic rituals. The rival to Bhakti was Tantra, which developed a set of esoteric rituals including sexual practices, which were at once a parody of and a challenge to Brahmanical rites. Tantrics broke social taboos though *panca ma-kara* (the use of five prohibited substances and acts), in which the participants ritually denied caste distinctions.[26] Tantric beliefs were widespread in India from Kashmir down to Tamilnadu, though they were ignored in the colonial period, especially by European orientalists, who preferred the more intellectual *Upanishadic* philosophy, the exception being Sir John Woodroff.[27]

It is no accident that women played a dominant role in the Tantric Kaula Kapalika cults. Yoginis or female ascetic-sorceresses were feared because of their association with Tantric practices. Yogini temples became widespread in north India from the tenth century CE. They had a distinct circular structure open to the sky, possibly suggesting a spatial translation of the *yogini cakra* (ritual circle) or the female vulva. The temples to 64 yoginis in Orissa contained mostly animal-faced yogini figures, arranged in a circle in niches and facing a Siva shrine in the centre. The exceptions were the royal temple of 81 yoginis belonging to the Kalacuri dynasty in Bheraghat and Khajuraho's rectangular 64-yogini temple.[28]

*The mother cult*
Prehistoric north-west India was part of a large swathe extending from the Indus valley to Asia Minor where a matriarchal religion of sexual cults and sacred prostitution was practised. The Great Mother, the pregnant goddess of fertility, was worshipped throughout the world in her sheltering, protecting, and nourishing character.[29] This cult was suppressed by the Aryans, who brought their own male-centred pantheon to India in 1800 BCE. Even though recent research has shown

that Vedic rituals contained sexual allusions, the general Vedic dislike of sexual cults is revealed in their contempt for the phallic gods of the non-Aryans.[30]

The mother cult continued at folk level in the worship of small terracotta figurines. However, her influence can be seen on the margins of temple art, in the decorative 'monsters', *makara*, *kirttimukha*, and *vyala* (the last a rampant leonine monster), described as different masks of the pre-Aryan goddess.[31] The feminine principle re-emerged with explosive force early in the first millennium in connection with the rise of the Siva-Sakti cult, which might have been prefigured in the Indus civilization. It is quite remarkable that while women had an inferior status in Hindu society, on the level of belief they played a dominant role. The supremacy of the Goddess is expounded in different myths. In the myth of Durga, the gods, when they felt powerless against the Buffalo Demon, relinquished their weapons to her in a symbolic castration. The Great Goddess is paradoxically a virgin mother. Her companions are the horrific seven mothers (*saptamatrika*), central to Tantric thought.[32]

Neumann describes the mother as the 'Freudian' unconscious, but there could be a more subversive role for the Goddess: challenging Aryan, male rationality. The Goddess is the mother who nourishes, but is terrifying if her anger is aroused. Nothing expresses the antithesis of the male construct of rationality better than the elemental figure of Kali, the dread goddess. When she goes on the rampage, she literally lets her hair down, her 'unbound' hair signifying cosmic chaos, as she becomes unstoppable in her pure nakedness.[33] Married women in India are admonished to tie their hair, for loose hair is a sign of inauspiciousness, in other words a threat to the social order. Finally, in the symbolic opposition between the right and the left in the collective thinking of many cultures, the right hand represents maleness, speech, intellect, and, above all, the sacred. Conversely, the left (*sinistra* in Latin) stands for the sinister, night, death, the chthonic, the profane, and threatening aspects of sexuality. In Sanskrit too *vama* not only means left but also a woman, and finally the Goddess. It makes perfect sense that the Kaula Kapalika Tantric practice is described as left-handed in relation to established rituals.[34] In short, it is in these subversive aspects of Indian thought that we may seek to uncover the 'enigma' of Hindu erotic art.

# Part II

# Indo-Islamic Art and Architecture (*c.*712–1757 CE)

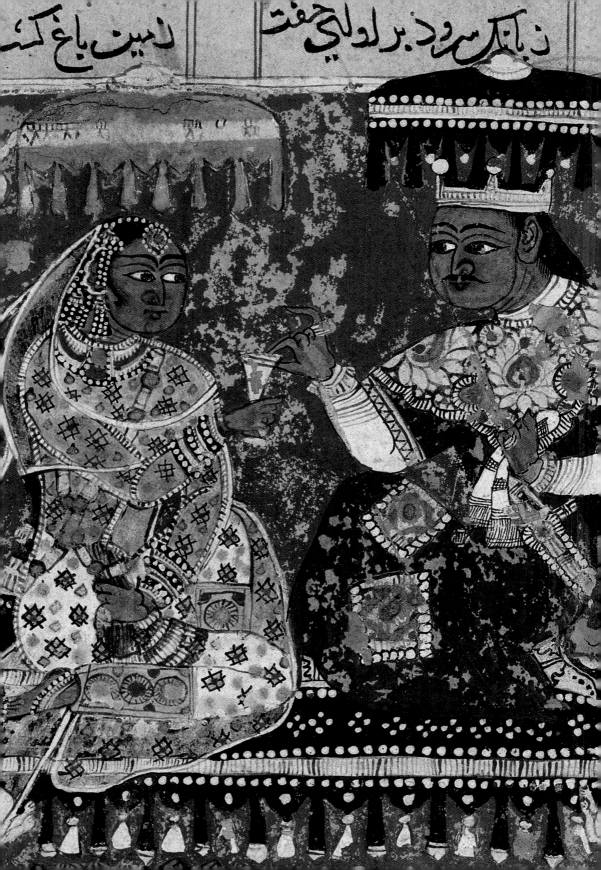

# The Turko-Afghan Sultanate of Delhi (1206–1526 CE)

5

The arrival of Islam forced a crisis of conscience in Hindu and Buddhist civilizations, bringing to an end the first chapter of Indian history. The rise of the Arabs under Islam in the seventh century profoundly altered power relations in the vast land mass stretching from Spain in the West to the borders of China in the East. The Arabs, and the Turks and the Mongols after them, founded cosmopolitan empires, virtually cutting off Europe from world trade along the lucrative Silk Route and the Mediterranean. The monotheistic Islamic civilization, essentially extraterritorial and a blend of diverse pre-Islamic elements—Greek philosophy, Roman architecture, Hindu mathematics, and the Persian concept of empire—deeply affected the societies it came to rule. The Arabs had arrived in Sind (in modern-day Pakistan) by 712 CE but little remains of their brief occupation.[1] The common assumption that Islamic mosques were built in India only after the Turkish conquest in the twelfth century has been challenged by recent research. Not only were mosques built in the eighth century by the Arabs in Sind, but pre-conquest mosques existed in the wealthy Gujarati port of Bhadreswar—the local Jain rulers, trade partners of the Arabs, had allowed the resident Ismaili merchants to build mosques in the area.[2]

From the tenth century, the northern plains of India were convulsed by the raids of the neighbouring Turks and Afghans, who were lured by the legendary wealth of the temples and won control in 1206 CE. The regions that stood in the path of the Islamic war machine suffered most. Buddhist and Hindu monuments disappeared almost overnight, the first mosques being built with their debris. The Turks and Afghans were the latest in the waves of invaders that had been entering India since antiquity. However, the crucial difference was the new phenomenon, Islamic monotheism, which brought an egalitarian ideology that struck at the very roots of the Hindu caste hierarchy. The oppressed lower castes flocked to the crescent banner, which promised

them personal dignity and social equality. Essentially pragmatic, the young Sultanate of Delhi soon forged a working relationship with the indigenous population. In general, the country enjoyed stability under the Sultanate. The pilgrim tax and poll tax (*jaziya*), imposed on Hindus and Jains, were the only reminders of their subordinate status.[3]

## A new architecture

The sultans were prolific builders. Islam introduced the mosque (*masjid*), the mausoleum (*muqbara*), the centre of learning (*madrasa*), and the covered inn (*caravanserai*) to India. Secular architecture, in the form of palaces, fortresses, and gardens, underwent considerable modification in accordance with Sultanate requirements. These changes radically altered the skyline in northern India, where mosques of elegantly spare design, relieved by abstract ornaments, replaced temples. The Tamil south (which remains almost entirely Hindu even today) continued to build temples decorated with figure sculptures. These temples, often of soaring height, were built essentially by the 'horizontal method' of placing successive layers of stone one above the other. Even the 'arches' were based on the trabeate method of posts and lintels. A different form, the pointed arch, which spanned wide spaces with elegance and created lofty vaults, was the contribution made by Islam to Indian architecture.[4] Islamic architecture effortlessly blended

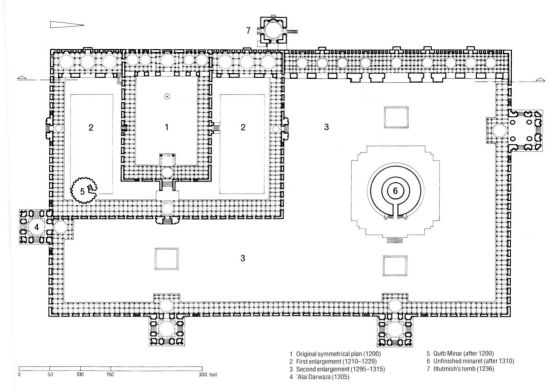

1 Original symmetrical plan (1200)       5 Qutb Minar (after 1200)
2 First enlargement (1210–1229)       6 Unfinished minaret (after 1310)
3 Second enlargement (1295–1315)       7 Iltutmish's tomb (1236)
4 'Alai Darwaza (1305)

0   50   100   150     300 feet

**55**

Quwwat ul-Islam mosque, Delhi, ground plan, from 1206.

At its most basic, the mosque is an open quadrangle that accommodates the faithful during prayer, and is surrounded on three sides by pillared cloisters, inspired by the Prophet's house. The sermon is delivered from the pulpit, called the *minbar*. The *qibla*, the side pointing towards Mecca, contains the walled recess known as the *mihrab*. Later, the *mihrab* was reached through the *iwan*, a vaulted hall fronted by an imposing portal.

universal elements, such as the dome and the arch, with the local genius of Arabia, Iran, North Africa, Spain, Central Asia, and South and South-East Asia. The early Indian *masjids* looked to such famous models as the Great Mosque in Damascus and the Seljuk *madrasas* of Iran. Yet it is their South Asian features that gave them their unique flavour. As imported labour was costly, Indian craftsmen were hired whose use of Hindu temple mouldings in mosques reflects the 'empathic' response of local craftsmen to Islamic requirements.[5]

The mosque is the anchor of the faith, its origins remarkably simple. The only requirement for a Muslim is to turn towards Mecca while praying (to the west in the case of the subcontinent) [55]. In 1206 CE, the founding Sultan, Qutb ud-Din Aybak, embarked on the first congregational or Friday mosque (*jami masjid*), the Quwwat ul-Islam ('Might of Islam') in Delhi, which had been chosen as the seat of the Sultanate. Not only was it imperative to accommodate the sizeable Muslim congregation swollen by recent converts, but the young Sultanate was expected to impress non-Muslims in India and to rival Muslim powers abroad. The mosque's large courtyard was marked on the west side by an arcade whose 'unkempt' appearance was the result of the use of disparate columns from 27 demolished Hindu temples. It was the lofty Qutb Minar, attached to the Quwwat, that emerged as the spectacular monument of the Sultanate. Its immediate inspiration

## 56

Sultanate buildings, Delhi, thirteenth century.

**(a)** (left, background) Qutb Minar, thirteenth century, height 219.9 feet.

The four diminishing storeys of the minaret are broken by projecting balconies, each differently designed with combinations of engaged columns, flutings, and star patterns. The red stone acts as a foil to the ornamental bands with elegant carvings of foliage, scrolls, and, above all, Arabic inscriptions extolling Islam's triumph over unbelievers. Interestingly, later Indian craftsmen inscribed details of their work in Devanagari (Sanskritic script) on the pillar.

**(b)** (right, foreground) Alai Darwaza, fourteenth century.

The vaulted hall inside is crowned with a low dome, while its arched portals on four sides are echoed in the smaller mock arches with perforated stone screens. The combination of red sandstone and marble panels anticipates later Mughal work, while Timurid decoration is substantially modified by the Indian lotus.

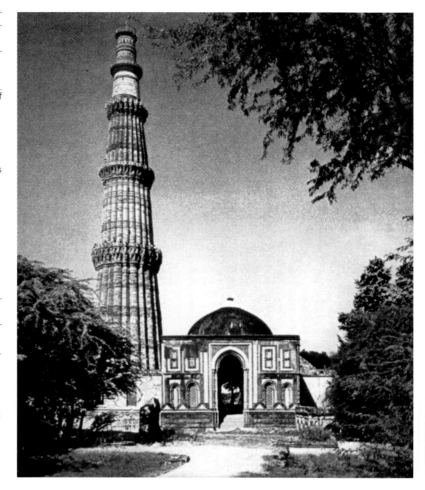

was the minarets of Afghanistan, admired by Aybak, but its obvious Indian feature is its deep red sandstone surface. In Islam, minarets are ostensibly for the *muezzin* to call the faithful to prayer. But from Seville to Samarqand, in lands where non-Muslims predominated, these high towers became symbols of the might of Islam [**56a**].[6]

It may seem strange that such assured works could be produced within 50 years of the founding of Muslim rule. But regardless of their own religious persuasion, Indian builders were professionals whose flexible skills had already served Buddhist, Hindu, and Jain patrons. Admittedly, in the case of Islamic architecture, they had to learn an entirely new vocabulary, but they were able to adjust their skills in the light of new requirements. Indeed, the reputation of Indian builders in the Islamic world led to their conscription by sultans for work in their main cities, most famously in Samarqand.[7] However, the continued use of the post and lintel system in Indian Muslim buildings even as late as the Mughal period, the preference for dressed stone rather than

brick, and the richness of the decoration (albeit abstract now) betray the unmistakable hand of the Indian craftsman.

In the next centuries the only additions to the Quwwat were extensions of its large courtyard, while architectural energies were expended elsewhere. Sultan Ala ud-Din Khalji (1296–1316), who saw himself as a second Alexander, planned a minaret that would dwarf the Qutb. All that is left of this grandiose project is the harmonious 18-metre-high victory gateway. In keeping with the sultan's mentality, the inscriptions sing his praises rather than the customary encomium to Allah [**56b**].[8]

## Urban planning

Between 1320 and 1388, Muslim architecture became considerably indigenized, as the Tughlaq sultans standardized building practices by setting up a department of architecture and initiating bold experiments in urban planning. In Delhi, Sultan Muhammad bin Tughlaq (1325–51) not only expanded the citadel of Tughlaqabad and built the urban complex of Jahanpanah, he was also the first Delhi sultan to try to control the Deccan by raising an impregnable fortress capital at Daulatabad. The huge administrative citadels within cities, notably Tughlaqabad, were protected by crenellated walls of rubble masonry faced with painted stucco. The north African explorer Ibn-e-Batuta marvelled at the beautiful paintings and mosaics in Muhammad's 'Palace of A Thousand Pillars'.[9] An open-minded intellectual, Muhammad sought to consolidate his empire with Hindu support, taking part in Hindu festivities and lifting the ban on the construction of temples.

Muhammad's nephew, Firuz Shah (1351–88), was more ambivalent about his relationship with the Hindus since his mother was most probably a Hindu. He raised the city of Firuzabad and undertook the construction of public buildings as a pious duty, accepting the conservation and restoration of buildings and the upkeep of workshops (*karkhanas*), gardens, and irrigation canals as a royal responsibility. The emergence of Delhi as the intellectual capital of Sunni Muslims can be attributed to Firuz, for he built the largest *madrasa* of the period. Why the pious sultan commissioned a curious three-tiered pyramidal building, surmounted with an Asokan pillar, is not entirely clear. Brought to Delhi from a great distance by boat, this 'symbol of idolatry' was prominently displayed in the capital.[10]

## Mausoleum architecture

The most original Indian contribution to Islamic architecture was the royal mausoleum, a visible emblem of royal authority. And yet, by incorporating the *mihrab* in its design, the mausoleum never failed to remind the faithful of the ruler's piety even in death. The tomb was an image of Koranic earthly paradise, a garden watered by the four

Ghiyas ud-Din Tughlaq's mausoleum, Delhi, fourteenth century.

The red sandstone and marble mausoleum is placed inside a pentagon-shaped fortification, in the midst of a lake, reached by a causeway resting on arched piers. Flanked by four lofty doorways on its four sides, the tomb's rubble and masonry structure is faced with marble and red sandstone, the marble dome making its first appearance in India.

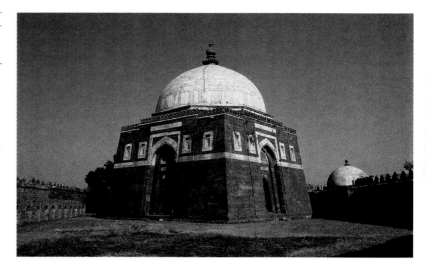

celestial rivers. This promise of what lay beyond was made clear in an inscription in the early sultan Iltutmish's tomb. First appearing in Islamic Egypt, the design of a sepulchre set in a lake or a garden was to be taken to supreme heights in the Taj Mahal.[11] The Sultanate mausoleums, originating in the Turko-Iranian domed square tombs, but developing into an octagon decorated with Indian motifs, were soon emulated by those of court officials, provincial governors, and sundry pretenders. The first landmark in tomb architecture was Ghiyas ud-Din Tughlaq's elegant mausoleum [**57**]. By contrast, the pious Firuz's tomb was a square pile of rubble and masonry crowned with a shallow dome. Somewhat forbidding, though graceful, it reflected Firuz's suspicion of ostentation.

After Firuz, building activities suffered a setback following the devastation of Delhi by Timurlang, except for the rise of open pavilion tombs—slender square or octagonal structures, resting on plinths and supporting kiosk domes (*chhatris*), set in the midst of lush parks. The mausoleum that took the octagonal tomb to its pinnacle came, fittingly, at the close of the Delhi Sultanate. This was the stately grave of Sher Shah, a brilliant soldier of fortune, who ruled briefly in Delhi after driving the Mughal emperor Humayun out of India. The sepulchre, designed by Aliwal Khan, was meant to exalt this ruler of humble origin [**58**].[12]

## Provincial sultanates (fifteenth and sixteenth centuries)

During the fifteenth and sixteenth centuries, as the centre lost its grip after Firuz Tughlaq's death, the provincial viceroys began asserting their independence, establishing themselves in Multan and Gujarat in the west, the Deccan in the south, Jaunpur in the north, and Bengal in the east. They initiated ambitious architectural programmes, their

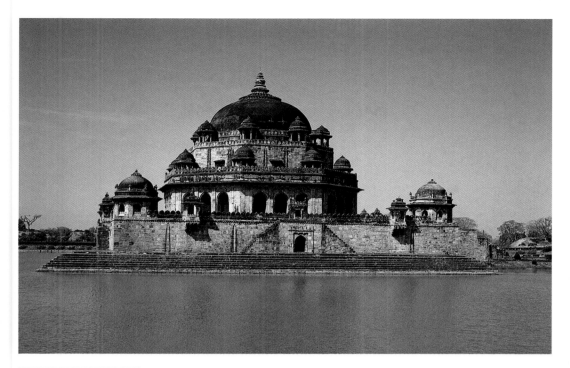

**58**

Sher Shah's pavilion tomb, Sasaram, Bihar, 1530–40.
This, the largest tomb of its time (145 feet high and 229 feet wide), is on an island in an artificial lake reached by a causeway, the lake reminding believers to quench their thirst before entering paradise. The eight-sided pyramid, rising in three diminishing stages, rests on a high plinth flanked by corner pavilions. Its varied shape and use of materials such as sandstone and glazed tiles and its imposing shallow dome, echoed by many smaller cupolas, make it an arresting sight.

immediate inspiration being metropolitan Tughlaq architecture, out of which a remarkable variety of styles emerged in response to local conditions. At Jaunpur, for instance, a great cultural centre, the triumphal portal of the *iwan* (domed hall) in the Atala Masjid (*c*.1394) attained the scale of the monumental pylons of Egypt. On the other hand, the mosques of the Ahmad Shahi dynasty (1408–1578 CE) in Gujarat made full use of rich temple decorations as well as indigenous building methods, such as corbel domes resting on pillars. A Gujarati speciality was the perforated stone screen, nowhere seen in greater brilliance than in the decorative tree motif of the Sidi Sayyid Mosque at Ahmedabad (1516). Deccan sultans, for example the Bahamani Sultanate (in present-day Karnataka), were unusual in drawing directly upon Iranian, Seljuk, and Timurid forms, as a way of proclaiming their independence from Delhi [**59**].[13]

### Secular architecture

Among secular buildings, fortresses, as key elements in defence strategy, are of major importance. There remain impressive fortifications in many parts of India. Protected by moated battlements, they usually perch on top of a ridge (frequently with a township or settlement at the bottom) that provides them with a commanding view of the surrounding terrain. Among these, the Mughal forts of the later period are well preserved, while for sheer picturesque quality few can compete with Rajasthani forts. However, the latter have gone through

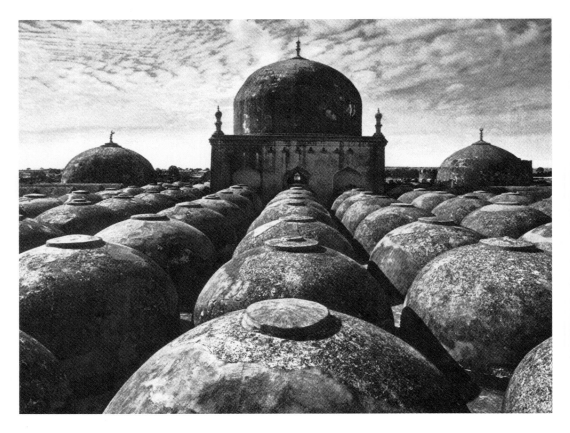

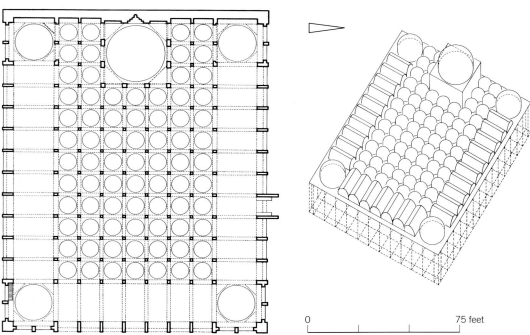

*Jami masjid* (Friday mosque), Gulbarga, 1367: **(a)** view over roof of the mosque looking west towards Mecca; **(b)** plan and axonometric view.

Built in the Bahamani capital during the reign of Mahmud I by the architect Rafi, a native of Qazwin in Iran. The roofing over of the entire rectangular courtyard, with numerous cupolas resting on arches, offered a novel alternative to the open courtyard mosques. To emphasize the importance of the prayer hall at the western end, an imposing dome was placed over it. The multipartite structure is also a reminder of Jain and Hindu temples.

so many stages that we cannot be confident as to their original forms (see chapter 7). With constant threats from hostile Hindu and rival Muslim powers, defence was a high priority for the sultans, as illustrated in the Deccan [**60**].[14]

Literary evidence endorses the variety and importance of secular buildings. However, most early palaces have either perished or have been rebuilt so extensively that their original form can no longer be ascertained. A description of the arrangement of royal domestic spaces in India, which were probably grander versions of affluent households prevailing all over the East, could be found in the writings of the ancient Mauryan author Kautilya [**61**].[15]

## The Vijayanagara empire (1336–1564)

There are two significant Hindu architectural achievements which were a synthesis of Hindu and Muslim concepts. One occurred in the cosmopolitan empire of Vijayanagara, founded in the fourteenth century by a Hindu dynasty and a remarkable example of the complex interface of Islamic and Hindu cultures. This South Indian state was the political rival of the Bahamani Sultanate, its rulers styling themselves 'sultans among Hindu kings'. The pioneering historian R. Sewell encouraged the idea that the Vijayanagara rulers were leaders of the Hindu resistance to Muslim advance in the south. Recent historians, who question this view, contend that the Vijayanagara monarchs displayed a flexible approach, adopting Islamic customs for international affairs, while preserving Brahmanic rituals for local matters. The lucrative seaborne trade covering a considerable area from the Mediterranean to the China Seas that touched the South Indian port of Bhatkal was largely in Arab hands. In an astute move to stake a claim in it, the Vijayanagara emperor Krsnadevaraya (1509–30)

Fortress at Gulbarga, fourteenth/fifteenth century.

Its design and layout sought to redress the lack of natural defences. A wide moat encloses a two-part defence, the inner wall rising above the 48-foot-thick outer wall. Massive bastions are fitted with revolving platforms for cannons, while walls have holes for musketry. A meandering projection with four gates and guarded courts deflects enemy attack by providing cover, bastions, and battlements. The doors, between a formidable pair of outer bastions, are fitted with anti-elephant spikes for added protection.

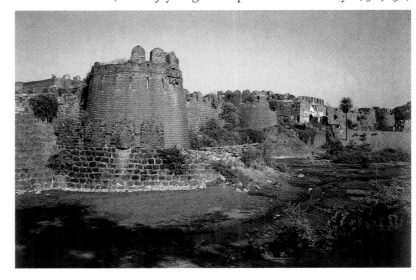

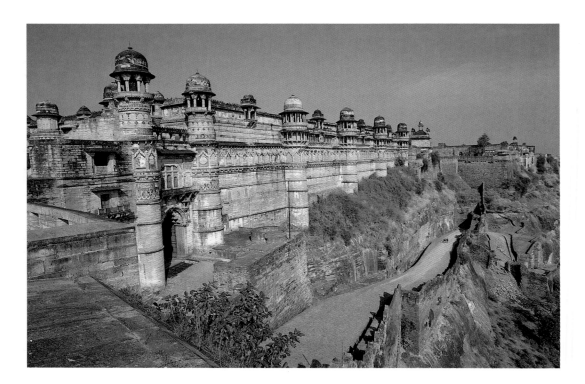

**61**

Man Singh's palace fortress, Gwalior, sixteenth century. This, at the summit of a high plateau, is an ambitious effort by a Hindu monarch to combine indigenous and Islamic elements. Its interior design, which influenced the Mughals, consists of a series of courtyards enclosed by apartments with screened galleries. The circular buttresses of the fortress are surmounted by high domed kiosks (*chhatris*), bands of blue and yellow glazed tiles relieving the light red sandstone walls.

adopted Islamic customs, even appearing in public in Muslim dress.[16] He introduced firearms, imported horses, improved fortifications, and instituted efficient revenue collection. At the same time he was an active patron of Hindu religious foundations.[17] While Vijayanagara temples followed the Dravidian tradition, especially as interpreted by the Colas, it is significant that secular buildings were modelled on Bahamani architecture, a bonding agent for this heterogeneous empire.

*Secular and sacred architecture*

Hampi, the capital of the empire, was a cosmopolitan commercial centre inhabited by a mixed population that included Portuguese gunners and Muslim cavalry who served in the Vijayanagara army. Muslims were allowed to build mosques within the citadel. The Portuguese traveller Domingo Paes described Hampi in the period 1520 to 1522: 'The king has made within it a very strong city, fortified with walls and towers. Inside are broad and beautiful streets with rows of fine houses where live many merchants.' Hampi was ringed with concentric walls and gate towers, marking two spatial zones where the sacred and the secular met, namely the temple area and the urban settlement. Within the latter was the royal precinct, which held 'the pulse of the empire'.[18]

The secular masonry buildings, expressing imperial ideology and cosmopolitan values, employed Bahamani-type arches, domes, and

The hundred-pillared hall with its multi-storeyed platform is situated between the king's palace and the royal Ramacandra temple. This lavishly decorated platform played a crucial part in legitimizing royal authority during the annual Mahanavami festival, associated with the goddess in the epic *Ramayana*. On that day, the emperor assumed the persona of the ideal king, Rama, while the chiefs who assembled in the capital took part in a state ceremonial reaffirming his omnipotence.

vaults and were based on square, rectangular, or octagonal plans. In their use of particular masonry techniques and fine plaster the buildings could well be mistaken for mosques at Gulbarga, the Bahamani capital. Their decoration was geometric and foliate, while the moulded bases, overhanging eaves, and pyramidal towers synthesized Dravida and Islamic forms. The multi-lobed arches, a Vijayanagara feature, were adopted as niches for Hindu deities. The most imposing structure at Hampi was the elephant stable, as befitted this royal animal. It is a long building with a row of 11 square chambers entered through arched doorways. Above them is a series of domes of different shapes arranged symmetrically.[19]

In the sacred part of Hampi, temples dedicated to the local goddess Pampa and her consort Virabhadra represented a triangular patronage network comprising the emperor, the temple, and the chiefs. However, the fifteenth-century Ramacandra temple in Dravida style, situated in the royal centre, was mainly associated with the monarch, as suggested by friezes on its outer walls portraying royal processions. In the next century, temples acquired the more familiar Vijayanagara style, sporting prominent gate towers (*gopuras*). Another Dravida feature inherited from the Cola period was the growing importance of the dance. Domingo Paes remarked that the dance poses (*karanas*) on temple walls were used as aides-memoires by court dancers, a practice in line with the South Indian tradition [**62**].[20]

## Bengali temples (sixteenth to nineteenth centuries)

The second example of Hindu–Muslim synthesis, namely Bengal, evolved its own cultural tradition from the eighth century onwards. Bengal and Bihar, known as the eastern lands from the Gupta times, were a major centre of Buddhism. Its final flowering in India took place

| | |
|---|---|
| *bangla*—temple architectural form based on bamboo and mud hut | *dalan*—rectangular temple building with a colonnaded veranda |
| *chala*—temple roof based on sloping thatched roof (do-chala = twin-roofed) | *jor-bangla*—twin-hut temple form *ratna*—pinnacle style of temple |

in the great university monasteries of Nalanda (Bihar) and Paharpur (Bangladesh) during the Pala period (*c.*760–1142). This was when Buddhists lost their separate identity as they increasingly shared Tantric rituals and cults with the Hindus. Characteristic of Bengal were the unadorned early brick temples, which have not survived, but a plethora of Buddhist and Hindu cult icons, from the Eastern workshops, in grey-black chlorite or metal, have.[21]

The Turko-Afghans who conquered Bengal in the thirteenth century built impressive mosques in a provincial style that blended Muslim and indigenous elements. The synthetic culture of Sultanate Bengal witnessed the rise of an anti-caste Bhakti movement led by the Vaisnava saint Sri Chaitanya (1486–1533), which gave a new impetus to temple building. Bengali brick temples, built between the sixteenth and nineteenth centuries, do not fit the general canon, though elements such as Orissan *sikharas* were incorporated into Bengali temples. The basic rectangular shape of a Bengali temple was taken from the domestic bamboo and mud hut (*bangla*) with sloping thatched roofs that coped with the heavy rainfall of the region. The first temples were of the *jor-bangla* type, with one hut serving as the shrine while the second formed the front porch, *jor-bangla* being the most distinctive Bengali contribution to Indian architecture. The Bengali temples are also classified according to their curved roofs with curved cornices (*chala*), the simplest being those with two-roofs (*do-chala*) and the most elaborate the eight-roofed temples. With the experience gained from Islamic buildings, the builders used arches, domes, and vaults for the superstructures of these brick temples. The second development was the *ratna* style, whose lower part consisted of a rectangular 'hut' structure with curved cornices, but which was crowned by multiple pinnacles, sometimes as many as 25. In a developed example the central domed chamber was enriched with multiple-domed side chambers and pinnacles, and with pillared and triple-arched entrances. Later another temple form emerged, the *dalan*, with a colonnaded veranda. Finally, Neoclassical temples in the shape of a rotunda made their entry during the colonial period.[22]

A characteristic feature of Bengali temples is the rich sculptural frieze worked in terracotta at the base or above the entrances of temples [**63**]. In addition to popular religious themes, from the eighteenth century the reliefs demonstrated a keen interest in secular

**63**

Krishna Chandra temple, Kalna, *c.*1751.

This is an elaborate example of a many-pinnacled Bengali temple decorated extensively with terracotta reliefs.

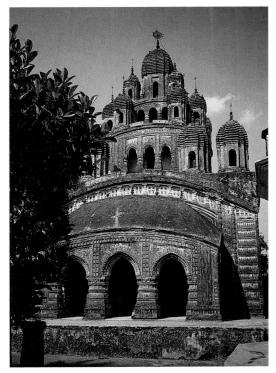

subjects—battle scenes, boating parties, entertainments, processions, Europeans involved in various activities, and even European galleys. In the Shyamaraya temple in Bishnupur, men are depicted riding on elephants or sitting in chairs with pet dogs, while women travel in palanquins or are seated on couches reading books or looking out of windows. These temples received the lavish support of the landed aristocracy (zamindars), such as the Mallas of Bishnupur, who by the seventeenth century were only nominally under the rule of the Mughal emperor. With the expansion of overseas trade in the eighteenth century, prosperous Bengali merchants became involved in temple building. The names of the architects, some of whom were considered to be masters of their craft, are mentioned in the temple inscriptions, as well as the patrons' power and wealth.[23]

## Painting during the Sultanate period

The Indo-Islamic era brought changes in the practice, scale, format, organization, and genres of painting in India. Monumental sculpture as an art form declined, while wall painting was eclipsed, though not entirely replaced, by small-scale paintings illustrating texts.

### Illuminated manuscripts

Around the tenth century, a new phenomenon, the illustrated book, made its appearance around the globe from Chartres through Isfahan

**64**

Detail from palm leaf manuscript of the *Pancaraksa*, Bengal, *c.*1057 CE.

This text on Buddhist Tantric goddesses from the Pala period was commissioned in the fourteenth year of King Nayapala's reign by Queen Uddaka. These royal manuscripts were elegantly written, sumptuously illustrated, and preserved between elegant wooden covers.

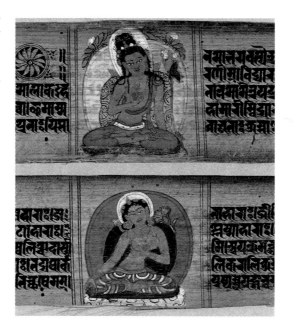

to Beijing. Paintings became a portable commodity, private collections were formed, and illustrated books came to denote wealth and prestige. No expense was spared on materials and craftsmanship. Opulently produced manuscripts, bought and sold, presented, ceremonially exchanged, or acquired as war booty, were precious objects which only persons of royal or noble birth could afford. Unlike the communal art of the temple, calligraphers and painters were employed by the scriptoria belonging to patrons of substantial means whose taste became paramount. In particular, Muslim calligraphers who transcribed the word of Allah enjoyed a high reputation in a society that prized the art of the book.

Even though writing had been known in India since Asokan times, it had been confined to secular subjects, or to stone and metal inscriptions that served as public documents. Sacred texts such as the Vedas were orally transmitted because of the importance of enunciating each word perfectly. In India, the earliest illustrated texts were the tenth-century Tantric Buddhist treatises, which came out of monasteries at Nalanda in Bihar and Paharpur in Bengal [**64**]. However, in less than two centuries a flourishing painting tradition grew up on the west coast under the patronage of Jain merchants, who set up great libraries and commissioned artists to illustrate two major texts, *Kalpasutra* and *Kalakacarya Katha*.[24]

The Sultanate art of the book introduced paper and effected other changes in Indian painting. The long-held belief that Delhi sultans followed the Sacred Tradition (*Hadith*) in forbidding the painting of living forms has now been thoroughly disproved. The sultans bought

Arabic, Turkish, and Persian texts for their libraries and commissioned new ones. In search of work, scholars and scribes from Baghdad, Bukhara, Samarqand, and other Islamic seats of learning came to Delhi, which acquired renown as an international centre for trade in manuscripts.[25] Although actual paintings from the Delhi Sultanate have not been identified with certainty, we know from contemporary accounts that the sultans had picture galleries where they took their leisure, though the pious Firuz Tughlaq replaced human figures with floral paintings in his own chambers. However, other Tughlaq sultans even tolerated Hindu themes.[26]

The only Sultanate paintings known to have survived are from the provinces. They demonstrate the process of the fusion of Persian/Near Eastern and Indian painting conventions. The most famous, those illustrating the *Ni'mat Nama* (*Book of Delicacies*), were produced for Ghiyas ud-Din Khalji, sultan of Malwa (1469–1500), who, disillusioned with war, withdrew from the cares of state [**65**]. A sixteenth-century historian writes about this grand eccentric with his Epicurean approach to food and sex. An absolute ruler, he was able to fulfil his fantasies on an unprecedented scale, collecting 16,000 slave girls, dressing some of them in male attire, and teaching them different professions so that only women might serve him.[27] The style of the *Ni'mat Nama* illustrators seems at first glance to be a provincial variant of Persian painting. A closer look at the treatment of faces and

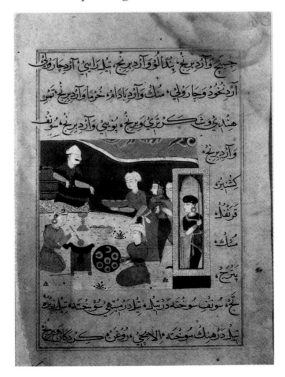

**65**

A page from the *Ni'mat Nama*, Mandu, fifteenth/sixteenth century.

The Indian artist, trained by a Persian master, uses a Persian manner for the foreign female slaves dressed in Persian male costume but reserves Indian conventions (especially the profile view) for the Indian female slaves. This selective use of Persian or Indian style to signal the cultural origins of the particular figure [see also **67**] is difficult to explain.

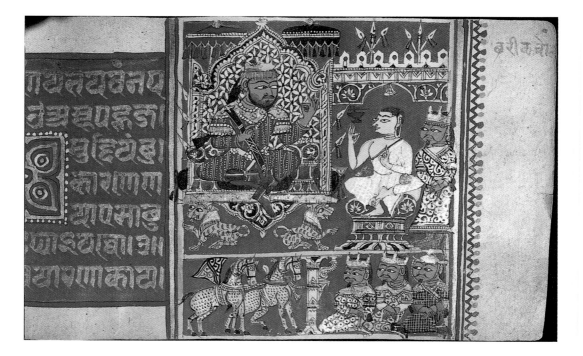

**66**

A page from the *Kalakacarya Katha*, 1414.

Paintings illustrating the *Kalpasutra* and *Kalakacarya Katha* are known for the projecting further eye of the faces in three-quarter view, the use of primary blues and reds, highlighted with gold, and the lively depictions of textiles for which Gujarat was famous the world over.

costumes reveals Indian authorship. The hands of two Indian artists, trained by a Persian master, have been identified. The more accomplished one interprets Persian elements deftly and imaginatively in the light of his own experience. (Paradoxically, the less skilled one copies Persian models more slavishly.) These works are important in that they demonstrate the process by which styles are transferred and assimilated by artists. Here the Indian artist's own conventions act as essential schemata which are modified in the light of the new style.[28]

The two Indian artists identified as the illustrators of the *Ni'mat Nama* seem to have been part of a painting tradition that prevailed in north and north-west India during the Sultanate period, particularly between the fourteenth and sixteenth centuries, about which we only have sporadic information. Among these artists, the Gujarati ones mentioned earlier are best known among scholars as 'Jain painters' because of the large quantity of Jain subjects painted by them. Paper introduced from Iran and Syria allowed these artists to experiment with formats and dimensions which had not been possible in narrow, palm leaf manuscripts [**66**]. Jain merchants and bankers were particularly enthusiastic about commissioning illustrated manuscripts celebrating Jain saints. Many of these were produced with cheap material, their calligraphy and painting bereft of elegance. Their existence strongly suggests that patronage was no longer confined to the wealthy or to royalty but included lesser merchants and people of more modest means.[29]

The so-called Jain painters have lately been reappraised in the light of the complex relationship between Islamic and Indian art and between Hindu/Jain and Muslim patronage. The Jain *Kalakacarya Katha* tells the story of how the abduction of the saint Kalaka's sister by the king of Ujjain was avenged by an ancient Sahi or Saka (Scythian) king. In ancient India, Sakas and Yavanas were the most prominent foreigners, and Yavana was the term later applied to Arabs and Turks. It is interesting that in some Jain manuscripts the painters represent the ancient Saka king in contemporary Arab costume or with the Mamluk (Islamic Egyptian) painting convention of three-quarter faces and sidelong glances. Conversely, a recently discovered illustrated Indian copy of the Persian epic *Shah Nama* could be mistaken for a *Kalakacarya Katha* [**67**].[30] There is evidence that 'hybrid' painting styles such as these, and that of the *Ni'mat Nama*, arose out of the inter-mixture of cultures; the artists, trained in Gujarati workshops, were possibly provided with samples of Persian and Mamluk painting by their Muslim patrons. In the late fifteenth century, the Mediterranean trade was dominated by the Mamluks of Egypt who, in partnership with Gujarati merchants, were the major suppliers of cotton, opium, lac, and other Indian produce to the West.[31] Painting on cotton as a major export from Gujarat to Egypt has been amply attested by the discovery of Gujarati textiles in graves in Fostat near Cairo.[32] The recent identification of Mamluk elements in Jain paintings offers further visual evidence of this trading connection.

**67**

Siyavash with his bride Farangish, *Shah Nama*, fifteenth century.
In this Indian copy of the Persian epic *Shah Nama*, the artist uses Indian and Iranian painting conventions interchangeably as the situation demands. For instance, Indian female characters are represented full-bosomed in the Indian tradition, while the Persian women are depicted as flat-chested in accordance with Persian painting.

*Secular painting*

Illustrated texts, many of them secular, and of a quite different genre, were commissioned by the Muslim and Hindu aristocracy of the sixteenth century: 'Even now, / I remember her eyes / trembling, closed after love, / her slender body limp, / fine clothes and heavy hair loose / a wild goose / in a thicket of lotuses of passion'.[33] Thus rhapsodized the eighth-century Kashmiri poet Bilhana about his beloved Campavati in the *Caurapancasika* (*Fifty Verses of a Love Thief*). The gentle eroticism of Bilhana's *Caurapancasika* marks a turning point in Indian culture, as the formal elegance of high Sanskrit yields to the intimate atmosphere of vernacular literature in Hindi, Bengali, and other provincial languages. Works such as the *Rasika Priya* of Kesav Das (1555–1617) elaborate a complex typology of ideal lovers and their mental states in which two emotions predominate: the heroine's intense longing for the absent lover and the joy of consummation. A new canon of feminine beauty permeates literature and art, according to which women are celebrated as passionate lovers, braving stormy nights and untold hazards to keep their rendezvous. These romantic lyrics offer a new outlet for Bhakti or devotional religion, in which the intensity of love outside marriage becomes a metaphor for the desire of the soul (Radha) for God (Krsna).[34]

The *Caurapancasika* inspired a major series of paintings that became the benchmark for pre-Mughal art, not least because this set was the first to be discovered by modern scholars. Over the years many more have come to light that give us an ever clearer idea about painting in North India on the eve of Mughal conquest. A 'transparent' narrative device in the *Caurapancasika*, which tells the story by placing the aristocratic hero and heroine in an everyday architectural interior, becomes a long-lasting convention. These paintings essentially belong to the romantic world of Rajasthan that was foreign to Jain piety. Since most Hindu kingdoms were on the defensive in the sixteenth century, it is likely that they were produced in the independent Rajput kingdom of Mewar [**68**].[35]

This painting tradition turned for inspiration to the Bhakti poems of Jayadeva and other poets. Ostensibly religious, the paintings capture the leisurely life at the courts of the Rajput kingdoms of north-west India, especially from the seventeenth century onwards. A related genre is the *Ragamala* ('garland of musical modes') painting, perhaps the most perfect marriage of literature, music, and painting. The modes of classical Indian music are conventionally divided into six male *ragas*, each having six wives, the 36 *raginis*. Each personification of these modes evokes a particular mood related to the time of the day or the season, a number of which found expression in painting.[36]

Literature and painting such as this might have remained parochial without the growing rapprochement of Hindu and Muslim cultures

**68**

Campavati standing next to a lotus pond, *Caurapancasika*, Mewar, *c*.1500.

The heroine's triangular torso, dilated pupils (the Sanskrit poetic metaphor of fish-shaped eyes as a mark of beauty), grey-blue patterned skirt, and chequered bedspread follow Jain conventions but the new element is the division of the picture into several planes by the use of Sultanate architecture: an open roof-top pavilion, projecting eaves with brackets, and crenellations in profile, the pavilion itself surrounded by flowering trees.

in the fourteenth century. Initially the conquerors had kept aloof from Hindu culture; Hindus on their part considered anybody outside the caste system as beyond the pale. The first signs of synthesis are evident in the work of the Indo-Turkish poet Amir Khusraw (1253–1325). Muslim Sufis and Hindu Bhakti saints began building bridges between the two communities. Syncretic movements such as the Satya Narayana cult (a blend of the Muslim saint Satya Pir and the Hindu god Vishnu) appealed to Hindu and Muslim villagers alike, as the sayings of the Muslim mystic Kabir came to be universally quoted in India. In the fourteenth century the Sufi Maulana Dau'd's text *Candayana* uses the story of the adulterous love of Laurak and Canda to inculcate the synthesis of Bhakti and Sufi doctrines [69].[37]

The conventions of Jain sacred painting, modified in the secular *Caurapancasika* paintings as well as in illustrations to Muslim texts, are now known to have affected a much larger area of northern and central India than had hitherto been assumed. The style can also be seen in wall paintings at Man Singh's palace in Gwalior. In short, it is not correct to hold, as some do, that Jain painters influenced the paintings of Muslim Malwa and Hindu Rajasthan. These painters, perhaps the majority from western India, were professionals who adjusted their

style according to the particular needs of their clients, whether Jain, Hindu, or Muslim.[38] The experience of these painters, who were to join the Mughal emperor Akbar's workshop, proved to be valuable in the formation of Mughal painting.

# The Mughal Empire (1526–1757)

6

## The Mughal court and state

The Mughal empire was one of the three great empires of the sixteenth century, along with those of Charles V of Spain and the Chinese Son of Heaven. The Mughals brought about qualitative changes in Indian society that were global in scope, anticipating a secular, pluralistic outlook that we tend to associate with our age. The landed classes had been in decline in a number of societies, giving rise to the rule of absolute monarchs, whose power base was an efficient, loyal bureaucracy. The impersonal state, whose urbanism, individualism, and 'objective' approach to nature laid the foundations of 'modernity', is more commonly associated with Renaissance Florence (c.1400–1600), but the same phenomena could be discerned during the Edo period in Japan (c.1600–1868) and in Mughal India (1526–1757). Yet it is not easy to understand why this burgeoning 'modernity' in Mughal India failed to take firm roots. Mughal 'urban' culture remained the personal achievement of the monarchs and the court. Lacking the social infrastructure that a large professional class, for instance, would have provided, these developments could not be sustained. Noble households dominated the urban economy in a patron–client relationship between the sovereign and the aristocracy, especially in the later period. The artisans attached to workshops essentially served these dominant groups.[1] Other impediments to 'modernity' included the Hindu caste system, which discouraged social mobility, and the Mughal law of inheritance, whereby an official's personal property reverted back to the emperor after his death. Although this was a disincentive to wealth accumulation and encouraged conspicuous consumption, the 'urban' outlook itself had a powerful impact on Mughal patronage.[2]

Contemporary literature bears witness to a new curiosity about everyday life that was a product of heightened individualism. Mughal autobiographies and diaries, written not only by monarchs but also by the ladies of the harem, were comparable in their lively detail and immediacy to Lady Murasaki's *Tales of Genji* and Bocaccio's *Decameron*. Babur (emperor 1526–30), the founder of the Mughal dynasty, reveals his enthusiasms, admits his mistakes with disarming candour, and offers penetrating observations about life around him. For much of

**Detail from *Squirrels in a Chenar Tree***

[See **78**.]

present-day India, the refined urbanity and elegant lifestyle of the Mughal court, its standards of haute cuisine and its codification of Indian classical music remain the essential benchmark. Mughal blood sports were taken up by the British Raj, as was the game of polo. Mughal emperors took their sartorial elegance as seriously as their collections of curiosa, jewellery, and precious objects of jade and hardstone.[3]

Mughal curiosity about science and technology was a sixteenth-century phenomenon. Mughal artillery proved decisive in battles, even though firearms had been introduced in the Deccan a century earlier through contacts with Iran and Syria. The age witnessed a rapid development in global communication, in part the result of European expansion. European travellers, some of them Jesuits, made their way to the Chinese and Mughal empires, which resulted in the exchange of objects and modes of thinking between the cultures. In India, however, curiosity about western things and ideas was confined to the Mughal emperor and his courtiers and did not filter down to other groups.

During the Mughal period the incipient 'urbanism' affected the subject matter of art, hitherto the preserve of the three great religions, Buddhism, Hinduism, and Islam. Mughal painting expressed a lively engagement with the external world, which may be loosely termed 'realism'. Renaissance *mimesis* is universally familiar as the cornerstone of western art history, yet a similar concern was expressed in Mughal history painting and portraiture. The art of the book had transformed patronage during the Sultanate, a process that reached a climax during the Mughal era. Art became an autonomous activity, fostering a close relationship between the patron and the artist; it ceased to be a communal concern. The Mughal emperors were fervent patrons of the arts, their multifaceted personalities informing their patronage—Akbar, the brilliant creator of a vast efficient empire; Jahangir, the endearing hedonist; and Shah Jahan, the royal architect and avid collector of precious objects—each was unique in his personal style of patronage. Yet, in at least one instance, patronage was not confined to royalty but included a grandee of the realm (see below).

## The reign of Akbar

Two cultural streams flowed in the veins of Akbar's grandfather, Babur, the founder of the Mughal empire: the Turko-Mongol tradition of his ancestors, Chinghis Khan and Timurlang, Marlowe's 'scourge of God', and the Persian culture which had deeply impressed the Mongols. A ruthless soldier, Timurlang had a weakness for beautiful things, collecting artisans from all over Asia in order to turn his capital, Samarqand, into a cultural wonder. Babur's temperament, as is evident from his remarkable autobiography, is an expression of this mixed heritage of violence and refinement, a characteristic shared in varying degrees by all three early emperors.[4]

Akbar, the greatest Mughal emperor (1556–1603), was a brilliant intellectual with a prodigious memory. Formally unlettered, he compensated this drawback by having courtiers read to him regularly. His doctrine of religious tolerance (*sulh–i kul*) wrought a political revolution by removing discrimination against the Hindus and basing his rule on the 'twin pillars' of Indian society, Hindus and Muslims. He created a centralized bureaucracy by organizing officials into military ranks (*mansabdar*), promoted on merit and owing loyalty solely to the emperor, which largely replaced the quasi-feudal land-holding system (*Jagirdari*) of the Delhi Sultanate. Akbar made the land tax more efficient and improved communications by expanding the arterial Grand Trunk Road, founded by Sher Shah. The pilgrim route from Agra to Ajmer was lined with stations for imperial use and miniature towers for milestones. Munim Khan's bridge in Jaunpur (1569) was an engineering feat. Akbar weakened the Islamic view of the ruler as God's deputy on earth, in favour of a doctrine of divine kingship. This enabled him to dispense impersonal justice to all by decree, thereby stripping Islamic judges of their traditional authority.

### Early Mughal architecture

Mughal architecture made clear political statements through a complex, syncretic imagery of varied pedigree. The different, and at first sight conflicting, influences from Timurid Central Asia, Iran, India, and the West were moulded into an organic unity through a powerful theory of kingship. Mughal architecture, disseminated throughout the empire by the viceroys, came to stand for imperial authority. Being descended from the nomads, the Mughals always retained a soft spot for tents, which they furnished with colourful carpets and costly fabrics.[5] However, it has been argued that Mughal experiments in urban design were inspired by the symmetrical, four-square gardens (*chahar bagh*), whose spaces were divided into modules—the particular Persian interpretation of the Koranic paradise garden.[6] The empire's founder, Babur, barely had time to lay out gardens for planting the Iranian fruits he missed in India. His son Humayun, destined to spend the best part of his life in exile, only realized a few of his architectural ideas. It was left to Akbar to commission the first major building from two architects from Bukhara in order to fulfil his filial duty by building a mausoleum to his father, Humayun. This centrally planned sepulchre in the centre of a four-square garden with running pools, streams, and open pavilions is the first of the Mughal paradise gardens [**70a, b**].[7]

### Urban planning

A brilliant general, whose empire rivalled Asoka's, Akbar built a network of fortress palaces between 1565 and 1571 aimed at imposing iron control over his considerable territory.[8] The first to be completed was the fort at Agra, which superseded Delhi as the main capital. With its fine masonry work and its elegant Delhi Gate made of sandstone inlaid with white marble, the fort came to serve a ceremonial rather

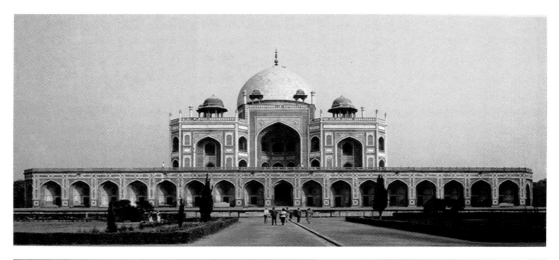

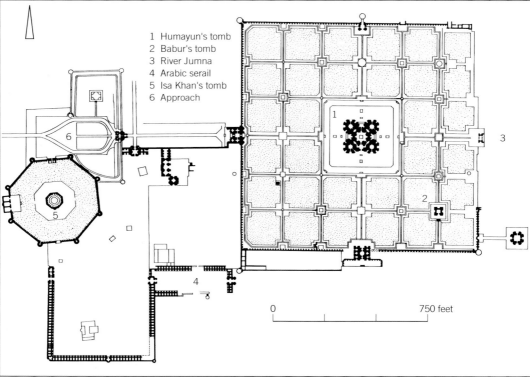

1 Humayun's tomb
2 Babur's tomb
3 River Jumna
4 Arabic serail
5 Isa Khan's tomb
6 Approach

0          750 feet

than a strategic purpose. The *zanana* (women's quarters), misleadingly called the Jahangiri Mahall, impresses us with its red sandstone and marble work and deeply carved surfaces. It was the first of Akbar's buildings inspired by the Man Mandir at Gwalior, in the use of details such as its peacock-shaped brackets.[9] Then followed the Ajmer Fort for overseeing Rajasthan; the Lahore Fort for securing the most vulnerable north-west frontier; a fort on the picturesque Dal lake in

An almost identical pattern is
used for all the four elevations
of this red sandstone and
marble building to reinforce
the simple geometry of a
symmetrical edifice. Its lotus
dome of white marble is
relieved by smaller *chhatris*
(kiosks). The high portal of the
south-facing main entrance is
shaped like a scooped-out,
arched niche, echoed by the
two smaller ones on either
side. The Timurid nine-fold
plan of the grave chamber
inside, recalling the Islamic
paradise, came to be used in
residential architecture.

Kashmir; and finally the Allahabad Fort, which guarded the eastern flank of the empire.

Akbar's most ambitious project was the citadel at Fatehpur Sikri, his new capital, where he introduced Indian concepts of royalty to assert his independence of the Islamic clergy. It was founded around the shrine of Salim Chishti at Sikri as a thanksgiving to the saint, and in 1579 Akbar read the *khutba* here—ostensibly a legitimizing act on the part of an Islamic sovereign, the *khutba* actually consolidated Akbar's own authority. Akbar assumed personal control of the shrine, encouraging Salim Chishti's descendants to join the imperial service. Different aspects of the city give architectural expression to the twin elements in Akbar's ideology: his personal rule and the Indianization of the empire.[10]

Fatehpur Sikri, which in its heyday held about a quarter of a million people, is irregularly laid out on an east–west axis, its over eight miles of walls broken only by a natural lake.[11] However, what is not evident today is that the citadel was once surrounded below by a large settlement built of less permanent material. The layout of Sikri and many of its features reflect the Gujarat-Rajasthan building tradition, not least the influence of Man Singh's palace at Gwalior on Akbar's living quarters [71]. The precise function of many of the Sikri buildings remains conjectural, though some can be clearly identified as fulfilling the needs of a Muslim state: a Friday mosque, an administrative centre, residential palaces, baths, caravanserais, gardens, centres of learning, bazaars, and workshops. Some of the buildings may have been inspired by the Mughal tent culture, but above all the buildings and the spacious terraces and courtyards that separate them constitute the geometrical realization of a theory of kingship. Indeed, this was acknowledged by the historian Abu'l Fazl.[12]

Sikri's Friday mosque, the largest of the period and the focal point of the citadel, stood at the summit of a windswept ridge. Its open courtyard harked back to Sultanate architecture, the prayer hall consisting of an *iwan* (domed hall) whose façade was dominated by a central *pishtaq* (portal) which, though large and high, was lightened by a series of *chhatri* kiosks. It is interesting that the *iwan*, designed as a detached building, has been compared to a Hindu temple sanctum.[13]

Fatehpur Sikri was a city of contrasts. The counterpoint to the stark Buland Darwaza (triumphal gateway) [72]—whose scale and position overwhelm us—is provided by the open pavilion palaces. The delicate white marble tomb of Salim Chishti, decorated with perforated stonework, also offers a contrast to the sombre red Sikri sandstone. (Of course, we should remember that the dark red sandstone interiors were transformed by rich carpets and silk fabrics.)[14]

The brackets deriving from Gujarati architecture in the *zanana* (commonly identified as the Rajput princess Jodha Bai's palace but this

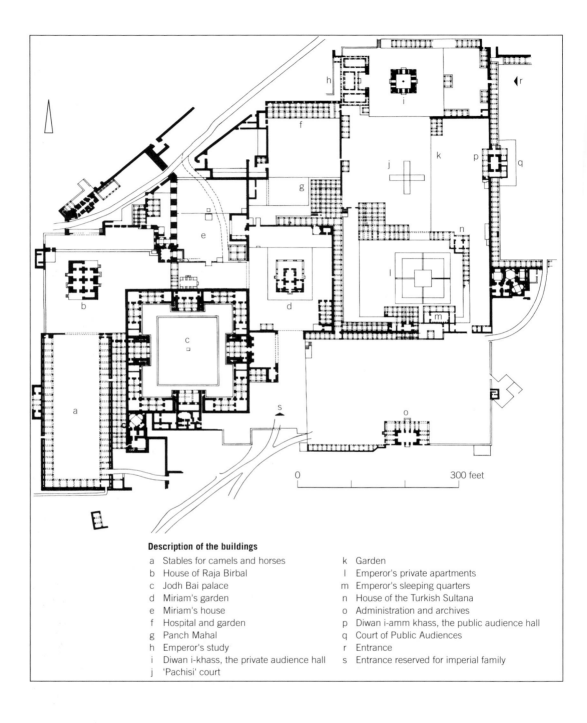

**Description of the buildings**

a Stables for camels and horses
b House of Raja Birbal
c Jodh Bai palace
d Miriam's garden
e Miriam's house
f Hospital and garden
g Panch Mahal
h Emperor's study
i Diwan i-khass, the private audience hall
j 'Pachisi' court

k Garden
l Emperor's private apartments
m Emperor's sleeping quarters
n House of the Turkish Sultana
o Administration and archives
p Diwan i-amm khass, the public audience hall
q Court of Public Audiences
r Entrance
s Entrance reserved for imperial family

**71**

Plan of Akbar's palace
enclosure, Fatehpur Sikri,
1569–74.

The layout of the palace
buildings offers some
interesting insights: the city
entrance led to the public
audience hall (*diwan i-amm
khass*) and to the secretariat,
then came the more exclusive
hall for the reception of high
courtiers (*diwan i-khass*). This
was followed by the emperor's
private quarters in the heart of
the complex. The women's
quarters (*zanana*) and the
houses of Akbar's intimates
backed onto the lake, which
gave the residences protection
against sudden attack. This
arrangement also provided
Akbar with easy access to all
the important parts of the
complex.

is now challenged) are seen as an expression of Akbar's respect for
the faith of his Hindu consorts.[15] One of the unusual structures is
the Panch Mahall, its five superimposed pavilions topped by a large
single kiosk. This pleasure palace, which allows cool breezes to flow
through its rooms in the summer, suggests an imaginative method of
ventilating buildings in a dry, hot desert climate.

The Buddhist idea of the universal ruler (*cakravartin*) and Akbar's
interest in solar symbolism probably influenced the beehive-shaped
'Gujarati' capital resting on a slender Hindu pillar in the midst of the
*diwan i-khass*. This giant 'mushroom' is strongly suggestive of the
ancient concept of *axis mundi*. The circular platform on its capital is
reached by walkways at each corner. Sitting on this central platform,
Akbar gave audience, his courtiers humbly approaching him from all
four directions, while his attendants stood below.[16] Finally, built as a
striking evidence of his intellectual openness was the House of
Worship, where leaders of the major faiths met to hold free and
vigorous debates. Whether Akbar's syncretic *Din i-Ilahi* (Divine
Faith) was a new religion, as claimed by some, or not, it helped to
strengthen the emperor's personal rule at the expense of the Muslim
divines. Akbar's urban experiment came to an end when Fatehpur
Sikri was abandoned after 15 years; he was obliged to move to Lahore to
secure the border threatened by the Safavid empire in Iran.

**72**

Buland Darwaza, Fatehpur
Sikri, sixteenth century.
Following Akbar's victory in
the Deccan, Sikri was
renamed Fatehpur Sikri, 'City
of Victory', and
commemorated with a
triumphal gateway on the
south side of the Friday
mosque. Not only does the red
sandstone edifice tower above
the city, but its dramatic scale
becomes obvious as the visitor
begins the slow climb up the
steep flight of steps to the
entrance. It was probably
deeply satisfying to the young
emperor that the portal
surpassed even Timurlang's
grandiose ones in Samarqand.

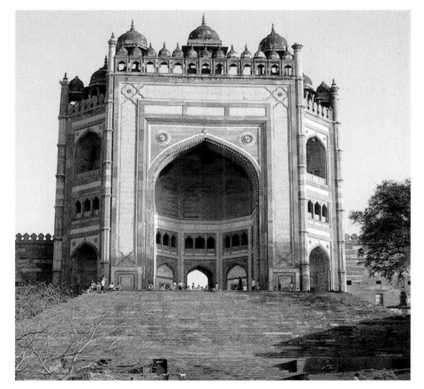

*The Mughal painting workshop*
Akbar laid the foundations of Mughal painting, a unique confluence of Persian, Indian, and European art. The emperor rejected the orthodox view that artists transgressed by seeking to rival God's creation and insisted that they felt all the more humble before God's omnipotence because they could not infuse painted figures with life. The Mughal emperors, who received instruction in painting as part of their education, cultivated the art of the book with a rare passion. Their exquisite volumes were placed on stands, each individual page scrutinized for its elegant lines and delicate brushwork, which needed to be enlarged to be fully appreciated (the glass lens was already in use at this time). During his flight from Agra, the emperor Humayun never lost sight of his book collection; his first thoughts on returning to Agra were of his library, and it was from its steps that he fell to his death.

We owe much valuable information on the production and consumption of art in India to the Mughal period. While in exile in Iran and Afghanistan, Humayun invited the Persian artists Abd us-Samad and Mir Sayyid Ali to set up a royal workshop (*karkhana*) in Agra. Abu'l Fazl gives us details of this workshop, which was inherited by Akbar and turned by him into one of the largest artistic establishments of the time. Muslim *karkhanas* were collaborative enterprises comprising paper makers, calligraphers, illuminators, gilders, illustrators, and binders, all supervised by a master [**73**]. However, Akbar's *karkhana* was more hierarchical than the Persian ones, the master being in charge of the composition, while the execution was left to junior artists.[17]

Paper, initially imported from Iran, began to be manufactured in the Punjab from the sixteenth century. Paints were made from animal, vegetable, and mineral substances, brushes from animal hair. The production of artist's materials was controlled for quality during Akbar's reign.[18] Many layers of paper were glued on top of one another to form a 'hardboard' painting surface. This was primed, burnished with agate, and then a freehand drawing was made or a stencil traced onto it. The preliminary brush drawing was done in red or black paint, the burnishing repeated after each stage of painting, giving a dazzling finish. Safavid painting, introduced by the two Persian masters, continued to be the model, while regularly imported stencils indicated the colours to be used. The work was divided among different artists specializing in foundation drawing, background, figure work, and portraiture, only master painters being allowed to do the outline drawing.[19]

*Painters at Akbar's court*
From the attention lavished on miniature paintings in the Mughal period one might imagine that wall paintings had gone out of favour. This is, however, disproved by ample literary evidence, their depiction

**73 Daulat**

Self-portrait with Abd al-
Rahim the scribe, Mughal,
c.1610.

The painter and the scribe, the
two chief elements in
manuscript production, are
shown with the tools of their
respective trades at the wishes
of the emperor Jahangir.
Daulat also portrayed himself
in the company of other
painters at the court, a
reflection of burgeoning
artistic individualism.

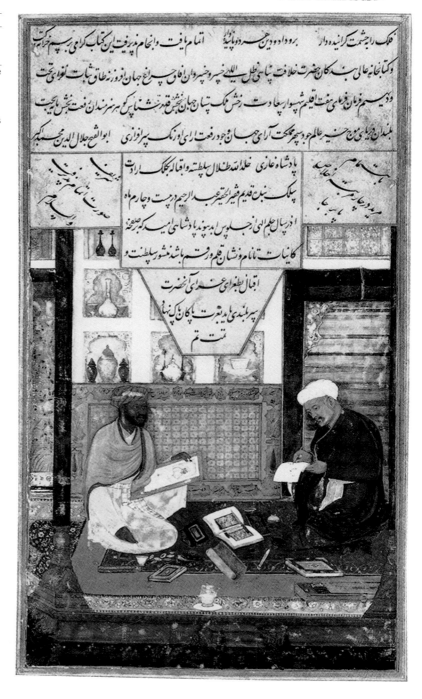

in miniatures, and from surviving fragments on walls. But undoubtedly the ablest artists and most ambitious works were connected with the art of the book. The artist continued to be a craftsman who had no independent status. As late as the time of Shah Jahan, painters born in the imperial household were called *khanazad* (second-generation servants).[20] Artists, their children, and their apprentices were part of the imperial household, which met all their needs. The Mughal painters Abu'l Hasan, son of Aqa Riza, and Manohar, son of Basawan, were born in the imperial household during Akbar's reign. Given training from an early age, they graduated from pattern books to the human figure, and practice in the drawing of flowers was meant to arouse their aesthetic feeling.

The highly competitive atmosphere at the court spurred artists to surpass themselves. The emperors conducted weekly inspections of paintings attended by courtiers, who offered criticisms. Out of over a hundred painters, including the woman artist Nadira Banu, about a dozen rose to prominence as masters with distinctive skills and personalities. They were rewarded with high positions and honours. Abu'l Fazl's *Ain i-Akbari* ranks artists in order of merit.[21] However, before the reign of Akbar's son Jahangir it is less common to find individual artists signing specific paintings. This raises the question: in these collaborative works, to what extent can we ascribe an artistic style to the patron's taste or to artistic personality?

The frenzied movement, feverish activity, clashing colours, and high drama which characterize the paintings of Akbar's early period have been attributed to his taste, much as Jahangir's introverted personality is seen to be mirrored in the intimate works of his reign. But it is equally interesting that the two leading artists at Akbar's court, Daswanth and Basawan, seem to have left a clear stamp of their temperaments on their art. The brief, tragic life of Daswanth is the stuff of romance, reflecting the topos of genius better known in the West than in India. Considered by Abu'l Fazl to be the finest Mughal painter, a view fully shared by Akbar, Daswanth became a legendary figure in his lifetime. The son of a humble palanquin bearer, his compulsive habit of drawing on walls brought him to Akbar's notice, who arranged for Abd us-Samad to train him. Daswanth 'became matchless in his time ... but the darkness of insanity enshrouded the brilliance of his mind, and he died a suicide', writes Abu'l Fazl.[22] It is interesting to note that this is the only recorded case of self-conscious artistic neurosis in pre-modern India.

Daswanth has been identified with particularly dramatic, expressionist works, and it is significant that after his death in 1584 Mughal painting moved away from a Dionysian frenzy towards an Apollonian lyricism associated with the other master, Basawan. According to Abu'l Fazl, our invaluable guide in these matters, in 'designing, painting faces, colouring, portrait painting, and other aspects of this art,

Basawan has come to be uniquely excellent. Many perspicacious connoisseurs give him preference over Daswantha'.[23] Basawan focused on pictorial composition, subtle tones, foreshortening, and the complex arrangement of figures in a landscape, evidence of his exposure to European art.

Akbar's workshop under Mir Sayyid Ali and Abd us-Samad recruited Indian painters in large numbers, whose formative works are preserved in the *Tuti Nama* (*The Tales of a Parrot*, a popular Indian folk tale, completed in the mid-sixteenth century). Even though Safavid and Timurid artists continued to serve in Akbar's workshop, it was the immediacy of feeling in western Indian art that enabled Mughal painting to cut its Persian umbilical cord, namely the Safavid subordination of detail to an overall formal arrangement. The *Tuti Nama* is valuable also for showing us how young Gujarat artists such as Daswanth and Basawan were in the process of absorbing Persian art.[24] Work began on the first landmark in Mughal art, *Hamza Nama*, in around 1562, its overall unity imposed by the workshop. The mythical adventures of the Prophet's uncle, Amir Hamza, interspersed with moral lessons, were illustrated with paintings on a larger format than the average Safavid works (14 x 10 inches) and painted on cotton rather than paper [**74**]. Rediscovered in the nineteenth century, some 200 out of 1,400 works have survived (mainly in the Österreiches Museum für Angewandte Kunst, Vienna and the Victoria and Albert Museum, London). While the visual impact of objects, such as brightly coloured polychrome tiles and richly patterned carpets, together with the luminous colours of Safavid painting liberated Indian artists from their hitherto limited palette, they themselves brought a freshness to details such as the leaves of trees or women drawing water from a well. But, above all, the dramatic and violent movement depicted in the *Hamza Nama* is alien to the remote, ordered sensibility of the Safavid artist.

As part of his objective of gaining Hindu confidence, Akbar turned to the Sanskrit epics *Mahabharata* and *Ramayana* soon after the arrival of learned Brahmins at the House of Worship in Sikri in 1580. These were translated, and provincial governors were instructed to make copies of them in an effort to disseminate Hindu classics throughout the empire. The second major painting series, for the *Razm Nama*, the Persian translation of the *Mahabharata*, was commenced in 1582 under the supervision of Daswanth, the emperor's favourite [**75**].[25]

*History painting*
The powerful drawing style developed in these two early projects with their depiction of psychologically related figures laid the foundations of Akbar's history painting. A revolutionary development in Indian art, Akbar's historical narratives perfectly express his theory of

Khurshidshehr frees Hamid, *Hamza Nama*, Mughal, *c*.1570.

In this episode, the princess chops off the giant's head to set free her prince. The gory scene is offset by lush tiles, carpets, and other details. The immediacy of the scene is heightened by the 'cropping' of the foreground. Some 100 craftsmen, including 50 painters, worked on the epic. The combination of aerial perspective for distance and eye-level perspective for the foreground suited the inclusive panoramic treatment of the subject matter.

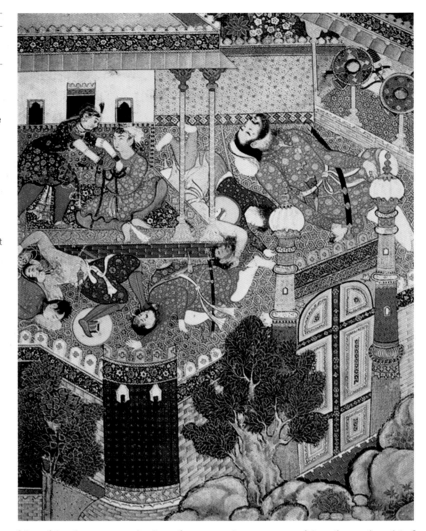

kingship: in every painting the sovereign assumes his role as the chief actor in the historical spectacle taking place before us. An archival office headed by Abu'l Fazl and manned by 14 clerks made faithful records of daily events, while court officials were encouraged to write their memoirs. Although this obsession with detail earned the dynasty the sobriquet 'paper government', it is thanks to Abu'l Fazl's *Akbar Nama* (*History of Akbar*) and *Ain i-Akbari* (*Laws of Akbar*) that we get an unrivalled insight into the age and into the mind of the great emperor. And if Abu'l Fazl was too close to the throne to be objective, the corrective was supplied by Badauni, the orthodox historian who disapproved of Akbar's liberalism.[26]

Akbar was in need of a narrative style that could do justice to his eventful reign, which revolved round the court, the hunt, and the battlefield. The earliest example of an illustrated text used as an

**75 Daswanth**

A night assault on the
Pandava camp, *Razm Nama*,
Mughal, 1582–6.

Thirty of the early illustrations
from this imperial album are
full of frenzied action,
dynamic movement, and
violent colour, qualities
associated with Daswanth's
genius. This nightmarish
vision of the frenzy of war,
verging on the macabre,
designed by Daswanth but
executed by Sarwan,
highlights Daswanth's brilliant
imagination.

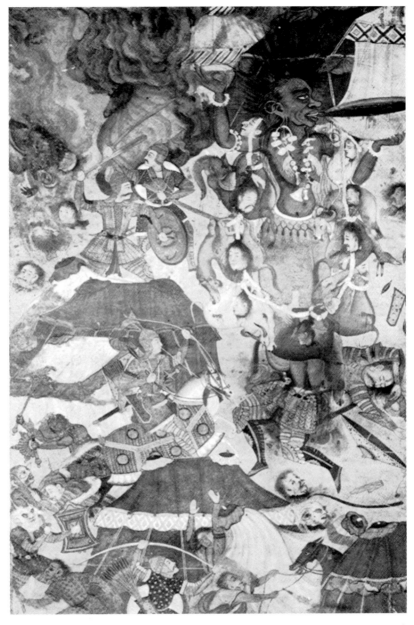

exercise in political legitimization, *Timur Nama* (*History of Timurlang*)
traces Akbar's genealogy back to the illustrious Mongol warrior. It is
significant that the paintings in this text constantly juxtapose Akbar
with Timurlang. For instance, scenes of Akbar hunting are modelled
on those of Timurlang. The central text of Akbar's reign, however, was
the *Akbar Nama*, the illustration of which was entrusted to Basawan,
who rose to prominence after Daswanth's suicide [**76**].[27]

Akbar's search for a convincing pictorial 'reporting' style was aided

Akbar brings the elephant
Hawai under control as
courtiers anxiously watch him,
*Akbar Nama*, Mughal, *c*.1590.
The painting is a symbolic
confirmation of the sovereign's
virility. Basawan favours the
consistent chiaroscuro of
Europrean art, especially in
the treatment of elephants, at
the expense of Safavid pure
colours, clarity of design, and
attention to detail. *Akbar
Nama's* other famous scenes
include the siege of Chitor,
whose reduction was crucial
to Akbar's securing of
hegemony, the building of
Fatehpur Sikri, and subjects
related to his personal life.

by his discovery of European art, traces of which can be discerned in works as early as the *Hamza Nama*. However, his meeting with the Portuguese came at a significant moment. In 1572, on his visit to Cambay, on the Gujarat coast, the emperor gave an audience to the Portuguese officials who were keen to extend their economic hold in India. Six years later, the Jesuits arrived at Fatehpur Sikri to participate in religious debates, bearing gifts that included an illustrated Royal Polyglot Bible, published in Antwerp by Christopher Plantin in 1568–73. Akbar, his courtiers, and his artists must have pored eagerly over these 'wonderful works of the European painters who have attained worldwide fame'.[28]

Akbar built up a collection of European religious paintings (his favourite subject), as well as secular ones, together with engravings, tapestries, and a musical organ. The actual absorption of European conventions by Mughal artists cannot be dated precisely, although it is known that European prints began flooding the empire in the late sixteenth century. The first stage of wonder and experimentation probably gave way to selective appropriation. Among early responses, there exists a precocious copy of St John from Dürer's *Crucifixion* by the 13-year-old Abu'l Hasan.[29] At the end of Akbar's reign, the impact of Mannerism begins to be palpable, as for instance in the night scene from Jami's *Baharistan*, painted by Miskina, who uses subtle atmospheric light and deep dramatic colours.[30] Although history painting dominates Akbar's period, there was no shortage of intimate works like these, which were meant for private delight.

## The reign of Jahangir

Akbar's eldest son, Salim, by his Rajput queen, Jodha Bai, succeeded him, assuming the name Jahangir ('Seizer of the World'). Having lived in the shadow of his father, Jahangir's response was to withdraw into a private world of pleasure. A man of refined sensibility, his overindulgence in the good things of life ultimately led to alcoholism and physical decline but he took Mughal painting to great heights, creating a symbiotic relationship between the patron and the artist. Jahangir's sharply observed journal, *Tuzuk i-Jahangiri*, offers us a mirror as much to his personality as to the age itself.[31]

As heir apparent, he had caused the ageing emperor a great deal of sadness by his rebellion and the murder of Akbar's close companion, Abu'l Fazl. However, Jahangir made his architectural debut with the pious act of building his father's mausoleum at Sikandra, renamed Paradise Town in honour of the great emperor. As had become the practice, the sepulchre was set in the midst of a four-square garden of paradise, with lofty minarets at four corners of the entrance gateway, the first of the multiple-minaret designs that became a common feature of the later Mughal style. Its square ground plan, which

consists of progressively diminishing layers, reminds us of Buddhist *stupas*. This is an early example of a Jahangiri building whose rich surface texture is created with red sandstone, white marble, stone intarsia (inlay), tile work, and painted stucco.[32]

### Nur Jahan and female patronage

A more opulent tomb, built much later, was dedicated to the father of the charismatic Nur Jahan ('Light of the World'), the pivot of Jahangir's life. Although legends tell of young Jahangir's love for Nur Jahan, he probably met her after becoming emperor. Once she was married to the emperor, a junta centring on her family assumed enormous power, taking advantage of Jahangir's progressive alcoholism. Nur Jahan was accorded the rare honour of having coins struck in her name. One of the major women patrons in India, she may have inspired more Persianate ornaments and popularized the use of more realistic figures, hitherto discouraged as an un-Islamic, Hindu predilection. But her greatest contribution lay in architecture and gardens.[33] Nur Jahan's informed taste in architecture is demonstrated in her most important commission, Itimad ud-Daula, the tomb for her father, a two-storeyed white marble sepulchre with decorative inlays set in the midst of the prescribed four-square garden. A rich texture is provided by delicate *pietra dura* work (marble inlaid with precious and semi-precious stones). The decorative motifs include representations of wine decanters and fruits of Safavid inspiration that promise the delights of paradise.[34]

### Royal gardens

Jahangir emulated his Timurid ancestors in building hunting lodges whose shooting towers were dotted with animal heads as trophies, but clearly gardens were a particular favourite of his, and his enthusiasm in this area was shared by Nur Jahan. The garden increasingly rivalled the citadel as an emblem of royal power and as the site where the divine king received his adoration. Seventeenth-century Mughal gardens, which fused Rajput, Iranian, and Timurid traditions and put a new gloss on the Islamic paradise garden, were integrated into the layout of cities. In his autobiography, the emperor enthuses about the gardens of Agra with their water reservoirs, channels, and plants. Their designer, Khwaja Jahan, was rewarded with the high rank of a *Mansabdar*.[35] Jahangir waxes eloquent about the clear waters and flowering trees of Kashmir, where he made his summer residence. The harnessing of nature by connecting waterfalls, canals, and terraces to the natural streams and springs of Kashmir equally reflects the taste of his milieu, in which women of the *zanana* were active patrons. In fact, it is only now that scholars recognize Nur Jahan's share in the gardens of Jahangir's period.[36]

## Jahangir and painting

By all accounts, Jahangir's patronage of painting remains the outstanding achievement of his reign. A man of discriminating taste, Jahangir's collection included European, Persian, and Deccani paintings as well. In his time, illustrated manuscripts gave way to self-contained, decorated albums (*muraqqas*) of miniature paintings. In these *muraqqas*, two calligraphic pages facing each other are often followed by two related paintings, thus giving the albums a greater unity.[37] When Jahangir set up his rebel court at Allahabad, one of his first acts was to give the émigré Iranian painter Aqa Riza charge of his painting workshop. Jahangir took particular pleasure in the company of artists, whom he honoured in different ways, conferring a very high title on Abu'l Hasan and sending Bishndas as part of a diplomatic delegation to the Safavid court of Iran. Jahangir was particularly proud of his discerning eye:

My liking for painting and ... judging it have arrived at such a point that when any work is brought before me ... I say on the spur of the moment that it is the work of such and such a man. And if there be a picture containing many portraits and each be the face of a different master, I can discover which face is the work of each of them.[38]

The weekly inspection of an artist's work in progress, initiated by Akbar, was taken even more seriously by Jahangir. The prestige acquired by painters at the Mughal court led to a growing demand for masterpieces, which makes the task of telling an original from a copy rather difficult.

## The development of naturalism

Seventeenth-century Mughal painting is dominated by two tendencies: the formal Persian arrangement of lines and colours and the new requirements of naturalism. Jahangir's attachment to mimesis was noted by the British envoy, Sir Thomas Roe, who, on giving an English miniature to the emperor, was immediately presented with a plethora of copies by court artists.[39] When asked by Jahangir to identify the original, Roe was momentarily at a loss, which pleased Jahangir no end. The origins of the Jahangiri style lie in the series produced in 1601 at Allahabad in Aqa Riza's Persian idiom. Yet the growing importance of naturalism is tellingly illustrated by the fact that Aqa Riza's own son, Abu'l Hasan, became its leading exponent [**77**].

From these early exercises, Jahangir's workshop went on to develop naturalistic colour compositions, as lyrical understatement with a concern for tonal values became fashionable in the paintings of his reign. Naturalism, in part inspired by European prints, enabled painters to invest faces and figures with solidity, to set up psychological

*Deposition from the Cross,*
Mughal, 1598.

This was commissioned by
Jahangir in Lahore after a
Flemish print of a lost
Raphael, or possibly of Vasari.
The figure rising from the
grave in the lower left-hand
corner reappears in other
painters' works. To the Mughal
artist, such a 'playful'
juxtaposition of Deposition
from the Cross and Last
Judgement (the waters and
the land giving up their dead,
and angels sounding the
trumpets of eternity) posed no
doctrinal problems, as it would
to a Christian.

relationships, and generally to tell a story more convincingly. Single
figures were now placed against plain backgrounds or distant land-
scapes, which often quoted details of European pictures. Above all, the
Renaissance concept of 'consistent lighting' was explored, creating
tensions between naturalism and the formal arrangement of lines and
colours.

Alongside such stylistic changes, artistic individualism under
Jahangir became more pronounced. The younger generation in the
royal workshop—including Basawan's son Manohar and Aqa Riza's
son Abu'l Hasan, as well as Balchand, Daulat, Govardhan, Bishndas,
Mansur, Bichitr, and Padarath—all signed their individual works.
Daulat sketched four of his colleagues and himself, and Abu'l Hasan

depicted himself presenting his work to Jahangir. These self-represen-tations were clear indications of the artists' assertion of their worth. Among these versatile masters, let us consider two very different per-sonalities, Abu'l Hasan and Govardhan. Each of them had a personal style that gave expression to naturalism in remarkably different ways.

Abu'l Hasan, a colourist by preference, was given the title Nadir uz-Zaman ('Light of the Age') by the sovereign, who considered his work to be perfect [**78**]. His portraits, with their soft outlines and subtle shading, deftly capture individual faces, as in the painting that celebrates the occasion when Jahangir conferred the title Shah Jahan ('King of the World') on the 25-year-old prince, Khurram [**79**].⁴⁰

Very little is known about Govardhan, whose career also spanned Shah Jahan's reign. Although he was one of the most accomplished portraitists of the time, he was fascinated by the nude as depicted in western art, modelling individual figures softly and observing the details of bony fingers and toes with sensitivity. The naked yogis he was so fond of painting, with their erotic overtones, gave him scope to display his virtuosity with light and shade [**80**].⁴¹

*Prince Khurram* (Shah
Jahan), Mughal, *c.*1618.
The prince confirms in the
inscription on the painting the
convincing likeness. The artist
plays on the contrast between
Khurram's bright amber robe
and patterned scarf and sash
and the dark emerald
background, sprayed with tiny
jewel-like flowers. The
bejewelled gold aigrette of
European origin, held up by
the prince, is the artist's way of
telling us that the prince is a
man of refinement.

## Portraiture

As artistic personalities flourished, so too did a wide range of styles and
genres which developed during Jahangir's reign: portraits, dynastic
subjects, and animal, flower, and literary paintings replaced the epic
narratives of Akbar's reign. Although Akbar had compiled a large
album of portraits of his courtiers and himself, not until Jahangir's time
do we encounter psychological portraits of variety and depth. The
formal court scenes, with ensembles of courtiers, based on workshop
stencils of their likenesses, depicted individuals accurately enough to
be recognizable, thus serving as official records, a practice begun by
Akbar [81].[42]

Portraits served also as instruments of diplomacy. Bishndas was
sent to the court of Shah Abbas of Iran; Manohar's likeness of Jahangir

## 80 Govardhan

A rustic concert, Mughal, c.1625.

Govardhan was unique among Mughal painters in choosing to represent life outside the court, an interest that finally took Mughal art away from the magic world of Safavid art. Genre scenes such as this, which were less concerned with finish, are in many ways more rewarding for the wealth of observation they contain.

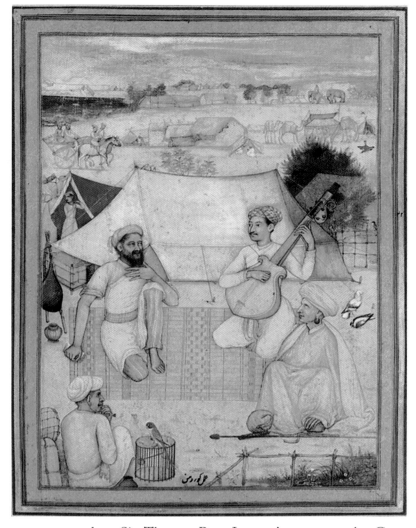

was presented to Sir Thomas Roe, James I's envoy to the Great Mughal. The latter survives only as a print in the seventeenth-century English travel compendium *Purchas His Pilgrimes*.[43] A rare portrait, purported to be that of Nur Jahan, epitomizes the empress's unconventionality, for royal ladies, who seldom appeared before artists, were usually portrayed in stereotypical forms. The hunting gun she holds suggests that she was a good shot, a prowess admired by the monarch himself.[44] Royal women, including the daughters of Jahangir, Shah Jahan, and his successor Aurangzeb, were patrons as well as amateur painters. On the other side of the coin, women artists were attached to Jahangir's *zanana*. Among them, we know of Nadira Banu, a pupil of Aqa Riza, and a princess, Sahifa Banu [**82**].[45] Few portraits are more intriguing than the late allegorical ones of Jahangir. Their complex iconography, partially revealed in poems inscribed on the paintings,

The courtier Abd ur-Rahim, Khan i-Khanan, a detail of *Jahangir Receiving Prince Parviz*, Mughal, 1610.

This study of an experienced and wary courtier is one of the most penetrating in Mughal art. Abd ur-Rahim, commander-in-chief of the Mughal army, employed 20 artists in his *karkhana* who illustrated the *Ramayana* and the *Mahabharata* as well as *ragamala* paintings. His life gives us a rare glimpse of patronage by a Mughal high official.

often conceals political messages. Jahangir's imaginary encounter with contemporary monarchs underlines the political message of a 'Pax Mongolica' reinforced by motifs such as the nimbus (halo), a solar symbol, the world map, and the juxtaposition of the lion and the lamb [**83**].[46]

Mughal animal paintings reflect Jahangir's curiosity about the natural world [**84**].[47] At Jahangir's insistence, numerous paintings of animals, birds, flowers, and plants served as objective records of the flora and fauna of the realm. Jahangir's curiosity had a morbid side as well, which inspired *The Dying Inayat Khan*, a drawing of tragic intensity [**85**]. It is also rare that a drawing should survive from the period, since drawings were not collected but only used by artists as the basis for paintings.[48]

One cannot leave Jahangir's reign without mentioning the magnificent display of wealth at the court. One typical ceremony held on special days was the weighing of the sovereign and the princes against gold, silver, and other precious materials. These were later distributed among the poor, a practice that had roots in ancient India. The emperor's collection of objets d'art included Chinese figures and vases, gem-studded weapons, articles of personal attire such as jewelled turban pins, and objects of domestic use, such as jade wine cups, enamelled hookah bases, magnificent carpets, and precious stones.

**82 Sahifa Banu**

*Shah Tamasp*, Mughal, early seventeenth century.

The princess was one of the painters who belonged to Jahangir's *zanana* but little else is known about her. However, this is one of the rare paintings that can be clearly identified as the work of a female artist. Her portrait of the Persian emperor was based on stencils available in the Mughal workshop.

## The reign of Shah Jahan

In 1628 Jahangir's third son, Khurram, better known as Shah Jahan ('King of the World') (1628–58), seized the throne by putting his rivals to death. Mughal treasures acquired a legendary reputation in his time, but the pomp and circumstance of Shah Jahan's reign had an underlying political message. A heterogeneous ruling class created by Akbar had supplanted the hereditary aristocracy, but it had become entirely

**83 Bichitr**

*Jahangir Prefers a Sufi to Kings*, Mughal, 1615–18. The ageing emperor sits on a throne inspired by a European hour glass, symbolizing time. Winged cherubs turn away in despair, as Jahangir spurns worldly monarchs, the Ottoman sultan (based on a European print) and King James I (based on the English painter John de Critz), for the company of the Sufi mystic. An interesting comment on the artist's high profile in this period is the inclusion of himself at the bottom.

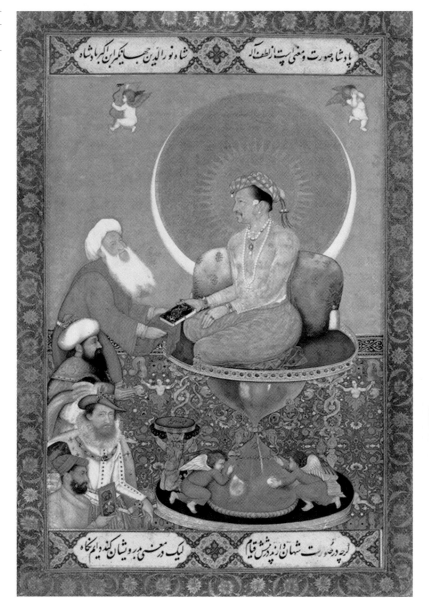

dependent on the sovereign's personal charisma, which was sustained by the imperial myth. Shah Jahan codified Mughal personal rule through court rituals, architecture, and painting, formalizing the existing social pyramid with the emperor at its apex. His art and his treasures lent a grandeur to his reign that impressed his subjects no less than it did foreign visitors. The monarch spent part of each day examining gems and inspecting the work of painters, carvers, engravers, goldsmiths, enamellers, and architects [**86**].

Yet all was not well in the state of the Grand Mughal. A long reign

**84 Mansur**

*Chameleon*, Mughal, seventeenth century.

A striking work by Jahangir's favourite animal painter, it forms part of a systematic documentation of natural history undertaken by the emperor. Mansur was a master of studied elegance and possessor of a clinical eye. Jahangir writes about the purpose of these paintings: 'As these animals appeared to be very strange, I described them in my memoir and had them painted by artists, so that the amazement that arose from hearing of them might be increased.'

of peace and the glittering life at court camouflaged the inner decay of the realm, a decline hastened by Shah Jahan's inordinate love of precious objects. Life at court had become artificial, governed by strict rules of etiquette that glorified the increasingly intolerant emperor at the expense of the nobles. Shah Jahan's policy of territorial expansion was a costly failure, while the oppression of peasants reached an intolerable level.

### Later Mughal architecture

Shah Jahan's first love was architecture, which was a synthesis of his aesthetic and political ideas. It was a love shared by the courtiers and even by the ladies of the royal family, who continued to play their part in commissioning buildings. Literary sources inform us that a critical appreciation of architecture was taken for granted at the court, the emperor providing aesthetic leadership through his department of architecture. The leading architects enjoyed a high reputation, notably Abd al-Karim and Makramat Khan, who were associated with the building of the Taj Mahal.[49]

Abandoning Akbar's architectural ideology, which sought to reconcile Hindus and Muslims, Shah Jahan consciously returned to the

Sultanate roots. The most singular aspect of his architectural style was its formal harmony, which was enhanced by the magical quality of the soft white marble he used. Buildings were governed by hierarchical stresses, seeking bilateral symmetry through the emphasis on both wings of the central axis, in contrast to previous centrally planned structures. Architectural uniformity was achieved by the repetition of a few significant forms and motifs embodying a complex symbolic message that reinforced the doctrine of divine kingship. The motifs themselves had a mixed Iranian, Hindu/Buddhist, and European

**86**

Shah Jahan's nephrite wine
cup, dated the thirty-first year
of his reign (1657).

No less outstanding than the
larger works produced during
his reign, this exquisite wine
cup in the shape of the head of
an ibex was among emperor
Shah Jahan's personal
possessions, probably used
on special occasions.

**87**

Taj Mahal, Agra, seventeenth century.

The symmetry and lucidity of its design is complemented by the delicate Makrana marble which changes colour in response to natural light, from the rosy Indian dawn to the shimmering moonlight. Its Timurid chamfered octagon, with a central portal and two-level niches, is dominated by a lotus dome with four cupolas at its four corners. The red sandstone forecourt is entered through a deep arched entrance crowned with small domed *chhatris*.

pedigree: columns with multifaceted capitals (*muqarnas*); cusp-arch bases; deeply carved naturalistic acanthus plants with cypress bodies; baluster columns; semicircular arches; cornucopia motifs (*purna ghata*); finally, so-called *bangala* curved roofs and cornices. The most prominent decoration, however, was the *pietra dura* work that had been a feature of Mughal architecture since the time of Jahangir.[50]

Although Shah Jahan's first architectural commission was his father's tomb at Lahore, the lack of warmth for this virtually mandatory enterprise is noticeable. The tomb's unusual layout was dictated by Jahangir's wish to be buried under an open sky. The impressive quality of this first major example of *pietra dura* work stems from the four lofty minarets at its four corners.

Royal tomb design attained perfection in the building that commemorates Shah Jahan's beloved queen, Mumtaz Mahall (1593–1631).

The emperor, grief-stricken by her death in childbirth, chose leading architects to design a flawless memorial to her [**87**]. Yet, as we shall see, the Taj Mahal was also the first monument to translate Shah Jahan's concept of absolute authority into architecture. Situated by the river Yamna, the Taj Mahal was the ultimate Islamic paradise garden, as confirmed by the inscription at its entrance. The sepulchre, set at the end of a four-square garden, is divided by four wide waterways, which are further subdivided into four narrow ones, which flow into a central marble pool. The central axis of the tomb, which rests on a raised platform, is balanced by symmetrical structures on either side, a simple yet effective design marked by four slender minarets. The Taj also contains a mosque, an assembly hall, and dwellings of tomb attendants, as well as bazaars and caravanserais whose income supported the tomb. The inclusion of domestic buildings is a reminder that the Taj is the earthly replica of a heavenly mansion and an example of the interchangeability of Mughal secular and funerary architecture. The most celebrated decorations of the building consist of flowers in *pietra dura*—rose, narcissus, and tulip—beloved of the Mughals. Compared with the rich texture of Itimad ud-Daula, the decoration here is remarkably restrained. In the interior, an inlaid marble cenotaph received the favourite queen's remains and, later, those of Shah Jahan.[51]

From the very outset a powerful myth grew up around the Taj Mahal, which has been termed a 'love poem in stone'. However, its dimensions suggest Shah Jahan's desire to create concrete symbols of his absolute power. The tomb is 250 feet high, the enclosure is 1000 × 1860 feet, and the whole complex covers 42 acres. It is evident that its allegorical significance goes far beyond its immediate function. As has been argued, in addition to the symbolism of the mausoleum as a paradise garden, the apocalyptic imagery and the passages inscribed on its surface allude to it as the throne of God on the day of resurrection, an idea that is associated with the Islamic concept of the heavenly mansion.[52]

## Urban planning

In 1639, Shah Jahan embarked on an ambitious urban project, the new capital north of Mughal Delhi, which he named Shahjahanabad. His aim was to restore the former glory of the Sultanate capital, which had been superseded by Agra. The city, originally planned by the masters Hamid and Ahmad, was completed in 1648 by other architects, but the controlling hand remained that of the emperor. Shahjahanabad has been studied as an example of a pre-modern city taking the form of an 'imperial mansion', this being essentially an extended royal household.[53] Known today as the Red Fort, this irregular rectangle, two and a quarter miles in circumference, was once surrounded by residences belonging to Shah Jahan's nobles. The Red Fort symbolizes the political

heart of modern independent India, even though the locus of administration remains the New Delhi of Edwin Lutyens and Herbert Baker (see chapter 11).

The Red Fort is served by imposing gateways, the Delhi and Lahore Gates in particular. The Lahore Gate led through a covered arcade to the public audience hall (*diwan i-amm khass*), the secular hub of the empire, as the Friday mosque was its spiritual centre. Although Shah Jahan deployed a variety of architectural symbols to underscore his divinity, none is as insistent as this red sandstone audience hall. This was where he was to elaborate further the political ideas he first realized in the Taj Mahal. The architectural sources of the *diwan i-amm khass* were mixed: the building itself drew upon the Iranian *Chihil Sutun* (Hall of Forty Pillars), even as the *jharoka*, the ceremonial balcony where the emperor appeared before his subjects, offered a fresh gloss on the age-old Indian custom of *darsan*, the viewing of deities or great personages by the common people.[54]

The architecture was the setting for a choreographed imperial spectacle that reinforced the aura of divine kingship. Here the emperor made his daily appearance in a public renewal of his indivisible authority. The nobles and their retinue were arranged in the hall in a strict hierarchical order, the highest nobles being placed closest to the ceremonial balcony. When everyone had assembled, standing to attention and waiting with bated breath, the emperor made his solemn entrance onto the resplendent balcony. This ceremonial balcony, which emerged as the supreme symbol of Mughal kingship, reaffirming ideas of hierarchy and subordination, was situated in the central bay at the eastern end of the hall. In contrast to the plainness of the hall itself, the marble enclosure was studded with rubies, emeralds, and other precious stones and richly embellished with *pietra dura* work. The

**88**

Throne *jharoka* in the *diwan i-amm khass*, Red Fort, Delhi, completed 1648.

This was situated in the central bay at the eastern end of the hall. It was studded with precious stones and richly embellished with *pietra dura* work, the chief one showing Orpheus playing his lute surrounded by wild animals. The 'princely' Orpheus here represents Solomon, who in turn represents Shah Jahan.

**89**

*Jami masjid* (Friday mosque), Delhi, seventeenth century.
The mosque is placed on a substantial plinth, above a high ridge, in order to be visible from afar. The extensive courtyard above the lower level is enclosed by colonnaded cloisters, approached by an impressive flight of steps at the entrance. Its four corners contain cupolas recalling Sultanate pavilion tombs. The western end is marked by a colonnaded portal surmounted by a large lotus dome in the centre, which is flanked by two smaller ones. Two slender minarets rise on either side of the portal.

sovereign, seated here on a marble throne, gave audience and conducted public business from an exalted height.[55]

At each corner of the platform in the *jharoka*, a baluster column held up a deeply curved *bangala* roof or baldachin, widely used by Shah Jahan as a sign of authority. The baluster column, associated in western iconography with religious and royal personages, was adapted from western prints by Shah Jahan as a symbol of his divine status. In addition, Mughal emperors used Greek and Roman and Judaeo-Christian myths to construct their doctrine of royal authority, the most popular being that of the wise king Solomon. Orpheus of Greek mythology, the pacifier of animals, was used to further reinforce the Solomonic myth. The European motifs were not mere exotica but formed an indispensable part of Mughal ideology. In this world of shifting imagery, meaning had no fixed status. However, the underlying symbolism had a clear purpose—the legitimization of Mughal rule [**88**].[56]

The more intimate private audience hall (*diwan i-khass*) was meant for the close associates of the monarch. The simple marble piers on its outside belied its richly ornamented interior in which a silver ceiling was held up by jewel-encrusted marble walls. The focus of this chamber was the fabled Peacock Throne studded with rubies and emeralds. A famous inscription in here assures us that 'if there be paradise on earth, it is this, it is this'.[57]

For Shah Jahan, who was more religious than his forebears,

mosques had a special sanctity. His favourite was the exquisite Moti Masjid of white marble in the Agra Fort, crowned with three lotus domes and *chhatris*. But unquestionably it was the massive *jami masjid* (Friday mosque) in Delhi that served as the symbol of the faith. This, the largest Friday mosque in India, remarkable for its clarity of design, brought mosque architecture in India to an impressive climax, marking the restoration of Delhi as a capital [**89**].⁵⁸

### Shah Jahan and painting

Shah Jahan's public support of the Islamic injunction against images earned him the reputation of being indifferent to painting. But this

**90 Govardhan**

*Shah Jahan and Dara Sikoh on Horseback*, Mughal, c.1632.

The favourite son is granted here the privilege of holding the parasol, the foremost symbol of royalty in India. This delicate gem-like painting, which shows the Mughal mastery of line and a subtle range of shimmering tones, offers us a glimpse of the tragic Dara, the foremost intellectual of his time and a great patron of Hindu philosophy, later to be murdered by his brother, Aurangzeb.

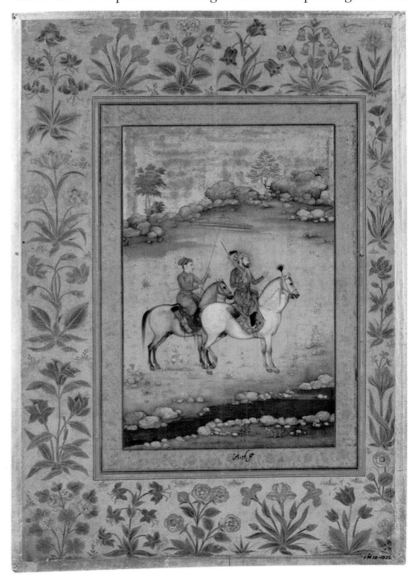

was not the case. As in other spheres, the emperor exercised strict control over painting projects so that they underlined his theory of kingship, but within these constraints his artists produced works of great richness, finish, and refinement, even when dealing with gory subjects such as the beheading of rebels.[59] Striking innovations during his reign included the use of form to express hierarchy and a new genre of panoramic landscapes with deeper perspectives and vivid treatments of fortresses and woods. A fashion for equestrian portraits was taken up rapidly by the provincial governors, especially the Rajput princes [**90**]. Rembrandt had one such portrait. His pen and ink sketches after Mughal paintings, which retain his mastery of line and tone without destroying the essential character of Mughal art, add an unusual chapter to the history of cultural borrowings.[60]

*Historical narrative*
History painting, in abeyance since the reign of Akbar, appeared with renewed vigour as a prime vehicle for sustaining the Mughal theory of kingship, much as architecture had been exploited for its own symbolic language. Military campaigns, which once again became necessary as rebellions broke out in various parts of the empire, continued to be painted as in Akbar's times, with the difference now that the emperor's agents, rather than himself, were shown engaged in maintaining law and order. Some of the finest examples of history painting are in the official chronicle of Shah Jahan, the *Padshah Nama* [**91**]. A number of illustrations to this royal text by Balchand, Bichitr, Bishndas, Daulat, Payag, and other major artists include formal court scenes. A favoured pictorial device here was to place the haloed emperor in the ceremonial balcony, while the courtiers were depicted in profile below him, arranged symmetrically rather than interacting with one another. It is interesting to note that the lower echelons were portrayed in livelier poses.

These court scenes give us useful information about the interiors of buildings, not least about wall paintings, which can be seen in the background, attesting to their continued importance.[61] However, more intimate works of the period have their own appeal. Their major exponent, Payag, was fascinated with chiaroscuro and used it to give the Mughal art of storytelling a new intensity. The clever use of a single, centrally placed light source enabled him to delineate the different figures vividly and yet invest them with a sense of mystery.[62]

## Deccani painting
Before we leave the subject of Mughal painting, it is worth considering a parallel tradition that offered an artistic counterpoint to Mughal art. While both Mughal and Deccani painting owed a great deal to the Safavids, they represent two very different historical processes. The

*The Capture of Port Hoogly,
Padshah Nama*, Mughal,
*c.*1634.

The Portuguese had fortified
the port city, threatening
indigenous commerce and
forcibly converting the local
Muslim population. On 24
September 1632, the Mughal
forces stormed Hoogly,
undermining its defences. The
unknown painter captures the
drama of the siege. The
precious album was given by
the Nawab of Avadh to Lord
Teignmouth in *c.*1798, who
then presented it to George III.
It was seen by the public for
the first time in 1997–8 in
Delhi, London, and
Washington, DC.

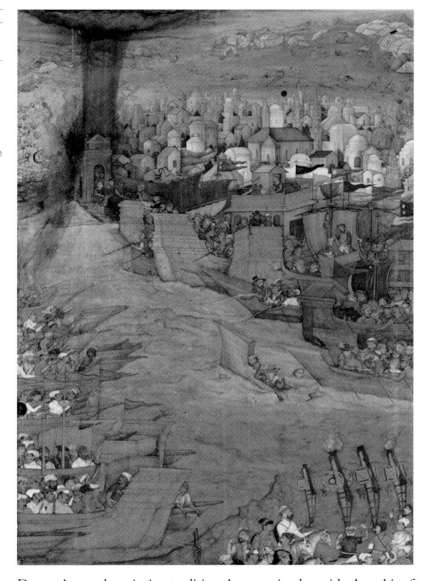

Deccan boasted a painting tradition that remained outside the orbit of
Mughal painting until the Deccan sultans lost their independence to
the Mughals. Following the demise of the southern Vijayanagara
empire in 1564, the rival Bahamani dynasty in the Deccan splintered
into the Sultanates of Ahmadnagar, Bijapur, Bidar, Berar, and
Golconda. These successor states, which had close links with Safavid
Iran through trade and marriage, fell prey to the Mughals on account
of their lucrative foreign trade and diamond mines, which until the
eighteenth century were the major source of this precious stone.
Golconda was renowned internationally for its dyed textiles, and later
for the export of chintz, while in the eighteenth century Bidar acquired

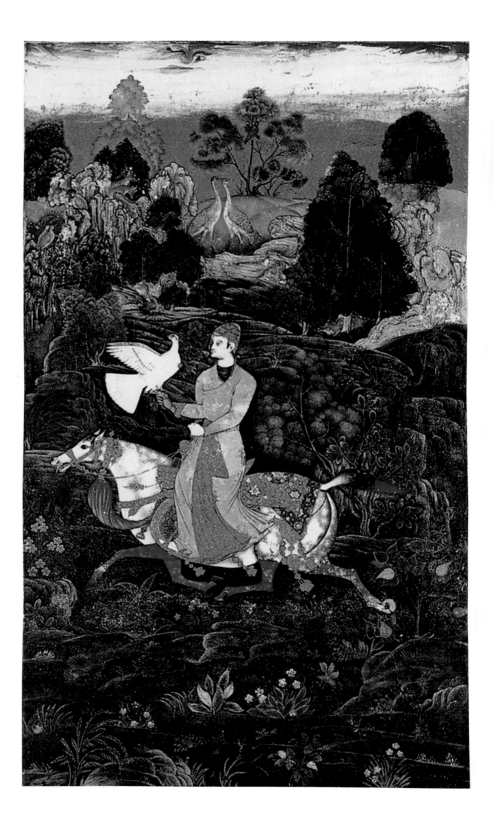

a high reputation for its refined inlaid metalwork, the so-called Bidriware.[63]

The most familiar Deccani paintings are those associated with Ibrahim Adil Shah II (1586–1627) of Bijapur, an enlightened patron of poetry, music, and painting. They are portraits with fully rounded figures, seen through flowing, transparent skirts. Ibrahim also had portraits painted of himself, attired in coloured silk garments and adorned with jewellery, in standing or seated poses against a low-key background. Ibrahim, whose ancestors were Ottoman Turks, represented a synthesis of Hindu and Muslim cultures. His mother tongue was Marathi but he was well-versed in Persian. Hindus, notably his adviser Antu Pandit, enjoyed positions of power within his kingdom. A skilled painter and calligrapher himself, Ibrahim inspired innovations in painting.[64]

However, it is the intriguing case of Ibrahim Adil Shah's favourite court painter, Farrukh Husain, that has continued to attract scholarly attention [**92**]. He has been identified as Farrukh Beg, who was born around 1547 and received his training in Khorasan in Persia. He joined Akbar's *karkhana* at its initial stages but mysteriously disappeared between the years 1590 and 1605. It is almost certain that during this period this talented painter was working for Ibrahim. Subsequently, he rejoined the Mughal court and was honoured by Jahangir with the title Nadir al-Asr ('Wonder of the Age').[65] Around 1627, as the Deccani kingdoms increasingly succumbed to the Mughals, so Deccani painting failed to resist the influx of Mughal art.

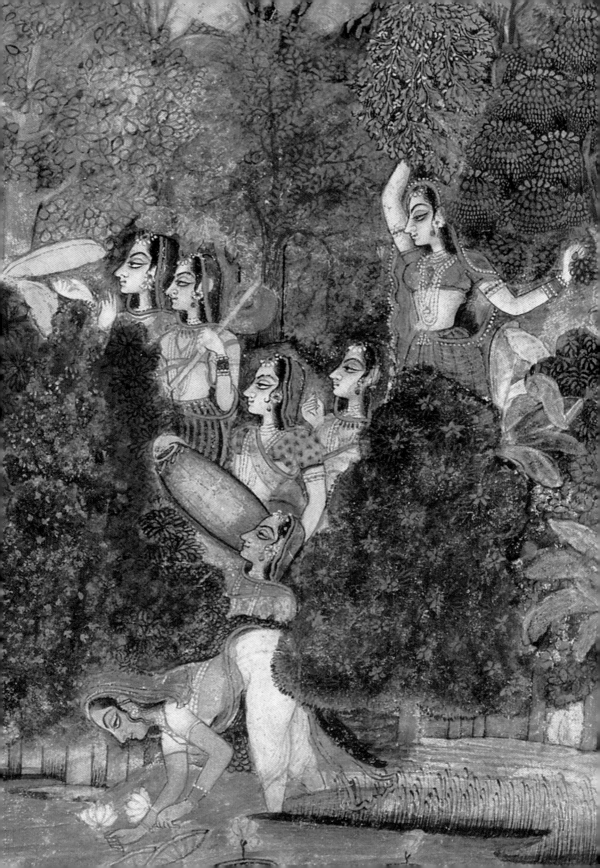

# Rajasthani and Pahari Kingdoms (c.1700–1900)

Rajasthan, regarded as the homeland of the Ksatriyas (warrior and ruling castes), lies in the western and central regions of North India [see map, p.6]. Rajput courtly culture reflected a complex set of social relations dominated by 'feudal' clans linked by blood. The ruler was the chief among equals, the whole structure held together by traditional notions of chivalry. Unlike the urban, bureaucratic Mughal empire, the Rajput states were dominated by the 'rustic nobility' whose roots were in the soil. Thus folk elements constantly surface in Rajasthani architecture and painting.

The Rajputs, who had resisted Muslim advances for centuries, were finally pacified by the Mughals with matrimonial alliances and high positions within the imperial system. The process was accompanied by the transformation of Rajput taste in art and architecture. Lying north of Rajasthan in the foothills of the Himalayas, the Hill States of Basohli, Guler, Kangra, and Jammu, ruled by Rajputs, came into being during the eighteenth century as the Mughal state went into decline.

## The palaces and cities of Rajasthan

The Rajput strongholds, the great desert fortresses of Rajasthan, though much rebuilt over centuries, bear witness to the turbulent history of the area. One of the earliest surviving structures in Rajasthan is an impressive tower of victory built by Rana Kumbha in 1458 to celebrate Rajput recovery from the dominance of the Delhi Sultanate. The tower gives the impression of a series of Hindu temple halls stacked one above the other. The Rajput palaces are among the major examples of secular architecture from pre-colonial India.[1] As Rajput princes joined Mughal imperial service in the sixteenth century, their palaces back in Rajasthan began displaying Mughal taste in both the interior and exterior of buildings. And yet in important ways they differed from Mughal palaces. The exteriors of Rajput palaces, such as those at Udaipur and Jaipur, were in many respects like those of Mughal ones, though lacking the symmetry of the latter [93]. Yet in

City Palace, east front,
Udaipur, eighteenth century.
This shows how Rajput
palace-fortresses, often
strategically located at the
summit of a ridge, made full
use of the surrounding
landscape. Its east face
overlooking Lake Pichola
consists of many planes, but
none dominant, thus
reinforcing a sense of
asymmetry so different from
the façades of Mughal forts.

essence Rajput structures were fortified palaces rather than Mughal 'palaces within fortresses'. The former also made extensive use of inner courtyards for social and ceremonial purposes. The antecedent here was Man Singh's palace at Gwalior.[2]

*Interior design*

Rajput interiors, following the Mughal pattern, comprised three parts: public and private audience halls and the private quarters of the ruler, which introduced the strictly segregated women's area (*zanana*). But, as with façades, so with ground plans: Mughal order and symmetry were purposely altered in favour of 'picturesque irregularity'. It is sometimes difficult to trace a clear architectural plan in the interior, and this cannot be wholly explained by the fact that many of these evolved gradually over a long period. It is clear from details of the buildings that architects understood the principles of formal symmetry but that they playfully subverted them.

Palace interiors were enlivened by wall hangings, screens, velvets, embroideries, and carpets, whose lavish use may have originated in the Sultanate period. The Rajput palaces also adopted Mughal *shish mahals*—rooms decorated with mirror fragments. In the case of Rajput versions, the mirror discs on the walls were no different from those used in rural women's skirts in Rajasthan, an indication of the relationship between high and folk art.[3] Likewise, palace wall paintings were more refined versions of those to be found inside and outside of *havelis*, which were a distinct feature of Rajasthan. These houses of noblemen and affluent merchants were built around a shared central courtyard. Several *havelis* formed a *mohalla* belonging to a particular profession, for instance the stone cutters, dyers, and producers of printed cloths, thus ensuring privacy and caste segregation in a town.[4]

## Jaipur

Sawai Jaisingh II, the eighteenth-century ruler of Jaipur and a Mughal official, was responsible for striking examples of Rajput architecture: some of the earliest observatories in the world and the centrally planned city of Jaipur, founded in 1727. In both types of architecture, the perfect blend of function and aesthetics makes them unique creations. Jaisingh had studied Greek, Arabic, and Sanskrit astronomical works. He kept himself abreast of the latest research in Europe and was a collector of western scientific instruments. Because of his knowledge of astronomy, the Mughal emperor assigned to him the task of devising an accurate calendar for official purposes. When Jaisingh was planning his observatory, he was convinced that the instruments available were too small to achieve the degree of accuracy that he sought. So, instead of placing astronomical instruments within his observatories, he designed the structures themselves as instruments. Elegant architectural forms were created by combining geometrical shapes—hemispheres, arcs, cylinders, cubes, and isosceles triangles [**94**].[5]

In building Jaipur, which took its name from its ruler, Jaisingh's search for perfect symmetry might have stemmed from his scholarly interest in astronomy and mathematics. The city is also a rare example of urban planning based on the Hindu symbolic ground plan, the *vastu-purusa-mandala*, whose application had until now been confined

**94**

Samrat Yantra, Jaipur, Rajasthan, eighteenth century.

The smaller of the two sundials in Jaipur, this structure can tell the correct time within 20 seconds. The Maharaja of Jaipur built over 30 of these monumental instruments in many parts of northern India with the aim of constructing an accurate calendar for administrative purposes.

The straight, stone-paved
streets were laid out on a
rectangular grid plan,
although this had to be
somewhat modified to take
into account peculiarities of
the terrain, such as the hill on
each side. The palace of the
ruler and the observatory were
placed in the centre,
according to the concept of
the sacred middle
(*brahmasthana*), while the
residential quarters of the
different castes, shaped in
squares and rectangles,
conformed to sacred
geometry.

to temples [**95**].[6] A playful relief to the formal symmetry of Jaipur is
provided by the pink sandstone Hawa Mahal (Palace of Breezes). Built
in 1799, its beehive façade acts as a giant screen whose many windows
provide seclusion for the aristocratic women of the *zanana*; from these
windows they enjoyed the cool summer's breeze or watched public
events below without being seen.[7]

## Rajasthani painting

Rajasthani and Pahari artists started absorbing Mughal innovations
from the seventeenth century but their art was very different in
temperament and outlook. Part of this difference lay in the more lyrical
approach of the Rajasthani artists and the pleasure they derived from
pure lines and colours. Unlike Mughal artists, Rajput artists (*citrera*)
were anonymous and did not enjoy the high status of their Mughal
counterparts. The art historian was thus obliged to fall back on dynas-
tic or geographical categories in order to explain the evolution of styles,
a development that has now been challenged.[8] The shift of emphasis in
the history of Rajput art from the ruler's taste to artistic personality
undoubtedly marks an advance in the study of this tradition, but styles
could well be products of particular workshops rather than hallmarks
of individual masters.

We have previously examined the art of the Rajput kingdom of
Mewar on the eve of Mughal conquest, the best-known example being
the *Caurapancasika* series. This tradition was continued at Mewar by
the influential Muslim painter Sahibdin, who illustrated the epic
*Ramayana* and other Hindu classics. Sahibdin continued the tradi-
tional Gujarati figure style, while adopting the rocks and ridges from
Mughal art. The employment of Sahibdin and other Muslim artists by
this state reminds us that the Mewar–Mughal conflict was political

rather than religious and that the Indian artist was prepared to serve any patron regardless of personal belief.[9] The Mughal style was first introduced in the region through the works brought back by Rajput rulers, later augmented by the arrival of Mughal artists at Rajput courts when the empire was in decline in the eighteenth century.

*Portraiture*
The paintings of Rajput and the Hill States demonstrate the genres favoured in these regions as well as the nature of the patronage that gave rise to them. Portraiture was the most popular genre introduced

**96**

*Maharana Jawan Singh of Mewar*, Udaipur, *c*.1835.
This painting captures striking details of the heat of the chase. The ruler, on horseback and adorned with a halo, pursues a wild boar. The gory details of the hunt are set against the cool green shrubs of the Aravalli hills, in a skilful combination of social comment and aesthetic statement.

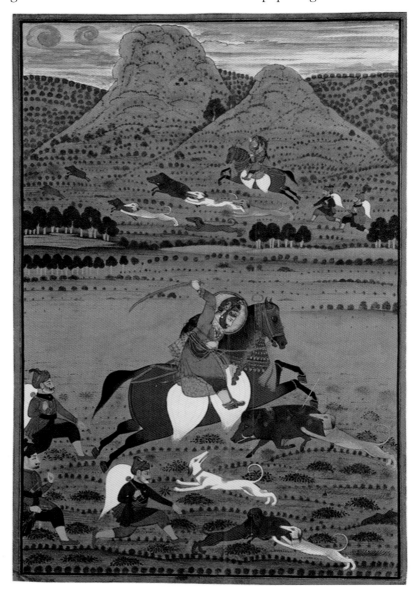

**97**

*Raja Ajmat Dev*, Mankot,
1730.

The artist uses four dominant
colours: dark grey-green for
costume, bright red for bolster
and picture border, turmeric
yellow for the background,
and chaste white for the floor.
Delicate and yet incisive
drawings of details such as the
Raja's profile and the hookah
add a human touch. The artist
heightens our interest by
'cropping' part of the hookah
as it and the sword cross over
onto the red border itself.

**98**

*Brijnathji and Durjan Sal Sight
a Pride of Lions*, Kotah,
eighteenth century.

The forests next to the Kotah
fort and along the wild
Chambal river are captured
with a conviction that springs
from the artist's personal
knowledge of the landscape.
The animals are vivid,
imparting a surreal
atmosphere to the scene. The
work has recently been
attributed to an anonymous
eighteenth-century master,
assisted by the known artist
Shaikh Taju, whose works on
Hindu themes show the
influence of Deccani painting.
However, this attribution is not
universally accepted.

from the Mughal court. However, subtle changes occurred in the art of
portraiture on its journey from Agra to Mewar. Monarchs were no
longer depicted as formal individuals but as real human beings holding
court, celebrating festivals, or enjoying their favourite blood sport, the
hunt [**96**]. The mood of Rajasthani court paintings differed from the
austere elegance of Shah Jahani paintings in their boisterous scenes of
merrymaking during festivals such as that of spring (*holi*). The
Rajasthani and Pahari artists imposed their own experience and sensi-
bility on Mughal naturalism even as they recorded real events.
Compared with Mughal portraits, the profile of the sitter became
increasingly idealized. Perhaps the perfect specimen of this type of
portraiture is to be found not in Rajasthan but in the Hill State of

Mankot. The artist who painted Raja Ajmat Dev in the early eighteenth century achieves a brilliant resolution of the underlying tension between representation and formal symmetry. His colour scheme is radically simple, the forms sparing [**97**].[10]

As in Mughal painting, monarchs are portrayed by Rajasthani artists engaged in various activities. Among these, few can rival the hunting scenes commissioned by the eighteenth-century rulers of the Rajasthani state of Kotah, a genre developed to satisfy the rulers' tastes. The artists recorded these scenes of forests and wild beasts with an

immediacy that reminds us of Blake's lines, 'Tyger! Tyger! burning bright / In the forests of the night' [**98**].[11]

The variety and importance of Hindu deities as the subject matter of Rajput painting marked another departure from Mughal art. Furthermore, if Mughal art brings to mind history painting and portraiture, Rajasthani and Pahari artists are remembered today for lyrical paintings extolling romantic love and the perennial Indian concern with feminine beauty. It is interesting that when Mughal art was at its zenith, neither the nude nor the beauty of women fired the artist's imagination.

At Kishangarh, set in the midst of idyllic mountains and lakes, a new vision of the romance of Radha and Krsna came into being during the brief reign of Raja Sawant Singh (1748–57). The Mughal artist Bhavanidas, who founded the Kishangarh school, was invited to the state by its first ruler, a Rajput official in the Mughal empire. But Kishangarh's fame rests on the artist Nihal Chand and his patron Sawant Singh, poet, painter, and a devotee of Krsna. Early art historians, who were moved by the romantic story of the love between the king and a professional singer, Bani Thani, identified her with the heroine of Nihal Chand's paintings, but as a recent work suggests, the inspiration for the canon might have been more prosaic. There are, for instance, similarities between the eyes of the Nihal Chand heroine and

**99 Nihal Chand**

*Radha and Krsna Recline in a Lotus*, Kishangarh, *c.*1745.
Nihal Chand created a new, mannered type of slender beauty with curved almond-shaped eyes, arched eyebrows, sharp aquiline nose, and pointed chin.

those of the conventionally painted cult image of Srinathji—in fact, the convention pervades all Gujarat-Rajasthan painting [**99**].[12]

In the eighteenth century, as political turmoil followed the dismemberment of the Mughal empire, the Hill States, nestling deep in the Himalayan valleys, developed into a cloistered fairy-tale world, where men were imagined as perpetually elegant and women eternally enchanting, poised, and aristocratically aloof. As suggested by the conventions used in an illustrated *Devi Mahatmya* text from Kangra (1552), the *Caurapancasika* style had arrived in the hills by the sixteenth century. From this evolved the recognizable Pahari style in Basohli during the reign of Kirpal Pal (1678–95).[13] Bhanudatta's *Rasamanjari*, a fifteenth-century treatise on the typology of lovers, is illustrated in the *Caurapancasika* tradition of depicting open pavilions and figures with 'staring eyes', but now the range of colours has become richer and 'hotter' [**100**].[14]

## Pahari painting

Pahari painting is particularly interesting because it throws light on the nature of patronage in these regions. In the absence of signed works, the art historian Ananda Coomaraswamy and others after him identified each Pahari style with a regional kingdom such as Basohli, Guler, Jammu, or Kangra. More recently, scholars have sought to establish the authorship of works by examining the relationship between artist and patron, ascribing a greater degree of individualism to the artist than was previously assumed. The family of artists became the basis of different styles in the Pahari kingdoms, thus loosening the hold of geographic and dynastic categories.[15]

Pandit Seu (*c.*1680–1740), a Brahmin from Kashmir, settled in Guler as a court artist (*citrera*). As a painter, his status was equal to that of a lowly carpenter (*tarkhan*). It was the custom for the son to take up the father's profession and to learn to draw by practising on a wooden board (*takhti*) covered in clay. The talented ones progressed from community work such as painting temple murals to court patronage. Some of the myths relating to the artists suggest that they often resented being dependent on royal patronage.[16]

With Nainsukh (*c.*1710/24–78), the most talented son of Pandit Seu, Pahari painting reached a major turning point. Nainsukh is associated with the introduction of Mughal naturalism into the Hill States, although the process may have already begun with his father. Nainsukh's portraits—the arrangement of his figures, his use of colour, and his naturalistic drawing—all point to a sure grasp of the late Mughal art produced at the court of Muhammad Shah (1719–48). Nainsukh, who entered the service of Balwant Singh of Jasrota in the 1740s, captured his reign with great fidelity. Although his court scenes are impressive, Nainsukh's finest works are his intimate portraits of the

**100**

'Disguising her real intent; the *gupta parakiya* heroine', *Rasamanjari, c.*1660–70.

This (*following pages*) comments on the nature of illicit love, which involves subterfuge and deception. The love bites of the previous night are explained away by the heroine as caused by her being accidentally scratched by a cat that was chasing a mouse. The artist uses a deep red horizon as well as open-petalled lotuses in a lily pond and chirping birds in leafy trees to evoke the break of dawn.

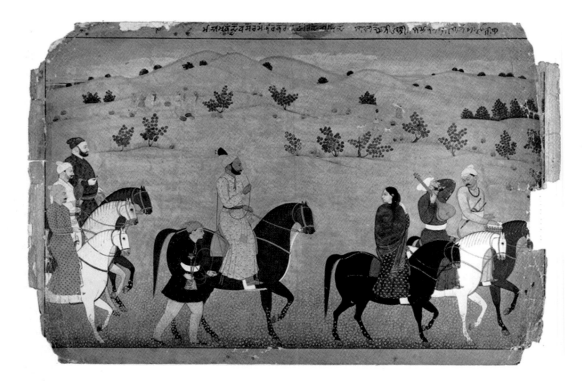

**101 Nainsukh**

*A Leisurely Ride: Mian Mukund Dev with Companions*, Jasrota(?), c.1740.

Nainsukh's style is recognizable by the subdued colour field he uses, with a few highlights picked out sparingly in somewhat brighter colours. His finished paintings, or sketches in preparation for painting, especially portraits (and his own portrait), show his ability to capture the features of his subjects with unusual sensitivity.

ruler, a token of the special relationship he enjoyed with him. Balwant Singh's death in 1763 ended this special relationship. Nainsukh was then forced to seek employment at the court of Amrit Pal of Basohli (1757–76), presumably at the suggestion of his brother Manaku, who was an artist at the court. With Nainsukh's arrival, the burning colours of Basohli gave way to a graceful, lyrical naturalism [101].[17]

Pahari art produced in Kangra under Sansar Chand (1775–1823) is identified with the last vision of feminine beauty before the colonial era [102].[18] Although Kangra paintings have suffered from overexposure through reproduction, in their original state these lyrical paintings represent a delicate balance between the stylized and the real. Sansar Chand's active patronage of art and his substantial painting collection are known from the accounts of visiting Europeans. With his fall from power in the middle of the nineteenth century, this flourishing tradition came to an end. As colonial rule tightened its grip on the sub-continent, and western taste overtook the indigenous courts, the artists faced competition from oil painting, mechanically reproduced prints, and ultimately photography. The only court that doggedly refused to give way to the new taste was that of Mewar, a state that re-emerged during the nationalist period as a symbol of Indian resistance.[19]

**102**

*Radha Goes at Night to
Krsna's House*, Kangra,
c.1790.

This Kangra feminine ideal
was the common legacy of
Pahari artists, including those
who worked for Sansar Chand,
whose roots must lie in the
delicate drawings of
Nainsukh. They created a
striking canon of beauty:
remote, aristocratic, and
serene. In their lyrical
treatment of Bhakti poetry,
complemented by cool colour
combinations, the Radha and
Krsna theme becomes a
vehicle for portraying courtly
life in this idyllic Himalayan
valley.

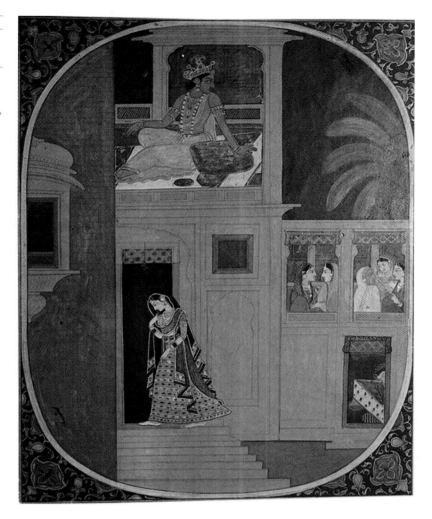

# The Non-Canonical Arts of Tribal Peoples, Women, and Artisans

8

Before we enter the colonial and modern periods, it would be useful to explore the rich mine of tribal art (the hunting-gathering communities), women's art, and the arts of everyday use. There is a curious silence in Indian art history about these groups 'hidden from history'.[1] Their arts, as part of social rituals, have an ephemeral character and are therefore considered to be merely functional and appropriately the preserve of anthropologists. The view of the applied arts as being inferior to the fine arts has been an implicit assumption of Indian art history grounded in the Renaissance hierarchy of the arts. However, such an evaluation is also prevalent in Indian society, which itself is a reflection of the social position of these groups. Yet they have produced an enormous variety of arts, and in order to appreciate these so-called minor arts, which do not conform to the canon, we need to turn to the artists, their intentions, and the aims of those for whom their art was created.

The fine arts of sculpture and painting are primarily concerned with image-making, dominated by a clear narrative content. On the other hand, the decorative arts are primarily engaged in creating abstract symmetrical patterns. As E. H. Gombrich points out, there is an essential difference between the perception of meaning that governs the visual arts and the sense of balance, order, and symmetry that is paramount in decoration.[2] Rhythm and structure, animation, and stylization are the elements that rule decoration, the individual motifs forming an integral part of an overall order. In short, the decorative arts are ruled by the tension between an innate sense of order and creative ingenuity. Our own appreciation of Indian decorative arts can be anchored on this insight.

103

Votive image, goddess on winged bull, Karnataka, nineteenth century.

The goddess is treated here in a rough but highly effective fashion. She rides a celestial bull with the look of a gentle goat with delicate wings—a folk interpretation of the Great Mother that is far removed from the canonical interpretations of the goddess.

## Tribal art

Neolithic hunter-gatherers have existed in India since prehistoric times. Although they had faced pressure to conform from the dominant Hindu society over millennia, until the colonial period many of these groups were able to preserve their own artistic traditions. Their lifestyle began to be threatened from the nineteenth century, in part because land was increasingly exploited for economic ends and hunter-gatherers were categorized as 'tribes' as part of an overall Raj strategy of political control.[3] In the 1940s, the anthropologist Verrier Elwin drew our attention to the rich but disappearing art of tribal India. He regretted the loss of their artistic tradition under the impact of the modern age. A special feature of the art of the Uraons, Gonds, Murias, and Saoras of Bihar is the use of their body as a 'site' for decoration. They dress their hair with beads, they adorn themselves with bangles, armlets, and bracelets. Gond women in particular show off their heavy silver headdresses, while cowrie shell ornaments enjoy universal popularity among tribal women. Wooden ceremonial masks are an indispensable element in dance dramas, such as the Chho masks of Purulia on the Bihar–Bengal border. The Santhal tribes of Bengal and Bihar show artistic skill in their marriage litters of wood, ornately carved with social scenes, while the Saoras of Chotanagpur commemorate the dead with pictures painted with rice paste.[4]

Tribal peoples practise wall paintings, a custom they share with Hindu village communities. Among the Warli tribe of Maharastra, the women paint the inner, darkest walls of the wedding chamber with bright pigments of red ochre and white rice paste. These nuptial paintings follow a complex process, accompanied by symbolic rites. Their main subject is Palaghata, the Warli goddess of fertility. The humiliation of the black naked goddess at the hands of the Vedic god Indra is a constant theme among the Warlis, a mythical expression of their defeat by Brahmanical religion. Imagined as a stocky, square diagrammatic figure without human features, she is ritually unveiled during the wedding.[5] Warli men and women also produce secular paintings, such as the *caukat*, a pictogram centring on the square, which stands for the four corners of the earth. The square is enclosed by geometric shapes and natural scenery rendered in the neolithic rock art style.

A striking genre of sculpture mediates between tribal and village cultures, namely the wooden effigies of spirits (*bhuta*) in the coastal regions of Karnataka in South India. In a 'carnivalesque' ritual conducted by low-ranking Brahmin priests, caste distinctions are temporarily obliterated and the Hindu pantheon subverted. The *bhutas* are totemic, semi-divine creatures, and occasionally even the god Siva is imagined as a *bhuta*. As with the nature spirits the *yaksas*, whose origins are non-Vedic, the *bhutas* need to be propitiated in order to deflect their

demonic wrath. Hereditary artists carve the *bhuta* sculptures with an array of tools on untreated jack-wood [**103**].[6]

## Women's art

In ancient India, cultivated women, including princesses and courtesans, were expected to be accomplished in drawing and painting, and professional women painters are occasionally encountered in literature. However, since the names of even male painters are seldom recorded, it is difficult to recover any useful information about women artists. On a lower social level, women's contribution was tacitly acknowledged. The cloth paintings (*picchwais*) that hang behind images in temples at Nathadwara in Rajasthan are taken to be produced by men, although their production depends upon women's participation as cheap family labour. However, not only did a few Rajasthani women rise to be masters of their craft, but some probably worked outside on murals because of their proven skills.[7]

*Domestic painting and women artists*
The domestic art of floor painting, with variant forms in different regions, such as *alpana* in West Bengal, *rangoli* in Maharastra, and *kolam* in South India, is associated with ceremonies marking rites of passage, such as birth, puberty, marriage, and death. Female rituals involving art have played a more significant role in Hindu social life than the ministrations of Brahmin priests, but the images have usually been seen as the preserve of anthropologists rather than art historians. It is also no accident that the Great Goddess is the central figure in this ritual matriarchy, for this is an activity, albeit temporary, that releases women from their subordinate status in society.[8] Women teach *alpana* to girls to enable them to perform wish-fulfilment rituals (*brata*), such as obtaining suitable husbands. Part of the ceremony consists of drawing with fingers on the floor, with colours made of rice powder and other natural substances, while rites relating to life cycles or harvests are enacted. There is an emphasis on balance and symmetry as well as on abstractions based on natural forms such as leaves and flowers. Although governed by conventions, *alpana* demands imagination and skill, thus giving scope for individual talent.[9]

Other forms of art were also used to celebrate key social occasions. Ritual decorations with elaborate scenes from Hindu epics and myths on the mud walls of rural huts are more ambitious than floor painting. The best known among them are Madhubani paintings, named after the agrarian town of Madhubani in the Mithila region of Bihar, a region of considerable antiquity. Since these paintings use cheap and perishable materials that need periodic repainting, mothers need to teach their daughters the techniques of painting in order to ensure continuity [**104**].[10]

## Embroidery

Embroidery, needlework, and other forms of women's art have recently been brought to our notice by feminist art historians. Among domestic art, a term that belies its quality and brilliance, *kanthas* or embroidered and patchwork quilts, bedspreads, and other furnishings made by women of East Bengal (now Bangladesh) are especially interesting. *Kanthas*, the product of thrift in a poor household, are produced from discarded saris, while the embroidery on them is done with threads removed from the saris. These colourful works of great ingenuity and beauty are based on patchwork and a few simple threads—red, yellow, blue-black, and green. The embroidery reinforces the thin material in order to make it more durable.

The *kantha* artists developed the convention of a many-petalled lotus medallion in the centre, surrounded by floral borders and *kalka* motifs in four corners—the *kalka*, possibly of Mughal origin, inspired the Scottish paisley design. The *kantha* is an extension of the Bengali *alpana* in its use of the lotus derived from the symbolic *mandala* diagram. Its presence in domestic art suggests a residual folk memory of the widespread Tantric cults of Bengal [105].[11]

Many of the women who produced *kanthas* were Muslim. They made elaborately decorated *kanthas* that were presented on formal occasions to mosques and were used for covering saints' tombs. Some

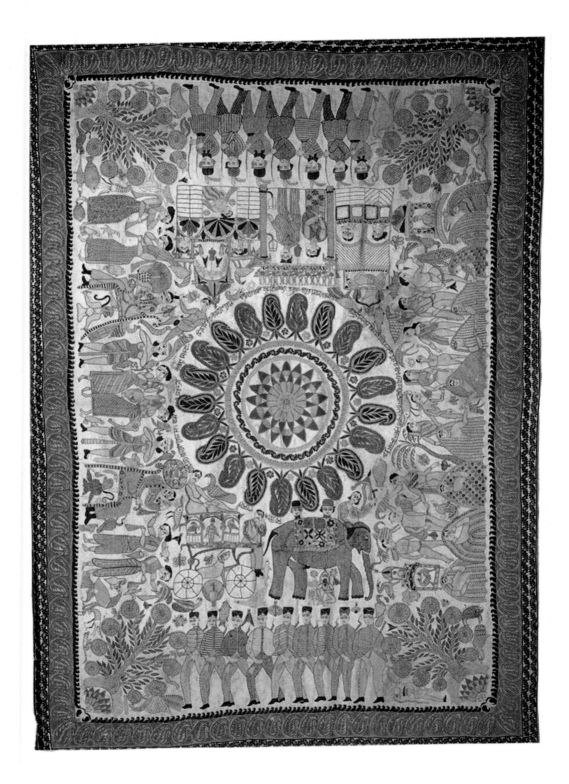

of the *kantha* motifs stemmed from local Bengali imagery. A whole series of conventions grew up in connection with the making of *kanthas*. While there were some differences in the motifs used by Hindu and Muslim women, the basic lotus *mandala* in the centre and a few other features were shared by them. There were also Mughal motifs blending Sufi and Buddhist-Hindu ideas, such as the tree of life. Indeed, *kanthas* are emblematic of the synthesis of Hindu and Muslim rituals and beliefs. The use of discarded garments for producing *kanthas* came to be associated with renunciation among Muslim and Hindu mystics.[12]

## The everyday arts

*Performance art and the* patua

Since antiquity India has enjoyed a tradition of performance art that combines visual arts and drama. The *citra katha*, a type of rolled-up scroll painting, forms the narrative thread in performances of wandering minstrels, a tradition that spread from T'ang dynasty China (618–906 CE) to medieval Europe. Today, the paintings unfolded at bardic recitals in India are associated in Rajasthan, for instance, with the Pabuji cult, in Gujarat with the Garodas, in Andhra with the Nakkashi, and in Bengal with the village scroll painters, the *patuas*. The Rajasthani scroll paintings known as *pat* are produced by a specialist painter caste for the minstrels, who are often a husband-and-wife team. They belong to a patronage system involving painters, reciters, and wealthy sponsors of this devotional art.[13]

In Bengal, however, the *patua* is both artist and reciter. The *patuas* of Bengal are low-caste landless labourers who often profess a dual Hindu–Muslim identity. One of their favourite themes is the cult of Satya Pir and the Hindu god Vishnu, yet another example of Hindu–Muslim synthesis. During the colonial period, *patuas* modified their craft to include secular topics. More recently, the communist movement in West Bengal enlisted the services of scroll painters for disseminating revolutionary messages. Controversially the Indian government has sought to educate the non-literate masses in family planning and other socially useful topics through the medium of *pats*.[14] An important variant of the *pat* or *pata* tradition is the so-called *jadupat* (magic painting) of the Santhal tribes of Bengal (it is a misnomer and not confined to them) [**106**].[15]

*Eastern design and western industry*

If the initial theme of the Great Exhibition of 1851 at the Crystal Palace in London was the triumph of European science, the exhibition turned into an object lesson in traditional decoration practised by the non-industrial societies of the East.[16] Indian decorative arts drew the particular attention of critics of western industrial arts, notably Owen

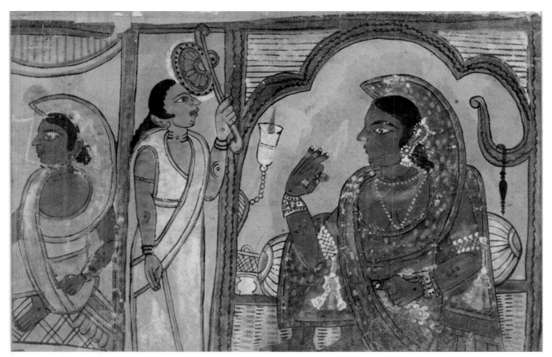

**106**

*Caksudana pata*, a *jadupat* ('magic painting'), Santhal Parganas, Bihar, *c.* twentieth century.

Part of the Santhal 'post-mortem' custom consists in these itinerant artist-magicians having a supply of partially completed paintings, with just the iris in the eye of the figure missing. On the death of someone in the community, the artist arrives at the deceased's dwelling. According to the Santhals, the 'blind' soul of the departed cannot find its way in the afterworld until its sight is restored. Therefore, on payment of a fee by the family of the deceased, the *jadupatua* adds the iris to the painted figure. The figures in these *caksudana* (eye-bestowing) paintings are painted against a pale grey-green background.

Jones, William Morris, and Sir George Birdwood. In India, Birdwood declared, 'everything is hand wrought, and everything down to the cheapest toy or earthen vessel, is therefore more or less a work of art ... embodying a system of decoration founded on perfect principles, which they have learned through centuries of practice to apply with unerring truth'.[17] Birdwood's romantic anti-industrial utopia was predicated on the so-called village republics of India. Village crafts-men, living in a harmonious community, produced goods that had not been contaminated by the Industrial Revolution. Later, in the 1920s, partly under the impact of Mahatma Gandhi, the Indian elite 'rediscovered' the simple, rustic village folk. The nationalist pioneer in this was Gurusaday Dutt, a Bengali official in the imperial bureaucracy, whose campaigns created an intense interest in the village arts among the urban elite. These included the *kantha* and other domestic arts produced by women.[18]

### Metalwork and jewellery

Metalwork, not only of gold and silver but also of less precious metals, and metal casting go back to the Indus civilization. One of the fascinating examples of early technology is the Meherauli pillar in Delhi associated with the Gupta emperor Candragupta II (fifth century CE). Made of pure iron, it has not shown any signs of rust in all these centuries.[19] Bronze sculptures from the Cola period and inlaid Bidriware from the eighteenth century are justly renowned. Brass,

Mango necklace, gold, pearls, rubies, and semi-precious stones, Tamilnadu, *c.* nineteenth century.

This 24-carat gold necklace encrusted with precious and semi-precious stones is a typical example of temple jewellery from Tamilnadu. Its lower part is made up of mango motifs, the sacred fruit of fertility; a personal ornament for deities and temple dancers, it is also worn by wealthy women.

copper, and tin were commonly used for household utensils in India. Glass making was introduced in India as early as the eighteenth century but its use was confined to glass painting. Only in the twentieth century did glass and porcelain replace metal utensils.

Jewellery in India served not only as an adornment but also as talismans. Personal jewellery was associated with each stage of an individual's life, signifying, as we have seen, the importance of ornament in all aspects of ancient Indian culture. Hindu property law, which did not allow women to own property, sought to protect a married woman by allowing her to keep her personal jewellery, to which her husband could lay no claim. Gold and silversmiths in India use a wide variety of techniques, such as punching, engraving, enamelling, inlaying, and silver filigree techniques to create an enormous range of personal ornaments in all the regions of India. Some of the earliest recorded cases of women's personal jewellery are seen in the bronze girl from Mohenjo Daro or the *yaksi* at Sanchi [1, 5]. The Mughals brought to India the advanced *kundan* technique of setting precious stones in gold. Some of the most spectacular inlaid jewellery comes from Tamilnadu [107].[20]

*Textiles*

India was the largest exporter of textiles before the industrial age. Especially between 1600 and 1800, its textiles became renowned from Europe to China. In India there is an astonishing variety of spun, woven, and embroidered fabrics and costumes in response to the social and ritual demands of each tribe, caste, or community. Among the range of cotton textiles, muslins from Bengal and printed cottons from western and southern India are justly famous. However, equally varied are silk fabrics, whose cultivation was introduced from China. Woollen garments, a type known as cashmere in the West, were the speciality of temperate areas such as Kashmir.

Muslin, a gauze-like, diaphanous fabric, named 'woven air' because of its delicate quality, is produced in East Bengal (present Bangladesh) and was mentioned as an export commodity as early as the first century CE. In 1576, when Bengal was incorporated into the Mughal empire, the emperor and his court came to prize muslins. The fine *jamdani* variety of muslin, enhanced with hand-embroidered work (*chikan*), began to be produced in Mughal workshops in Bengal by Muslim weavers. *Jamdani* is easily recognisable by its blue-black patterns and silver designs on a fine field of cotton, further reinforced with sprays of paisley (*kalka*) flowers.[21] Muslin is produced from a particular variety of fine, soft cotton, which is grown around Dhaka, making it the major product of the region. Dhaka emerged as a prosperous town in the Mughal period thanks to its lucrative cotton trade with South-East Asia. When the East India Company founded its settlement in Bengal in the late seventeenth century, it began exporting muslin to Europe. During the British Raj, with the advent of cheap textiles mass-produced by Lancashire mills, handloom weavers gradually lost their livelihood.[22]

Gujarati and Rajasthani printed fabrics, which sport brilliant colour combinations, were eventually superseded with the invention of synthetic dyes in the nineteenth century. Until then, India had led the market in dyed, block-printed, and painted fabrics. We have seen, for instance, that inexpensive Gujarati textiles were found in graves in Fostat in Egypt. India's pre-eminence in this field can be explained by its invention of an efficient dyeing process, the so-called mordant or 'resist' dyeing. While this technique is popular in Gujarat and Rajasthan, *palampores*—printed bedspreads decorated with the 'tree of life' motif—were produced on the Coromandel coast by stencilling and hand-painting processes.[23]

Indian printed textiles, known in the West as 'chintz' or 'calico', played a crucial part in colonial trade, gradually overtaking the export of spices, which had initially been the motive behind European expansion. The English East India Company, founded in 1600, set up factories in India to export Indian textiles to Europe, of both coarse

**108**

**108**

Chintz hanging, painted and dyed cotton made for the European market, Coromandel coast, mid-eighteenth century.

The rustic scene here is based on European engravings and ceramic sources. Even though modified to suit European taste, chintz retained an Indian sensibility. The hybrid motif, such as the flowering tree in *palampores* (bedspreads) and wall hangings, provides a fascinating glimpse into the cross-fertilization of cultures.

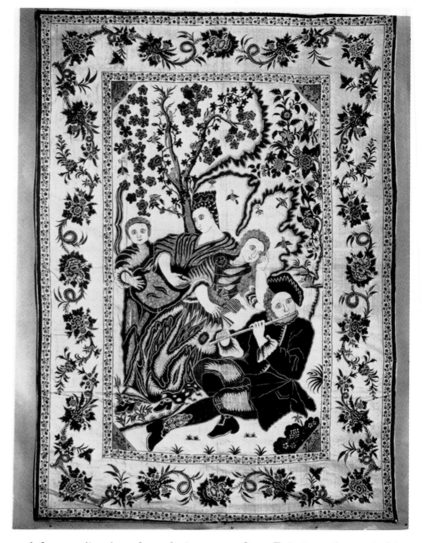

and fine quality, based on designs sent from Britain to be copied by Indian weavers [**108**].[24] As colonial trade expanded, the production of chintz shifted from Gujarat on the west coast to Coromandel on the east. The variety, irregularity, and free-flowing naturalism of Indian printed fabrics, imported in ever larger quantities from the seventeenth century as furnishings and wall hangings, helped liberate European taste from the abstract regularity of classical design. Much admired for their brilliant, washable colours and their lightness, by the eighteenth century even the middle classes could afford them. Samuel Pepys presented a chintz to his wife when she was decorating her study.[25] Such was its popularity among those who could afford it that English weavers staged riots, eventually forcing its import to be banned. However, it continued to be smuggled into Britain.

Meanwhile, folk and popular art continue to flourish in the subcontinent in other forms, taking into account modern developments, a striking example of which is the modern rickshaw art of Bangladesh [**109**].[26]

# Part III

# Colonial Art and Architecture (1757–1947)

# The British Raj: Westernization and Nationalism

9

Profound changes took place in art and architecture during the colonial era. The introduction of European academic naturalism transformed all aspects of Indian art from working practices to the relationship between artists and their patrons. Despite the fascination Mughal and Rajput courts felt for European naturalism, its systematic introduction would not have been possible without an ambitious policy of dissemination devised by the Raj.

In 1757, a minor incident in Bengal was to change the course of world history. The Honourable East India Company gained control of the province after defeating the reigning Mughal viceroy. In less than a century, the modest English colony was transformed into a world empire. Unprecedented material prosperity emanating from the Industrial Revolution, scientific achievements, and the ideology of progress all contributed to a sense of cultural superiority that became the hallmark of the British empire. A traditional society such as India was no match for such an explosion of power and overflow of resources. However, as the nineteenth century progressed, the language of nationhood, a legacy of European Enlightenment, was internalized by the Indian intelligentsia to fashion their own weapon of resistance. The period is characterized by a dialectic between colonialism and nationalism and the construction of cultural difference in a rapid globalization of culture.

One of the most powerful impacts of the British Raj was on artistic taste. Victorian illusionistic art and the notion of artistic progress took firm roots in India, giving rise to new genres such as oil portraits, naturalistic landscapes, and academic nudes. Artistic individualism began to be prized by artists and patrons as art schools, art societies, and exhibitions provided the network for promoting academic art. At the turn of the nineteenth century, however, as the nationalist movement gathered force, it led artists to reassess the relationship between the western canon, hitherto taken to be universally valid, and pre-colonial taste that was being eroded with the rise of illusionistic art. In the 1920s, the advent of international modernism in India

confused these issues further as primitivism and indigenism came to be closely identified in the new nationalist ideology of art.

## Indian art of the Raj

The first sign of change was the loss of courtly patronage in India with the fall of the Indian powers in the late eighteenth century. This forced artists to compromise their work with inferior material and craftsmanship. However, not all such art was of low quality. Artists in Patna in Bihar and Murshidabad in West Bengal developed a clean, linear style that formed a bridge between earlier courtly art and later East India Company paintings.[1]

The East India Company employed artists for its wide-ranging economic surveys and documentation of natural history. British residents commissioned paintings of Indian flora and fauna from Indian artists who were trained in western techniques such as perspective, chiaroscuro, and the picturesque idiom popularized by the landscape artists Thomas and William Daniell [110].[2] The new rulers also engaged artists to produce ethnographic subjects, especially castes and professions, which enjoyed popularity during the Enlightenment. Among Company artists, Shaikh Mohammad Amir of Karraya was in demand for his elegant renderings of residences, carriages, domestic servants, pets, and other aspects of British life in Calcutta.[3]

The rise of Calcutta as a rapidly expanding urban centre drew village scroll painters (*patuas*) to the city. Although their 'pen-and-wash' paintings, sold at the pilgrim centre of Kalighat, did not interest the British or the Bengali elite, they were the first truly popular urban art in India. Sensing the growing demand, Kalighat *patuas* organized their production on a large scale with the assistance of female labour.[4] A more revolutionary development was the introduction of the techniques of mechanical reproduction. The woodblock and metal printmakers appropriated Kalighat imagery and plied their trade in

close proximity to the vernacular printing presses that were springing up in Calcutta at the time, which by the end of the nineteenth century had become a staple of popular consumption, the most famous being the Calcutta Art Studio [111].[5]

As traditional art declined, the Indian rulers as well as the leading Indian elite turned to collecting western art and sitting for portraits by European artists. The Marble Palace in Calcutta, for instance, boasts a fascinating *mélange* of Victorian art. By the middle of the nineteenth century, the taste of the elite, and to some extent of the underclass, had become thoroughly Victorian. Yet a formal control of art education was not envisaged by the Raj until the 1850s. In 1854, the East India Company embarked on a project of improving Indian taste as part of its moral amelioration. Art schools and art societies, two key Victorian institutions, became the instrument for disseminating academic art, while the westernization project was overseen by the Director of Public Instruction. Initially art schools were set up in the three main colonial cities, Calcutta, Mumbai (Bombay), and Madras, to train artisans. Vigorous campaigns by Henry Cole, William Morris, George Birdwood, and other influential figures to save the Indian decorative arts had compelled the Raj to address their plight. Accepting that the Indian artisan had little to learn from the West in matters of taste, the

*Courtesan Playing a Violin,*
colour lithograph based on
Kalighat painting, nineteenth
century.

Its radical simplification owes
something to European prints.
Kalighat artists cast a sardonic
gaze on the contemporary
social scene, their favourite
subject being courtesans
entertaining city fops or
engaged in other activities.
The printmakers found it
convenient to appropriate the
iconography of Kalighat,
which prompted some of the
Kalighat artists to take up
printmaking.

government argued that he needed instruction in naturalist drawing
to compete in the modern world. A uniform syllabus, based on that of
the School of Industrial Arts at South Kensington, London, was
devised for all the art schools. Unfortunately, artisans could not afford
to attend school, nor did they take to academic art. The schools were
subsequently flooded with boys from the English-literate social strata,
as they inexorably turned into fine art institutions. Portrait painting
was the most subscribed course, given that portraits had become a
vogue among the Indian gentry.[6]

### The profession of the artist

The advent of academic art was accompanied by a social revolution in
India. In contrast to the earlier humble position of court artists, the

colonial artists enjoyed the elevated status of independent gentlemen, in part because they now hailed from the elite. The growth of art exhibitions, art journalism, and the rise of an art-conscious public changed the public's perception of art and the artist. However, while gaining freedom, they faced an uncertain economic future. Art societies, originally founded by British residents, became with the admission of Indians an instrument of Raj patronage. As an official put it, 'if a zeal and a genuine love of art were widely diffused among our wealthier Indian fellow subjects, a hugely favourable, lucrative and useful career would be opened to hundreds and hundreds of aspiring young men'.[7]

When Indian artists began showing at exhibitions organised by art societies, they were at first placed in the category of 'native artists'. But this segregation broke down under the influx of Indian participants. By the end of the century, a number of Indian women also took part in exhibitions. The careers of early salon artists such as Pestonji Bomanji, Manchershaw Pithawalla, and Annada Bagchi were launched at these shows. Among the subjects exhibited, landscapes were a novelty for Indian artists. Even though landscapes were mentioned in ancient literature, and Mughal paintings contained background landscapes, the objective study of natural scenery was a colonial phenomenon initially influenced by the English Picturesque movement [**112**].[8]

*Gentleman artists*

The most celebrated academic artist was Raja Ravi Varma (1848–1906), the first of the gentleman artists nourished by the Romantic image of

the artist as an uncompromising individualist. A member of the royal family of Travancore, Varma learned by watching European painters at work at the court. He entered the 'low' profession of painting against his family's objections, rising to be a fashionable portrait painter, prized as much by the Raj as by the Indian aristocracy. He exhibited widely and organised his studio with business-like efficiency, engaging agents for securing commissions and travelling the length and breadth of the country fulfilling them.

However, Varma's lasting fame rests on his history paintings, adapting Victorian salon art to bring to life ancient Indian epics and literary classics. The new canon of beauty—a mixture of Kerala and Guercino—created by him was greeted by the Indian nationalists as

**113 Raja Ravi Varma**

*Sita Vanavasa*, c.1890s.
This leading academic painter turned his history paintings into mass-produced oleographs, thereby appealing to all Indians, from the most exalted to the humblest. Even today, one comes across his voluptuous women reincarnated in cheap calendars and 'Bollywood' films (Bombay film studios gained this epithet for their popularity in the Third World).

endorsing their own literary 'inventions' of the past. Though Varma scrutinized black and white reproductions of Victorian art for inspiration, in the final analysis his paintings conjure up the atmosphere of Indian princely courts familiar to the artist [113].[9]

### The Bengal School

Ravi Varma died a national celebrity in 1906. However, in a curious twist of fate, almost immediately after his death Varma's works were denounced as hybrid, undignified, and above all 'unspiritual'. Such a change of opinion resulted from the upsurge in nationalist sentiment in the second half of the nineteenth century, which fed on the potent myth of India's spirituality. The circle of cultural nationalists in Bengal led by the poet Rabindranath Tagore (1861–1941) (better known simply as Tagore) reasserted their faith in Indian civilization, dismissed by colonial westernizers at the opening of the century. They discovered the Theosophists and other European enemies of Victorian materialism to be soulmates. This alliance between Indian and European critics of progress spearheaded debates on Indian identity—debates that closely mirrored developments in nationalist politics.[10]

To this set belonged the English art teacher Ernest Binfield Havell, an influential figure in the creation of nationalist art in India. In 1896, Havell came to head the art school in Calcutta, determined to direct the Indian youth towards their own heritage. A trenchant critic of Renaissance naturalism, Havell proclaimed that India's spirituality was reflected in its art, because India had repudiated such a materialist conception of art. The emerging indigenous (*swadeshi*) ideology of art demanded the creation of a style that would be in accord with Indian national aspirations.[11] Varma's imagining of the past was spurned by Havell and the nationalists precisely because it was 'tainted' with academic naturalism. Havell's first step in countering academic training at the art school was to acquire a fine collection of Mughal paintings for the benefit of the students; but when he introduced an Indian mode of teaching, his students went on strike. The nationalist press accused Havell of trying to deprive Bengalis of western art education, so deeply had western taste penetrated the province.[12]

In the midst of general hostility, Havell found an ally in the young artist Abanindranath Tagore (1871–1951), a nephew of the poet. The Tagores had been in the forefront of a cultural renaissance in Calcutta. Abanindranath had a liberal education at home, with freedom to develop his creative potential. Although he received instruction in academic art from an English art teacher, he found it to be incompatible with his own temperament. His search for an 'indigenous' style eventually led to his paintings on the divine lovers, Radha and Krsna, which introduced to the Bengali audience an alternative, emaciated ideal of feminine beauty. Used to the buxom

women of Ravi Varma, they were quite startled and vaguely dissatisfied. Although Abanindranath was already alienated from western art when he met Havell, it was Havell who introduced him to the delicate skills of the Mughal masters. *The Last Moments of Shah Jahan*, Abanindranath's first major work painted in a consciously Mughal manner, was an exercise in nationalist historicism. Yet ironically it was saturated with the melancholy spirit of Victorian art, its sombre mood coloured by the loss of the artist's little daughter.[13] This tentative exercise in the Mughal idiom failed to satisfy him, for he felt that the work lacked feeling (*bhava*), the quality he wanted to capture in art.

Abanindranath's search for a more appropriate style coincided with his meeting with Kakuzo Okakura Tenshin around 1900. The Japanese art critic had arrived in Calcutta to forge a pan-Asian alliance with the intellectual circle led by Tagore. In the late nineteenth century, the 'open door' policy had imposed westernization on a prostrate Japan. European academic art, which arrived in Japan as part of the westernization process, ousted indigenous art from popular esteem. The challenge to western values came at the turn of the century, from the cultural movement led by Okakura. The Japanese thinker, who recognized India as the ultimate source of the ancient Buddhist art of Japan, shared with Tagore an unswerving faith in the common destiny of Asia. One of the tenets of pan-Asianism was the contrast between Asian spirituality and European materialism, a romantic worldview in search of the roots of indigenous traditions and a form of cultural resistance to European colonialism. Western stereotypes such as 'the Oriental mind' were appropriated by pan-Asianists as a powerful focus for Asian resistance.[14]

Okakura's traditional (*nihonga*) art movement was realized in art by his pupils, Yokoyama Taikan and Hishida Shunso. He arranged for them to work in Calcutta with Abanindranath, where they studied Indian art. Under Taikan's influence Abanindranath discarded the strong colours and hard outlines of Mughal painting in favour of the light brush strokes and delicate lines of Japanese art. With his wash technique Abanindranath produced atmospheric works in the spirit of Far Eastern art, some of which appeared in the art journal *The Studio* in 1905 and in Okakura's influential periodical, *Kokka*, in 1908.[15]

A few months prior to the nationalist unrest of 1905, Havell had brought Abanindranath to the Calcutta Art School to 'Indianize' art teaching with a select group of students who would rediscover 'the lost language of Indian art' [114]. Abanindranath, who led the Bengal School, the first art movement in India, aimed to create an 'oriental art' by assimilating different Asian cultures. The target of the Bengal School was academic art, which was branded as a colonial hybrid lacking 'authenticity', the prime example being Ravi Varma's work. Some

**114 Abanindranath Tagore**

*Bharat Mata*, c.1905.

The first major nationalist unrest broke out in October 1905, following the forced partition of Bengal by the Raj. This was spearheaded by two key demands, self-government (*swaraj*) and indigenous self-sufficiency (*swadeshi*). Abanindranath's political act was to paint the portrait of Mother India (*Bharat Mata*), personified as a Bengali lady holding four symbolic objects in the fashion of Hindu deities. However, the objects themselves were not conventional but emblems of nationalist aspiration: food, clothing, secular knowledge, and spiritual knowledge.

influential figures in Bengal and academic artists refused, however, to dismiss all academic art out of hand as being inimical to Indian cultural aspirations. An acrimonious battle of styles raged for years, throwing up writing of great vivacity.[16]

## Muslim nationalism in art

By 1914, not only were the orientalists able to shake off opposition at home, they also won recognition abroad, with exhibitions in Paris and London in 1914, in Berlin in 1923, and again in London in 1924. At the last London exhibition, an English critic extolled the 'Indian artists' mission to the world'. The Germans, whose romantic attachment to India and their defeat in the First World War made them more sympathetic to the movement, described it as a powerful cultural struggle for redemption. An important aspect of the Bengal School was the merging of individual differences of style within a common vocabulary. But apart from the blend of Mughal and Far Eastern art, what held the movement together was the nationalist subject matter. Stories relating the past glories of the nation, themes exuding noble sentiments, and deep pathos were preferred. The vehicles for such noble themes were stooping emaciated figures, dripping with an aura of acute spirituality. An oppressive sense of loss was conveyed in these historicist works, a lamentation for the nation degenerating under a foreign yoke.

The *swadeshi* ideology of art, a reflection of militant Hindu nationalism, tended to privilege Hindu culture as the kernel of the Indian nation, thereby disinheriting other communities. Such developments created a feeling of unease among the Muslims. Abdur Rehman

**115 Abdur Rehman Chughtai**
*The Resting Place, c.*1927. Chughtai, who chose the *Rubayyat* of Omar Khayyam and other Muslim classics to construct his own historicist vision of the past, represents a cross-fertilization of cultures: as Beardsley and the Decadents drew upon eastern art, so Chughtai sought inspiration in the eastern elements of Art Nouveau. Chughtai's remarkable draughtsmanship was quickly recognized by the orientalists, who hailed him as one of their kind.

Chughtai (1897–1975), an outstanding Muslim painter from Lahore, represents the awakening of Muslim political and cultural identity in India partly in response to Hindu cultural nationalism [**115**].[17]

By the 1920s, academic art was in retreat in India. A new generation of artists in Calcutta tried to regroup under Hemen Mazumder, a painter of academic nudes, and Atul Bose, a fine draughtsman, while a group of landscape painters in Bombay continued to offer a challenge to the orientalists. However, both the westernizers and the orientalists were overtaken by events. Pan-Asianism was on the wane, as the differences among Asian intellectuals became irreconcilable. In 1921, Mahatma Gandhi launched his mass non-cooperation movement against the British empire, when political activism made any artistic contribution to nationalism rather problematic. But most of all the Bengal School was dealt a crushing blow by Cubism and other European avant-garde movements, which began to infiltrate Indian culture through books and journals.

## Colonial architecture in India

Colonial architecture profoundly altered the topography of urban India, though less so in rural India. The first signs of colonial transformation of Indian architecture are seen in the European architecture of successive Portuguese, Dutch, Danish, French, and British settlements.

### Religious architecture

The earliest Christian churches were built not by the colonizers but by Indian Christians in South India in the first few centuries after Christ (a little later the Jews built synagogues in India). Today, very little remains of these early endeavours. In the seventeenth century, the Portuguese invited the dreaded Inquisition and the Jesuits to Goa for the consolidation of Christianity in the subcontinent. They also erected spectacular churches in the Mannerist and Baroque styles prevalent in the Iberian peninsula. The churches in Goa were a blend of *vastusastra* and Vignola, a tradition that is yet to be studied properly. The sixteenth-century Italian architect Jacopo Vignola's modular building system, imported by the Portuguese to India, was easily comprehended by the Indians, used to their own modular, the *vastu-purusa-mandala* [see **22**]. Furthermore, Indian designers must have felt at home with the rich drama of the Baroque church, its decorative impulse akin to the spirit of the Hindu temple [**116**].[18]

### Secular architecture

Fortified settlements based on Renaissance central planning were some of the major secular structures introduced by the Portuguese in India. The English fortifications of the East India Company

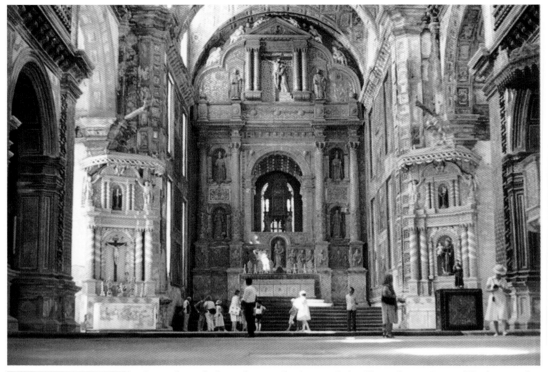

**116**

Church of the Holy Spirit, nave and high altar, Goa, seventeenth century.

Among the major churches in Goa, the most striking ones are the Cathedral of St Catherine, the Church of Our Lady Divine, and this church. Its grand, airy conception—it has a central hall but no side aisles—focuses our attention on the high altar framed by a great round arch. The inspiration was Vignola's II Gesù in Rome.

introduced the advanced plans of the French engineer Vauban, who turned city walls into artillery platforms and angled them mathematically to cover all lines of fire. Despite queries raised by architectural historians, Calcutta, Bombay, and Madras were not centrally planned cities.[19] Unlike the Royal Ordinance of 1573 issued to the Spanish colonies, the British trading company was suspicious of any central planning that involved unnecessary expense. The streets were fairly regularly laid out. Modest churches and hospitals catered respectively to the spiritual and bodily needs of the European population. The paramount consideration was defence, while the governor's residence served as a symbol of authority. The building style used the Tuscan order, as prevailed in contemporary Britain. The port cities employed a sizeable Indian artisan population, which meant that the Indian and European communities were segregated in Black and White Towns. While the Company was suspicious of ostentation, private residents felt free to indulge their taste for opulence.[20]

With the victory over the Mughal governor Siraj-ud-Daula at Plassey in 1757 the British were able to venture out of the fortified port cities into the Indian countryside for the first time and gradually imposed their control over it. Interactions between Indian and western cultures produced architecture of great variety, ingenuity, and occasionally elegance, especially domestic architecture. Judged against the dominant western canon, Indo-British buildings were viewed as the

'unhappy bastards' of the colonial encounter. However, if one can renounce metropolitan standards and view them as products of a different context and experience, they repay careful study. Many of the imposing public buildings were constructed by East India Company engineers with the help of Indian builders. The inspiration was often European architectural texts, and there was always a time lag of around 20 years between the rise of a style in Britain and its introduction into India.[21]

After 1757, Fort William in Calcutta was redesigned as a massive fortification with the latest devices, but it lost its strategic importance as threats from rival colonial powers and Indian rulers in the subcontinent faded, leaving the British in almost total control. A renewed sense of insecurity, which surfaced during the Uprising of 1857, encouraged yet another conception of defence. Exclusive settlements inhabited by European civil and military officials, the cantonments, came into existence outside Indian towns. Within the cantonment, the army barracks were placed behind the open parade ground that could be used to train cannons at the enemy. These precautions were taken against a sudden insurrection by the native population.

*Indian Neoclassical architecture*
The first public building of symbolic importance, the Neoclassical Government House in Calcutta, was modelled on the British stately home Kedleston Hall in Derbyshire.[22] The architecture of the colonial cities was motivated by the need to project an awe-inspiring image of the Raj. These buildings were also wish-fulfilments of colonial 'nabobs', who sought to recreate English stately homes in India. The Neoclassical style of these lavish residences was modified by the exigencies of climate and landscape, most notably in the use of shutters for windows. The sparkling white mansions (the *chunam* or quicklime white gave them the sheen) on the waterfronts of Calcutta and Madras were much admired by visiting Europeans: 'Viewed from the Hooghly, Calcutta has the appearance of a city of palaces. A row of large superb buildings ... produce a remarkable striking effect'.[23] The Indian 'merchant princes' of Calcutta, trading partners of the Company, followed suit with their impressive residences. What does not feature in books on colonial architecture is the fashion for Neoclassical architecture among urban Indians. The imposing Palladian mansion in Calcutta, the Marble Palace, is one example of the syncretic imagination lavished on this type of 'hybrid' domestic building. Many of these are being demolished to make room for high-rise buildings in response to the population explosion in Calcutta. But perhaps the most original contribution to colonial culture was the domestic bungalow, derived from the rustic Bengali hut, a cool, low-slung, single-storeyed, high-ceilinged residence perfectly adapted to the tropical climate.[24]

**117 R. Chisholm and C. Mant**

Laxmi Vilas Palace, Baroda, nineteenth century.

An example of a fascinating pastiche of European and Indian styles celebrating hybridity and exuberance is the Laxmi Vilas Palace at Baroda designed by the army engineer Major C. Mant.

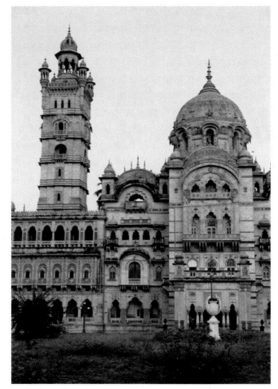

**118**

The Victoria Terminus, Mumbai (Bombay), nineteenth century.

This vast station in Mumbai, linking the west coast with north-east and central India, was in an early Gothic style with an Oriental feeling, an opulent Indian version of St Pancras Station in London.

The first Indian ruler to commission a Neoclassical building was Mir Jaffar, the puppet ruler of Bengal, who was placed on the throne by the English after Plassey. He engaged the East India Company engineer Duncan Macleod in 1825 to build the substantial palace in Murshidabad, inspired by Government House in Calcutta. European architecture was also adopted by the nawabs (rulers) of Lucknow. But they were 'blackmailed … into creating European buildings, often to the direct advantage of the Company, who subsequently used them for their own purposes'.[25] And even their alliance with the East India Company did not spare the nawabs from destruction.

In the early nineteenth century, classical architecture was used to celebrate an empire held to be as enduring as that of Rome. This confidence was shaken by the Uprising of 1857, after which, abandoning aggressive anglicization, the Indian Raj turned to the notion of 'a timeless India', to be sheltered from the onslaught of western progress. Instead of reform and change, tradition and order became the dominant motto. Refashioning itself as the heir to the Mughal empire, the Raj opted for the Indo-Sarasenic style of architecture, especially for the palaces of the Indian nobility [**117**].[26] Ironically, as more and more Indian rulers were brought within the imperial fold after 1857, they increasingly succumbed to a western lifestyle, collecting European art objects and sitting for academic portraits. Hindu and

Muslim forms were combined in many of the palaces of the Indian nobility, in which 'the two races remained distinct with the Hindu firmly subordinated'.[27] This was to underline the fact that only Raj paternalism was able to keep the peace in a land that 'lacked' cultural or national cohesion. During the Victorian era, revolutionary amenities such as the railways placed the Raj on a new footing in India, as exemplified by the sumptuous railway station in Mumbai [118].[28]

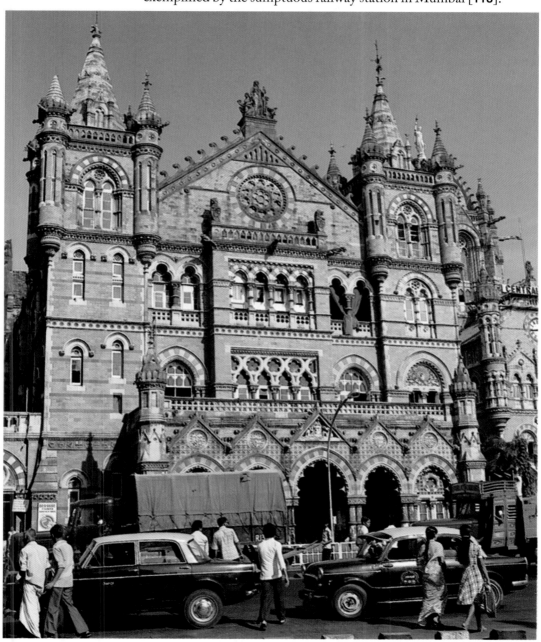

## 119

Plan of New Delhi.

As the administrative and ceremonial capital of the Raj, New Delhi sought to learn from other western capitals around the world. Its symmetrical geometry is dominated by the wide central axis used for grand processions, which starts from the viceroy's residence and then makes its way past the secretariat buildings and the circular council chamber. The planners wished to attain an axial symmetry that revealed a series of views as one moved around the city.

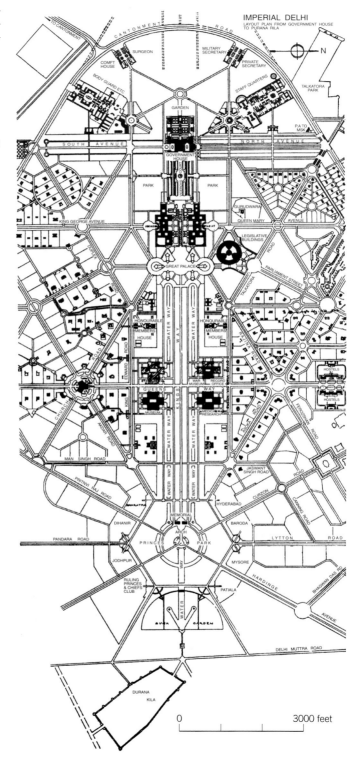

IMPERIAL DELHI
LAYOUT PLAN FROM GOVERNMENT HOUSE
TO PURANA RILA

Lutyens decided to employ 'Indic forms, rigorously controlled and subordinated within a European classical idiom, to express the imperial ideal', for this residence of the highest dignitary of the Raj.

The triumphalist ideology of the empire was expressed in official architecture such as the Victoria Memorial Hall in Calcutta, conceived by the viceroy, Lord Curzon, as a fitting memorial to the queen. It is a classical edifice of white marble, with some Indian details.[29] The swan-song of imperial architecture was the new capital in Delhi, announced in 1911 to coincide with Edward VII's visit to India [**119**]. The removal of the Indian government from the colonial capital of Calcutta to Delhi, considered the heart of the indigenous empire, was a symbolic appeasement of the nationalists. It also enabled the Raj to extricate itself from the hotbed of seditious politics. To the pro-Indian officials, the choice of Indian, possibly Mughal, architecture would have narrowed the gulf between the Raj and its Indian subjects. But this was not to be. The appointment of Edwin Lutyens as the chief architect made the choice of a Neoclassical style for Delhi inevitable [**120**]. However, the imagination of his collaborator, Herbert Baker, was fired by the romance of empire as a partnership between the ruler and the ruled. He considerably diluted Lutyens' classicism in the Secretariat buildings designed by him.[30] It was also largely because of Baker that nationalist artists were commissioned to decorate his buildings with murals celebrating Indian culture, first in New Delhi and later in India House in London. It was ironic that, from the inception of New Delhi in 1911 to its actual completion in 1932, the political situation in India had reached such a crisis point that the capital remained the hollow seat of an empire in its final decades.

# Modernism in India

December 1922 is a convenient starting point for a discussion about the modernist art movement in India. At the end of 1922, through Rabindranath Tagore's intervention, an exhibition of the works of Paul Klee, Wassily Kandinsky, Johannes Itten, and other Bauhaus artists was held in Calcutta.[1] This momentous event brought modernism right to the doorsteps of Bengal, though its impact was not immediately obvious. International modernism added an extra dimension to the earlier dialectic between colonial and indigenous art. The problematic relationship between global modernity and national identity was the dominant theme of Indian art through the twentieth century as indeed of arts of the Third World in general. Modernity, associated with western capitalism and colonial expansion, has involved international communication on an unprecedented scale, giving artists unlimited access to art from all ages and lands. The Industrial Revolution, which ushered in the modern age in the eighteenth and nineteenth centuries, uprooted communities and undermined social cohesion. Fragmentation of life and art made intellectuals outsiders in their own society, causing alienation and angst, forcing a crisis of identity. These have become the cornerstones of modern art, formally expressed in radical distortion and fragmentation.

In the 1920s, India was still an essentially non-industrial country in which social cohesion had not yet broken down. While colonial rule gave rise to a crisis in cultural identity, this did not necessarily lead to the western sense of alienation of the self. Indeed nationalism—and nationalist art as represented by the Bengal School—was built on the real or imagined unity of all Indians, which could hardly encourage social alienation of the artist. As Indian artists were increasingly exposed to the European avant-garde from the 1920s, each artist responded to the above issues of modernism in their own way. But one problem they could not resolve was the contradiction between a modern sense of alienation and the cultural cohesion expected of a nation engaged in an anti-colonial struggle.

## Indian artists and Cubism

Art from the 1920s until 1947, the year of Indian independence, was dominated by three powerful personalities, the poet Tagore, Amrita

Detail of 121

Sher-Gil, and Jamini Roy, all of whom responded to modernism in their own unique ways. However, the first Indian response to modernism was a fascination with Cubism, which had become the most widely emulated artistic style in the world. The pioneering figure in this context was Abanindranath Tagore's brother, Gaganendranath (1867–1938), who came to prominence in 1917 with a series of cartoon lithographs. Since the 1870s in Bengal, caricature had been a prime device in art and literature for exposing pretension and mocking contemporary manners. The satirical tradition continued into the twentieth century, but few matched the unsentimental eye of Gaganendranath [121].[2]

In the 1920s, Gaganendranath's discovery of Cubism released an unprecedented creative energy in the artist [122].[3] In order to grasp the nature of Gaganendranath's appropriation, we need to compare it with the reception of Cubism in European countries other than France. But first let us remind ourselves of Cubism's contribution to modern art. European painters since Giotto had related different objects within a picture by means of consistent, directional lighting. The unique importance of Analytical Cubism (the Braque-Picasso experiment of 1909–10) rests on the fact that it finally destroyed the pictorial illusionism created by 'directional lighting'. This was achieved by setting up conflicting relationships of light and shadow 'within' a picture frame, thereby dissolving the solidity of an object.[4]

**121 Gaganendranath Tagore**

*Dhanyeswari*, lithograph, c.1918.

His ferocious social cartoons pilloried double standards, cant, and hypocrisy. The Brahmin pays lip service to religious duties, while indulging in prohibited food, alcohol, and whores. The bold lines and large, flat colour areas in his cartoon lithographs are reminiscent of the cartoonists in the German satirical magazine *Simplicissimus*.

Significantly, these revolutionary implications of Cubism did not affect German expressionists such as Georg Grosz, for instance, as much as Cubism's decorative possibilities, namely that objects could be distorted and fragmented at will to create dazzling patterns. To Gaganendranath, who was remote from the European scene, the decorative possibilities of Cubism, with its broken surfaces and the play of light and shadow, proved to be the most gripping. These later works, including Gaganendranath's flights of poetic fancy, may be termed 'post-Cubist', both to indicate the source and its transformations. Indeed, a German critic at an exhibition of modern Indian art in Berlin in 1923 quite perceptively spotted this affinity between the Indian artist and the Expressionists. The complex patterns developed by Gaganendranath in his later painting derived also from his use of a kaleidoscope, a contraption that fascinated him.[5]

## Primitivism and Indian art

The second development in Indian modernism needs to take into account another global phenomenon with its roots in the history of western thought: primitivism.[6] In the late nineteenth century, the nationalist art fairs in Bengal gave the decorative arts the recognition they deserved. But it was Mahatma Gandhi's Satyagraha movement that for the first time brought the vast rural population of India into the orbit of the anti-colonial struggle (Gandhi, however, did not directly address the tribal peoples in India). The Gandhian movement gave a new voice to the peasant and forced the urban elite to accept that

Indian society was predominantly rural.[7] In the first phase, artistic nationalism had identified the nation with the past; from the 1920s, it began equating the nation with the soil. This was the time when educated Bengalis discovered Kalighat painting and the village scroll painting (*pat*).

*The creation of the 'noble savage'*
However, from the 1920s it was the Santhals, hunter-gatherers of eastern India, who emerged as the ideal 'noble savage' in Bengali consciousness. This stereotyped image of 'primitive' groups in India had already been created by colonial anthropology.[8] Santhal women were romanticized by the Bengal School, but in the university founded by Tagore at Santiniketan, Santhals or *adibasis* (original inhabitants of India) came to stand for the timeless purity of the primitive, set against the corruption of civilization.[9] This paved the way for the admiration of tribal art by the elite, who discovered its affinities with European modernist works.

The quest for rural (and tribal) art as an expression of indigenous resistance to colonialism became a significant aspect of modern art in India. However, in the interactions between elite and folk/popular/tribal artists, despite the undoubtedly idealistic objective, an asymmetrical relationship between them was inevitable. For instance, the elite artist could with all sincerity participate in folk lives in order to gain an insight into folk art, but the reverse was virtually impossible. This underlying tension of our modern age has never been resolved.

## Rabindranath Tagore (1861–1941)

The first major modern painter in India, who made primitivism a vehicle for his artistic expression, the great poet Rabindranath Tagore was also the first Indian to make an effective use of bold 'expressionist'

distortions in his painting. Tagore took up painting somewhat play-fully at 67, when his international reputation as a poet was at its zenith. The first exhibition of Tagore's paintings took place in May 1930 at the Galerie Pigalle in Paris. Henri Bidou, the champion of the Surrealists, drew clear analogies between Tagore's 'automatic painting' and the work of the Surrealists. Similarly, in Germany, where Tagore was a legendary figure, a reviewer commented on his work, 'How necessary it was for the revival of imagination to descend to the depth from where life comes, so as to be rid of the awful routine of illusionism. They are interesting because they show that ... between these Indian abstractions and the modern European ones there is an association of ideas.'[10] Tagore's paintings made a considerable stir in European intellectual circles, which can be partly attributed to his legendary reputation. But importantly, Europeans, already attuned to the poetic licence of Paul Klee and Max Ernst, did not fail to respond to the sheer power of his radical imagination.

Tagore's affinity with the European avant-garde was not a form of emulation but simply a parallel approach to artistic primitivism. There are several crucial aspects to Tagore's paintings that display his unmistakably personal style. Tagore's paintings originated in his game of creating shapes out of crossed-out texts, his 'erasures'. On the drafts of his writings, he often experimented with the Bengali script and the visual effects of different page designs. Tagore, along with the Bengali intelligentsia, was fascinated with the innovative combinations of text and image developed by Art Nouveau and Jugendstil illustrators, especially by Adolf Hölzel. Secondly, his 'erasures', produced with pen and ink and wash within a limited range of colours, began to take on human and animal shapes. They demonstrated his interest in the totemic art of the North American west coast Haida people and of Oceania [123].[11]

**123 Rabindranath Tagore**
*Bird*, c.1930.
Tagore's most striking creations were mask-like faces, some in profile, some frontally treated, hieratically simple, expressionless, like primitive masks. Tagore's faces concentrate on the 'unbeautiful, and on raw emotions', in a rejection of naturalism. The other striking subjects are birds and a variety of antediluvian monsters, sometimes reptilian, other times canine, that seem to lurk in the depths of the primal forest.

Among Tagore's primitivist imagery gathered from around the world, there is, interestingly enough, none from India, even though he was drawn to the simple lives of the Santhals in Bengal. What we must remember is that tribal art was not yet widely known in India. Freud, who had offered a new insight into automatic drawing, children's art, and naive art, gave European Expressionists and Surrealists a weapon to combat the academic canon. As with the European avant-garde, Tagore's primitivism sprang from an inner psychological need. This is where Tagore's painting differed from the bulk of his literature, in which his style was Olympian and formal, seldom plumbing the unconscious. In his late years, he sought escape from the formal conventions of literature into a personal, erotic, and enigmatic language of art.[12] Tagore found the Bengal School unacceptably parochial and sought refuge in what he regarded as the universal in art.[13] His direct and untutored approach made him the most radical painter in India and an inspiration to the younger generation.

### Amrita Sher-Gil (1913–41)

The second major figure in Indian modernism was the legendary Amrita Sher-Gil, the first professional woman artist in India, who died tragically young. Sher-Gil was born in Budapest in 1913 to a Sikh nobleman and a cultivated Hungarian-Jewish musician. In 1934, Amrita returned to India after training in Paris, declaring with youthful impetuosity that she wished to see the art of India break away and produce something vital connected with the soil, yet essentially Indian. Sher-Gil's primitivist longings were first kindled by Gauguin's Tahitian paintings. She declared her artistic mission to be the interpretation of the lives of poor, mute, unsung Indians, 'the silent images of infinite submission … angular brown bodies strangely beautiful in their ugliness'.[14] Apart from her well-known Gauguinesque paintings, she also produced a thick 'textural' style related to the Neue Sachlichkeit movement, which had influenced Hungarian artists. She came to adopt the style on her visits to Hungary, where she met a number of artists. Sher-Gil had commenced yet another style with dramatic colours and flat shapes but this was cut short by her sudden death. In her works, what comes across is her instinctive sympathy for women, as in *The Child Bride* [**124**].

**124 Amrita Sher-Gil**

*The Child Bride*, 1936.
As early as 1925, Sher-Gil had entered in her diary: 'Poor little bride, she did look forlorn as she sat in a lonely corner [surrounded by ladies in gorgeous robes] … there was an expression of weariness in the [bride's] liquid eyes. She seemed to guess the cruel fate [awaiting her].' In 1936 she appears to have realized this incident in this moving study.

Paradoxically, it was not her painting style, which was less radical than Tagore's, but her vital personality that marked her out as the quintessential modern artist as an alienated outsider. With her mixed parentage, she embodied the contradictions and ambiguities inherent in the modern concepts of ethnicity, nationalism, and cultural 'purity'. Unconventional and brash yet vulnerable, she shared with many gifted people a voracious sexual appetite that outraged her contemporaries. She had a series of bisexual affairs and her feelings for men were

ambivalent. One of her lovers, the English journalist Malcolm Muggeridge, described her as a 'mixture of rose water and methylated spirit'. In the final analysis, she represents the emancipated woman whose work takes precedence over everything else, a professional woman in a world of men.[15]

## Jamini Roy (1887–1974)

The third leading modernist before 1947 was Jamini Roy, whose primitivism made a consistent ideological statement. Whereas works produced in Santiniketan and by Sher-Gil idealized the 'children of the soil', Roy took these ideas to their logical conclusion. A member of the landed gentry, Roy received his training at the Calcutta Art School. In his early career, Roy searched for an 'authentic' national expression in art, flirting with an array of styles from both East and West, ranging from academic naturalism and Impressionism to orientalism and Chinese wash painting. The process by which he eventually discovered the style that fulfilled his spiritual and intellectual needs was slow. It was attended with a spiritual crisis at one point, when he questioned the very need for painting. After seeking inspiration in the art of Kalighat, Roy turned to rural India, to the Santhals, who were already being romanticized by the Bengali nationalists, and finally to the scroll paintings of his own village in the Bankura district of West Bengal. By the end of an exciting voyage of discovery he was creating bold and simple works that were marked by a fresh vision of traditional Bengal [125].[16]

Roy's achievements as a nationalist artist must be set against his own definition of indigenous art. Firstly, he was convinced that genuine indigenous art could not be produced with foreign commercial pigments. With this in mind, he gave up oil painting, turning to indigenous earth colours and organic pigments. Secondly, Roy ultimately rejected Kalighat in favour of village scroll painting because he found the former to be too closely associated with the urban and colonial milieu of Calcutta. His indigenism sprang from a social commitment to art. Renouncing artistic individualism, a sine qua non of colonial art, he sought to make his workshop anonymous, deliberately subverting the 'aura' of authenticity of an elitist painting by producing collaborative works and refusing to sign them.[17]

## Developments in art on the eve of Independence

The strong undercurrent of romantic primitivism was not confined to the three leading figures. From the 1930s, it radicalized art with its stress on rural art at Tagore's 'holistic' Visva Bharati University in Santiniketan. Nandalal Bose, an influential teacher at Santiniketan and a leading member of the Bengal School, gave up historicism in favour of traditional village art, encouraging students to commune

**125 Jamini Roy**

*A Woman,* 1940s.

Roy brings to perfection his quest for a style that combines the bold lines of modernism with the folk scroll paintings (*pat*) of Bengal. Roy's great reputation as a painter rests on his process of simplification, the ruthless paring down of unnecessary details to get at the essential form, culminating in a few bold lines and colours.

directly with nature. However, he was eclectic in drawing upon both western and eastern art. But above all, for Nandalal, only the primitive Santhals had retained the sense of humanity that had been lost with colonial rule. Nandalal's innovative teaching was given a radical twist by his pupil Binode Bihari Mukherjee: 'In his mural based on the lives

of saints (who were significantly peasants and artisans) Mukherjee works out a rhythmic structure to comprehend the dynamic of Indian life ... between community and dissent. A radical consciousness of traditional India is visualised'.[18] Ramkinkar Baij, the leading sculptor at Santiniketan, created a heroic image of the Santhals, injecting a new robustness to outdoor sculptures with the use of unconventional materials such as rubble, cement, and concrete [**126**]. This was a significant departure, because the major sculptor before him, Debiprosad Raychaudhury, had produced monumental sculptures on patriotic themes, but these were confined to bronze and other more conventional materials.

The second development on the eve of Independence was the widening of the social horizon of artists, a number of whom, including two leading Bombay artists, M. F. Husain and K. H. Ara, came from a humble background. Although this widening brought in new sensibilities, these artists, despite their non-elite origins, did not produce artisanal works. They joined the colonial-modernist artistic milieu, governed by the rules of the market and an urban artist–patron relationship. Above all, their individualistic outlook was quite different from that of the village potter, for instance. The desire of many of the artists of this period, from both elite and non-elite backgrounds, to return to rural roots did not make their art less genuine; it is simply that their works were different from the art of the traditional village

craftsman or -woman. These contradictory and at times irreconcilable tensions—cosmopolitan versus nationalist, urban versus rural—gave a certain urgency to the works of modern artists in India.

During the closing decade of the colonial era, art and literature moved towards greater social commitment, in sympathy with the burgeoning socialist movements in the country. This was reflected in the 'progressive art' groups that sprang up in various parts of India that strongly rejected artistic nationalism in favour of social justice and equality. Progressive artists were self-confessed modernists pitted against the 'dead wood' of tradition, their idols Jamini Roy, Amrita Sher-Gil, and Tagore and their target the 'historicist' Bengal School. They established close links with Marxist intellectuals, especially the Indian People's Theatre Association (IPTA) and the Progressive Writers groups. The earliest Progressive Artists Group was formed in Calcutta in 1945, in the shadow of the Bengal famine of 1943. Its members included the sculptor Pradosh Das Gupta and the painters Paritosh Sen, Gopal Ghose, Nirode Mazumder, Subho Tagore, and Zainul Abedin. Among them, Abedin became renowned for some of the most haunting sketches of the great famine. The first artists' commune in India was established in the village of Cholamandalam near Madras. Of these various initiatives, the Bombay Progressive Artists Group has been the most influential. The impact of these new ideas was to be felt in the decades following Independence.

# Part IV

# Postcolonial Art and Architecture (1947–2000)

# Art After Independence

The subcontinent's independence was achieved in 1947 at the cost of partitioning the country into two separate states, India and Pakistan. Yet again, in 1971, Bangladesh was created out of East Pakistan. There are certain broad trends in art and architecture in the postcolonial period. International modernism, which had made only a hesitant entry into India before Independence, gathered speed after 1947. In the 1950s, artists enthusiastically joined the global 'race' for abstraction, and yet, in keeping with the Indian tradition, few artists fully renounced the human figure or the narrative. The first challenge to semi-abstract art came in the 1970s and continues today. Representational art was reinstated in the 1970s, but it was now tinged with irony or political overtones. This was a reflection of greater politicization of art and the influence of postcolonial writings and the women's movement on art. This was also the period when global modernism came under attack as subcontinental artists began to reassert their cultural identity. Many of the artists of this generation discovered their roots in the soil and the common people, seeking to obliterate the distinction between high, elite and low, 'subaltern' art.

## India

*Architecture*

The first prime minister of independent India, Jawaharlal Nehru, dreamed of creating a secular state, based on economic and social justice, which would offer moral leadership to the Third World. A modernist who favoured state intervention in all spheres, symbolized by the Five Year Plans, Nehru played a proactive part in a national art policy headed by the Lalit Kala Akademi (an officially sponsored artists' forum) and the National Gallery of Modern Art in the capital. Nehru gave a boost to artists by suggesting that one per cent of the cost of a public building should go towards its decoration with murals and sculptures.

Modern architecture had arrived in India before Independence but it was to be found not in official buildings but in commercial ones. Art Deco cinema halls, office buildings, and apartment blocks in Mumbai and Calcutta, built from the 1930s, were its most imaginative examples.

Detail of 132

International modernism in public architecture was, however, consciously inaugurated by Nehru in a bid to look to the future rather than the past, recently sullied with blood and strife. In 1951, he invited the French architect Le Corbusier to design the capital at Chandigarh for the new truncated state of Punjab (most of Punjab was now in Pakistan). Le Corbusier's uncompromising functionalism consciously broke with the past 'historicism' of imperial architecture. This was followed by the avant-garde architecture, with a 'whisper' of the Mughal, of Louis Kahn in Ahmedabad (and Dhaka in Bangladesh). The era saw the debut of leading Indian modernist architects, among whom Balakrishna V. Doshi (b. 1927), for instance, worked with Le Corbusier. As with modern painting and sculpture, the international style gave rise to the problem of accommodating the national within the global. Modernist architecture abhors superfluous surface decoration, an attitude reinforced by the use of modern materials such as concrete, glass, and steel. There were tensions between the modernist canon and the Indian visual language, which has historically rested on decoration.[1] What caused anxiety among post-Independence architects was this: how could they avoid pastiche, namely the attachment of Indian motifs to essentially modernist architecture? Apart from the fact that elaborately decorated nineteenth-century buildings have faced disgrace in the twentieth, 'historicist' Raj edifices were perceived as flaunting a meretricious orientalist imagery.[2]

Misgivings among Indian architects gathered force in the 1970s and 1980s as part of a wider questioning of modernism as being exclusively western. Charles Correa (b. 1930), an internationally acclaimed Indian architect, articulated the problem facing architects in India as 'the necessity to simultaneously both rediscover India's past and invent its future'.[3] Correa found the solution in the revival of earlier practices, exploring the functions of Indian buildings, rather than their decoration, in his search for authenticity [127]. A pioneer in low-cost housing in the Third World, he developed two concepts inspired by Indian climate and ideas: 'open-to-the-sky' space and tube houses that conserve energy in a hot, dry climate. He has also used open courtyards and clusters of huts for the Gandhi Ashram in emulation of Gandhian values and explores the indigenous planning of space in the *vastu-purusa-mandala*. Balakrishna Doshi, on the other hand, borrows Mughal structural features, and Uttam Jain (b. 1934) is another architect who has introduced indigenous modes of building in his work. The architectural historian G. H. R. Tillotson pleads for a revival and not reproduction of Indian craftsmanship in building, which he feels is lacking in modern buildings in India.[4] Yet, in the final analysis, what matters is how effectively modern and local elements are synthesized in an architecture that works.

**127 Charles Correa**

Dome and inlaid floor, Inter-University Centre for Astronomy and Astrophysics, Pune University.

This scientific institution was one of two complementary projects (the other at Jaipur) expressing architecture as a model of the cosmos. Correa, who believes that modern scientific and Hindu notions have remarkable similarities, explores the relationship between the modern discipline of astronomy, our twentieth-century understanding of the expanding universe, and Hindu notions of the cosmos. The small openings in the dome accurately represent the stars of the night sky, while the floor pattern is of ancient Ayurvedic origin, and links the seasons with the constellations.

## Semi-figurative art

The reception of modern art in India is encapsulated in the comments of the German art historian Hermann Goetz. Indian art, he argues, had faced a crisis during colonial rule, which ended with the rise of modernism, when 'the best artists started again on their quest for true art, not from a superficial imitation of the past, but from an under-standing of the basic principles underlying all genuine creations'.[5] The 1950s to '70s were dominated by non-figurative art, a global phenomenon. The backdrop to it was the politics of the Cold War; the 'free world' artists identified with formalism and abstraction, while

narrative art was dismissed as being comparable to the Socialist Realism of the USSR. The critic Geeta Kapur writes, 'We developed a quiet, almost quiescent, aesthetic. The … figure was withdrawn from the work of some of the major Indian artists, leaving behind the merest signs of the human presence in nature'.[6] However, if we are to look for a common thread here, it is the insistent return of the figure, the perennial subject of India, set against the background of abstraction. Paradoxically, de-colonization made Indian artists more, rather than less, conscious of their Indian identity as they confronted global modernity. Indeed, the tensions generated by the conflicting demands of global modernity and national specificity became a major preoccupation of Third World artists.

In 1947, the year of Indian Independence, the Bombay Progressive Artists Group was launched, which made a big impact with a much publicized exhibition the following year. However, without a clear ideology that they could share, the Progressives soon fell apart, two of them heading for Europe. With the notable exception of M. F. Husain, Europe became the training ground of all the leading Indian artists. London had traditionally been the destination of Indian artists reared on English academic art. Sher-Gil in the 1920s was the first artist to break with tradition in choosing Paris, the Mecca of modernism. In the 1940s, the Bengali sculptor Chintamoni Kar was the second Indian to spend some years in Paris. His sculpture was judged the best at an international competition held in Sweden. After Independence, many of the Indian and Pakistani artists in Europe joined the Académie Montparnasse of André Lhote (1885–1962). A minor painter who used Cubist mannerisms to create his rhythmic semi-geometrical shapes, Lhote had emerged as an influential teacher in the 1950s.[7]

Apart from S. H. Raza, Indian artists with European experience returned to India to mould the post-Independence artistic milieu. By the 1950s, the centre of gravity in modern art had shifted from Paris to New York and London. And yet what these artists brought back with them were semi-figurative styles based on post-war French developments in abstraction. They introduced the pleasure of colour and texture in a country where until then narrative and meaning had been paramount in painting. Ram Kumar, who had been associated with radical political groups in France, chose on his return themes of social injustice and alienation, treated with a dark palette and with snatches of Cubism. He soon moved on to abstraction in his vision of Benares as a configuration of shades and textures, the colourful city reduced to stretches of clay, sand, and sky.[8] Jehangir Sabavala, a craftsman and perfectionist, became engrossed with the possibilities offered by Cubism after his return to Bombay, developing over the years a lyrical form of semi-figurative work.[9]

Krishen Khanna (1925– ), who gained prominence in the late 1960s, was born in West Punjab, which is now in Pakistan. After studying in England, he moved to India where he worked for a commercial bank for a while. In 1961 he became a full-time painter. A politically committed artist, he has been an active member of the Artists' Protest Movement. The American-British painter R. B. Kitaj's powerful political statements made a deep impression on him. Khanna began in a semi-figurative style but, partly because of his belief in the political role of art, the image never disappeared from his work [**128**]. An exception to the general non-figurative trend was Satish Gujral who was also born in West Punjab and went to the Mayo College of Arts in Lahore. He left Pakistan in 1952 for Mexico where he worked with the Marxist muralist Siqueiros, before settling in India. Gujral's paintings in the 1960s had a strong Mexican social realist flavour with brooding sculpturesque figures.[10]

### Maqbool Fida Husain (b. 1915)

During the first three decades after Independence, the most successful artists were the one-time Bombay Progressives, Husain, Souza, and Raza; the last two were also the first Indian diaspora artists. From a poor Maharastran family, Husain rose from being a humble painter of hoardings advertising Hindi movies to the undisputed leader in modern Indian art 'in the range of his themes [and] the quality of excellence which he has maintained over three decades'.[11] Flamboyant, courting controversy, displaying a generosity of spirit, Husain epitomizes the optimistic Nehruvian era itself. The high point of his career was the São Paulo Biennale of 1971, where he exhibited alongside Picasso [**129**].[12]

With his prodigious output and endless experimentation, he remains an enigma to the critics: 'They have barely been able to

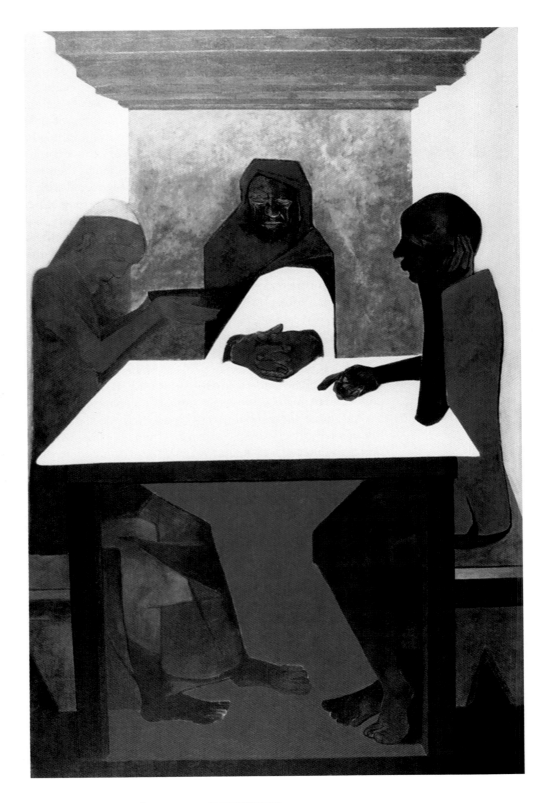

**128 Krishen Khanna**

*Emmaus,* 1979.
In this modern retelling of the theme of Christ at Emmaus, Khanna uses a limited range of colours to create an atmosphere of subdued drama.

categorize one phase of his when he has stormed his way into another'.[13] Geeta Kapur, on the other hand, feels that:

[one] can only ask of him what his own work had promised; authentic understanding of the traditional—the 'typical' Indian. Having recognized it [with] something of a brilliant intuition, having embodied [it] in a series of lucid and memorable images, he let go of it, too soon and too easily.[14]

### Francis Newton Souza (b. 1924)

A Catholic from Goa, Souza joined the Bombay art school in the last days of the Raj, only to be expelled for taking part in student unrest. The 'angry young man' of Indian art, Souza drew the attention of the Bombay police by exhibiting a full frontal nude of himself. The most articulate among the Bombay Progressives, Souza declared: 'Today we

**129 Maqbool Fida Husain**

*Mother Teresa II,* 1980s.
Husain uses 'collages' of bold colours bounded by nervous outlines and random associations of fragmentary images in order to make political and cultural statements. He often paints a series of works to develop his monumental themes, recycling forms by ransacking eastern and western cultures, distilling essences, and deconstructing icons.

**130 Francis Newton Souza**

*Half-nude Girl in a Chair,*
1960.

Souza's is a personal vision based on Hindu erotic sculpture, Christian iconography, and a facility with the nude. His nudes could be grim though displaying an innocent sexuality. In an interview published in *The Studio* (1964) he explained that he painted in artificial light, with the help of an overhead projector to 'blow up' photographs and 'pin-ups' from 'girlie magazines'. The method enabled him to keep his inspiration fresh and spontaneous.

paint with absolute freedom [with regard to] contents and techniques, almost anarchic, save that we are governed by one or two sound elemental laws of aesthetic order ... We have no pretensions of making vapid revivals of any school'.[15] Souza chose London, rather than Paris, as his destination in 1949, and received critical acclaim in the 1960s [**130**].[16]

### Sayed Haider Raza (b. 1922)

Childhood memories of mysterious Indian forests drew Raza to landscapes, a rare subject among post-Independence artists. Another product of the Bombay art school, Raza discovered German Expressionism through Langhammer and Rudy von Leyden. His cityscapes progressed from an architectonic view of Bombay to an appreciation of its

moods, seasons, and colours. In 1956, some years after moving to Paris, he became the first Asian artist to win the Prix de la Critique. The French critic Jacques Lassaigne marvelled at his timeless landscapes and uninhabited cities suspended in the air beneath a dark sun.[17] From the 'transfigured nature' of his early years, Raza moved on in the 1990s to paintings inspired by ancient Indian Upanishadic philosophy and the Tantric cult [**131**].[18] Tantric art gained popularity in the 1960s in India and the West. In 1971 a pioneering Tantric artist, Nirode Mazumder (1916–82) offered a penetrating analysis of the connection between his artistic aims and Tantric philosophy [**132**].[19]

### K. G. Ramanujam (1941–73)

An individualist whose work cannot be easily categorized, Ramanujam was part of the Cholamandalam village, the artists' commune founded near Madras by K. C. S. Pannikar. Congenitally deformed, Ramanujam considered himself to be too ugly to find a woman to share his life, deciding to end his life at the age of 32. His works were never shown in his lifetime. Cholamandalam influence can be discerned in Ramanujam's use of folk elements, such as his oversized male and female figures which resemble the papier mâché puppets carried in religious processions in Tamilnadu. Ramanujam frequently reincarnates himself in his fantastic paintings: a slightly grotesque figure flanked by his wish-fulfilment women [**133**].[20]

## Modern art in Pakistan

The massive population transfers in the aftermath of the Partition in 1947 included Muslim artists, who moved from India to the newly formed East and West Pakistan. In the formative years the destinies of artists belonging to the two wings of Pakistan were interlinked. West Pakistan had inherited the key colonial institution, Mayo School of Arts in Lahore (renamed National College of Arts). Two leading Muslim artists, the orientalist Abdur Rehman Chughtai (1897–1975) and the academic painter Allah Bukhsh (1895–1978), who enjoyed

## 131 Sayed Haider Raza

*Jala Bindu*, 1990.

In this Tantric work, a series of colours is orchestrated around the *bindu*, the focal point of meditation, considered the ultimate source of reality in Indian philosophy. Raza conjures up a world of Rajasthani colours—blazing vermilions, mustard yellows, Prussian blues, and pitch blacks—in his painting.

*Chandani Holding Gurudas's Feathers*, c.1968.

'For the last 20 years I have tried to find solutions, maintaining as far as possible the symbolism of colours according to the *gunas* [loosely translated as spiritual essences], time etc. in my paintings, conceiving my works by series, each of the pictures in a series being a temporal image related to the point marking the centre, from which the whole picture generates and to which the figures developing first in the form of a lotus [a Tantric symbol] will ultimately return'.

pre-eminence as a painter of landscapes and Hindu mythology, became venerable figures in Pakistan. The Pakistani artists showed a particular aptitude for calligraphy and colours and probably felt more at home with abstract design, but the figure continued to be a dominant subject with them.

Because subcontinental artists, irrespective of their religious affiliations, had partaken of the same artistic ideas and movements and had faced very similar problems of responding to the international avant-garde, we can trace very similar developments in the three parts of the subcontinent. As with the younger Indian generation's impatience with the Bengal School, a non-figurative generation was emerging in Pakistan that challenged the earlier artistic concerns. Speaking on the role of international modernism in Pakistan, the art historian Akbar Naqvi remarked that he wished to explore closely 'how much Pakistani artists took from Europe and what did they leave out'.[21] In 1949, the modern movement in Pakistan was launched with an eye

**133 K. G. Ramanujam**

*Untitled*, 1972.

He creates an imaginary 'bricolage' universe made up of heterogeneous elements—architectural constructions, Tamil gods, sacred animals, children's books, snatches from the French Impressionists, and Venetian scenes. A Venetian cavernous arch, for instance, allows us an entry into a garish carnival such as one sees in South Indian films. His fantasy figures ride composite beasts with elongated lambs' heads and serpents' tails in an imaginary space.

to developments in American art but with scarcely any knowledge of the neighbouring Bombay Progressives, for instance. And yet interactions did take place. The moving spirit behind the Karachi Fine Art Society was an Indian diplomat.[22]

In the 1940s, the Bengali artist B. C. Sanyal's Lahore School of Fine Art had introduced a modicum of modernism in the Punjab. In the initial years of Pakistan, Anna Molka (1917–95), an energetic East European married to a Pakistani artist, joined the department of fine arts at Punjab University. An Expressionist painter herself, she encouraged modern art.[23] The first major modernist painter was Zubeida Agha, who is discussed in the next chapter in the section on female artists.

In the 1950s a group of artists formed the independent Lahore Art Circle. In 1952, Cubism was introduced by Shakir Ali (1916–75) at the National College of Art. A mystical painter and an inspiring teacher, Ali gave a lead to the younger generation through his Group of Five. After his training at the Bombay art school, Ali had worked at André Lhote's studio in Paris.[24] He then spent a period in Czechoslovakia learning textile design. His development from traditional art through Cubism to colouristic canvases was cut short by his early death. Among successful painters, the portraitist Ismail Guljee (b. 1926) from Sind province enjoyed lavish state sponsorship. Impressed by the visiting American painter Elaine Hamilton, Guljee enthusiastically plunged into action painting, creating dazzling surfaces enhanced with

gold and silver leaf and calligraphy. However, he did not relinquish his lucrative portrait commissions.[25] It is often forgotten in tracing the trajectory of modernism that there have been serious and talented naturalistic artists, as evident in the landscapes of Khaled Iqbal (b. 1929), Zulqarnain Haider (b. 1939), Shahid Jalal (b. 1948), and Ijazul Hassan (b. 1940), to name the best-known ones.[26]

### Sadequain Naqvi (1930–87)

It is against this background of nascent modernism that Sadequain, the celebrated Pakistani artist and a prizewinner at the Paris Biennale of 1961, made his debut. Sadequain's versatility ranged from fine calligraphic miniatures to monumental paintings, though it is in public murals that he created a permanent niche for himself. In the words of the poet Faiz Ahmed Faiz, Sadequain was a visionary whose phantasmagoric creations expressed the emotional and social unity of all material things caught up in an upward struggle.[27]

Descended from a family of calligraphers in North India, Sadequain joined the Progressive Writers and Artists Movement in the 1940s. He then spent a period in Paris augmenting his skills. A short spell in the barren, cacti-ridden desert terrain by the sea at Gadani, near Karachi, became Sadequain's epiphany. In the ensuing allegorical works on the labouring man's spiritual struggle, the spiky cactus came to be a metaphor for the human condition; when it was accompanied by Kufic (a decorative form of Arabic script) calligraphy, it represented the fall of man [**134**].[28]

Between 1966 and 1970, the political situation in Pakistan worsened. In 1976, Sadequain's exhibition in Lahore was greeted with violent protests by conservative elements. Under threat in his final years, Sadequain's defiance died down. He turned to more neutral calligraphy, especially *tughra* (word pictures), combining abstraction with meaning, one of the first modern artists to use it to explore painterly texture.[29] Sadequain's use of Islamic calligraphy was part of a growing trend in Pakistan, culminating in the calligraphic competition at the Islamic Summit in Lahore in 1974, followed two years later by a German–Pakistan conference on the subject.[30] This phase of Sadequain's work, however, is seen by some as a retreat from his earlier social commitment.[31] Disillusioned, before his death the artist visited India, where he was received with enthusiasm.

### Ahmed Parvez (1926–79)

The prolific and controversial Ahmed Parvez is considered to be one of the four 'touchstones' of Pakistani art. Parvez was born in Rawalpindi on the North West Frontier. His parents' separation caused deep problems in his personal relationships but it also fuelled his precocious creativity. Parvez was discovered by Shakir Ali and the modernist

**134 Sadequain (Naqvi)**

*Composition from Ghalib,*
1968.

Sadequain incorporates the
Hindu and Buddhist concept
of *maya* (illusion) to reinforce
the imagery of struggle. He
treats the nude in an original
manner, and his work is
imbued with an undercurrent
of sexual symbolism and
fantasy, as in the
sadomasochistic tropes of
Urdu and Persian *ghazals*
(lyric poems).

Group of Five. But it was in London, he claimed, that he at last found
himself. Not only did Parvez create art out of waste products and
rejected pieces, but he used his own bodily waste in his art.[32] However,
his wide range of media included the sensuous use of pastels during his
'abstract-lyrical' outbursts. His praise of nature in a *tachiste* vein is
recorded in the painting *Untitled (Orchard)* of 1970. In 1976, Parvez
pictured his own body in the form of a cross, a man with an orange-like
head with the molten fire of the sun behind him, in a mystical-erotic
riot of jewel-like colours. Similarities with the English painter Alan
Davie, who also uses glittering, gem-like colours, have been noted by
critics and also acknowledged by the painter himself. Parvez died
tragically in poverty without fulfilling his promise.

### Shahid Sajjad (b. 1936)

Of the sculptors in Pakistan—a rare breed—the mystical Shahid Sajjad is by far the most outstanding. He has been described as a primitivist, at odds with civilization and its discontents. Ever restless, he started his career in a printing firm, only to abandon it soon after. He spent some years with a sculptor in Japan, learning bronze casting through a painful process of trial and error. At the end of his training he came to develop a respect for the tools and materials as traditional artists did. To Sajjad, spontaneous experience and the intimate relationship of craft with life were the vital elements in an artist's armoury. Sajjad returned to the wood produced in northern Pakistan, a material hitherto considered unsuitable for carving [**135**]. He applied automotive paints and the blowtorch to this material in order to leave deep scorch marks and patterns on its surface and to expose the inner grains. Sajjad's early sculptures give the impression of totemic figures, his work progressing to heroic reliefs. One of his most important works expresses a political allegory: a thick garment with deep folds, but without the body inside, hangs from the gallows, a poignant comment on the Pakistani leader Zulfiqar Ali Bhutto's execution.[33]

## Modern art in Bangladesh

The Partition of India led Zainul Abedin (1918–76) to emigrate to East Pakistan (renamed Bangladesh after the War of Liberation in 1971). One of the most distinguished artists of Pakistan and claimed by some critics to be its first modernist, Abedin had trained in Calcutta and was part of the Progressive Artists Group in the 1940s [**136**]. In 1948, he was appointed by the government of East Pakistan to head the newly founded art school in Dhaka, which became the focus of the modernist movement in the 1950s. The Government Art Institute followed presently, and in 1954 the first All Pakistan Arts Exhibition was held in Dhaka, in which West and East Pakistani artists took part.[34]

Not only Abedin but S. M. Sultan (1923–94) and other contemporaries of Abedin had trained in the art schools of Calcutta. Of these, Abedin and Sultan continued with the Calcutta schools' concern with rural life, and Abedin's 'naturalist' style was later regarded by some critics as conservative.[35] Other artists in the 1950s wedded folk forms with bold simplification. The drawings of Quamrul Hasan (b. 1921), who had been involved in the village regeneration movement in pre-Partition Bengal, combined rural motifs with geometrical forms, seeking inspiration in the simplicity of village clay pots and dolls. Safiuddin Ahmed (b. 1922), a versatile graphic artist, whose rural themes included Santhal women, took up abstraction after moving to Dhaka. Anwar ul-Haq (b. 1918) specialised in landscapes. Murtaza Bashir (b. 1933) progressed from socially committed imagery to abstraction.[36] This shift towards non-figurative art was spearheaded by

**135 Shahid Sajjad**
*Hostage I*, 1992–4.
Inspired by Gauguin's sculptures, he found his first 'primitives' in the Chittagong hills where he began wood carving. Sajjad learned from the tribal people about their use of the local trees for sculpture. He experiments with different crafts over long periods not only to master them but to seek an intimate relationship with them.

**136 Zainul Abedin**

*Famine*, 1943.

In 1943 Abedin won recognition with his harrowing images of the victims of the great famine of Bengal, created with deft expressionist sketches of considerable intensity.

the younger generation, who admired the works of Zubeida Agha, Shakir Ali, and Sadequain. Among this generation, Mohammad Kibria has been a particularly sensitive artist in exploring subtle textures in his mixed media works.

The watershed for the artists of East Pakistan was the War of Liberation in 1971 that created Bangladesh. While it was a period of great suffering, it also offered a new national identity and a new optimism, which had a profound effect on art and artists. The private language of abstraction was felt to be inadequate for expressing the political struggle as it demanded readily intelligible and affecting images. Later, the leading artists of Bangladesh, including Abedin, were to produce works based on their own experiences of genocide and resistance ranging from the abstract to the figurative.[37]

In the general atmosphere of optimism that followed the founding of Bangladesh, the young state stepped forward as a patron, establishing academies and art galleries. These were to support artists through exhibitions and publicize their works with monographs and other publications. Among these, the most important is the Bangladesh Shilpakala Academy, the official sponsor of Bangladeshi art. Every year since 1974, the Academy has organized a national art exhibition and an exhibition devoted entirely to young artists.[38]

The most significant development since the 1980s, as also seen in other parts of the subcontinent, has been the marketing of art and the expansion of art galleries, subsidized by private concerns. In the 1960s

there were only the Arts Ensemble Galleries in Dhaka. After 1971 galleries proliferated in the capital.[39] Since the 1990s, as poverty, political instability, and forces of conservatism have overwhelmed Bangladesh, there is a feeling that the optimism of 1971 has gone sour. Some critics complain that once again artists are returning to a personal language of abstraction, abandoning social commitment as earlier feelings of unity begin to fade.[40]

The War of Liberation produced a remarkable artist in Bangladesh. Shahabuddin (b. 1950), who showed promise in his student years, joined the armed struggle for independence, an experience that deeply coloured his mature work. He left for Paris in 1974, where he received further training, and has lived there since. From 1979, Shahabuddin began exploring the expressive potentials of the human form, as recalled from his war experiences. His most striking works are his male figures in motion, which he uses to great effect in capturing the drama of the struggle and eventual victory [137].[41]

# The Contemporary Scene

**12**

From the 1970s, the art scene in India started undergoing considerable changes, and in the 'free market' era of the 1980s artists became more conscious of market forces, as galleries willing to sell works of art mushroomed in the main cities. Narrative art with recognisable subject matter returned with renewed vigour, but it made very different statements. The human figure continued to be treated not in naturalistic detail, which is a characteristic of European art even today, but in a typical Indian fashion entirely as an expressive medium. Artists distilled elements from personal experience to create Platonic types that made universal statements. Another important feature is that, with some notable exceptions, artists preferred ambiguous, floating poetic spaces like those of Chagall to European single-point perspective. Such perspective was closer to the use of space in Indian miniatures.

Artists of considerable originality, for instance the self-taught artists Sudhir Patwardhan (b. 1949) and Gieve Patel (b. 1940) in Mumbai, made their debut in this period. Among a number of major figures, I have focused on several with individual visions that exemplify the variety and richness of this pictorial trend. The following four are characterized by their poetic, super-realist rendering of reality. Ganesh Pyne (b. 1937) started as a watercolourist in the Bengal School mode. His discovery of the pictorial world of Klee enabled him to inject a modern sense of fragmentation and ambiguity into his own work. In addition, *The Outsider* by the English existentialist writer Colin Wilson struck a chord in his own temperament, which has always been marked by an acute sense of alienation.[1] Pyne's work demonstrates a craftsmanship perfected through years of concentrated study of a few self-imposed themes [**138**].

The hyper-realism of the Calcutta artist Bikash Bhattacharjee (b. 1940), with strong light and deep shadows like an art photograph, swims against the tide of fashion in India.[2] There is an undercurrent of violence in his work, as in his sinister Victorian dolls treated in the manner of Surrealist sculptor and painter Hans Bellmer, though their styles are quite dissimilar. Bhattacharjee's portraits of Bengali lower middle-class women are deceptively academic. On closer inspection, they reveal themselves to be the stuff of bad dreams. These scary aliens

Detail of 147

**138 Ganesh Pyne**

*The Sage*, 1979.

Pyne describes his picture settings as a twilight zone, the meeting point of day and night, of life and death, of love and agony—where everything is seen in a different light. His persistent motifs are anthropomorphic masks with gleaming eyes, Jurassic animals, bleached skeletons, and stunted humans, surrounded by dark pools of water. These subtly textured paintings with exquisite detail conjure up a mysterious world that exists outside the normal commerce of life.

that inhabit the twilight world seem to emanate from the slums of Calcutta.[3] Another poetic realist, Jogen Chowdhury (b. 1939), who spent some years in Paris, delights in combining the erotic with the grotesque in sagging, wrinkled flesh, the excrescences on the epidermis erupting like pustules and tumours [**139**].[4] The lyricism of Manjit Bawa (b. 1941) springs from his training in silk-screening. Bawa's boneless, amoebic humans and beasts float in fluorescent candy-coloured space: pink, violet, emerald green, sky blue, tangerine. Bawa,

## Postcolonial art criticism

The developments in Baroda must be set against the rise of postcolonial art criticism, which treats art as a form of cultural discourse rather than as the embodiment of self-evident truth. As the sacrosanct western canon and its claims to universality began to be questioned, women's art and non-western art, until now judged condescendingly against classical taste, won a new recognition. This challenge to the dominant canon was radically different from the earlier modernist assaults on it, which never really questioned the western colonial, capitalist hegemony or the unilinear trajectory of western art history. The concept of colonial discourse laid bare the culturally constructed nature of many of the artistic 'truths'. This important development in the academic field coincided with the emergence of new art critics, notably Geeta Kapur. She challenged Europe's leading question: 'How can Indians appropriate western modernism without misunderstanding and reducing it?' These theoretical developments gave Indian artists an increasing self-assurance about their work. They also felt confident enough to mount protests against the international art market controlled by western art critics, gallery owners, and art dealers.

*Man and Woman*, 1987.
In this work, Chowdhury makes his monochromatic grotesques stand out against the dark void behind them. The metaphor of over-ripeness is applied to humans and inanimate objects, which take on the qualities of an ageing organism, decaying and corrupt. An ordinary pillow in a Bengali bedroom with the word 'love' embroidered on it, slightly stained and crumpled with use, floats in a bare space. Another series, *Reminiscences of a Dream*, brings out his eccentric vision of the lotus, a cultural icon, alongside dead fish and stale vegetables.

who is inspired by the eighteenth-century Hill State painters of his home state of Punjab, seeks the iconic simplicity of Indian mythology. Since the themes are universally familiar, 'you can concentrate instead on the form, the colour, the space', he explains.[5]

## The new pictorialism

The fine arts department of the Maharaja Sayajirao University of Baroda (Madhya Pradesh) was a major force in the re-emergence of pictorialism of the 1970s, the paper *Vrischik* (scorpion), published from Baroda, becoming a powerful ideological weapon in the dissemination of radical ideas. In the 1960s, Baroda had established close links with the Royal College of Art in London, a link that has led to significant cross-fertilizations, in part because of a shared interest in figurative art. The English painter Howard Hodgkin has had close associations with Baroda artists, notably Bhupen Khakhar. Another British artist, Timothy Hyman, a passionate advocate of expressionist realism in painting, made a controversial visit to Baroda in 1980–1, contributing to the ongoing debate at the university. Geeta Kapur, writing for *Vrischik*, launched a frontal assault on post-Independence non-figurative art as being part of a conformist international formalism that claimed primacy of style over meaning.[6] These ideas came to a head at the 'Place for People' exhibition held in Bombay and Delhi in 1980–1, where the new pictorialists, Sudhir Patwardhan, Bhupen Khakhar, Vivan Sundaram, and others, consciously repudiated non-figurative

modernism as playing hostage to western capitalism. They also sought in a postmodernist vein to end the distinction between fine and popular/folk arts.

The fine arts department of the University of Baroda was founded in 1949 on the novel idea of offering art as a vocation; art students took courses in art history and the humanities as part of their all-round training. This intellectual background provided the basis for a consciously thought-out artistic programme, which received a boost with the appointment of the artist and pedagogue K. G. Subramanyan. Subramanyan vigorously implemented the teaching principles of his mentors, Nandalal Bose and Binode Bihari Mukherjee, introducing the Santiniketan mural tradition in collaboration with a traditional painter from Rajasthan. Together they undertook public mural projects inspired by Bengali terracotta reliefs. Subramanyan himself acquired a first-hand knowledge of the traditional arts by working for the state-owned Handloom Board.[7]

Subramanyan's objective was to obliterate the gulf between the artisan and the modern artist, incorporating the 'living traditions' of rural and tribal art into the Baroda curriculum. Subramanyan, whose romantic primitivism equated the formalist universe of non-illusionist art with tribal art, 'found the structural mechanism of Cubism answering certain questions about the two-dimensionality of Indian folk art and vice versa'.[8] This formalism, he claimed, had fallen into disfavour during the post-Independence regime of semi-figurative art.

**140 Gulammohammed Sheikh**

*City for Sale*, 1981–4.
Sheikh discovered the wealth of Indian miniatures at the Victoria and Albert Museum in London: 'it was in the landscape that I invested my new-found understanding and excitement, sensation and experiences'. Sheikh feels that Mughal aerial perspective, which opens up layers of shifting viewpoints, better expresses Indian landscapes than European single-point perspective. He applies the idea of fluid space in his paintings in conjunction with a 'spinning structure', like the ancient Indian literary device of containing a story within a story.

Subramanyan threw down his gauntlet at the 'modernists', reasserting the pioneering importance of the Bengal School, which had been dismissed by artists from Sher-Gil onwards. He sought to 'contextualize' creativity and reintegrate art with cultural, social, and environmental issues. Finding postcolonial theory congenial to his own enterprise, Subramanyan put forward 'language', by which he possibly meant artistic conventions, as the transformative element in art. The role of the artist, he asserted, needed to be merged with the function of the work of art.

Two of the most original talents to emerge from Baroda are Gulammohammed Sheikh and Bhupen Khakhar, both of whom use narrative art to express multiple levels of meaning. Sheikh (b. 1937), also a noted poet, was the first artist from Baroda to receive training at the Royal College of Art in London.[9] His 'polysemic' cityscapes are conceived as vast panoramas in the manner of the Shah Jahan *Padshah Nama* [140]. They express his personal and social concerns, and are made up of complex layers consisting of sexual symbolism, Koranic imagery, memories of childhood, and episodes from everyday life. Sheikh often uses the courtyard as an emblem of the frontier between the home and the world in an Indian household. He writes:

Living in India signifies living simultaneously in several times and cultures ... The past is a living entity which exists in parallel with the present, each illuminating and sustaining the other ... With the convergence of periods and cultures, the citadels of purism explode. Tradition and modernity, private and public, interior and exterior incessantly separate and reunite.[10]

Bhupen Khakhar (b. 1934), born in an artisan community, was trained as a chartered accountant, which still provides his main income. He came to Baroda to study art criticism but found painting more attractive. Khakhar collects 'kitschy' imagery to construct an elaborate narrative genre, employing playful irony in his portrayal of the banal lives of inconsequential people as they lead their daily lives, adroitly capturing their awkward gestures in stiff, frontally posed studio portrait-like figures.[11] He revels in mock chandeliers and leather furnishings and makes careful inventories of the objects in an interior. From miniature colours, Khakhar moved on to garish enamel and calendar paints, including the actual paint used for decorating the interiors of small establishments such as a barber's saloon or a watch repairer's shop.[12] His meticulous constructions are full of care and humility, his iconic figures are surrounded with all the attributes of their daily activity.[13]

Khakhar's 'Pop' art is more 'naive' than satirical, since the high–low distinction in art is less obvious in India. However, we would fail to appreciate the sense of alienation, irony, and personal vulnerability in Khakhar's work unless we take into account his homosexuality in a society which is yet to come to terms with it. His cityscapes often offer

us a protagonist, his alter ego, a voyeur who gazes on the distant
scene with ironic detachment, tinged with a touch of melancholy
[**141**]. Khakhar's symbolic 'outing' is expressed in his panoramic work
*You Cannot Please Everybody*, purchased by London's Tate Gallery
in 1998.[14]

The most articulate, politically committed of Subramanyan's
students is Vivan Sundaram, who works with a global perspective,
seeking artistic equivalents of the Marxist ideological struggle.
Although he has produced elegant paintings, it was logical that
Sundaram would eventually turn to the political art of installations. In
1991, Sundaram chose to comment on the Gulf War, viewed by many
in the Third World as a ruthless form of western colonialism. His
installation is visualized as modern warfare in an ancient land, a war
game that belies the grim reality. The game is about war, destruction,
and death. As he points out, 'Operation Desert Storm, the battle
between Iraq and the Allied Forces early this year, was projected in the
mass media as bloodless high-tech warfare'.[15]

## Women artists of the subcontinent
*India*
The most significant development in the subcontinent since the 1970s
has been the rise of female artists as a self-conscious group. The aims

and issues of women's art, especially in the wake of the women's movement of the 1970s, are quite distinct from those of men and transcend the political frontiers that separate the three nations of India, Pakistan, and Bangladesh. Does gender override other considerations, even though some of these woman artists do not perceive themselves as feminists? It is problematic whether women's art can be defined by something inherently 'feminine', but women's experience in a male-dominated world is palpably different to men's. Woman artists of the subcontinent constitute a group in which certain concerns, anxieties, and aspirations are shared, given that they have not yet achieved anything like equality with men in social and cultural spheres.[16] It is no coincidence that many of the artists included here have been active from the 1970s, the period when feminism made its mark. Some of them, as part of that movement, seek to subvert with irony the common perception of woman's role as either nourishing or destructive and to engage in an examination of sexuality.[17]

Women's consciousness sharpened at the turn of the century under the impact of colonial education and nationalist concerns. The earliest evidence of woman artists in colonial India is the art exhibition held in Calcutta in 1879, in which 25 amateur woman artists took part. In the early twentieth century Tagore's niece Sunayani Debi, a housewife, won celebrity status as a naive artist, while Amrita Sher-Gil was the first professional woman artist in India. In the first decades after Independence, a few woman artists, namely Shanu Lahiri, sister of Nirode Mazumder, Kamala Roy Chowdhury, Kamala Das Gupta, wife of the sculptor Pradosh Das Gupta, and Amina Ahmad, wife of the sculptor Chintamoni Kar, were seeking to establish their professional credentials. In the Nehruvian era, it is argued, women groped for individual expression within the dominant artistic framework, caught in the dialectic between the representation of women in art and their self-representation as women.[18]

### Meera Mukherjee (1923–98)

Meera Mukherjee, the most outstanding Indian sculptor to emerge in the post-Independence period, produced works of considerable power. A heroic individualist, she denied any feminist content in her work, considering herself to be a professional first and a woman second.[19] Mukherjee had her first lessons in sculpture from a traditional sculptor, gaining further technical training later in Munich. On returning to India, she renounced her western training in favour of traditional art, turning to the bronze-casting techniques of the Bastar tribe. She lived with the Bastars in order to gain an insight into their life and work, a participatory experience that included an anthropological study of the Bastar crafts: 'To my mind, every artist must also be an artisan, who brings to his work a devotion' [142].[20]

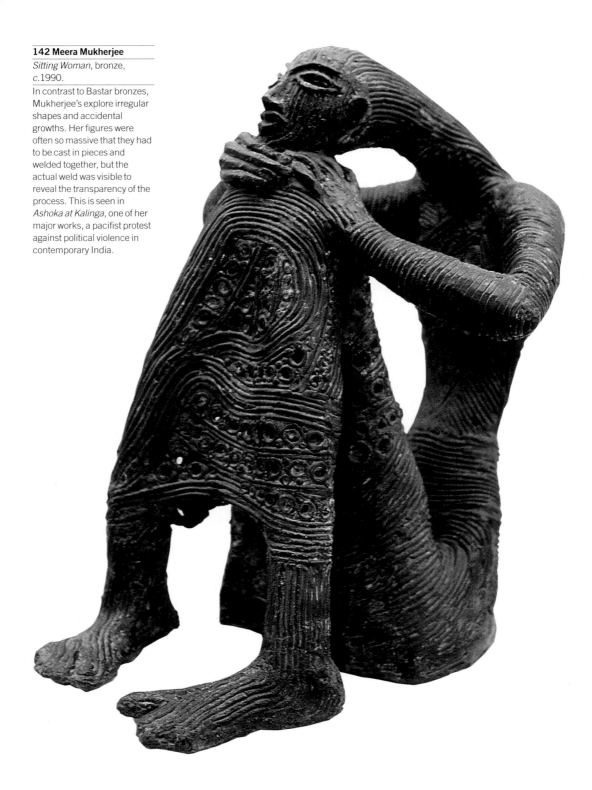

**142 Meera Mukherjee**

*Sitting Woman*, bronze, *c*.1990.

In contrast to Bastar bronzes, Mukherjee's explore irregular shapes and accidental growths. Her figures were often so massive that they had to be cast in pieces and welded together, but the actual weld was visible to reveal the transparency of the process. This is seen in *Ashoka at Kalinga*, one of her major works, a pacifist protest against political violence in contemporary India.

But she also came to the conclusion that, unlike the circumscribed world of the traditional artisan, the modern individualist artist was engaged in solving new problems and exploring new experiences. It is a token of her intellectual honesty that she was acutely aware of the fact that while the modern artist could profit from traditional art, the asymmetrical relationship between the underclass and the elite was a dilemma that could not be easily resolved. Despite sincere efforts, the tribal must remain the Other. Meera Mukherjee was impressive in her austerity, enjoying her isolation and self-imposed poverty, living solely for her work. She viewed her own life as a romantic struggle, lent intensity by the strength required for her monumental projects.[21]

## Nasreen Mohamedi (1937–89)

Nasreen was rare among Indian artists in pursuing pure, minimalist lines, colours, shades, and textures. While at St Martin's School of Art in London in the 1960s, she wrote cryptically, 'It is a most important time in my life. The new image for pure rationalism. Pure intellect which had to be separated from emotion—which I first begin to see now. A state beyond pain and pleasure. Again a difficult state begins.'[22] From her early colourful abstract expressionist landscapes and organic forms, she went on to minimalist black and white ink and pencil drawings. Whole sheets were filled with landscapes of light grey wash punctuated with calligraphic marks as in Arabic script. Occasionally, she used black ink to add tone and texture. Gradually nature yielded to the grid and the geometry of straight lines, aided with precision instruments. Her black and white photographs of Arab lands reveal the same formalist play of pure geometric and architectural shapes.[23] In her final years of illness, Mohamedi wrote wistfully of Kandinsky as she faced a crisis of confidence: 'Again I am reassured by Kandinsky—the need to take from outer environment and bring it an inner necessity.'[24]

## Autobiographical painting

Feminism made women reassess their lives and aspirations. Women artists spoke with a different and concerted voice on modernity and social commitment, interweaving personal histories with collective memories. The following three artists confronted the new consciousness in an autobiographical mode. Anjolie Ela Menon (b. 1940) found her personal expression after her meeting with the Mexican painter Francesco Toledo in Paris, who introduced her to layered surfaces and textures on hardboard. She aims at distancing her subjects to add a touch of mystery, as in her window series, in which the subjects are confined within actual window frames. She also uses accidental factors like wiping the paint off a figure to lend a *nonfinito* quality to her work [**143**].[25]

Nalini Malani (b. 1946), who was an art student in the West during

the late 1960s, was politicized by the student revolts of the time. Her early narratives focus on women's role in the family in a consciously subversive juxtaposition of the mundane and the unexpected. They allude to urban life, the human figures in them recalled from memory (she does not draw from life) [**144**]. 'For me,' she says in celebration of hybridity, 'a single subject cannot possibly be contained in one frame, so I have to repeat the idea by cloning and recycling images.'[26] Her 'political' art almost inevitably led her to installations which make reference to global issues of postcolonialism and Third World poverty. Nearer home, in order to draw public attention to the decaying

**144 Nalini Malani**

*Balancing Act*, 1983–4.

Her busy compositions seem like unrelated film stills floating in an ambiguous space. Her sources and media are heterogeneous: oils, watercolours, photocopies, and monoprints jostle with borrowings across time and space: Goya, Delacroix, Ravi Varma, Degas, Binode Bihari Mukherjee, Sher-Gil, Frida Kahlo, and Persian miniatures.

traditional murals of Nathadvara in Rajasthan, she organized a session of performance art. The paintings she did at the Chemould Gallery in Bombay covered entire walls. At the end of the show, to insist on their contingent and non-commercial purpose, she had them whitewashed over to be ready for the next show.[27]

Arpana Caur (b. 1954) challenges the male-dominated art world from a feminist perspective, as the universal merges with the autobiographical in her paintings. A child of divorced parents, Caur was influenced by her mother's prize-winning novel *Homeless*, based on their experience. She dwells on the claustrophobia of living in cramped lodgings, their trials and tribulations. She uses a range of female types in her work, from the young child to the mother, the widow, and the emblematic Mother Earth. She also reinterprets the heroines of eighteenth-century Basohli painting in a feminist light. As women in her paintings grow to heroic proportions, men consequently diminish in stature. The image of women sewing in quiet domesticity serves in her work as a surrogate for women's productivity in general, the embroidered cloth becoming a signifier on different levels of meaning.[28] Caur has taken up Madhubani paintings done by women, transferring the motifs directly onto the canvas, preferring tensions and contradictions instead of harmonies, describing them as existing 'between

dualities'. In 1995, she was invited to commemorate the anniversary of Hiroshima's destruction by the city's memorial museum. Her painting, *Where Are All the Flowers Gone?*, alludes to the violence perpetrated on the city's inhabitants.

In the 1980s, a new group of woman artists was coming to the fore at Baroda, notably Nilima Sheikh (b. 1945), Madhavi Parekh (b. 1942), whose naive paintings drew upon village art, and Rekha Rodwittiya (b. 1958), who trained at Baroda and the Royal College of Art, London. Rodwittiya was briefly part of the younger group that

**145 Rekha Rodwittiya**
*Within Ivory Towers*, 1984.
Rodwittiya, a striking colourist, packs her figures into crowded spaces, making feminist statements through a combination of paintings and autobiographical writings.

**146 Nilima Sheikh**

*When Champa Grew Up (7),*
1991.
By means of this understated
pictorial device inspired by
Indian miniatures, Sheikh
expresses the horror of the
scene.

included the sculptors Ravindra Reddy and Rimzon.[29] She was invited to participate in the exhibition celebrating the declaration of human rights by the United Nations in Geneva in 1988 [**145**].

Nilima Sheikh discovered the radical imagination of Binode Bihari Mukherjee and Ramkinkar Baij through her teacher, Subramanyan. She was also exposed to Gulam Sheikh's multilayered landscapes inspired by Indian miniatures. Of the different media she has experimented with, tempera, the medium of Indian miniatures, has become her favourite. She has also revived the Mughal technique of making hardboard out of layers of fine paper and combines Mughal compositions with the spirit of Japanese *Ukiyo-e* to narrate everyday events. Nilima considers her mother's influence in her life and art to be decisive. A recurrent figure in her work is a crouching woman washing clothes or dishes, a common sight in India.[30]

Nilima Sheikh's memorable work is the series *When Champa Grew Up*, an indictment of the 'bride burning' phenomenon in India. Her personal acquaintance with the young victim represented, who died from third degree burns, gives it an unusual intensity. The choice of a quiet lyrical style brings home all the more forcefully the horror of the incident, its evocative power resting on the mythic contrast between the innocent young bride, Champa, and the evil mother-in-law. The pictorial language makes use of incidental details, such as the kitchen where she cooks and the sinister objects lurking behind innocuous utensils which would bring about her destruction [**146**].[31]

A brilliant sculptor of the post-1980s generation, Mrinalini Mukherjee (b. 1949) is the daughter of Binode Bihari Mukherjee and a

**147 Mrinalini Mukherjee**

*Woman on Peacock,* 1991.

Her mysterious primeval figures, often marked with hollows and crags, have a ceremonial grandeur about them, 'constantly crossing boundaries between the domestically improvised and the ambitiously monumental, between cheap simple fabrics for the home and the rhetoric of sculpture for a public gallery'.

student of Subramanyan at Baroda. She offers a subtle but complex feminist message through the medium of an unconventional material, a species of vegetable fibre resembling hemp. Mrinalini fully exploits the dynamics of the material, its capacity to fold, twist, drape, and stretch. She begins by dying the material in deep colours, such as purple or carmine, and then knots and weaves it. She then slowly builds up her totemic figures, some of them menacing, many of them sexually ambiguous, occasionally a flower symbolizing the genitals [**147**].[32]

## Pakistan

Political issues have a particular urgency in Pakistan, which has produced woman artists of originality and commitment. Since the Mughal period, there has been a tradition of Muslim women being accomplished in the arts, a tradition that continues today in Pakistan. Women have played an active role in Pakistani art, as professional artists and in pioneering art education. Anna Molka, an influential figure, opened art classes for women at the Punjab University in Lahore at a time when the first art institutions in the new capital at Karachi were also set up by women.

Acknowledged by many as the first modern artist in Pakistan, Zubeida Agha was introduced to Futurism by an Italian prisoner of war she met in the 1940s. Her first act of defiance was to paint a nude and a self-portrait, both subjects considered inappropriate for a woman artist in Pakistan.[33] Zubeida Agha's show in 1949, the very first modern

**148 Zubeida Agha**

*New York,* 1970.

Her early work is sombre, seeking to capture the essential forms or emotions, but lightened considerably after her visit to the West. She is known for her carefully designed, flat, diagrammatic cityscapes painted in primary colours evocative of stained glass, sometimes bounded by thick black outlines.

art exhibition held in Pakistan, unleashed a fierce controversy. However, Agha was defended by those who argued that a different kind of art was required for the times [**148**].[34]

As artists' work in Pakistan was often dictated by the demands of state patronage, women received few public commissions. To survive, they had to create an alternative scene that presented their work and struggle. The resulting works were characterized by irony and defiance, calling into question social and political injustices as much as women's marginalization. An exhibition held in 1995 in Britain in the city of Bradford brought together 25 woman artists, who were remarkable for revealing a new sensibility. Most of them were from the National College of Arts in Lahore and their works challenged the male-dominated tradition. However, the artists shown were widely varying in their approach and interests. There is, nonetheless, an understated quality and a concern with texture and subtle chromaticism that unite a few of them.

Salima Hashmi, daughter of the leading Pakistani poet Faiz Ahmed Faiz, uses an intimate scale and the 'off-centre' compositions of illuminated manuscripts in order to convey her political message. Her *Poem for Zainab*, on the abused wife of an imam, purposely uses delicate hyacinth paper for the tragic subject in order to underline the mixture of vulnerability and resilience in women's existence.[35] Another artist, Sabah Husain, learnt the art of paper and printmaking in Japan. This demanding traditional skill has brought her an inner richness. Husain enjoys the tactile pleasure of paper making and is trying to introduce its use among artists in Pakistan. She has applied her knowledge of Indian classical music, and the Ragamala genre, to evoke abstract images of different sounds in her work [**149**].[36]

Naazish Ata Ullah, an influential art teacher and printmaker, addresses gender issues in her politically charged *Chaddar and Shrouded Image* series, produced during a period of political oppression in Pakistan. For others, notably Nilofar Akmat and Sylvat Aziz, the trauma of Partition and displacement provides a potent creative source. Among the younger generation, Sumaya Durani has chosen the medium of conceptual art to scrutinize the institution of marriage. Finally, Durriya Kazi is a rare artist in Pakistan since there are few sculptors in the country, let alone woman sculptors. She makes syncretic use of South Asian traditions: Tantra, Sufism, Islamic decorations, and Hindu temple forms.[37]

## Bangladesh

After 1947, Muslim women of Bangladesh began taking up art as a profession. The first major woman artist was the figurative sculptor Novera Ahmed (b. 1930), who now lives in Paris. She established herself with her relief mural for the Dhaka University library in 1957

## 149 Sabah Husain

*Zard Paton Ka Ban (Forest of Yellowing Leaves)*, 1993.

Smudges, splodges, lines, and marks made with Japanese sumi ink on semi-transparent handmade paper highlight the translucence and the layered textures in her work. Committed to the women's struggle, she creates work that is full of unexpected delights and optimism.

and the first open-air sculpture there in 1959, inspired by village dolls. Ahmed has preferred to use unconventional materials such as cement for her sculptures. She was followed by the sculptor Shamim Sikder and the painter Farida Zaman, whose subtle, intricately textured series *Fishermen's Net* won wide recognition in the 1970s.

The 1980s and 1990s, which witnessed many changes in the Bangladeshi art scene, affected the careers of woman artists, who are now more visible and active. Nasreen Begum's unconventional experiments with watercolours and mixed media, Nazli Mansur's works combining satire and nostalgia that challenge patriarchy, and Naima Haq's illustrations for children's books have all won wide

acclaim. Some of the most moving images from Bangladesh are Rokeya Sultana's *Madonna* series, which include recurrent, haunting images of mother and daughter. The memory of her mother fleeing with her during the genocide attending the War of Liberation in 1971 becomes in her work a metaphor for women's struggle [150].[38]

## The future of art in the subcontinent

Moving into the new millennium, the artistic scene in the South Asian subcontinent is changing rapidly as a new generation of artists begins to take over. Questions of national identity in the face of increasing globalization of art hold a special place in their minds. Partly because of the communication revolution (including easy and inexpensive travel and the internet), the legacy of colonialism, and the growing generation of children born of Indian parents spread across the world, the definition of an outsider or insider in India is becoming harder to sustain. In a global celebration of cultural hybridity, the concept of nationhood becomes problematic—are British artists born of South Asian parents British or Asian? To the younger generation this question seems meaningless, and an artist such as Anish Kapoor simply refuses to make a choice. The western canon has dominated the world for the last 100 years. The consequence of this has been to evaluate artists from the colonial world by western standards. Thus in the art markets of the 'international art capitals', London and New York, the western avant-garde has occupied a privileged position. In the 1990s, South Asian artists began to challenge this dominance. For their part, market forces as represented by western art galleries and notable auction houses, Sotheby's, Christie's, and Bonhams, have turned eastwards, setting up branches in Indian cities and holding auctions there. A number of recent sales in London and New York have centred on modern art in India and Pakistan. In South Asia art galleries are mushrooming as more and more young artists are taken up by them. But in all this, the most visible and critical presence has been that of woman artists and art critics, and perhaps in them lies the future development of Indian art.

# Notes

## Preface

1. P. Mitter, *Much Maligned Monsters: History of European Reactions to Indian Art* (Oxford, 1977 and Chicago, 1992); E. W. Said, *Orientalism* (London, 1978). See also S. Edwards, *Art and Its Histories: A Reader* (New Haven, 1999), which places my ideas in this book in an art historical context.
2. J. Fergusson, *The History of Indian and Eastern Architecture* (London, 1876).
3. E. H. Gombrich, 'Norm and Form: The Stylistic Categories of Art History and Their Origins in Renaissance Ideals', in *Norm and Form: Studies in the Art of the Renaissance* (London, 1966), 81–98.
4. P. Mitter, *Art and Nationalism in Colonial India 1850–1922: Occidental Orientations* (Cambridge, 1994).

## Chapter 1. Introduction

1. A. Naqvi, *Image and Identity: Fifty Years of Painting and Sculpture in Pakistan* (Karachi, 1998), xxxii.
2. John 14: 2. I am grateful to Peter Dronke for the reference.
3. K. K. Chakravarty and R. G. Bednarik, *Indian Rock Art and its Global Context* (Delhi, 1997); C. Maury, *Folk Origins of Indian Art* (New York, 1969); E. Neumann, *The Great Mother* (Princeton, 1963).
4. B. and R. Allchin, *The Rise of Civilisation in India and Pakistan* (Cambridge, 1982).
5. D. Srinivasan argues against its identification as the proto-Siva figure. However, her identification of the penis as part of the drapery is visually unconvincing: 'The So-Called Proto-Siva Seal from Mahenjo-Daro: An Iconological Assessment', *Archives of Asian Art*, 29 (1975–6), 47–58.
6. For an ecological explanation, see B. B. Lal, *The Earliest Civilization of South Asia* (Delhi, 1997). On the indigenous origins of the Vedic society see S. R. Rao, *Dawn and Devolution of the Indus Civilization* (New Delhi, 1991).
7. I found interesting parallels between my own approach and theoretical questions raised by Pierre Bourdieu. See the introduction to his *The Field of Cultural Production* (Cambridge, 1993).
8. K. Colleyer, *The Hoysala Artists: Their Identity and Styles* (Mysore, 1990); S. Settar, *The Hoysala Temples*, vol. I (Bangalore, 1992), 83; R. C. Sharma, *Buddhist Art of Mathura* (Delhi, 1984), 180.

## Chapter 2. Buddhist Art and Architecture

1. R. Thapar (ed.), *Recent Perspectives in Early Indian History* (Mumbai, 1995), for recent revisions of ancient Indian history. On the evolution of Indian religions see A. L. Basham, *The Wonder That Was India* (London, 1961); H. Bechert and R. F. Gombrich, *The World of Buddhism* (London, 1984); and R. F. Gombrich, *Theravada Buddhism* (London, 1988).
2. D. D. Kosambi, *An Introduction to the Study of Indian History* (Bombay, 1956), 136–75.
3. R. Thapar, *Asoka and the Decline of the Mauryas* (London, 1961).
4. V. Smith, *A History of Fine Art in India and Ceylon* (Oxford, 1930).
5. J. Irwin, *Burlington Magazine*, 115 (Nov. 1973), 706–20; 116 (Dec. 1974), 712–27; 117 (Oct. 1975), 631–43; 118 (Nov. 1976), 734–53.
6. F. Asher, *Art of Eastern India 300–800* (Minneapolis, 1980); J. G. Williams, *The Art of Gupta India* (Princeton, 1982), 3–7.
7. J. D. Willis, 'Female Patronage in Indian Buddhism', in B. S. Miller (ed.), *Powers of Art: Patronage in Indian Culture* (Delhi, 1992), 46–53; G. Schopen, 'What's in a Name: The Religious Function of the Early Donative Inscriptions', in V. Dehejia (ed.), *Unseen Presence* (Mumbai, 1996), 58–73.
8. D. Snellgrove, *The Image of the Buddha* (Paris, 1978).
9. V. Dehejia, 'Collective and Popular Bases of Early Buddhist Patronage: Sacred Monuments, 100 BC–AD 250', in Miller, *Powers of Art*, 36.

10. M. Cone and R. F. Gombrich, *The Perfect Generosity of Prince Vessantara* (Oxford, 1977).

11. A. Volwahsen, *Living Architecture: Indian* (London, 1969), 90–4.

12. S. L. Huntington, 'Early Buddhist Art and the Theory of Aniconism', *Art Journal*, 49 (Winter 1990), 401–7; V. Dehejia, 'Aniconism and the Multivalence of Emblems', *Ars Orientalis*, 21 (1991), 63; S. L. Huntington, 'Aniconism and the Multivalence of Emblems: Another Look', *Ars Orientalis*, 22 (1992), 14; G. Schopen, 'On Monks, Nuns, and "Vulgar" Practices: The Introduction of the Image Cult into Indian Buddhism', *Artibus Asiae*, 49, 1/2 (1989), 153–68.

13. V. Dehejia, 'On Modes of Narration in Early Buddhist Art', *Art Bulletin*, 72 (Sep. 1990), 374–92, identifies seven narrative modes.

14. S. L. Huntington, *The Art of Ancient India: Buddhist, Hindu, Jain* (New York, 1993), 74–85.

15. R. Thapar, 'Patronage and Community', in Miller, *Powers of Art*, 23, 26; V. Dehejia, 'Early Buddhist Patronage', in Miller, *Powers of Art*, 36, 40–2; V. Dehejia, *Early Buddhist Rock Temples: A Chronological Study* (London, 1972).

16. J. Fergusson, *The History of Indian and Eastern Architecture* (London, 1876).

17. Volwahsen, *Living Architecture: Indian*, 101–3.

18. A. Foucher, 'Les Débuts de l'Art Bouddhique', *Journal Asiatique*, 10e série, 17 (Jan.–Feb. 1911), 55–79; A. K. Coomaraswamy, 'The Origin of the Buddha Image', *Journal of American Oriental Society*, 46 (1926), 165–70.

19. J. Boardman, *Diffusion of Classical Art in Antiquity* (London, 1994), 109–45.

20. J. M. Rosenfield, *The Dynastic Arts of the Kushans* (Berkeley and Los Angeles, 1993), 67.

21. Schopen, 'On Monks, Nuns, and "Vulgar" Practices'.

22. Huntington, *Art of Ancient India*, 126–30.

23. L. Nehru, *Origins of the Gandharan Style* (Delhi, 1990).

24. J. Raducha, *Iconography of Buddhist Art* (Ann Arbor, 1983).

25. R. Knox, *Amaravati: Buddhist Sculpture from the Great Stupa* (London, 1992).

26. R. C. Majumdar, *The Classical Age* (Bombay, 1968).

27. W. T. de Bary, *Sources of the Indian Tradition*, 1 (New York), 255.

28. Huntington, *Art of Ancient India*, 191.

29. Among a number of key articles by W. Spink, see 'Ajanta's Chronology: Politics and Patronage', in J. G. Williams (ed.), *Kaladarsana* (New Delhi, 1981), 109–26. On landscape art in ancient India, see R. W. Skelton, 'Landscape in Indian Painting', in W. Watson (ed.), *Landscape Style in Asia* (London, 1980), 150–71.

30. D. Schlinglof, 'A Battle Scene in Ajanta', in H. Härtel and V. Moeller (eds), *Indologen-Tagung, 1971* (Wiesbaden, 1973), 196–203. See also his *Studies in Ajanta Paintings* (New Delhi, 1988), 408–12, for detailed discussion and identification of many of the puzzling episodes. V. Dehejia, 'Modes of Narration', *Art Bulletin*, 72 (1990), 374–92, suggests the notion of narrative networks at Ajanta.

31. P. V. Sastri and V. M. Ramakrishna Bhat, *Varahamihira's Brhatsamhita* (Bangalore, 1947), 67.

## Chapter 3. Hindu Art and Architecture

1. J. C. Harle, *The Art and Architecture of the Indian Subcontinent* (New Haven, 1994), 308–10 on Siva's dance.

2. A. M. Gaston, *Siva in Dance, Myth and Iconography* (Delhi, 1982).

3. S. Bhattacharya, *The Indian Theogony* (Cambridge, 1970); W. D. O'Flaherty, *The Hindu Myths* (Harmondsworth, 1975). The complex relation between local and canonical deities is discussed by C. Maury, *Folk Origins of Indian Art* (New York, 1969).

4. D. L. Eck, *Darsan: Seeing the Divine Image in India* (Chambersburg, PA, 1981).

5. T. S. Maxwell, *The Gods of Asia: Image, Text and Meaning* (Delhi, 1997), for discussion of Hindu theology.

6. Fergusson, *The History of Indian and Eastern Architecture* (London, 1876).

7. The most ambitious in this respect is the multi-volume *Encyclopaedia of Indian Temple Architecture* (eds M. W. Meister and M. A. Dhaky), the first volume of which was on South India, (Philadelphia, 1983).

8. A. Volwahsen, *Living Architecture: Indian* (London, 1969), 47.

9. S. Kramrisch, *The Hindu Temple*, vol. 1 (Calcutta, 1946), 46. See R. Wittkower, *Architectural Principles in the Age of Humanism* (London, 1973), 163, for a discussion of the similar Renaissance concept of proportions.

10. Kramrisch, *Hindu Temple*, 1, 318–31.

11. Dr Madhav Mitra of Jadavpur University has provided the following information: the philosopher Carvaka compares an 'unornamented' literary sentence to the naked body without ornament, both being imperfect or 'unbeautiful'. I am grateful to Dr Daud Ali for the reference to Vamana's *Kavyalamkarasutra*, 1.2, which mentions beauty in ornamentation (*saundaryamalamkaram*).

12. Kramrisch, *Hindu Temple*, I; A. Hardy, in his exciting work *Indian Temple Architecture: Form and Transformation, the Karnata-Dravida Tradition* (New Delhi, 1995), suggests that as energy moves away from the sanctum, it splinters and fragments in an ordered manner, governed by four types of movement: emanation, fragmentation, proliferation, and disintegration; M. Meister, 'The Language and Process of Early Indian Architecture', in his ed. *Ananda K. Coomaraswamy: Essays in Early Indian Architecture* (New Delhi, 1992), xxi–xxix.

13. *Chaos: Making Sense of Disorder*, brochure for an exhibition at the Science Museum (London, 3 November 1995 to 14 April 1996). Those who are numerate should consult B. Mandelbrot, *The Essence of Chaos* (London, 1983).

14. P. Mitter, *Much Maligned Monsters: History of European Reactions to Indian Art* (Chicago University Press, 1992), 304 (note 129).

15. J. G. Williams, *The Art of Gupta India* (Princeton, 1982), 37–9.

16. Williams, *Art of Gupta India*, 3–7 and passim; see also Asher, *Art of Eastern India*, and G. M. Tartakov and V. Dehejia, 'Sharing, Intrusion and Influence: The Mahisasuramardini Imagery of the Calukyas and the Pallavas', *Artibus Asiae*, 45, 4 (1984), 287–345.

17. Williams, *Art of Gupta India*, 45.

18. Huntington, *Art of Ancient India*, 208–10.

19. U. P. Shah, 'Lakulisa: Saivite Saint', in M. W. Meister (ed.), *Discourses on Siva: Proceedings of a Symposium on the Nature of Religious Imagery* (Philadelphia, 1984), 92–101.

20. Tartakov and Dehejia, 'Sharing, Intrusion and Influence', 287–345.

21. G. Michell, *The Hindu Temple* (London, 1977), 103. See also G. Michell, *An Architectural Description and Analysis of the Early Western Chalukyan Temples*, 2 vols (London, 1975), and G. M. Tartakov, *Durga Temple at Aihole: A Historiographic Study* (Delhi, 1997), for a critical appraisal of the historiography of the temple.

22. C. R. Bolon, 'Two Chalukya Queens and Their Commemorative Temples', in V. Dehejia (ed.), *Royal Patrons and Great Temple Art* (Bombay, 1988), 61–5.

23. Ibid., 65–74.

24. C. Berkson, *Ellora* (Delhi, 1992), 204.

25. C. Berkson et al., *Elephanta, the Cave of Shiva* (Princeton, 1983).

26. Ibid., 3–17.

27. D. C. Chatham, *Stylistic Sources of the Kailasa Temple at Ellora* (Ann Arbor, 1984).

28. Huntington, *Art of Ancient India*, 294–6.

29. R. Nagaswamy, 'New Light on Mamallapuram', *The Archaeological Society of South India Silver Jubilee Volume: Transactions for the Period 1960–62* (Madras, 1962), 37.

30. R. Nagaswamy, 'Innovative Emperor and his Personal Chapel', in Dehejia, *Royal Patrons*, 37–60.

31. Dehejia, *Royal Patrons*, 4.

32. B. Stein, *Peasant State and Society in Medieval South India* (Delhi, 1980), 337–8. See also R. Nagaswamy, 'Iconography and Significance of the Brhadisvara Temple, Tanjavur', in Meister, *Discourses on Siva*, 170–81, who disputes that it was a funerary monument.

33. S. R. Balasubrahmanyam, *Middle Chola Temples* (Faridabad, 1975), 14–86. See also V. Dehejia, *Art of the Imperial Cholas* (New York, 1990).

34. P. Pichard, *Tanjavur Brhadisvara: An Architectural Study* (New Delhi, 1995).

35. A. K. Coomaraswamy, E. B. Havell, and A. Rodin, *Sculptures çivaïtes* (Paris, 1921), 9. See also P. Kaimal, 'Shiva Nataraja: Shifting Meanings of an Icon', *Art Bulletin*, 81, 3 (1999), 390–419, for a recent reappraisal.

36. R. Nagaswamy, *Masterpieces of Early South Indian Bronzes* (New Delhi, 1983), 8–11.

37. B. Stein, *The New Cambridge History of India*, part I, vol. 2: *Vijayanagara* (Cambridge, 1989); B. Stein (ed.), *South Indian Temples: An Analytical Reconstruction* (New Delhi, 1978).

38. B. Natarajan, *The City of the Cosmic Dance* (Delhi, 1974).

39. Harle, *Art and Architecture of the Indian Subcontinent*, 337.

40. K. Thiagarajan, *Meenakshi Temple, Madurai* (Madurai, 1965); G. Michell (ed.), *Temple Towns of Tamil Nadu* (Bombay, 1993).

41. J. C. Harle, *The Temple Gateways of South India* (Oxford, 1963).

42. P. Mitter, 'Western Bias in the Study of South Indian Aesthetics', *South Asian Review*, 6 (Jan. 1973), 125–36.

43. V. Dehejia, *Early Stone Temples of Orissa* (Delhi, 1979). See W. Smith, *The Muktesvara Temple in Bhubaneswar* (Delhi, 1994), for a review of the literature on early temples.

44. D. Mitra, 'Lakulisa and Early Saiva Temples in Orissa', in Meister, *Discourses on Siva*, 103–18.

45. T. E. Donaldson, *Hindu Temple Art of Orissa*, 3 vols (Leiden, 1985–7).

46. F. A. Marglin, *Wives of the God-King: The Rituals of the Devadasis of Puri* (Delhi, 1985).

47. D. Mitra, *Bhuvaneswar* (New Delhi, 1966).

48. A. Boner et al., *New Light on the Sun*

*Temple at Konarka* (Varanasi, 1972); K. S. Behera, *Konarak: The Heritage of Mankind* (New Delhi, 1996); T. E. Donaldson, 'Ganga Monarch and a Monumental Sun Temple', in Dehejia, *Royal Patrons*, 125–43. For interesting conjectures on the reasons for its collapse, see S. Digby and J. C. Harle, 'When Did the Sun Temple Fall Down?', *South Asian Studies*, 1 (1985), 1–7.

49. H. Eschmann, H. Kulke, and G. C. Tripathi, *The Cult of Jagannatha and the Regional Tradition of Orissa* (Delhi, 1978).

50. Donaldson, 'Ganga Monarch', 126, 141.

51. K. Deva, *Temples of Khajuraho*, 2 vols (Delhi, 1990); E. Zannas, *Khajuraho* (The Hague, 1960).

52. D. Desai, *The Religious Imagery of Khajuraho* (Mumbai, 1996), 99–148.

53. Deva, *Temples of Khajuraho*, 149–54.

54. Desai, *Religious Imagery*, 153.

## Chapter 4. Minority Traditions, Ideal Beauty, and Eroticism

1. See E. Kris and O. Kurz, *Legend, Myth and Magic in the Myth of the Artist* (London, 1979), on the topos of artistic rivalry.

2. R. J. Del Bonta, *The Hoysala Style* (Ann Arbor, 1983); S. Settar, *The Hoysala Temples*, vol. 1 (Bangalore, 1992).

3. K. Colleyer, *The Hoysala Artists: Their Identity and Styles* (Mysore, 1990).

4. R. E. Fisher, 'Inspired Patron of Himalayan Art', *Royal Patrons and Temple Art*, 23–32.

5. On Vishnu's Vaikuntha image, see J. N. Banerjea, *The Development of Hindu Iconography* (Calcutta, 1956), 407–10.

6. P. Pal, *Bronzes of Kashmir* (New Delhi, 1988), 89–99.

7. G. Michell, *The Hindu Temple* (London, 1977), 155–8.

8. S. L. Huntington, *The Art of Ancient India: Buddhist, Hindu, Jain* (New York, 1993), 605–7. See also R. M. Bernier, *Temple Arts of Kerala: A South Indian Tradition* (New Delhi, 1982).

9. Huntington, *Art of Ancient India*, 614.

10 P. Pal (ed.), *The Peaceful Liberators: Jain Art from India* (Los Angeles, 1994).

11. K. Deva, *Temples of Khajuraho*, 2 vols (Delhi, 1990), 119–34; Huntington, *Art of Ancient India*, 494–7.

12. J. Jain-Neugebauer, *The Stepwells of Gujarat* (New Delhi, 1981).

13. See introduction to Pal, *Peaceful Liberators*.

14. K. Clark, *The Nude* (Harmondsworth, 1964); Vitruvius, *De Architectura*, *c.* 27 BCE, see M. H. Morgan (trans.), *Vitruvius: The Ten Books of Architecture* (New York, 1960).

15. Clark, *Nude*, ch. 3.

16. V. Dehejia (ed.), *Representing the Body* (New Delhi, 1997). See L. Nead, *The Female Nude: Art, Obscenity, and Sexuality* (London, 1992), for a feminist critique of Clark.

17. J. Brough (trans.), *Selections from Classical Sanskrit Literature* (London, 1951), 83.

18. Plato, *Symposium*, trans. M. Joyce (London, 1935), on the myth of the hermaphrodite.

19. J. J. Winkler, *Constraints of Desire: Anthropology of Sex and Gender* (New York, 1990).

20. E. H. Gombrich, *Symbolic Images* (London, 1972), 123–91; P. Mitter, *Much Maligned Monsters: History of European Reactions to Indian Art* (Chicago University Press, 1992), ch. 2.

21. D. Desai, *Erotic Sculptures of India: A Socio-cultural Study* (Delhi, 1975), is by far the most systematic and objective study of the subject.

22. See M.-P. Fouchet, *The Erotic Sculpture of India* (London, 1959), for an allegorical approach. On decadence in art see P. Mitter, '"Decadence in India": Reflections on a Much-used Word in Studies of Indian Art', in J. Onians (ed.), *Sight and Insight: Essays on Art and Culture in Honour of E. H. Gombrich at 85* (London, 1994), 379–98.

23. T. E. Donaldson, 'Propitious-Apotropaic Eroticism in the Art of Orissa', *Artibus Asiae*, 37, 1/2 (1975), 75–100.

24. F. A. Marglin, *Wives of the God-King: The Rituals of the Devadasis of Puri* (Delhi, 1985).

25. M. Meister, 'Juncture and Conjunction; Punning and Temple Architecture', *Artibus Asiae*, 41 (1970), 226–8. On Siva's marriage see S. Punja, *Divine Ecstasy: The Story of Khajuraho* (Delhi, 1992).

26. See S. Gupta, D. J. Hoens, and T. Goudriaan, 'Hindu Tantrism', *Handbuch der Orientalistik*, 2.4 (Leiden, 1979).

27. J. Woodroff, *Sakti and Sakta* (London, 1920).

28. V. Dehejia, 'Kalachuri Monarch and his Circular Shrine of the Yoginis', *Royal Patrons*, 77–84, and *Yogini Cult and Temples* (New Delhi, 1986), 115–7.

29. E. Neumann, *The Great Mother* (Princeton, 1974).

30. D. M. Srinivasan, 'Significance and Scope of Pre-Kusana Saivite Iconography', in M. W. Meister (ed.), *Discourses on Siva: Proceedings of a Symposium on the Nature of Religious Imagery* (Philadelphia, 1984), 39.

31. C. Maury, *Folk Origins of Indian Art* (New York, 1969).

32. K. A. Harper, *Seven Hindu Goddesses of Spiritual Transformation: The Iconography of the*

*Saptamatrikas* (Lewiston, 1989), and S. K. Panikkar, *Saptamatrikas* (Delhi, 1996).

33. Neumann, *Great Mother*.

34. R. Needham (ed.), *Right and Left: Essays on Dual Symbolic Classification* (Chicago, 1973).

## Chapter 5. The Turko-Afghan Sultanate of Delhi (1206–1526 CE)

1. R. Thapar, *A History of India*, vol. I (Harmondsworth, 1975), ch. 10, on Muslim expansion in India.

2. M. Shokoohy, *Bhadresvar: The Oldest Islamic Monuments in India* (Leiden, 1988).

3. P. Jackson, *The Delhi Sultanate: A Political and Military History* (Cambridge, 1999).

4. R. Hillenbrand, *Islamic Architecture: Form, Function and Meaning* (Edinburgh, 1994), 31–3.

5. M. W. Meister, 'Style and Idiom in the Art of Uparamala', *Muqarnas*, 10 (Leiden, 1993), 344.

6. J. Bloom, *Minarets: Symbols of Islam* (Oxford, 1989).

7. A. Volwahsen, *Islamic India* (Lausanne, n.d.), 40.

8. C. B. Asher, *The New Cambridge History of India*, part I, vol. 4: *Architecture of Mughal India* (Cambridge, 1992), 6–7.

9. K. S. Lal, *History of the Khaljis* (London, 1967), 334.

10. A. Welch, 'Architectural Patronage and the Past: The Tughluq Sultans of India', *Muqarnas*, 10 (Leiden, 1993), 311–22; A. Welch and H. Crane, 'The Tughluqs: Master Builders of the Delhi Sultanate', *Muqarnas*, 1 (New Haven, 1983), 123–66.

11. Asher, *Architecture of Mughal India*, 5, 14; J. Dickie, 'The Mughal Garden: Gateway to Paradise', *Muqarnas*, 3 (Leiden, 1985), 128–37.

12. C. B. Asher, 'The Mausoleum of Sher Shah Suri', *Artibus Asiae*, 34, 3/4 (1977), 273–99.

13. C. Tadgell, *The History of Architecture in India* (London, 1990), 183–6; Volwahsen, *Islamic India*, 43–5.

14. Tadgell, *History of Architecture in India*, 142–7, 192–7.

15. M. B. Garde, *A Handbook of Gwalior* (Gwalior, Madhya Pradesh, 1936).

16. P. B. Wagoner, '"Sultan Among Hindu Kings": Dress, Titles and the Islamicization of Hindu Culture at Vijayanagara', *Journal of Asian Studies*, 55, 4 (Nov. 1996), 851–80.

17. B. Stein, *Vijayanagara* (Cambridge, 1989).

18. D. Paes and F. Nuniz, *A Forgotten Empire*, trans. R. Sewell (London, 1900).

19. J. M. Fritz et al., *Where Kings and Gods Meet: The Royal Centre at Vijayanagara, India* (Tucson, 1984), 122–45.

20. A. L. Dallapiccola et al., *The Ramachandra Temple at Vijayanagara* (New Delhi, 1992); J. Fritz, G. Michell, et al., *The City of Victory Vijayanagara* (New York, 1991), 30–3.

21. S. L. Huntington, *The 'Pala–Sena' Schools of Sculpture* (Leiden, 1984); S. L. Huntington, *The Art of Ancient India: Buddhist, Hindu, Jain* (New York, 1993), 226; F. Asher, *Art of Eastern India 300–800* (Minneapolis, 1980).

22. D. J. McCutchion, *Late Mediaeval Temples of Bengal* (Calcutta, 1972).

23. G. Michell (ed.), *Brick Temples of Bengal, From the Archive of David McCutchion* (Princeton, 1983).

24. See J. P. Losty, *The Art of the Book in India* (London, 1982), ch. 1, 18–36.

25. K. Khandalavala and M. Chandra, *New Documents of Indian Painting* (Bombay, 1969), 4.

26. S. Digby, 'The Literary Evidence for Painting in the Delhi Sultanate', *Bulletin of the American Academy of Benares*, 1 (Varanasi, 1967), 53–4.

27. Quoted in M. C. Beach, *The New Cambridge History of India*, part I, vol. 3: *Mughal and Rajput Painting* (Cambridge, 1992), 11.

28. R. W. Skelton, 'The Ni'mat Nama: A Landmark in Malwa Painting', *Marg*, 12 (1958), 44–50.

29. M. Chandra and U. P. Shah, *New Documents of Jaina Painting: A Reappraisal* (Bombay, 1975); Losty, *Art of the Book*, 43–7. Robert Skelton has suggested that modest patrons commissioned cheaper paintings.

30. B. N. Goswamy, *A Jainesque Sultanate: Shah Nama and the Context of Pre-Mughal Painting of India* (Zurich, 1988).

31. J. M. Rogers, *Circa 1492* (New Haven and London, 1991), 70–1.

32. M. Gittinger, *Master Dyers to the World* (Washington, DC, 1982), 31–57.

33. B. S. Miller, *The Hermit and the Love-Thief* (New York, 1978), 5.

34. On the paintings see D. Barrett and B. Gray, *Indian Painting* (London, 1978); on the cult of Krsna see A. L. Dallapiccola (ed.), *Krishna the Divine Lover* (Lausanne, 1982).

35. Losty, *Art of the Book*, 48–54, on this debate; M. Chandra, *Mewar Painting* (Delhi, 1971).

36. K. Ebeling, *Ragamala Painting* (Basle, 1973).

37. Losty, *Art of the Book*, 52–4, 69.

38. S. Doshi, *Masterpieces of Jain Painting* (Bombay, 1985).

## Chapter 6. The Mughal Empire (1526–1757)

1. S. P. Blake, *Shajahanabad: The Sovereign City in Mughal India, 1639–1739* (Cambridge, 1991), xiii.

2. On the Mughal economy see I. Habib, *The Agrarian System of Mughal India: 1556–1707* (London, 1963), and T. Raychadhuri, *Mughal Empire Under Akbar and Jahangir* (Calcutta, 1953).

3. For an informative and lively account see B. Gascoigne, *The Great Moghuls* (London, 1971).

4. *Baburnama*, trans. A. Beveridge, 2 vols (London, 1921).

5. M. Brand and G. L. Lowry (eds.), *Fatehpur-Sikri* (Bombay, 1987), preface, 2.

6. A. Petrucelli, 'The Geometry of Power: The City's Planning', in Brand and Lowry, *Fatehpur-Sikri*, 50.

7. See E. Koch, *Mughal Architecture: An Outline of its History and Development (1526–1858)* (Munich, 1991), 44–6, where he quotes Simon Digby on the architects; J. Dickie, 'Mughal Garden: Gateway to Paradise', *Muqarnas*, 3 (Leiden, 1985), 128–37.

8. Koch, *Mughal Architecture*, 66–8. On Akbar see Abu'l Fazl Allami, *Akbarnama*, trans. H. Beveridge, 3 vols (Calcutta, 1907–39). On Akbar's ideology see C. B. Asher, *Architecture of Mughal India* (Cambridge, 1992), 40.

9. Koch, *Mughal Architecture*, 54.

10. Asher, *Architecture of Mughal India*, 55–6.

11. I. Habib, 'The Social and Economic Setting', in Brand and Lowry, *Fatehpur-Sikri*, 80.

12. Petrucelli, 'Geometry of Power', 50–64.

13. A. Volwahsen, *Islamic India* (Lausanne, n.d.), 54–5.

14. Ibid., 131–6.

15. R. Nath, *Medieval Indian History and Architecture* (New Delhi, 1995), 41; R. Nath, *Some Aspects of Mughal Architecture* (New Delhi, 1976), 7.

16. Nath, *Aspects of Mughal Architecture*, 16; Koch, *Mughal Architecture*, 60.

17. M. C. Beach, *The New Cambridge History of India*, part I, vol. 3: *Mughal and Rajput Painting* (Cambridge, 1992), 39.

18. Abu'l Fazl Allami, *A'in i-Akbari*, vol. I, trans. H. Blochmann (Calcutta, 1875–1948), 107.

19. D. P. Agrawal, *Conservation of Manuscripts and Paintings of Southeast Asia* (London, 1984).

20. E. Koch, 'The Hierarchical Principles in Shah-Jahani Painting', in M. C. Beach and E. Koch, *King of the World, the Padshahnama* (London, 1997), 132.

21. Abu'l Fazl, *A'in i-Akbari*, I, 107–8.

22. Ibid., 108.

23. Ibid.

24. P. Chandra, *The Tuti-nama of The Cleveland Museum of Art and the Origins of Mughal Painting* (Graz, 1976).

25. Beach, *Mughal and Rajput Painting*, 39.

26. Abu'l Fazl, *A'in i-Akbari* and *Akbarnama*; Badauni, *Muntakhab al-Tawarikh*, G. S. A. Ranking (trans.) et al. (Calcutta, 1884–1925).

27. Beach, *Mughal and Rajput Painting*, 62–7.

28. Abu'l Fazl, *A'in i-Akbari*, I, 96; see E. Maclagan, *The Jesuits and the Grand Mogul* (London, 1932), for the interactions between Jesuits and Akbar's court.

29. Beach, *Mughal and Rajput Painting*, 76–7.

30. D. Barrett and B. Gray, *Indian Painting* (London, 1978), 87–8.

31. Jahangir, *Tuzuk-i-Jahangiri*, trans. A. Rogers and ed. H. Beveridge, 2 vols (London, 1909–14).

32. Koch, *Mughal Architecture*, 70.

33. E. B. Findly, *Nur Jahan, Empress of Mughal India* (New York, 1993), ch. 9.

34. Asher, *Architecture of Mughal India*, 130–2.

35. See M. Hussain et al. (eds), *The Mughal Garden* (Rawalpindi, 1996), especially chs 3, 4, and 5.

36. Koch, *Mughal Architecture*, 86.

37. E. Kühnel and H. Goetz, *Indian Book Painting* (London, 1926).

38. Jahangir, *Tuzuk*, II, 20–1.

39. On Thomas Roe see W. Foster, *Early Travels in India* (London, 1921).

40. R. W. Skelton et al., *The Indian Heritage, Court Life and Art Under Mughal Rule* (London, 1982), 37.

41. Beach, *Mughal and Rajput Painting*, 83; S. C. Welch, *Imperial Mughal Painting* (New York, 1978), 95.

42. See J. Seyller, 'A Sub-imperial Manuscript: The Ramayana of Abd ur-Rahim Khankhanan', in V. Dehejia (ed.), *The Legend of Rama, Artistic Visions* (Bombay, 1994), 85–100, and M. Haq, 'The Khan i-Khanan and his Painters, Illuminators and Calligraphists', *Islamic Culture* (1931), 621–30, on patronage of artists by this high official.

43. Findly, *Nur Jahan*, 117–18.

44. Beach, *Mughal and Rajput Painting*, 96.

45. S. P. Verma, *Mughal Painters and their Work: A Bibliographical Survey and Comprehensive Catalogue* (Delhi, 1994), 309, 339; C. Stanley Clarke, *Mughal Art and Achitecture* (Delhi, 1988, reprint), plate 18.

46. R. Ettinghausen, *Paintings of the Sultans and Emperors of India* (Delhi, 1961); R. W. Skelton, 'Imperial Symbolism in Mughal Painting', in P. P. Soucek (ed.), *Content and*

*Context of Visual Arts in the Islamic World*
(London, 1988), 177–87.

47. Jahangir, *Tuzuk*, 215–16.

48. Beach, *Mughal and Rajput Painting*, 109.

49. Koch, *Mughal Architecture*, 93–6.

50. E. Koch, *Shah Jahan and Orpheus* (Graz, 1988), 13–15. Ebba Koch has traced the Italian origins of the Mughal *pietra dura* technique, though she allows that Indian stonecutters had mastered it so well that the Iranian historian Qazwini took it to be entirely indigenous. Other scholars, however, disagree with her and argue for its indigenous origins.

51. Koch, *Mughal Architecture*, 98–101; Asher, *Architecture of Mughal India*, 214–5.

52. W. E. Begley, 'The Myth of the Taj Mahal and a New Theory of Its Symbolic Meaning', *Art Bulletin*, 61, 1 (1979), 7–37. Begley's concept of the Throne of God is questioned by Koch, *Mughal Architecture*, 99, who interprets it as a heavenly mansion.

53. Blake, *Shahjahanabad*, xii.

54. Koch, *Shah Jahan and Orpheus*, 12–16.

55. Ibid., 14–15.

56. Koch, 'The Baluster Column', *Journal of the Warburg and Courtauld Institutes*, 45 (1982), 253–62.

57. Asher, *Architecture of Mughal India*, 196–7.

58. Volwahsen, *Islamic India*, 47.

59. Beach and Koch, *King of the World*, 132–3.

60. O. Benesch, *The Drawings of Rembrandt*, vol. V (London, 1957), 335.

61. Beach and Koch, *King of the World*, plates 17, 39.

62. For instance, the painting *Officers and Wise Men* at the Sterling and Francine Clark Art Institute, Williamstown, Pennsylvania.

63. J. Guy and D. Swallow (eds), *Arts of India: 1500–1900* (Victoria and Albert Museum exhib. cat., London, 1990), 104 (fig. 84), 118 (figs 97, 98), 119, 123.

64. M. Zebrowski, *Deccani Painting* (Berkeley and London, 1983), 92–9.

65. Personal communication of Robert Skelton. He made this identification, the complicated story of which is to be found in the following publications: R. W. Skelton, 'The Mughal Artist Farrokh Beg', *Ars Orientalis*, 2 (1957), 393–411; O. F. Akimuskin, *Il Muraka di San Pietroburgo, Album Minature Indiane e Persiane del XVI–XVIII Secolo e di Essemplari di Caligrafia di Mir Imad al-Hasani* (Lugano, 1994). See also A. Soudavar, 'Between the Safavids and the Mughals: Art and Artists in Transition', *Iran*, 37 (1999), 49–66.

## Chapter 7. Rajasthani and Pahari Kingdoms (*c.*1700–1900)

1. See G. H. R. Tillotson, *The Rajput Palaces: The Development of an Architectural Style, 1450–1750* (New Haven, 1987).

2. G. H. R. Tillotson, 'The Rajput Aesthetic: Ideals in Rajput Palace Design, 1450–1750', *South Asian Archaeology* (1987), 1166–8.

3. Tillotson, *Rajput Aesthetic*, 1173–5.

4. Personal communication of Raghubir Singh. See also K. Jain, 'Spatial Organisation and Aesthetic Expression in the Traditional Architecture of Rajasthan', in G. H. R. Tillotson (ed.), *Paradigms of Indian Architecture: Space and Time in Representation and Design* (London, 1998), 159–75.

5. P. Engel, 'Stairways to Heaven', *Natural History*, 102, 6 (June 1993), 48–56. See also A. Garrett, *The Jaipur Observatory and its Builder* (Allahabad, 1902).

6. D. N. Shukla, *Vastu-sastra* (Lucknow, 1960); A. Volwahsen, *Living Architecture: Indian* (London, 1969), 48–9. For a European viewpoint see S. Nilsson, *European Architecture in India, 1750–1850* (London, 1968), 193–5.

7. Tillotson, *Rajput Palaces*, 182–4.

8. A. K. Coomaraswamy, in *Rajput Painting* (London, 1916), pioneered the study of Rajput art. His courtly and geographical categories were followed by leading art historians, including W. G. Archer and K. Kandalavala. This scheme was challenged by B. N. Goswamy and E. Fischer in *Pahari Masters* (Zurich, 1992).

9. A. Topsfield, 'Sahibdin's Gita-Govinda Illustrations', *Chhavi*, 2 (Varanasi, 1981), 231–8; D. Barrett and B. Gray, *Indian Painting* (London, 1978), 138–9.

10. Goswamy and Fischer, *Pahari Masters*, 90–125; J. Guy and D. Swallow (eds), *Arts of India: 1500–1900* (Victoria and Albert Museum exhib. cat., London, 1990), 137, 143.

11. See S. C. Welch, *Kotah* (New York, 1997), 25.

12. N. N. Haidar, who places the style in its historical and cultural contexts, has revised some of the popular misconceptions regarding Kishangarh. See *The Kishangarh School of Painting: c.1650–1850* [Ph.D. thesis] (Oxford, 1995).

13. B. N. Goswamy et al., '"A Caurapancasika" Style Manuscript from the Pahari Area', *Lalit Kala*, 25 (1985), 9–21.

14. Goswamy and Fischer, *Pahari Masters*, 56.

15. The change first came about in 1968, when B. N. Goswamy established the existence of a family of artists who moved between different Hill States on the basis of genealogical

information preserved at the pilgrim centre in Haridwar in North India. He supplemented this data with British settlement records which traced the lands granted to artists by local rulers. B. N. Goswamy, 'Panda Records as a Basis of Style', *Marg*, 21, 4 (Sep. 1968), 17–62. See also W. G. Archer, *Indian Paintings from the Punjab Hills* (London and New York, 1973), whose view was subsequently challenged by Goswamy.

16. On Pandit Seu of Guler, see Goswamy and Fischer, *Pahari Masters*, 211–37.

17. B. N. Goswamy, *Nainsukh of Guler: A Great Indian Painter from a Small Hill State* (Zurich, 1997). Scholars are divided over the actual identity of Balwant Singh and whether he was from Jasrota.

18. On the generation after Nainsukh and Manaku of Guler that was influenced by Nainsukh see Goswamy and Fischer, *Pahari Masters*, 307–64.

19. A. Topsfield, *The City Palace Museum Udaipur: Paintings of Mewar Court Life* (Ahmedabad, 1990).

### Chapter 8. The Non-Canonical Arts of Tribal Peoples, Women, and Artisans

1. The phrase is borrowed from S. Rowbotham, *Hidden from History* (London, 1973).

2. E. H. Gombrich, *A Sense of Order* (London, 1979), 12.

3. A. Appadurai, *Modernity at Large: Cultural Dimensions of Globalisation* (Minneapolis, 1996).

4. V. Elwin, *The Tribal Art of Middle India* (Oxford, 1951).

5. Y. Dalmia, *The Painted World of the Warlis* (New Delhi, 1988), which also contains excellent translations of the songs relating to the images.

6. N. Poobaya-Smith, 'Bhuta Figures of South Kanara', in G. Michell (ed.), *Living Wood: Sculptural Traditions of Southern India* (London, 1992), 113–28.

7. T. Lyons, 'Women Artists of the Nathadwara School', in V. Dehejia, *Representing the Body* (New Delhi, 1997), 102–23.

8. P. Jayakar, *The Earthen Drum* (Delhi, 1980), 227–65, on the importance of the earth goddess throughout Indian history.

9. Publication Division of the Ministry of Information and Broadcasting, Government of India, *Alpana* (Delhi, 1976).

10. Y. Vequaud, *The Art of Mithila, Ceremonial Paintings from an Ancient Kingdom* (London, 1977). See J. Jain and A. Aggarwala, *National Handicrafts and Handlooms Museum, New Delhi* (Ahmedabad, 1989), 103, 115, for a consideration of a modern Madhubani artist.

11. G. S. Dutt, *Folk Arts and Crafts of Bengal: The Collected Papers* (Calcutta, 1990), section IV, ch. 4.

12. S. Rahman, 'Symbols and Rituals in the Art of the Nakshi Kantha', *Woven Air: The Muslin and Kantha Tradition of Bangladesh* (exhib. cat., London, 1988), 29–31.

13. V. N. Mair, *Painting and Performance* (Honolulu, 1988), 101; J. D. Smith, *The Epic of Pabuji, A Study, Transcription and Translation* (Cambridge, 1991). Originating in Buddhist storytelling accompanied with pictures, the genre of picture recitation spread to China where it was transformed into *pien-wen* (transformation texts) during the T'ang period (618–906 CE). The medieval German *Moritat*, brilliantly used in the twentieth century by Bertolt Brecht in his *Threepenny Opera*, also originated in the Indian picture recitation.

14. K. Singh, 'Changing the Tune, Bengali Pata Painting's Encounter with the Modern', *India International Centre Quarterly* (Summer 1996), 61–78.

15. Jain and Aggarwala, *National Handicrafts and Handlooms Museum*, 26.

16. P. Mitter, *Much Maligned Monsters: History of European Reactions to Indian Art* (Chicago University Press, 1992), ch. 5.

17. G. C. Birdwood, *The Industrial Arts of India* (London, 1880), 131–5.

18. Dutt, *Folk Arts and Crafts of Bengal*.

19. A. L. Basham, *The Wonder That Was India* (London, 1961), 219–20.

20. Jain and Aggarwala, *National Handicrafts and Handlooms Museum*, 62–3.

21. E. Haque, 'The Textile Tradition of Bangladesh', *Woven Air*, 9–11. *Periplus of the Erythrean Sea*, a first-century CE Greek mariner's guide, mentions muslin.

22. B. Stockley, 'An Introduction', *Woven Air*, 13–22.

23. Jain and Aggarwala, *National Handicrafts and Handlooms Museum*, 137–9.

24. J. Irwin and K. Brett, *Origins of Chintz* (London, 1970).

25. V. Murphy, 'Europeans and the Textile Trade', in J. Guy and D. Swallow (eds), *Arts of India: 1500–1900* (Victoria and Albert Museum exhib. cat., London, 1990), 158.

26. B. Osman, 'Transport Painting: The Decorated Rickshaws of Dhaka', *Arts and the Islamic World*, special volume: *Contemporary Art in Bangladesh*, 34 (Summer 1999), 71–2.

## Chapter 9. The British Raj: Westernization and Nationalism

1. M. and W. G. Archer, *Indian Painting for the British 1770–1880* (Oxford, 1955), is the pioneering survey.

2. T. Falk, 'The Indian Artist as Assimilator of Western Styles', in J. Bautze (ed.), *Interaction of Cultures: Indian and Western Painting 1780–1910* (Alexandra, Virginia, 1998), 29; M. Archer, *Natural History Drawings in the India Office Library* (London, 1972).

3. S. C. Welch, *Room for Wonder* (New York, 1978), 67–72.

4. W. G. Archer, *Kalighat Paintings* (London, 1971); J. Jain, *Kalighat Painting: Images from a Changing World* (Ahmedabad, 1999).

5. A. Paul (ed.), *Woodcut Prints of Nineteenth Century Calcutta* (Calcutta, 1983). For the background to the rise of new art forms, see P. Mitter, *Art and Nationalism in Colonial India 1850–1922: Occidental Orientations* (Cambridge, 1994), 14–21, and T. Guha-Thakurta, *The Making of a New Indian Art: Artists, Aesthetics and Nationalism in Bengal 1850–1920* (Cambridge, 1992).

6. P. Mitter, *Much Maligned Monsters: History of European Reactions to Indian Art* (Chicago University Press, 1992). This work also discusses the impact of Indian decorative arts at the Great Exhibition of 1851 in London. On art schools, see *Papers Relating to the Maintenance of Schools of Art in India as State Institutions, 1893–6* (Calcutta, 1898); Mitter, *Art and Nationalism*, chs 2 and 3.

7. E. J. Buck, *Simla Past and Present* (Bombay, 1925), 136.

8. On landscape see R. W. Skelton, 'Landscape in Indian Painting', in W. Watson (ed.), *Landscape Style in Asia* (London, 1980), 150–71; Mitter, *Art and Nationalism*, 86–90, 110–13.

9. B. Choudhury, *Lipir Shilpi Abanindranath* (Calcutta, 1973), 81; Mitter, *Art and Nationalism*, ch. 5, on Varma.

10. Mitter, *Art and Nationalism*, ch. 7; see also Guha-Thakurta, *Making of a New Indian Art*.

11. P. Mitter, 'The Doctrine of Swadeshi Art: Art and Nationalism in Bengal', *The Visva-Bharati Quarterly*, 49, 1–4 (May 1983–Apr. 1984), 82–95; Mitter, *Art and Nationalism*.

12. J. C. Bagal, *Centenary of the Government College of Art and Craft Calcutta* (Calcutta, 1964); E. B. Havell, 'New School of Indian Painting', *The Studio*, 44 (1908), 115 ff.

13. A. Tagore, *Jorasankor Dhare* (Calcutta, 1971).

14. S. Hay, *Asian Ideals of East and West* (Cambridge, Mass., 1970).

15. J. M. Rosenfield, 'Western Style Painting in the Early Meiji Period and its Critics', in D. Shively (ed.), *Tradition and Modernization in Japanese Culture* (New Jersey, 1971), 181–200; M. Kawakita, *Modern Currents in Japanese Art* (New York, 1974).

16. Mitter, *Art and Nationalism*, chs 8 and 9.

17. Chughtai's memoirs are used by kind permision of Chughtai's son, Arif Rehman Chughtai. See also *Chughtai's Paintings* (Lahore, n.d.). I am grateful to M. Nesom for allowing me to consult her Ph.D. thesis, *Abdur Rehman Chughtai: A Modern South Asian Artist* (Ann Arbor, 1984), the most scholarly and thorough account of Chughtai's life and art to date. For Chughtai's construction of Muslim identity, see my *Art and Nationalism*, 332–9.

18. A. Hutt, *Goa: A Traveller's Historical and Architectural Guide* (Buckingham Hill, Essex, 1988), 91.

19. S. Nilsson, *European Architecture in India, 1750–1850* (London, 1968), 39–47.

20. P. Mitter, 'The Early British Port Cities of India: Their Planning and Architecture, Circa 1640–1757', *Journal of the Society of Architectural Historians*, 45 (2 June 1986), 95–114.

21. P. Davies, *Splendours of the Raj* (Harmondsworth, 1985).

22. Nilsson, *European Architecture in India*, 101–7; more anecdotal but vivid is M. Bence-Jones, *Palaces of the Raj* (London, 1973), 41–67.

23. Nilsson, *European Architecture in India*, 26.

24. A history of European-style architecture for Indian patrons has not yet been undertaken. On the bungalow see A. D. King, *The Bungalow* (London, 1984).

25. R. Llewellyn-Jones, *A Fatal Friendship* (Delhi, 1985), vii.

26. H. R. Tillotson, 'Orientalising the Raj: Indo-Sarasenic Fantasies', C. W. London (ed.), *Architecture in Victorian and Edwardian India* (Bombay, 1994), 16–34.

27. T. R. Metcalf, *Imperial Vision: Indian Architecture and Britain's Raj* (London, 1989), 39.

28. J. Morris, *Stones of Empire: The Buildings of the Raj* (Oxford, 1983), 133–4.

29. On this edifice see P. Vaughan (ed.), *The Victoria Memorial Hall, Calcutta: Conception, Collections, Conservation* (Mumbai, 1997).

30. R. G. Irving, *Indian Summer: Lutyens, Baker and Imperial Delhi* (London and New Haven, 1981).

## Chapter 10. Modernism in India

1. See *Catalogue of the Indian Society of Oriental Art* (Calcutta, 1922–3) with comments by the art historian Stella Kramrisch.

2. See Gaganendranath's albums, *Birup Bajra* (*Play of Opposites*) and *Adbhut Lok* (*Realm of the Absurd*) (Calcutta, 1917), and P. Mitter, *Art and Nationalism in Colonial India 1850–1922: Occidental Orientations* (Cambridge, 1994), 170–5. See also R. Parimoo, *The Paintings of the Three Tagores* (Baroda, 1973).

3. K. Roy, *Gaganendranath Tagore* (Delhi, 1964).

4. J. Golding, *Cubism: A History and an Analysis 1907–1914* (London, 1968).

5. The German critic Max Osborn, quoted in *Rupam*, vols XV–XVI (1923), 74; E. H. Gombrich, *A Sense of Order* (London, 1979), 149.

6. On primitivism see P. Mitter, 'Primitivism', in D. Levinson and M. Ember (eds), *Encyclopedia of Cultural Anthropology*, vol. III (New York, 1996), 1029–32; C. Rhodes, *Primitivism and Modern Art* (London, 1994); S. Hiller (ed.), *The Myth of Primitivism: Perspectives on Art* (London, 1991); and the pioneering work, R. Goldwater, *Primitivism in Modern Painting* (1938).

7. J. Brown, *Gandhi's Rise to Power: Indian Politics 1915–22* (Cambridge, 1972).

8. A. Appadurai, *Modernity at Large: Cultural Dimensions of Globalisation* (Minneapolis, 1996).

9. D. J. Rycroft, 'Santhalism and Modern Indian Art: Reinterpreting Visual Representations of Adivasis in Pre-independent India, *c.*1907–47' (work in progress).

10. *Vossische Zeitung* of 16 July 1930. For a scholarly study of Tagore's painting see A. Robinson, *The Art of Rabindranath Tagore* (London, 1989). See also Parimoo, *Paintings of the Three Tagores.*

11. P. Mitter, 'Rabindranath Tagore as Artist: A Legend in His Own Time', in M. Lago and R. Warwick (eds), *Rabindranath Tagore: Perspectives in Time* (London, 1989), 103–21.

12. Mitter, 'Rabindranath Tagore'; W. G. Archer, *India and Modern Art* (London, 1959), 49–79. See also a new work in Bengali which argues that Tagore's colour blindness contributed to his vision: K. K. Dyson and S. Adhikari, *Ranger Robindranath* (Calcutta, 1997).

13. R. Tagore, *Rabindranath Tagore on Art and Aesthetics* (New Delhi, 1961), 58–64.

14. V. Sundaram et al., *Amrita Sher-Gil* (Bombay, n.d.), 42. The pioneering work on Sher-Gil is by her friend K. Khandalavala, *Amrita Sher-Gil* (Bombay, 1944). See also I. Singh, *Amrita Sher-Gil: A Biography* (Delhi, 1984).

15. I am preparing a chapter on Sher-Gil for my forthcoming work on Indian art between 1922 and 1947.

16. B. Dey and J. Irwin, *Jamini Roy* (Calcutta, 1944); Archer, *India and Modern Art*, 100–15.

17. The only information on this that is readily available is in *The Art of Jamini Roy, a Centenary Volume*, Calcutta, 1987. I have summarized the chapter in my forthcoming book (see note 15 above).

18. G. Kapur, *Contemporary Indian Art* (Royal Academy exhib. cat., London, 1982), 5.

## Chapter 11. Art After Independence

1. W. J. R. Curtis, 'Modernism and the Search for Indian Identity', *Architectural Review*, 182 (Aug. 1987), 32–8.

2. G. H. R. Tillotson, 'Architecture and Anxiety: The Problem of Pastiche in Recent Indian Design', *South Asia Research*, 15, 1 (Spring 1995), 30–47.

3. G. H. R. Tillotson, *The Tradition of Indian Architecture* (New Haven, 1989), 136. On Correa's architectural ideas, see his portfolio, *5 Projects, Correa* (n.d.), with essays by Kenneth Frampton, John Russell, Jyotindra Jain, and Gautam Bhatia.

4. Tillotson, *Tradition of Indian Architecture*, 127–47.

5. H. Goetz, 'The Great Crisis from Traditional to Modern Art', *Lalit Kala Contemporary*, 1 (Jun. 1962), 14.

6. G. Kapur, *Contemporary Indian Art* (Royal Academy exhib. cat., London, 1982), 6.

7. *Cintamoni Kar: A Retrospective Exhibition 1930–85* (Indian Museum exhib. cat., Calcutta, 1985).

8. G. Gill (ed.), *Ram Kumar: A Journey Within* (New Delhi, 1996).

9. R. Hoskote, *Pilgrim, Exile, Sorcerer: The Painterly Evolution of Jehangir Sabavala* (Mumbai, 1998).

10. On Khanna and Gujral see Kapur, *Contemporary Indian Art*, 16 and 30.

11. E. Alkazi, *M. F. Husain, the Modern Artist and Tradition* (New Delhi, 1978).

12. D. Herwitz, *Husain* (Bombay, 1988).

13. Alkazi, *M. F. Husain.*

14. R. Bartholomew and G. Kapur, *Husain* (New York, 1971). See also Herwitz, *Husain.*

15. Mentioned in G. Sen, *Bindu Space and Time in Raza's Vision* (Delhi, 1997), 47.

16. M. Levy, 'F. N. Souza: The Human and the Divine', *The Studio* (Apr. 1964), 134–9.

17. J. Lassaigne, *Raza* (Paris, 1966), unpaginated.

18. Sen, *Bindu Space and Time.*

19. N. Mazumder, 'On Tantra Art', *Lalit Kala Contemporary*, 12/13, (Aug.–Sep. 1971), 33–4; C. Douglas, 'Beyond Reason: Malevich, Matiushin, and Their Circles', in M.Tuchman (ed.), *The Spiritual in Art: Absract Painting 1890–1985* (Los Angeles, 1987), 192, discusses the importance of Tantra for early abstractionists.

20. The Phillips Collection, *Indian Art Today, Four Artists from the Chester and Davida Herwitz Family Collection* (Washington, DC, 22 Feb.–6 Apr. 1986), 26–7.

21. A. Naqvi, *Image and Identity: Fifty Years of Painting and Sculpture in Pakistan* (Karachi, 1998), xxx.

22. A. Naqvi, 'Transfers of Power and Perception: Four Pakistani Artists', in *Arts and the Islamic World*, special volume: *50 Years of Art in Pakistan*, 32 (1997), 9–15.

23. M. N. Sirhandi, *Contemporary Painting in Pakistan* (Lahore, 1992), 49–50.

24. Naqvi, 'Transfers of Power and Perception', 11.

25. Sirhandi, *Contemporary Painting in Pakistan*, 55–7.

26. See Naqvi, *Image and Identity*, ch 7.

27. F. A. Faiz, *Sadequain* (Karachi, 1966).

28. Naqvi, 'Transfers of Power and Perception', 14.

29. I. Hassan, *Painting in Pakistan* (Lahore, 1991), 81–5.

30. N. Sirhandi, in *50 Years of Art in Pakistan*, 21.

31. S. Hashmi, 'Framing the Present', *50 Years of Art in Pakistan*, 54.

32. Naqvi, *Image and Identity*, 312.

33. A. Naqvi, *'My Primitives' Wood Carvings 1992–4 Shahid Sajjad* (Karachi, 1994).

34. B. K. Jahangir, *Chitrashilpa: Bangladesher* (Dhaka, 1974).

35. J. Ahmed, *Art in Pakistan, Early Years* (Karachi, 1954).

36. F. Azim, *Charukalar Bhumika* (Dhaka, 1992)

37. S. M. Islam, *Muktijuddher Chitramala* (*Drawings and Paintings of the Liberation War*) (Dhaka, n.d.).

38. M. Khaled, *Twelfth Young Artists' Art Exhibition 1998* (Dhaka, 1998); A. Mansur, *Twelfth National Art Exhibition 1996* (Dhaka, 1996).

39. S. Ahmad, *A Grand Group Art Exhibition of Reputed Bangladeshi Artists* (Dhaka, 1991).

40. Mansur, *Twelfth National Art Exhibition*.

41. B. K. Jahangir, *Shahabuddin* (Dhaka, 1997).

**Chapter 12. The Contemporary Scene**

1. G. Sen, *Image and Imagination* (Ahmedabad, 1996), 124, 146; E. Datta, *Ganesh Pyne: His Life and Times* (Calcutta, 1998).

2. B. Bhattacharjee, *Recent Works* (exhib. cat., Calcutta, 1993).

3. U. Bickelmann and N. Ezekiel (eds), *Artists Today* (Bombay, 1987), 21–4.

4. Sen, *Image and Imagination*, 44–71.

5. Ibid., 74.

6. T. Hyman, *Bhupen Khakhar* (Mumbai, 1998), 17; G. Sheikh (ed.), *Contemporary Art in Baroda* (New Delhi, 1997), 217–24.

7. K. G. Subramanyan, *The Moving Focus: Essays on Indian Art* (Delhi, 1978), and *The Living Tradition* (Calcutta, 1987).

8. N. Sheikh, 'A Post-Independence Initiative in Art', in Sheikh, *Contemporary Art in Baroda*, 119.

9. Bickelmann and Ezekiel, *Artists Today*, 96.

10. G. M. Sheikh, 'Le Tableau unique de Sheikh', in *Returning Home* (Centre Georges Pompidou exhib. cat., Paris, 1985), 17.

11. Sheikh, *Contemporary Art in Baroda*, 166–70; G. Kapur, 'View from the Teashop', in her *Contemporary Indian Artists* (New Delhi, 1978).

12. Bickelmann and Ezekiel, *Artists Today*, 115–7.

13. Hyman, *Bhupen Khakhar*, 42.

14. Hyman, *Art International* (1990). Hyman's publication, *Bhupen Khakhar*, marked the purchase of his work by the Tate Gallery, London.

15. *Vivan Sundaram* (Little Theatre Art Gallery exhib. cat., New Delhi, 1991), 5.

16. G. Sinha (ed.), *Expressions and Evocations: Contemporary Women Artists of India* (Mumbai, 1996).

17. G. Sinha, *The Self and the World, an Exhibition of Indian Women Artists* (Delhi, 1997), 1–11.

18. V. Dehejia, in *Representing the Body* (New Delhi, 1997), raises the issue of women's representation and self-representation.

19. Sen, *Image and Imagination*, 38.

20. Sinha, *Self and the World*, 27.

21. Sen, *Image and Imagination*, 12.

22. Sinha, *Self and the World*, 31.

23. Sheikh, *Contemporary Art in Baroda*, 170–3.

24. G. Kapur, 'Nasreen Mohamedi', in Sinha, *Expressions*, 62.

25. R. Chawla, 'Anjolie Ela Menon', in Sinha, *Expressions*, 82–93.

26. Sinha, *Self and the World*, 39.

27. G. Kapur, 'Nalini Malani', in Sinha, *Expressions*, 136–41.

28. G. Sinha, 'Arpana Caur', in Sinha, *Expressions*, 163–8.

29. Sheikh, *Contemporary Art in Baroda*, 260.

30. Ibid., 192; Sinha, *Self and the World*, 51.

31. Sheikh, *Contemporary Art in Baroda*, 189–96; M. Marwah, 'Nilima Sheikh', in Sinha, *Expressions*, 117–22.

32. T. Wilcox, Exhibition Review, *Crafts Magazine*, quoted in Royal Festival Hall Galleries exhib. cat., 10 Dec.–22 Jan., 1995.

33 A. Naqvi, *Image and Identity: Fifty Years of Painting and Sculpture in Pakistan* (Karachi, 1998), 9–11.

34. I. Hassan, *Painting in Pakistan* (Lahore, 1991), 52–4.

35. S. Hashmi and N. Poobaya-Smith, *An Intelligent Rebellion: Women Artists of Pakistan* (Bradford, 1994).

36. P. Mitter, 'The Art of Sabah Husain', *Pakistan Music Village* (exhib. cat., London, 1995), 19; Hashmi and Poobaya-Smith, *Intelligent Rebellion*.

37. Hashmi and Poobaya-Smith, *Intelligent Rebellion*. N. Farrukh, *Pioneering Perspectives* (Lahore, 1998), discusses three major women artists, a printmaker, a painter and a potter. I received the work too late to include them here.

38. N. Khan Majlis, 'Women Artists of Bangladesh', in *Arts and the Islamic World*, special volume: *Contemporary Art in Bangladesh*, 34 (Summer 1999), 45–8.

Timeline
Further Reading
Museums and Websites
List of Illustrations
Index

| | **History** BCE | **Culture** BCE | **Art** BCE |
|---|---|---|---|
| **10000** BCE | *c.*10000<br>Stone Age society | *c.*10000<br>Hunting, gathering, stone tools | *c.*10000<br>Sculpture and rock painting |
| | *c.*7000 Neolithic society | *c.*7000 Hunting-gathering society with beginnings of settled society, agriculture, specialized crafts, Mother Goddess cult (?) | *c.*7000 Painted pottery; terracotta figurines |
| | *c.*2500<br>Indus Valley civilization | *c.*2500<br>Advanced urban culture: grid-plan cities, drainage, bathrooms, social stratification, use of bronze, dry dock for ships, trade with Mesopotamia, writing on seals (still undeciphered) | *c.*2500<br>Proto-Siva; seals depicting bulls and tigers, bronze female figure, and male figures |
| | *c.*1800 Indo-Aryan speaking people's settlements in riverine Punjab coincide with decline of Indus urban culture | *c.*1800 Pastoral society: rulers, priests, and common men, composition of the Vedas, sacrifice (integral part of Vedic religion), use of horse chariots | |
| | *c.*1000 End of tribal clans and chieftains and rise of republics and monarchies known as Mahajanapadas | *c.*1000 Mining of iron and spread of Aryan settlements along river Ganges up to Bihar; evolution of four great *varnas* or classes, core of caste system; growth of Brahmanical religion; rise of cities, merchant classes, trade and artisanal guilds, coinage; philosophical speculations based on concepts of *samsara* and *karma*, consolidated in Upanisads; beginning of composition of epic *Mahabharata* | |
| | *c.*600 Internecine rivalries in northern India leading to rise of Magadha; Indus region occupied by Iranian emperor Cyrus, 519 | | |
| | *c.*599–527<br>Mahavira, founder of Jain religion | | |
| | *c.*563–483<br>Gautama the Buddha | | |
| | | 486 Buddhism, first great world religion, supported by monastic order, centred on Bihar and Gengetic Valley; first Buddhist Council held at Magadha; growth of Dhammapada, Jatakas, and other Buddhist texts | |

468 BCE

*c.* **468** Jain religion preaches non-killing of all forms of life and a strict moral code of conduct

*c.* **500** Development of six major philosophical systems, grammar, and lawbooks; composition of epic *Ramayana*

**362–321** Nanda dynasty of Magadha, during whose reign Alexander of Macedon invades Iranian province of Indus, 327–325 BCE

**327** First contact between Indians and Greeks, giving rise to legend of Alexander meeting Indian ascetics and exchanging philosophical ideas

**321** Candragupta founds centralized Mauryan empire, which extends to south, where emperor fasts to death as a Jain

*c.* **321** Mauryan empire creates efficient bureaucracy, maintaining law and order by means of extensive intelligence system; first major political treatise, *Arthasastra*, by Kautilya, inspired by cosmopolitan empire; Greek ambassador Megasthenes, who spends many years at Mauryan court, leaves lively account of Indian society

**268–231** Asoka renounces war after Kalinga battle and converts to Buddhism, inaugurating unique empire based on pacifism

*c.* **268** Asoka seeks to inculcate moral lessons in his subjects through edicts inscribed on rock faces and pillars; calls third Buddhist Council and converts Sri Lanka; social reforms include animal hospital

*c.***268** Asokan stone pillars; Buddhist *stupa, caitya* (prayer-hall), and *vihara* (monastery)

*c.* **200** Rise of Gandhara-Bactria as major centre of Buddhism; growth of land trade along Silk Route connecting China and West via India and Central Asia; sea trade between Hellenistic Asia Minor, India, and China

**185** Sunga dynasty replaces Mauryas at Magadha as Maurya empire disintegrates

| | **History** BCE | **Culture** BCE | **Art** BCE |
|---|---|---|---|
| **180** BCE | **180–130** Successors of Alexander's generals occupy Bactria-Gandhara; Indo-Greek kings rule Gandhara (north-west India) from capital at Taxila | | |
| | **155–130** Indo-Greek king Menander | **155–130** King Menander associated with Buddhist text *Milinda Panha* (*Questions of Menander*) | |
| | **128** Rise of Satavahana dynasty in South India | | |
| | | | *c.***120** Inception of rock-cut monasteries, notably Buddhist, which continues until fifth century CE |
| | | | **120** Bhagavata (follower of Vishnu?) pillar of Heliodorus, Besnagar |

| | **History** CE | **Culture** CE | **Art** CE |
|---|---|---|---|
| **50** CE | | | *c.***50** Completion of decoration of Great Stupa, Sanchi |
| | | | **50–70** *Caitya* at Karle |
| | **78** Kanishka, Kushan emperor, ruling from Mathura in eastern India through Gandhara in north-west up to parts of Central Asia | **78** Kanishka convenes fourth Buddhist Council, which establishes supremacy of Mahayana sect; Buddhist philosopher Asvaghosa's *Buddhacarita* written at his court; cultural revolution associated with rise of Bhakti or devotional Hinduism, centring on great deities Vishnu Siva and the Goddess; completion of *Mahabharata*, which now includes key Bhakti text *Bhagvad Gita*; inception of *Puranas*; composition of Bharata's treatise on drama and dance (*Natyasastra*) and of moral-legal text *Laws of Manu;* saint Lakulisa influences religion of Siva | *c.* **78** First Buddha images in Gandhara and Mathura; rise of Jaina and Hindu images |
| | | | *c.***100** Anthropomorphic *linga* from Gudimallam, earliest dated image of *linga* |
| | **150** Rudradaman, of Saka (Scythian) origin, rules western India | **150** Saka king Rudradaman's inscription at Junagarh shows first use of classical Sanskrit | |

| History CE | Culture CE | Art CE |
|---|---|---|
| | | **200** Great Stupa at Amaravati completed |

**319–20**
Gupta empire founded by Candragupta I

**335** Samudragupta brings under his sway the whole of north India and extends hegemony in south

**375–415**
Candragupta II completes hegemony by conquering Saka kingdom on west coast

*c.*400–500
Golden Age of ancient India, centring on Gupta empire; multi-talented Samudragupta combines military prowess with intellectual and cultural accomplishments; Chinese Budddhist pilgrim Faxian visits Gupta empire, praises peace and prosperity; great poet and dramatist Kalidasa at Candragupta II's court; playwright Visakhadatta flourishes; Vatsyayana's *Kamasutra*; pillar of pure iron (now in Meherauli, Delhi), technical feat associated with Candragupta (?); birth of astronomers, Aryabhatta and Varahamihira— latter goes on to write first treatise on Hindu temple architecture and sculpture; great Buddhist monastic university founded at Nalanda in Bihar

*c.* 400 Creation of Gupta icons of Buddha; completion of Buddhist narrative paintings at Ajanta and Bagh; first Hindu temples, structural and excavated, emerge

*c.*415 Varaha image of Vishnu at Udaigiri

*c.* 500 Temple to Vishnu at Deogarh

*c.*500–760
Ellora and Elephanta produce finest examples of narrative sculpture to Siva

*c.* 500 Huna (Hun) conquest of north-west India and decine of Gupta empire

*c.*600 Tantric cults infiltrate major religions

*c.* 600 Emergence of rock-cut shrine in south India

*c.* 600–740
Calukya temples at Aiholi, Badami, and Pattadakal

600–30 Mahendravarman I, Pallava ruler of South India

606–47 Harsha, king of Kanauj, last imperial power

| History CE | Culture CE | Art CE |
|---|---|---|

**608 CE**

**608–42** Founding of Early Western Calukya dynasty in Deccan under Pulakesin II

*c.***620** Defeat of Harsha by Pulakesin II

**630–44** Chinese Buddhist pilgrim Xuanzang in India, describes society and culture; poet Bilhana composes *Caurapancasika*

**642** Defeat of Pulakesin II by Pallavas

*c.***650** Rise of regional hegemonies following break-up of Harsha's territory

*c.***650–700** Dravida temples developed, Mamallapuram and Kanchipuram

*c.***700–900** Buddhism spreads to Nepal and Tibet; Tamil saint Manikkavacakar and Sankara, great south Indian philosopher; Abhinavagupta composes aesthetic treatise in Kashmir; aestheticians Anandavardhana and Vamana; dramatist Bhavabhuti

**710–1027** Gurjara-Pratihara dynasty in north-central India

**712** Arab occupation of Sind

**740** Calukyas defeat Pallavas

*c.***757** Rastrakutas defeat Calukyas

*c.***750** Surya temple, Martand

**760** Kailasanatha temple, Ellora

*c.***760–1142** Buddhist Pala dynasty in Bengal

*c.***800** Candela kingdom of Bundelkhand founded

*c.***900–** Rise of vernacular literature in India; Saiva lyrics in Kannada by Dasimayya, Basavanna, Allama, and Mahadeviyakka

*c.***907** Parantaka I founder of Cola dynasty in south India

**954** Laksmana temple, Khajuraho

**985–1014** Rajaraja I establishes Cola empire reaching up to Sri Lanka

**995–1010** Rajarajesvara (present Brhadisvara) temple, Tanjavur

| History CE | Culture CE | Art CE |
|---|---|---|
| **997 CE** | | |
| **997–1030** Mahmud of Ghazni raids north-west India | | |
| | | *c.*1000 Rajarani temple, Bhuvaneswar; Vatakunnathan temple, Trichur, Kerala |
| | | **1017–29** Kandariya Mahadeva temple, Khajuraho |
| | 1030 Arab encyclopedist Albiruni leaves account of India | |
| | *c.*1050 Ramanuja, mystic philosopher of south India | *c.*1050 Surya temple, Modhera |
| | 1077 Embassy of Cola merchants to China | |
| | *c.*1100 Kalhana writes historical classic *Rajatarangini* in Kashmir; Jayadeva writes poem on divine love, *Gita Govinda*, in Bengal | *c.*1100 Lingaraja temple, Bhuvaneswar |
| | | 1117 Hoysala Cenna Kesava temple, Belur |
| | | *c.*1150 Vimala Vasahi Jain temple, Dilwara, Mount Abu |
| 1192 Muhammad Ghuri defeats Prithviraja Chauhan at Tarain | | |
| | | *c.*1200 Siva Nataraja temple, Cidambaram |
| 1206 Delhi Sultanate founded by Qutb ud-din Aybak | | 1206 Quwwat ul-Islam mosque and Qutb Minar, Delhi |
| **1211–27** Sultan Iltutmish of Delhi | | |
| | | *c.*1238 Surya temple, Konarak |
| | *c.*1250 Sarangadeva writes text on music, *Sangitaratnakara* | |
| | **1253–1325** Amir Khusraw, Indo-Turkish poet | |
| | 1293 Marco Polo visits south India | |
| **1296–1316** Sultan Ala ud-Din Khalji of Delhi | | |
| | *c.*1300 Maulana Daud's *Candayana* | *c.*1300 Victory Gateway (Alai Darwaza), Delhi; decorations of Mallitamma, Hoysala sculptor |
| **1325–51** Sultan Muhammad bin Tughlaq of Delhi | | *c.*1325 City of Tughlaqabad; tomb of Ghiyas ud-Din Tughlaq |
| | *c.*1330 Barni, historian and political theorist; Ibn Batuta's visit to India | |
| 1336 Vijayanagara Empire founded in south | | |
| 1345 Bahamani Sultanate founded in south | | |

| History CE | Culture CE | Art CE |
|---|---|---|

**1350 CE**

|  |  |  |
|---|---|---|
|  | *c.*1350 Lalla, female poet of Kashmir |  |
| 1357 Sultan Firuz shah of Delhi |  |  |
|  |  | *c.*1360 Firuz Tughlaq's three-tiered pyramid surmounted with Asokan pillar and his tomb |
|  |  | 1367 Jami Masjid, Gulbarga |
|  |  | *c.*1394 Atala Masjid, Jaunpur |
| 1414–1526 Sayyid and Lodi sultans of Delhi |  |  |
|  | 1440–1518 Kabir preaches anti-caste synthesis of Bhakti and Sufi ideas |  |
|  | 1459–1539 Nanak, Bhakti saint and founder of Sikh religion |  |
|  | *c.*1480–1564 Purandaradasa, poet saint of Karnataka |  |
|  | 1486–1533 Sri Chaitanya, Vaisnava Bhakti saint of Bengal |  |
| 1498 Vasco da Gama in south India |  |  |
|  | *c.*1500 Blind Surdas writes his poems | *c.*1500 Man Singh palace fortress, Gwalior; royal multi-storey platform, Vijayanagara; Jain texts, Nima't Nama, *Caurapancasika, Laur Chanda* illustrated |
| 1509 Rana Sanga of Mewar, Rajasthan |  |  |
| 1509–30 Krsnadevaraya, greatest ruler of Vijayanaragara |  |  |
| 1510 Goa, capital of Portuguese colony |  |  |
|  |  | 1516 Sid Sayyid Mosque, Ahmedabad |
| 1526 Babur's defeat of Delhi sultan at battle of Panipat; founding of Mughal empire |  |  |
| 1530–56 Humayun |  | 1530–40 Sher Shah's mausoleum, Sasaram |
|  | *c.*1532–1623 Tulasidas composes *Ramacaritamanasa*, Hindi version of *Ramayana* |  |
| 1540–55 Sher Shah defeats Humayun and becomes sultan of Delhi |  |  |
|  | *c.*1550 Mirabai, female mystic poet of Rajasthan |  |

**1555 CE**

| History CE | Culture CE | Art CE |
|---|---|---|
| | **1555–1617**<br>Kesav Das's *Rasikapriya* | |
| **1556–1605**<br>Akbar the Great | *c.*1556–1605<br>At Akbar's court: Abu'l Fazl and Badauni, leading historians; Tansen, composer and founder of north Indian classical music; Raja Birbal, humorist | *c.***1556** Mughal painting workshop founded; emergence of masters Daswanth (d. 1584) and Basawan, leading artists of Akbar's reign |
| | | *c.***1560** Tomb for Humayun, Akbar's first architecture |
| | | *c.***1562** *Hamza Nama* painting project commenced |
| | | **1565–71**<br>Red fort and Akbar's other fortresses built |
| | | *c.***1570** Building of Fatehpur-Sikri |
| | **1578** Meeting of Akbar and Jesuits | |
| **1580** First Jesuit mission to Akbar's court | | *c.***1580** *Razm Nama* painting project commenced |
| | **1582** Din i-Ilahi, Akbar's syncretic religion, promulgated | |
| | | *c.***1584** *Akbar Nama* history painting records Akbar's reign |
| **1586–1627**<br>Ibrahim Adil II shah of Bijapur | | |
| | | *c.***1590–1605**<br>Artist Farrukh Husain (Beg), Persian painter at Ibrahim Adil Shah's court in Bijapur |
| **1600** East India Company granted charter | *c.***1600** Tukaram, Maharastran mystic poet | *c.***1600** Sahibdin, painter of Mewar, produces major versions of Hindu epics; Catholic churches, Goa |
| | | *c.***1601** Aqa Riza, Persian painter working for Jahangir |
| **1605–27**<br>Jahangir | | *c.***1605** Akbar's tomb, Sikandra; tomb of Itimad ud-Daulah, which uses *pietra dura* decoration; creation of gardens, culminating in Kashmir; Abu'l Hasan, Mansur, Manohar, Daulat, Padarath, Bishn Das, Govardhan, Balchand, Bichitr, Bishndas, Payag, Nadira, and Sahifa Banu, prominent painters at Jahangir's court |
| | | **1623–59**<br>Minaksi-Sundaresvara temple, Madurai |

**1627 CE**

| History CE | Culture CE | Art CE |
|---|---|---|
| | | *c.*1627 Abd al-Karim, Makramat Khan, Hamid Mastar Ahmad, leading architects of Shah Jahan; Moti Masjid, Agra, and addition to forts |
| **1628–58** Shah Jahan | | |
| | | *c.*1631 Taj Mahal built as memorial to Shah Jahan's wife |
| | | 1648 Shahjahanabad (Red Fort), Delhi, completed; Friday Mosque, Delhi |
| | | *c.*1650 Ranganatha temple, Srirangam; corridor of temple, Rameswaram |
| | | 1650 Sahibdin of Mewar |
| **1658–1707** Aurangzeb | | |
| **1678–95** Kirpal Pal of Basohli Hill State | | |
| | | **1680–1740** Pandit Seu, painter and founder of family of painters |
| *c.*1700 Sawai Jaisingh II of Jaipur | | |
| | | *c.*1710–78 Nainsukh, son of Seu and most important Pahari painter |
| | *c.*1718–75 Ramprasad, mystic poet of Bengal | |
| | | 1727 Symmetrically planned city of Jaipur |
| **1748–57** Sawant Singh of Kishangarh, Rajasthan | | |
| | | *c.*1750 Nihal Chand, painter |
| | | *c.*1751 Krishna Chandra Temple, Kalna, Bengal |
| 1757 Battle of Plassey and founding of British East India Company Raj in Bengal | | *c.* 1757–1850 Company School of painting |
| | *c.*1760–1847 Tyagaraja, composer of south India | |
| | **1772–1833** Rammohun Roy, first Indian modernist thinker, inspires Latin American nationalists and becomes friend of Jeremy Bentham | |
| **1775–1823** Sansar Chand of Kangra Hill State | | |
| | 1784 Asiatick Society of Bengal, first Orientalist institution, founded in Calcutta | |
| | **1799–1803** Abu Taleb leaves lively account of visit to West | **1799–1802** Building of Government House, Calcutta |

**1809 CE**

## History CE

**1825–1907**
Pioneer nationalist, Dadabhai Naoroji, MP

**1857** Uprising led by Sepoys brings down East India Company

## Culture CE

**1809–31**
H. L. V. Derozio, university teacher, inspirer of radical Young Bengal movement

**1820–91**
Iswar Chandra Bidyasagar, great educator and social reformer of Bengal

**1828** Founding of Brahmo Samaj by Rammohun Roy

**1835** Raj introduces English system of education, which replaces traditional learning

**1836–86**
Saint Sri Ramakrishna, influential in revival of Hinduism

**1840–70**
Kali Prasanna Sinha, satirist, essayist, and editor/ co-translator of *Mahabharata* into Bengali

**1842–1901**
M. G. Ranade, pioneer Maharastran reformer

**1857** Novelist Bankin Chandra Chatterjee (1838– 1892) writes song on motherland, *Bande Mataram*, which becomes national anthem

**1859** Michael Madhusudan Datta (1824–73) writes Bengali epic poem, *Meghnadbadhkavya*

**1860** Dinabandhu Mitra (1830–73) writes controversial play *Nil Darpan*, highlighting white indigo planters' oppression of Bengali peasants

**1873–1938**
Muhammad Iqbal, India's greatest Muslim poet-philosopher and inspirer of idea of Pakistan

## Art CE

*c.*1851 Foundation of art schools in Madras, Bombay, and Calcutta

*c.*1870 Academic art flourishes, led by Ravi Varma (1846–1906)

**1875 CE**

| History CE | Culture CE | Art CE |
|---|---|---|
| | **1875** Leading Muslim nationalist Syed Ahmad Khan (1817–98) founds Mohammadan Anglo-Oriental College, which combines western knowledge with Islamic education; Hindu nationalist Dayananda Saraswati (1824–1883) founds Arya Samaj | |
| **1877** Queen Victoria declared Empress of India | | |
| | | **1878–87** Victoria Terminus railway station, Bombay |
| | ***c.*1880** Harish Chandra (1850–85), Hindi poet, dramatist, and Hindu nationalist | |
| **1885** Indian National Congress founded | | |
| **1885–1905** Early Congress dominated by moderate G. K. Gokhale (1866–1915) and extremist B. G. Tilak 'Father of Indian Unrest' (1856–1920) | | |
| | **1893** Ramakrishna's disciple Swami Vivekananda (1863–1902), founder of Ramakrishna Mission, triumphs at World Congress of Religions in Chicago | |
| | **1899** Indian film industry founded | |
| | **1900** Jagadish Chandra Bose (1859–1937), scientist, Fellow of Royal Society, and member of Austrian Academy of Sciences, Vienna, presents paper at International Congress of Physicists, Paris | |
| **1905** Partition of Bengal and Swadeshi agitation; first nationalist movement | ***c.*1905** Subramania Bharati (1882–1921), Tamil poet and nationalist, active | ***c.*1905** Nationalist Bengal School of painting, led by Abanindranath Tagore (1871–1951) |
| **1906** Muslim League founded | **1906** Aurobindo Ghose (1872–1950), influential Hindu nationalist, edits revolutionary periodical *Bande Mataram* from Calcutta | |
| **1909** Muslims granted separate electorate by Raj | | |
| **1911** Transfer of capital from Calcutta to Delhi | | ***c.*1911–32** Building of New Delhi |

**1912 CE**

| History CE | Culture CE | Art CE |
|---|---|---|
| | 1912 Sarat Chandra Chatterjee (1876–1938), Bengali novelist and social critic, publishes first stories | |
| | 1913 Rabindranath Tagore (1861–1941), India's greatest poet, awarded Nobel prize for book of poems *Gitanjali*, first non-European to receive it—a world figure during his lifetime; Dadasaheb Phalke (1870–1944) releases first major Indian feature film, *Harishchandra* | |
| **1914–18** World War I; use of Indian troops in Middle East | | |
| 1919 Massacre of unarmed gathering at Amritsar by government troops | | |
| **1920–4** Khilafat movement seeks to unite Indian Muslims in Pan-Islamic agitation | | |
| 1921 Mahatma Gandhi's nationwide Non-Cooperation movement | | 1921 Victoria Memorial, Calcutta, completed |
| | | 1922 Exhibition of Bauhaus artists in Calcutta; Cubist experiments of Gaganendranath Tagore (1868–1938) |
| | 1922 Kazi Nazrul Islam (1898–1976), great Bengali revolutionary poet and composer, publishes journal, *Dhumketu* (comet) | |
| | **c. 1930** | |
| | Faiz Ahmad Faiz (1912–?), Urdu poet | 1930 Europe-wide exhibition of expressionist works of poet Rabindranath Tagore (1861–1941); Amrita Sher-Gil (1913–1941) returns to India from Paris, creating a sensation with her life and work |
| 1930 Gandhi's nationwide Civil Disobedience movement and Salt March | 1930 C. V. Raman (1888–1970) wins Nobel prize for physics | |
| | 1934 T. S. Pillai (1914– ), Malayalam novelist and short-story writer, publishes first story | |
| 1935 Congress ministries formed in provinces | 1935 R. K. Narayan (1906–) publishes first novel in English | |
| | 1936 Prem Chand (1880–1936), Hindi novelist and short-story writer, sees publication of best-known novel, *Godan*, shortly before his death | |
| 1939 World War II; Raj enters India in conflict without consulting Congress, whose leaders resign en masse | | |

| | History CE | Culture CE | Art CE |
|---|---|---|---|
| **1940 CE** | **1940** Mohammad Ali Jinnah demands sovereign state of Pakistan | | ***c.*1940** Jamini Roy (1887–1974) acclaimed as foremost primitivist |
| | **1941** Subhash Chandra Bose (1897–1945), nationalist revolutionary, joins Japan with his Indian National Army, aiming to liberate India from outside | | |
| | **1942** Quit India movement launched by Gandhi | | |
| | **1943** Great 'man-made' famine of Bengal | | |
| | **1945–7** Progressive breakdown of law and order and mutiny of armed services, as Labour government prepares to grant India independence; communal riots, partition of India, and creation of modern states of India and Pakistan | | |
| | **1947** Jawaharlal Nehru first prime minister of India; Liaquat Ali Khan first prime minister of Pakistan | **1947** S. H. Manto (1912–55), Urdu short-story writer | |
| | **1948** Gandhi assassinated; Muhammad Ali Jinnah, founder of Pakistan, dies | | **1948** Exhibition of Bombay Progressives led by M. F. Husain (1915–) |
| | **1950** India becomes republic within Commonwealth | | ***c.*1950** Zainul Abedin (1918–76), leading artist of East Pakistan (later Bangladesh), lays foundations of art in that country |
| | **1951** Congress wins elections; Nehru inaugurates Five Year Plans | | ***c.* 1951** Le Corbusier builds Chandigarh |
| | | **1953** *Do Bigha Zamin* by Bimal Roy (1912–66) honoured at Cannes Film Festival | |
| | | **1955** *Pather Panchali*, by great film director Satyajit Ray (1921–92), released | |
| | **1956** Pakistan becomes Islamic republic | | |
| | | | **1961** Sadequain (1930–87) prize-winner at Paris Biennale |
| | **1962** India's disastrous war with China | | |
| | **1966–77** Indira Gandhi's first period as prime minister | | |
| | ***c.*1967** Maoist Naxalite movement emerges in eastern India | | |

**1970** CE

## History CE

**1972** East Pakistan declares
independence and
renames itself
Bangladesh

**1980** End of Congress
dominance in India

## Culture CE

## Art CE

*c.***1970** New pictorialism of
Baroda

*c.***1980** Meera Mukherjee
(1923–98) increasingly
recognized as major
sculptor, giving a boost
to women's contribution
to modern art

# Further Reading

## General works

This critical bibliography supplements the endnotes with a survey of major publications. There is no general work that covers all the periods satisfactorily. The best surveys, mainly of the Buddhist, Hindu, and Jain periods, are **J. C. Harle**'s elegant *The Art and Architecture of the Indian Subcontinent* (New Haven, 1994) and **S. L. Huntington**'s classic synthesis, *The Art of Ancient India: Buddhist, Hindu, Jain* (New York, 1993). See also **K. Fischer, M. Jansen, and J. Pieper**, *Architektur des Indischen Subkontinents* (Darmstadt, 1987). With the exception of **B. Gascoigne**'s vivid portrait of Mughal culture, *The Great Moghuls* (London, 1971), Indo-Islamic art scholarship tends to be specialist works on connoisseurship. (This is now being redressed by *The New Cambridge History of India* series.) However, for this period the most important publications are exhibition catalogues.

For colonial arts, there are few general books apart from my *Art and Nationalism in Colonial India 1850–1922: Occidental Orientations* (Cambridge, 1994), and *The Making of a New Indian Art: Artists, Aesthetics and Nationalism in Bengal 1850–1920* (Cambridge, 1992) by **T. Guha-Thakurta**. (I am preparing a sequel to my earlier volume for the period 1922–1947.) See also *The Raj: India and the British 1600–1947*, **C. A. Bayly** (ed.) (London, 1990). **N. Tuli**'s *The Flamed Mosaic: Indian Contemporary Painting* (Ahmedabad, 1997), **A. Naqvi**'s *Image and Identity: Fifty Years of Painting and Sculpture in Pakistan* (Karachi, 1998) and *Contemporary Art in Bangladesh*, a special volume of *Arts and the Islamic World* (1999), document the arts of the postcolonial period. G. Sinha (ed.), *Expressions ansd Evocations: Contemporary Women Artists of India* (Mumbai, 1996), surveys modern Indian women artists. On Indian art history as a form of colonial discourse, see my *Much Maligned Monsters: History of European Reactions to Indian Art*

(Chicago University Press, 1992). **S. Edwards** (ed.), *Art and Its Histories* (Newhaven, 1999), places my work within the wider context of art history. For a critique of Buddhist art, see **D. S. Lopez**, *Curators of the Buddha* (Chicago, 1995), and on patronage, **B. S. Miller** (ed.), *Powers of Art: Patronage in Indian Culture* (Delhi, 1992). Other new researches are: **G. H. R. Tillotson** (ed.), *Paradigms of Indian Architecture: Space and Time in Representation and Design* (London, 1998); **R. H. Davis**'s *The Life of Indian Images* (Princeton, 1997), which traces the history of responses to Indian sacred images; and, for feminist interpretations of women's roles in Indian art, **V. Dehejia** (ed.), *Representing the Body* (New Delhi, 1997).

## PART I. BUDDHIST AND HINDU ART AND ARCHITECTURE (*c.*300 BCE– 1700 CE)

### Chapter 1. Introduction

**P. Brown**'s standard survey, *Indian Architecture: Buddhist and Hindu Periods* (Bombay, 1971), is complemented by **A. Volwahsen**'s short, conceptually exciting *Living Architecture: Indian* (London, 1969). **K. K. Chakravarty and R. G. Bednarik**'s *Indian Rock Art and its Global Context* (Delhi, 1997) places Indian prehistoric art in a global context. **R. and B. Allchin**'s *The Rise of Civilisation in India and Pakistan* (Cambridge, 1982) provides a comprehensive account of prehistoric India; the older hypothesis of the Aryan destruction of the Indus cities supported by them has now been discredited. **N. S. Rajaram and D. Frawley**, *Vedic Aryans and the Origins of Civilization* (London, 1950), argues for the indigenous origins of Indo-Aryans.

### Chapter 2. Buddhist Art and Architecture

For the controversy on the origins of Indian sculpture, see **J. Irwin**'s articles in *Burlington Magazine*, 115 (Nov. 1973), 706–20; 116 (Dec.

1974), 712–27; 117 (Oct. 1975), 631–43; and 118 (Nov. 1976), 734–53. On Buddhist patronage, in addition to **B. S. Miller** (ed.), *Powers of Art: Patronage in Indian Culture* (Delhi, 1992), see **G. Schopen**, 'On Monks, Nuns and "Vulgar" Practices: The Introduction of the Image Cult Into Indian Buddhism', *Artibus Asiae*, 49, 1/2 (1989), 153–68; on endowment of images by monks and nuns and the general study of the Buddhist order, **S. Dutt**, *Buddhist Monks and Monasteries of India* (London, 1962).

**J. Marshall and A. Foucher**, *The Monuments of Sanchi*, 3 vols (Oxford, n.d), is the most important work on the Great Stupa. See **M. Cone and R. F. Gombrich**, *The Perfect Generosity of Prince Vessantara* (Oxford, 1977), on the continuing importance of the *Vessantara Jataka*. On the symbolism of the stupa: **A. L. Dallapiccola and S. Z. Lallement** (eds), *The Stupa, its Religious, Historical and Architectural Significance* (Wiesbaden, 1980); **J. Irwin**, 'The Stupa and the Cosmic Axis', in *Acarya Vandana* (D. R. Bhandarkar birth centenary vol., Calcutta, 1981), 249–69; and **J. Duran**, 'The Stupa in Indian Art', *British Journal of Aesthetics*, 36, 1 (Jan. 1996), 66–73. On early *caityas* and *viharas*, **V. Dehejia**, *Early Buddhist Rock Temples: A Chronological Study* (London, 1972). Also relevant on the origins of Indian architecture is **M. Meister** (ed.), *Ananda K. Coomaraswamy: Essays in Early Indian Architecture* (New Delhi, 1992). In addition to Susan Huntington's innovative work and Vidya Dehejia's critique on the Buddha image controversy, see **J. E. van Lohuizen-de Leeuw**, 'New Evidence With Regard to the Origin of the Buddha Image', *South Asian Archaeology* (1979), 377–99; **R. L. Brown**, 'Narrative as Icon: Jataka Stories in Ancient Indian and Southeast Asian Architecture', in J. Schober (ed.), *Sacred Biography in the Buddhist Traditions of South and Southeast Asia* (Honolulu, 1997), 64–109; **L. Nehru**, *Origins of the Gandhara Style* (Delhi, 1990); and **J. M. Rosenfield**, *The Dynastic Arts of the Kushans* (Berkeley and Los Angeles, 1993). On Buddhist iconography, **D. Snellgrove**, *The Image of the Buddha* (Paris, 1978), and on late Tantric Buddhism, **B. Bhattacharyya**, *The Indian Buddhist Iconography* (Calcutta, 1958).

On the latest research on the Great Stupa at Amaravati based on the British Museum collection, see **R. Knox**, *Amaravati: Buddhist Sculpture from the Great Stupa* (London, 1992). **C. Sivaramamurti**, *Amaravati Sculptures in the Madras Government Museum* (Madras, 1956), describes the Amaravati pieces inherited by the Madras museum. The unquestioned authority on Ajanta is **W. Spink**. See for instance his 'Ajanta: A Brief History', in P. Pal (ed.), *Aspects of Asian Art* (Leiden, 1972), 49–58; 'Ajanta's Chronology: The Crucial Cave', *Ars Orientalis*, 10 (1975), 143–70; and 'Ajanta's Chronology: Politics and Patronage', in J. G. Williams (ed.), *Kaladarsana* (New Delhi, 1981), 109–26. **A. Ghosh** (ed.), *Ajanta Murals* (New Delhi, 1967), is useful, as is the pioneering *Ajanta*, 3 vols (Oxford, 1931–46), by **G. Yazdani et al**. On Ajanta iconography see **D. Schlingloff**, *Studies in Ajanta Paintings: Identifications and Interpretations* (Delhi, 1987).

## Chapter 3. Hindu Art and Architecture

**R. Blurton**'s *Hindu Art* (London, 1992) provides an attractive introduction to the religion through its art. **T. R. Gopinatha Rao**'s magisterial *The Principles of Hindu Iconography*, 4 vols (Madras, 1916), and **J. N. Banerjea**'s more analytical *The Development of Hindu Iconography* (Delhi, 1974) are the standard texts. **H. Zimmer**'s *The Art of Indian Asia* (1955) and *Myths and Symbols in Indian Art and Civilization* (Princeton, 1946) render Hindu art and myths in a beautifully poetic language. For South India, **G. Jouveau-Dubreuil**'s *Iconography of South India*, trans. A. C. Martin (Paris, 1937), remains essential. **C. Maury**'s *Folk Origins of Indian Art* (New York, 1969) offers a new perspective on the relationship between folk and high art. The importance of Siva's dance in Hinduism is studied by **A. M. Gaston**, *Siva in Dance, Myth and Iconography* (Delhi, 1982), and **C. Sivaramamurti**, *Nataraja in Dance, Art and Literature* (Delhi, 1974). On Siva's paradoxical persona, see **W. D. O'Flaherty**'s classic *Asceticism and Eroticism in the Mythology of Siva* (Oxford, 1973). **M. W. Meister** (ed.), *Discourses on Siva: Proceedings of a Symposium on the Nature of Religious Imagery* (Philadelphia, 1984), contains recent research. On Ganesa, **P. Martin-Dubost**, *Ganesa* (Mumbai, 1997). On Vishnu, **K. Desai**, *The Iconography of Visnu* (Delhi, 1973), **H. D. Smith**, *Vaisnava Iconography* (Madras, 1969), and **T. S. Maxwell**, *Visvarupa* (Delhi, 1988). **M. S. Dhaky**'s *The Vyala Figures* (Varanasi, 1965) and **O. Viennot**'s *Les Divinités Fluviales Ganga et Yamuna aux portes des sanctuaires de l'Inde* (Paris, 1964) study key sculptural motifs. (On the Great Goddess see chapter 4 of the present book.)

An indispensable source for Hindu architecture is the multi-volume *Encyclopaedia of Indian Temple Architecture*, edited by **M. W.**

Meister and **M. A. Dhaky** and published by various academic presses. **S. Kramrisch**'s classic, *The Hindu Temple*, 2 vols (Calcutta, 1946), is complex but can be best understood by first reading **Volwahsen**, *Living Architecture: Indian*. Conceptually exciting is **A. Hardy**'s *Indian Temple Architecture: Form and Transformation, the Karnata-Dravida Tradition* (New Delhi, 1995). On patronage, as well as Miller, *Powers of Art*, **V. Dehejia** (ed.), *Royal Patrons and Great Temple Art* (Bombay, 1988), is indispensable.

On the Gupta period see: **J. G. Williams**, *The Art of Gupta India* (Princeton, 1982); **J. C. Harle**, *Gupta Sculpture: Indian Sculpture of the Fourth to Sixth Centuries AD* (Oxford, 1974); **P. Pal**, *The Ideal Image: The Gupta Sculptural Tradition and its Influence* (New York, 1978); and **F. Asher**, *Art of Eastern India 300–800* (Minneapolis, 1980). On the Deccan, **Hardy**, *Indian Temple Architecture*. On the Calukyas, **G. Michell**, *An Architectural Description and Analysis of the Early Western Chalukyan Temples* (London, 1975); **G. M. Tartakov**, *Durga Temple at Aihole: A Historiographic Study* (Delhi, 1997), which sheds new light on the temple; and **C. R. Bolon**, 'The Mahakuta Pillar and Its Temples', *Artibus Asiae*, 41, 2/3 (1979), 253–68.

On excavated monuments, **C. Berkson** (ed.), *Elephanta: The Cave of Shiva* (Princeton, 1983), should be supplemented with **S. Kramrisch**, *The Presence of Siva* (Philadelphia, 1984); **C. Berkson**, *Ellora: Concept and Style* (Delhi, 1992); and **D. C. Chatham**, *Stylistic Sources of the Kailasa Temple at Ellora* (Ann Arbor, 1984, dissertation facsimile), which analyses a major temple. On Pallava monuments, see the leading authority, **K. R. Srinivasan**'s *Cave Temples of the Pallavas* (Delhi, 1964), and **R. Nagaswamy**'s 'New Light on Mamallapuram', *Transactions of the Archaeological Society of South India—Silver Jubilee Volume* (Madras, 1962), 1–50.

On the southern temples of Cola and later periods, **S. R. Balasubrahmanyam**'s *Early Chola Temples* (Bombay, 1971), *Middle Chola Temples* (Faridabad, 1975), and *Late Chola Temples* (Madras, 1979) are standard works. **V. Dehejia**, *Art of the Imperial Cholas* (New York, 1990), and **P. Prichard**, *Tanjavur Brhdisvara: An Architectural Study* (New Delhi and Pondicherry, 1995), offer more recent material. **J. C. Harle**, *The Temple Gateways of South India* (Oxford, 1963), is the best scholarly monograph on the *gopuras*. For late South Indian architecture, **J. Michell**, *Architecture and Art of Southern India*, part I, vol. 6 of *The New Cambridge History of India* (Cambridge, 1995). **B. Natarajan**'s *The City of the Cosmic Dance* (Delhi, 1974) is a study of the sacred city of Cidambaram. For social and economic aspects of South Indian temples, **J. Heitzman**, 'Temple Urbanism in Medieval South India', *Journal of Asian Studies*, 46, 4 (Nov. 1987), 791–826, **B. Stein** (ed.), *South Indian Temples: An Analytical Reconstruction* (New Delhi, 1978), and **D. Dennis Hudson**, 'Madurai: The City as Goddess', in H. Spodek and D. M. Srinivasan (eds), *Urban Form and Meaning in South Asia: The Shaping of Cities from Prehistoric to Precolonial Times* (Hanover, 1993), 125–44. On ancient Indian portraiture, **P. Kaimal**, 'Passionate Bodies: Constructions of the Self in South Indian Portraits', *Archives of Asian Art*, 47 (1995), 6–16.

On Orissan temples, **K. C. Panigrahi**, *Archaeological Remains at Bhubaneswar* (Calcutta, 1961), and **T. E. Donaldson**, *Hindu Temple Art of Orissa*, 3 vols (Leiden, 1985–7), offer the most authoritative accounts. Orissan temples up to 1000 CE are covered by **V. Dehejia**, *Early Stone Temples of Orissa* (New Delhi, 1979), **W. Smith**, *The Muktesvara Temple in Bhubaneswar* (Delhi, 1994), and **V. Filiozat**, *The Temple at Muktesvara* (Delhi, 1995). **D. Mitra**'s *Bhuvaneswar* (New Delhi, 1966) and *Konarak* (New Delhi, 1976) remain masterly analyses of the sites. *Konarak: The Heritage of Mankind* (New Delhi, 1996) by **K. S. Behera** contains a useful survey of published material. *New Light on the Sun Temple at Konarka* (Varanasi, 1972) by **A. Boner et al.** is valuable for the Indian text but is somewhat unreliable. On Khajuraho and related styles, see **M. A. Dhaky**, 'The Genesis and Development of Maru-Gurjara Temple Architecture', in P. Chandra (ed.), *Studies in Indian Temple Architecture* (New Delhi, 1975), and **O. Viennot**, *Temples de l'Inde centrale et occidentale*, 2 vols (Paris, 1976). **S. Punja**, *Divine Ecstasy: The Story of Khajuraho* (Delhi, 1992), offers an intriguing theory on its erotic sculptures, which is refuted by **D. Desai**, *The Religious Imagery of Khajuraho* (Mumbai, 1996).

## Chapter 4. Minority Traditions, Ideal Beauty, and Eroticism

Information about Indian artists, workshops, and patrons in the Hoysala region is rare: **R. J. Del Bonta**, *The Hoysala Style* (Ann Arbor, 1983); **K. Colleyer**, *The Hoysala Artists: Their Identity and Style* (Mysore, 1990); **S. Settar**, *The Hoysala Temples*, 2 vols (Bangalore, 1992). On Kashmir, the standard work is **R. C. Kak**,

*Ancient Monuments of Kashmir* (London, 1933), but the best cultural background is in the twelfth-century historian **Kalhana**: *Kalhan's Rajatarangini*, trans. **R. S. Pandit** (New Delhi, 1958). **P. Pal**, *Bronzes of Kashmir* (New Delhi, 1988), offers a cross-section of this art. **R. M. Bernier**, *Temple Arts of Kerala: A South Indian Tradition* (New Delhi, 1982), **S. Kramrisch et al.**, *The Arts and Crafts of Kerala* (Cochin, 1970), and **W. A. Noble**, 'The Architecture and Organization of Kerala Style Hindu Temple', *Anthropos*, 76 (1981), 1–23, should all be consulted for Kerala. The exhibition catalogue **P. Pal** (ed.), *The Peaceful Liberators: Jain Art from India* (Los Angeles, 1994), is an excellent overview of Jain religious art. Also, see **A. Ghosh** (ed.), *Jaina Art and Architecture*, 3 vols (New Delhi, 1974–5); **U. P. Shah and M. A. Dhaky**, *Aspects of Jaina Art and Architecture* (Ahmedabad, 1975); and **E. Fischer and J. Jain**, *Art and Rituals: 2500 years of Jainism in India* (New Delhi, 1977). One aspect of Gujarati architecture shared by Jains, Hindus, and, later, Muslims not explored in the present book is the art of stepped wells: **J. Jain-Neubauer**, *The Stepwells of Gujarat* (New Delhi, 1981).

No single work develops the main arguments of the section on beauty and the erotic but the following are useful. On ideal human form in the West, **K. Clark**'s *The Nude* (Harmondsworth, 1956) is the standard work. See its feminist critique in **L. Nead**, *The Female Nude: Art, Obscenity and Sexuality* (London, 1992). The seminal essay on the Vasarian origins of western taste is **E. H. Gombrich**'s essay 'Norm and Form', in *Norm and Form: Studies in the Art of the Renaissance* (London, 1966). E. B. Havell and A. K. Coomaraswamy were the first critics of colonial art history: **E. B. Havell**, *Ideals of Indian Art* (Delhi, 1972 ed.); **A. K. Coomaraswamy**, *The Dance of Shiva* (Delhi, 1971 ed.) and *Transformation of Nature in Art* (New York, 1956). In *Much Maligned Monsters* (ch. 2) I chart the history of western representations of Hindu erotic art. **D. Desai**'s *Erotic Sculptures of India; A Socio-Cultural Study* (Delhi, 1975) is the only major scholarly study on the subject. See also **P. Chandra**, 'The Kaula-kapalika Cults at Khajuraho', *Lalit Kala*, 1/2 (1955–6), 98–107, and **T. E. Donaldson**, 'Propitious-Apotropaic Eroticism in the Art of Orissa', *Artibus Asiae*, 37, 1/2 (1975), 75–100. On Tantra, **A. Mukherjee**, *Tantra Art* (Delhi, 1966). Among studies of the Great Goddess: **N. N. Bhattacharyya**, *The Indian Mother Goddess*

(Calcutta, 1971); **J. S. Hawley and D. M. Wulff** (eds), *Devi: Goddesses of India* (Berkeley and Los Angeles, 1996); **V. Dehejia**, *Yogini Cult and Temples* (New Delhi, 1986) and her exhibition catalogue *Devi, The Great Goddess* (Ahmedabad and Munich, 1999). On the seven mothers, compare **S. K. Panikkar**'s challenging *Saptamatrikas* (Delhi, 1996) with **K. A. Harper**'s insightful *Seven Hindu Goddesses of Spiritual Transformation: The Iconography of the Saptamatrikas* (Lewiston, 1989).

## PART II. INDO-ISLAMIC ART AND ARCHITECTURE (*c.*712–1757 CE)

Among general surveys, **P. Brown**'s *Indian Architecture, Islamic Period*, 5th ed. (rev.) (Bombay, 1958) and **A. Volwahsen**'s short volume *Islamic India* (Lausanne, n.d.) are the most useful. Among Islamicists who stress the Islamic Middle Eastern aspects of Indo-Islamic architecture, see **R. Hillenbrand**, *Islamic Architecture: Form, Function and Meaning* (Edinburgh, 1994), and **O. Grabar**, *The Formation of Islamic Art* (New Haven, 1973), on the nature of Islamic art. On miniature painting as a synthesis of indigenous and Islamic art, **D. Barrett and B. Gray**, *Indian Painting* (London, 1978), provides the background while **J. P. Losty**'s *The Art of the Book in India* (London, 1982) is the best reference work.

## Chapter 5: The Turko-Afghan Sultanate of Delhi (1206–1526 CE)

On pre-conquest Islamic buildings, **M. Shokoohy**, *Bhadresvar, The Oldest Islamic Monuments in India* (Leiden, 1988). On Delhi Sultanate architecture, **C. Stephen**'s *Archaeology and Monumental Remains of Delhi* (Allahabad, 1967) is indispensable. On Tughlaq architectural patronage, **A. M. Husain**'s standard work, *Tughlaq Dynasty* (New Delhi, 1976), should be supplemented with **A. Welch**, 'Architectural Patronage and the Past: The Tughluq Sultans of India', *Muqarnas*, 10 (1993), 311–22. On Sher Shah's mausoelum, **C. B. Asher**, 'Legacy and Legitimacy: Sher Shah's Patronage of Imperial Mausolea', in K. P. Ewing (ed.), *Shari'at and Ambiguity in South Asian Islam* (Berkeley, 1988).

On Jaunpur architecture, **A. Führer**, *The Sharqi Architecture of Jaunpur*, Archaeological Survey of India, New Imperial Series, vol. XI (Calcutta, 1889), and on Gujarat, **J. Burgess**, *The Muhammadan Architecture of Ahmadabad*, 2 parts, Archaeological Survey of India, New

Imperial Series, vols XXIV and XXXIII (London, 1900–5). On the Deccan, **E. S. Merklinger**'s pioneering *Indian Islamic Architecture: The Deccan 1347–1686* (Warminster, 1981) should be combined with **G. Michell and M. Zebrowski**'s *Architecture and Art of the Deccan Sultanates* (Cambridge, 1999), part I, vol. 7, of *The New Cambridge History of India*. **M. B. Garde**, *A Handbook of Gwalior* (Gwalior, 1936), is useful for the region. Recent publications on Vijayanagara are part of an ambitious archaeological project: **J. M. Fritz et al.**, *Where Kings and Gods Meet: The Royal Centre at Vijayanagara* (Tucson, 1984), 122–45; **A. L. Dallapiccola et al.**, *The Ramachandra Temple at Vijayanagara* (New Delhi, 1992); **J. Fritz, G. Michell, et al.**, *The City of Victory Vijayanagara* (New York, 1991), 30–3. **B. Stein**'s *Vijayanagara* (Cambridge, 1989) offers a socio-cultural analysis of the empire, while **P. B. Wagoner**'s '"Sultan Among Hindu Kings": Dress, Titles and the Islamicization of Hindu Culture at Vijayanagara', *Journal of Asian Studies*, 55, 4 (Nov. 1996), 851–80, corrects Hindu nationalist views of the empire. On architecture and sculpture of post-Gupta Bengal, **F. Asher**, *Art of Eastern India 300–800* (Minneapolis, 1980), and **S. L. Huntington**, *The 'Pala–Sena' Schools of Sculpture*, in **J. E. van Lohuizen-de Leeuw** (ed.), *Studies in South Asian Culture*, vol. 10 (Leiden, 1984). For Islamic architecture, see **C. B. Asher**, *Islamic Monuments of Eastern India and Bangladesh* (Leiden, 1991). The Bengali temples were documented by **David McCutchion** (George Michell (ed.), *Brick Temples of Bengal, From the Archive of David McCutchion* (Princeton, 1983)).

**S. Digby**, 'The Literary Evidence for Painting in the Delhi Sultanate', *Bulletin of the American Academy of Benares*, 1 (Varanasi, 1967), 47–58, on Delhi Sultanate painting, and **K. Khandalavala and M. Chandra**, *New Documents of Indian Painting—A Reappraisal* (New Delhi, 1969), on provincial Sultanate paintings are the authoritative works. A landmark in the study of pre-Mughal painting is **R. W. Skelton**'s 'The Ni'mat Nama: A Landmark in Malwa Paintings', *Marg*, 12, 3 (1958), 44–50. On Jain painting: **M. Chandra**, *Jain Miniature Paintings from Western India* (Ahmedabad, 1949); **S. Doshi**, *Masterpieces of Jain Painting* (Bombay, 1985); and **M. Chandra and U. P. Shah**, 'New Documents of Jaina Paintings', *Sri Mahavira Jaina Vidyalaya—Golden Jubilee Volume* (Bombay, 1968). On Gujarati artists and Muslim patrons see **B. N. Goswamy**, *A Jainesque Sultanate:*

*Shah Nama and the Context of Pre-Mughal Painting of India* (Zurich, 1988). **J. M. Rogers**, *Circa 1492* (New Haven and London, 1991), 70–1, traces the trade between Gujaratis and the Islamic world, while **M. Gittinger**, *Master Dyers to the World* (Washington, DC, 1982), 31–57, documents the worldwide Gujarati textile trade. On art at the Rajput court, see **M. Chandra**, *Mewar Painting* (Delhi, 1971). **K. Ebeling**, *Ragamala Painting* (Basle, 1973), is the only study on that subject.

## Chapter 6. The Mughal Empire (1526–1757)

**E. Koch**, *Mughal Architecture: An Outline of its History and Development (1526–1858)* (Munich, 1991), and **C. B. Asher**, *Architecture of Mughal India* (Cambridge, 1992), part I, vol. 4, of *The New Cambridge History of India*, are two important general works. **B. Gascoigne**, *The Great Moghuls* (London, 1971), provides a good introduction to Mughal courtly culture. On Mughal cities see **S. P. Blake**, *Shajahanabad: The Sovereign City in Mughal India, 1639–1739* (Cambridge, 1991); on Mughal economy and polity, **I. Habib**, *The Agrarian System of Mughal India: 1556–1707* (London, 1963); **T. Raychadhuri**, *Mughal Empire Under Akbar and Jahangir; Introductory Study in Social History* (Calcutta, 1953). See also **O. Reuther**, *Indische Paläste und Wohnhaüser* (Berlin, 1925), for Mughal buildings. On Mughal gardens, **E. B. Moynihan**, *Paradise as a Garden in Persian and Mughal India* (London, 1980), and 'The Lotus Garden Palace of Zahir al-Din Muhammad Babur', *Muqarnas*, 5 (1988). Also **S. Crowe and S. Haywood**, *The Gardens of Mughal India* (Delhi, 1973); **J. Dickie**, 'The Mughal Garden: Gateway to Paradise', *Muqarnas*, 3 (Leiden, 1985), 128–37; and **M. Hussain et al.** (eds), *The Mughal Garden* (Rawalpindi, 1996).

The works of **Abu'l Fazl Allami**, *A'in i-Akbari*, trans. H. Blochmann and H. Jarrett, 3 vols (Calcutta, 1875–1948), and *Akbarnama*, trans. H. Beveridge, 3 vols (Calcutta, 1907–39), are indispensable for Akbar's reign. His religious ideas are discussed in **E. Wellesz**, *Akbar's Religious Thought Reflected in Mughal Painting* (London, 1952), and **S. A. A. Rizvi**, *Religious and Intellectual History of the Muslims in Akbar's Reign* (Delhi, 1975). On imperial ideology, **J. F. Richards**, 'The Formulation of Imperial Authority under Akbar and Jahangir', in J. F. Richards (ed.), *Kingship and Authority in South Asia* (Madison, 1978), and **R. W. Skelton**, 'Imperial Symbolism in Mughal Painting', in P. P. Soucek (ed.),

Content and Context of Visual Arts in the Islamic World (London, 1988). Jesuit influence on imperial imagery is discussed by **E. Koch**, 'The Influence of the Jesuit Mission on Symbolic Representations of the Mughal Emperors', in C. W. Troll (ed.), *Islam in India, Studies and Commentaries*, vol. 1 (New Delhi, 1982). **G. D. Lowry**, 'Humayun's Tomb: Form, Function and Meaning in Early Mughal Architecture', *Muqarnas*, 4 (1987), analyses Akbar's first major building. **M. Brand and G. D. Lowry** (eds), *Fatehpur-Sikri* (Bombay, 1987), contains recent research on this city by various authorities.

On the structure of the Mughal manuscript workshop and working methods: **S. P. Verma**, *Mughal Painters and their Work: A Bibliographical Survey and Comprehensive Catalogue* (Delhi, 1994); **P. Brown**, *Indian Painting Under the Mughals* (Oxford, 1924); **M. Chandra**, *The Technique of Mughal Painting* (Lucknow, 1949); **J. Seyller**, 'Model and the Copy: The Illustration of Three Razmnama Manuscripts', *Archives of Asian Art*, 38 (1985), 37–66; **D. P. Agrawal**, *Conservation of Manuscripts and Paintings of Southeast Asia* (London, 1984); and **A. Aziz**, *The Imperial Library of the Mughals* (Delhi, 1974). **P. Chandra**, *The Tuti-Nama of The Cleveland Museum of Art and the Origins of Mughal Painting* (Graz, 1976), traces the contribution of Gujarati painters to the Mughal style. A counter-argument is offered by **A. Krishna**, 'A Reassessment of the Tuti-nama Illustrations in the Cleveland Museum of Art (and Related Problems on Early Mughal Paintings and Painters)', *Artibus Asiae*, 35, 3 (1973), 241–68. **R. Ettinghausen**, 'Abdu's-Samad', *Encyclopedia of World Art*, vol. 1 (New York, 1960), 15–20, on one of the two Persian founding artists of the Mughal workshop. **M. C. Beach**, *The Imperial Image—Paintings for the Mughal Court* (Washington, DC, 1981), is especially informative on Mughal artists. On the reception of western art at the Mughal court: **E. Maclagan**, *The Jesuits and the Grand Mogul* (London, 1932); **E. Kühnel and H. Goetz**, *Indian Book Painting from Jahangir's Album in the State Library, Berlin* (London, 1926); **M. C. Beach**: 'A European Source for Early Mughal Painting', *Oriental Art*, 22, 2 (Summer 1976), 180–8, and 'The Mughal Painter Abu'l Hasan and Some English Sources for His Style', *Journal of the Walters Art Gallery*, 38 (1980), 7–33; **E. Koch**, 'Jahangir and the Angels: Recently Discovered Wall Paintings under European Influence in the Fort of Lahore', in

J. Deppert (ed.), *India and the West* (New Delhi, 1983).

Jahangir's autobiography, *Tuzuk–i–Jahangiri*, trans. A. Rogers and ed. H. Beveridge, 2 vols (London, 1909–14), is a major source for his ideas on gardens and other aspects of his reign. **E. B. Findly**, *Nur Jahan, Empress of Mughal India* (New York, 1993), and **E. Koch**, 'Notes on the Painted and Sculpted Decoration of Nur Jahan's Pavilions in the Ram Bagh (Bagh-i Nur Afshan) at Agra', in **R. W. Skelton** et al. (eds), *Facets of Indian Art* (London, 1986), on the patronage of one of the most powerful Mughal women. **M. C. Beach**, *The Grand Mogul—Imperial Painting in India 1600–1660* (Williamstown, MA, 1978), studies painting from the end of Akbar's reign to that of Shah Jahan. See also **A. K. Das**, *Mughal Painting During Jahangir's Time* (Calcutta, 1978).

On Shah Jahan's architecture and its symbolism the major work is by **E. Koch**, especially 'The Baluster Column—A European Motif in Mughal Architecture and its Meaning', *Journal of the Warburg and Courtauld Institutes*, 45 (1982), 253–62, *Shah Jahan and Orpheus* (Graz, 1988), and 'The Hierarchical Principles in Shah-Jahani Painting', in M. C. Beach and E. Koch, *King of the World, the Padshahnama* (London, 1997), 132. See also **S. Moosi**, 'Expenditure of Buildings under Shah Jahan—A Chapter of Imperial Financial History', *Proceedings of the Indian History Congress*, 46th Session (Amritsar, 1986), and **S. P. Blake**, 'Cityscape of an Imperial Capital: Shahjahanabad in 1739', in R. E. Frykenberg (ed.), *Delhi Through the Ages* (Delhi, 1986). **R. Nath**, *The Immortal Taj Mahal* (Bombay, 1972), considers the evolution of the mausoleum. **W. E. Begley and Z. A. Desai**, *Taj Mahal: The Illuminated Tomb* (Cambridge and Seattle, 1989), is a collection of contemporary documents on the monument. See also **W. E. Begley**, 'The Myth of the Taj Mahal and a New Theory of its Symbolic Meaning', *Art Bulletin*, 61, 1 (1979), 7–37, and **P. Pal, J. Leoshko, J. M. Dye III, and S. Markel**, *Romance of the Taj Mahal* (Los Angeles, 1989), 88–127. **M. C. Beach and E. Koch**, *King of the World, the Padshahnama* (London, 1997), an exhibition catalogue, contains much information on the arts of Shah Jahan. On the Deccan sultanates, **M. Zebrowski**'s *Deccani Painting* (Berkeley and London, 1983) is the standard work. See **R. W. Skelton**, 'The Mughal Artist Farrokh Beg', *Ars Orientalis*, 2 (1957), 393–411, on this controversial artist.

### Chapter 7. Rajasthani and Pahari Kingdoms (c.1700–1900)

**J. Tod**, *Annals and Antiquities of Rajasthan*, 2 vols (London, 1829–32), is the essential source book for the region. **G. H. R. Tillotson**, *The Rajput Palaces: The Development of an Architectural Style, 1450–1750* (New Haven, 1987), is a good introduction to Rajput architecture. **A. K. Coomaraswamy**'s classic *Rajput Painting* (London, 1916) is now dated. His identification of regions and courts as the foundation of style was followed by **W. G. Archer** in *Indian Paintings from the Punjab Hills* (London, 1973). On artists as the basis of style: **B. N. Goswamy**, 'Pahari Painting: The Family as the Basis of Style', *Marg*, 21, 4 (Sep. 1968), 17–62. See also **B. N. Goswamy and E. Fischer**, *Pahari Masters* (Zurich, 1992), and **Goswamy**'s biography of the leading Pahari artist, *Nainsukh of Guler: A Great Indian Painter from a Small Hill State* (Zurich, 1997). **M. C. Beach**, 'The Context of Rajput Painting', *Ars Orientalis*, 10 (1982), 11–18, discusses problems peculiar to this school. **A. Topsfield**, 'Sahibdin's Gita-Govinda Illustrations', *Chhavi*, 2 (Varanasi, 1981), 231–8, studies a major early Mewar artist. Recently, **J. Bautze** has made the most substantial contribution to these styles: 'A Contemporary and Inscribed Equestrian Portrait of Jagat Singh of Kota', in *Deyadharma—Studies in Memory of Dr D. C. Sircar* (Delhi, 1986), 47–64; 'Mughal and Deccani Influence on Early 17th-Century Murals of Bundi', in **R. W. Skelton** (ed.), *Facets of Indian Art* (London, 1986), 168–175; 'Drei "Bundi"-Ragamalas', *Ein Beitrag zur Geschichte der Rajputishen Wandmalerei* (Stuttgart, 1987); 'Portraitmalerei unter Maharao Ram Singh von Kota', *Artibus Asiae*, 59, 3/4 (1999), 316–50. See also **R. W. Skelton**, 'Shaykh Phul and the Origins of Bundi Painting', *Chhavi*, 2 (Varanasi, 1981), 123–9, and **B. Singh**, *The Kingdom that was Kota* (New Delhi, 1985). The latest is **S. C. Welch**, *Kotah* (New York, 1997). On Kishangarh art **E. Dickinson and K. Khandalavala**, *Kishangarh Painting* (New Delhi, 1959), is the pioneering work but see **N. N. Haidar**, *The Kishangarh School of Painting: c.1650–1850* (Ph.D. thesis, Oxford, 1995) for a critique of their work. **M. S. Randhawa**, *Kangra Ragamala Painting* (New Delhi, 1971). Mewar artists' status, genealogies, and other data are in **S. Andhare**, *Chronology of Mewar Paintings* (Delhi, 1987).

### Chapter 8. The Non-Canonical Arts of Tribal Peoples, Women, and Artisans

**V. Elwin**'s pioneering works on tribal arts are *The Tribal Art of Middle India* (Oxford, 1951) and *Folk Paintings of India* (New Delhi, 1967). **S. Kramrisch**, *Unknown India: Ritual Art in Tribe and Village* (Philadelphia, 1968), brought tribal and village art within art history. **P. Jayakar**, *The Earthen Drum: An Introduction to the Ritual Arts of Rural India* (Delhi, 1980), discusses the earth goddess in both 'low' and 'high' cultures. On tribal artists: **Y. Dalmia**, *The Painted World of the Warlis* (New Delhi, 1988); **S. Mahapatra**, 'Art and Ritual: A Study of Saora Pictograms', in L. Chandra and J. Jain (eds), *Dimensions of Indian Art*, 2 vols (Delhi, 1986); and **J. Jain**, *Painted Myths of Creation— Art and Ritual of an Indian Tribe* (New Delhi, 1984). On women's ritual art of Madhubani: **Y. Vequaud**, *The Art of Mithila, Ceremonial Paintings from an Ancient Kingdom* (London, 1977); **U. Thakur**, *Madhubani Painting* (Atlantic Highlands, NJ, 1982); and **M. R. Anand**, *Madhubani Painting* (Delhi, 1984). Bengali *kanthas* or patchwork quilts were first studied by **G. S. Dutt** (see next paragraph). See also the catalogue *Woven Air: The Muslin and Kantha Tradition of Bangladesh* (exhib. cat., London, 1988).

**George Birdwood**'s pioneering work, *The Industrial Arts of India* (London, 1880), should be supplemented with **K. Chattopadhyay**, *Handicrafts of India* (Delhi, 1975), **R. J. Mehta**, *Handicrafts and Industrial Arts of India* (Bombay, 1960), **H. Mode and S. Chandra**, *Indian Folk Art* (Bombay, 1985), and **M. W. Meister** (ed.), *Making Things in South Asia* (Philadelphia, 1988). **H. Glassie**, *Art and Life in Bangladesh* (Bloomington, 1997), is an excellent study of the crafts in Bangladesh. In the 1930s, **G. S. Dutt** was the first scholar to research scroll painters and other folk artists of Bengal; see his *Folk Arts and Crafts of Bengal: The Collected Papers* (Calcutta, 1990). On popular painting see **M. Archer**, *Indian Popular Painting in the India Office* (London, 1977). Among other forms of folk painting: **F. Wacziarg and A. Nath**, *Rajasthan: The Painted Walls of Sekhavati* (New Delhi, 1982); **R. W. Skelton**, *Rajput Temple Paintings of the Krishna Cult* (New York, 1976); **A. Ambalal**, *Krishna as Srinathji—Rajasthani Paintings from Nathadvara* (Ahmedabad, 1987); and the sociological study by **R. Maduro**, *Artistic Creativity in a Brahmin Painter Community* (Los Angeles, 1976). **V. N. Mair**, *Painting and Performance* (Honolulu, 1988), discusses the tradition of reciting with painted scrolls. On the decorative arts, see **J. Jain and A. Aggarwala**, *National Handicrafts and Handlooms Museum, New Delhi* (Ahmedabad,

1989), and *Aditi* (Festival of India exhib. cat., London, 1982). On commercial printed fabrics: **A. Buhler et al.**, *Indian Tie-dyed Fabrics* (Ahmedabad, 1980); **J. Irwin and K. Brett**, *Origins of Chintz* (London, 1970); and **V. Murphy**, 'Europeans and the Textile Trade', in J. Guy and D. Swallow, *Arts of India* (London, 1990). On urban popular art, **B. Osman**, 'Transport Painting: The Decorated Rickshaws of Dhaka', *Arts and the Islamic World*, special volume: *Contemporary Art in Bangladesh*, 34 (Summer 1999), 71–2.

## PART III. COLONIAL ART AND ARCHITECTURE (1757–1947)

### Chapter 9. The British Raj: Westernization and Nationalism

On painting under the impact of the East India Company, see **M. Archer**, *Natural History Drawings in the India Office Library* (London, 1972), *Company Drawings in the India Office Library* (London, 1972), and *Patna Painting* (London, 1948); **M. and W. G. Archer**, *Indian Painting for the British, 1770–1880* (Oxford, 1955); and **S. C. Welch**, *Room for Wonder—Indian Painting During the British Period 1760–1880* (New York, 1978). **R. W. Skelton**, 'Murshidabad Painting', *Marg*, 10, 1 (1956), 10–22, for the art of that place. See **J. Appasami**, 'Early Oil Paintings in Bengal', *Lalit Kala Contemporary*, 32 (Apr. 1985), 5–9, on Bengali artists who adapted western oils to their needs. On Kalighat painting, **W. G. Archer**, *Bazaar Paintings of Calcutta* (London, 1953), and **H. Knizkova**'s social and cultural study, *The Drawings of the Kalighat Style* (Prague, 1975). **J. Jain**, *Kalighat Painting: Images from a Changing World* (Ahmedabad, 1999), an exhibition catalogue, contains much new material, including some Muslim subjects.

On English art schools: **J. C. Bagal**, *Centenary of the Government College of Art and Craft Calcutta* (Calcutta, 1964), *Story of Sir J. J. School of Art 1857–1957* (Bombay, 1957), and *Papers Relating to the Maintenance of Schools of Art in India as State Institutions, 1893–6* (Calcutta, 1898). On Ravi Varma, **R. C. Sharma** (ed.), *Raja Ravi Varma: New Perspective* (New Delhi, 1993); **P. Mitter**, *Art and Nationalism in Colonial India 1850–1922: Occidental Orientations* (1994), ch. 4; **G. Kapur**, 'Ravi Varma: Representational Dilemmas of a Nineteenth Century Painter', *Journal of Arts and Ideas*, 17/18 (Jul. 1989), 59–80. Articles of two major critics of colonial art are **A. K. Coomaraswamy**, 'The Present

State of Indian Art', *Modern Review*, 2, 2 (Aug. 1907), 108, and **E. B. Havell**, 'The New Indian School of Painting', *The Studio*, 64 (Jun.–Sep. 1908), 107–17. On pan-Asian ideas, **K. Okakura**, *The Ideals of the East* (London, 1903), and **S. Hay**, *Asian Ideals of East and West* (Cambridge, Mass., 1970). **R. Parimoo**, *Painting of the Three Tagores* (Baroda, 1973), surveys the art of three early leaders of Indian cultural nationalism. On Abdur Rahman Chughtai, the most detailed and scholarly work is the doctorate dissertation by **M. Nesom Sirhandi**, *Abdur Rehman Chughtai: A Modern South Asian Artist* (dissertation facsimile, Ann Arbor, 1984).

On pre-Raj colonial structures, see **A. Hutt**, *Goa: A Traveller's Historical and Architectural Guide* (Buckingham Hill, Essex, 1988); **D. K. Basu** (ed.), *The Rise and Growth of the Colonial Port City in Asia* (Berkeley, 1979); and **P. Mitter**, 'The Early British Port Cities of India: Their Planning and Architecture Circa 1640–1757', *Journal of the Society of Architectural Historians*, 45 (Jun. 1986), 95–114. **A. D. King**, *The Bungalow* (London, 1984), studies a colonial innovation. **P. Davies**, *Splendours of the Raj* (Harmondsworth, 1985), and **J. Morris**, *Stones of Empire: The Buildings of the Raj* (Oxford, 1983), are popular books that offer varying flavours of colonial architecture. The major work on early architecture is **Sten Nilsson**'s *European Architecture in India, 1750–1850* (London, 1968). **R. Llewelyn-Jones**, *A Fatal Friendship: The Nawab, the British and the City of Lucknow* (Delhi, 1985), considers the connection between western architecture and colonial encroachment on a princely state. For the Raj meridian, **T. Metcalf**'s *An Imperial Vision: Indian Architecture and Britain's Raj* (London, 1989) explores Indo-Sarasenic style as an expression of hegemony. **R. G. Irving**'s *Indian Summer: Lutyens, Baker and Imperial Delhi* (London and New Haven, 1981) traces the politics behind the building of the imperial capital.

### Chapter 10. Modernism in India

**W. G. Archer**'s pioneering *India and Modern Art* (London, 1959) is now dated in terms of ideas. **R. Tagore**, *Rabindranath Tagore on Art and Aesthetics* (New Delhi, 1961), is indispensable for appreciating his painting. See also **P. Mitter**, 'Rabindranath Tagore as Artist: A Legend in His Own Time?', in M. Lago and R. Warwick (eds), *Rabindranath Tagore: Perspectives in Time* (London, 1989), and **A. Robinson**, *The Art of Rabindranath*

*Tagore* (London, 1989). The pioneering work on Sher-Gil is **K. Khandalavala**, *Amrita Sher-Gil* (Bombay, 1944), which should be supplemented with **V. Sundaram et al.**, *Amrita Sher-Gil* (Bombay, n.d.). On Jamini Roy, **B. Dey and J. Irwin**, *Jamini Roy* (Indian Society of Oriental Art publication, Calcutta, 1944), and *The Art of Jamini Roy, Centenary Volume* (Calcutta, 1987). On art teaching at Santiniketan: **J. Chakravarti et al.**, *The Santineketan Murals* (Calcutta, 1995); **S. Kumar et al.**, *The Santiniketan Murals* (Calcutta, 1995); *Nandalal Bose, Centenary Exhibition* (National Gallery of Modern Art exhib. cat., New Delhi, 1983). On Benode Bihari Mukherjee, see the *Art Heritage Journal* (1978–9), 76–7. On the major Santiniketan sculptor Ram Kinkar, see **J. Appasami**, 'Ramkinkar's Contribution to Contemporary Art', *Art Heritage Journal*, 22 (Sep. 1976), 25–7, and *Ramkinkar* (Delhi, 1961). For other major sculptors, see **P. R. Rao** (ed.), *D. P. Roy Chowdhury* (Bombay, 1943), and *Cintamoni Kar: A Retrospective Exhibition 1930–85* (Indian Museum exhib. cat., Calcutta, 1985). Outstanding artists in Bengal who made their debut on the eve of independence are **Somnath Hore** (*Tebhaga: An Artist's Diary and Sketchbook,* trans. S. Zutshi, Calcutta, 1990) and **Paritosh Sen** ('Reflections', *Lalit Kala Contemporary* (Sep. 1968), 32–3). For other Mumbai (Bombay) artists not discussed in the book, see **V. R. Amberkar**, *Hebbar: An Artist's Quest* (New Delhi, 1974); **R. Chatterjee**, *Bendre: The Painter and the Person* (Bombay, 1990); and for a Chennai (Madras) artist see **J. James**, 'K. C. S. Paniker', *Lalit Kala Contemporary*, 22 (Sep. 1976), 10–15.

## PART IV. POSTCOLONIAL ART AND ARCHITECTURE (1947–2000)

### Chapter 11. Art After Independence

On post-independence modernist architecture in India under Le Corbusier, see **N. Evenson**, *Chandigarh* (Berkeley and Los Angeles, 1966). Scholarly monographs on leading architects such as Charles Correa or B. V. Doshi do not yet exist. On more general developments: **A. D. King**, *Colonial Urban Development* (London, 1976), and **G. H. R. Tillotson**, 'Architecture and Anxiety: The Problem of Pastiche in Recent Indian Design', *South Asia Research*, 15, 1(Spring 1995), 30–47; also **P. Pethe**, 'Indian Architecture—Quest for Identity', *Architect Trade Journal*, 17, 5/6 (1987), 17–20.

On modernist painting and sculpture in general: **U. Bickelmann and N. Ezekiel** (eds), *Artists Today: East–West Arts Visual Encounter* (Bombay, 1987); **U. Beier**, 'Contemporary Art in India', *Aspect Journal, Indian Issue* (Jan. 1982), 4–16; **M. Fukuoka** (ed.), *Contemporary Indian Art: Glenbarra Art Museum Collection* (Hemeji, 1993); **E. Alkazi** (ed.) *India: Myth and Reality: Aspects of Modern Indian Art* (Oxford, 1982); and *Indian Art Today, Four Artists from the Chester and Davida Herwitz Family Collection* (The Phillips Collection, Washington, DC, 1986). On the Progressive Artists Group in Calcutta, see **P. Dasgupta**, 'The Calcutta Group: Its Aims and Achievements', *Lalit Kala Contemporary*, 31 (Apr. 1981). The Bombay Progressive Artists Group is best studied in essays on individual artists: **M. Levy**, 'F. N. Souza: The Human and the Divine', *The Studio* (Apr. 1964), 134–9; **R. von Leyden**, 'Studies in the Development of Ara', *Marg*, 6, 2 (1951), 52–5; **F. Nissen**, 'V. S. Gaitonde—Contemporary Indian Artists 8', *Design*, 2, 2 (Feb. 1958), 16–27; **R. L. Bartholomew and G. Kapur**, *Husain* (New York, 1971); **D. Herwitz**, *Husain* (Bombay, 1988); and **G. Sen**, *Bindu Space and Time in Raza's Vision* (Delhi, 1997). On modernism and Tantra: *Tantra* (Hayward Gallery exhib. cat., London, 1971), and **M. Khanna**, 'The Digitized Cosmos: Symbol and Meaning of Ritual Mandalas', *Art Heritage Journal*, 9 (1989–90), 88–93.

For individualists, **R. Bartholomew**, 'Satish Gujral—Contemporary Indian Artists 10', *Design*, 2, 4 (Apr. 1958), 14–16; 'Ram Kumar: The Early Years', *Art Heritage Journal*, 4 (1984–5), 84–9, a reprint of *The Hindustan Times Weekly*, Sunday 23 Oct. 1955; **G. Gill** (ed.), *Ram Kumar: A Journey Within* (New Delhi, 1996); Krishen Khanna is discussed in **R. Bartholomew**, 'Attitudes to the Social Condition: Notes on Ram Kumar, Satish Gujral, Krishen Khanna and Ramachandran', *Lalit Kala Contemporary*, 24–5 (Sep. 1977–Apr. 1978), 31–9; **R. Hoskote**, *Pilgrim, Exile, Sorcerer: The Painterly Evolution of Jehangir Sabavala* (Mumbai, 1998); and *J. Swaminathan* (Gallery Chemould exhib. cat., Bombay, 1965), which includes 'Poem to my friend, Swaminathan, the Painter' by Octavio Paz.

For Pakistan, **A. Naqvi**, *Image and Identity: Fifty Years of Painting and Sculpture in Pakistan* (Karachi, 1998), is the most comprehensive but see also **I. Hassan**, *Painting in Pakistan* (Lahore, 1991), and **M. N. Sirhandi**, *Contemporary Painting in Pakistan* (Lahore, 1992). On Sadequain, **F. A. Faiz**, *Sadequain* (Karachi, 1966).

J. Ahmed, *Art in Pakistan, Early Years* (Karachi, 1954), provides useful information on art in East Pakistan (later Bangladesh); see also **S. Ahmad**, *A Grand Group Art Exhibition of Reputed Bangladeshi Artists* (Dhaka, 1991), and **S. M. Islam**, *Muktijuddher Chitramala (Drawings and Paintings of the Liberation War)* (Dhaka, n.d.). *Arts and the Islamic World*, special volume: *Contemporary Art in Bangladesh*, 34 (Summer 1999), is a major addition to knowledge about art of the region.

## Chapter 12. The Contemporary Scene

On Indian 'postmodernism', two leading theoreticians are **K. G. Subramanyan**, *The Moving Focus: Essays on Indian Art* (Delhi, 1978) and *The Living Tradition* (Calcutta, 1987), and **Geeta Kapur**, *Contemporary Indian Artists* (New Delhi, 1978) and 'A Stake in Modernity: Brief History of Contemporary Indian Art', in C. Turner (ed.), *Tradition and Change: Contemporary Art of Asia and the Pacific* (Brisbane, 1993), 27–44. On the Baroda school, see **G. Sheikh** (ed.), *Contemporary Art in Baroda* (New Delhi, 1997). On Gulam Sheikh's painting, 'Le Tableau unique de Sheikh', in *Returning Home* (Centre Georges Pompidou exhib. cat., Paris, 1985); **T. Hyman** on *Bhupen Khakhar* (Mumbai, 1998); and for an article on an important artist not discussed in the book see **H. Winterberg**, 'Interview with Laxma Gaud', *Lalit Kala Contemporary*, 15 (Apr. 1973). On associates of Baroda, **A. Rajadhayaksha**, 'Sudhir Patwardhan: The Redemption of the Physical', *Art Heritage Journal*, 9 (1989–90), 4–9; *Vivan Sundaram*, (Little Theatre Art Gallery exhib. cat., New Delhi, 1991); **Gieve Patel**, *Railway Station Series* (Gallery Chemould exhib. cat., Bombay, 1975). On individualists: **E. Datta**, *Ganesh Pyne: His Life and Times* (Calcutta, 1998); **M. Jakimowicz-Karle**, *Bikash Bhattacharjee* (Bangalore, 1991); **R. Chawla**, *Ramachandran: Art of the Muralist* (Bangalore, 1994); **G. Sen**, *Image and Imagination* (Ahmedabad, 1996), on Jogen Chowdhury; **K. B. Goel**, *Manjit Bawa* (Centre for Contemporary Art exhib. cat., 1990–1). On South Indian sculptors: **J. James**, *Contemporary Indian Sculpture: The Madras Metaphor* (New Delhi, 1993), and **V. Lynn**, '"Between the Pot and the Sword": The Art of N. N. Rimzon', *Art Asia Pacific*, 3, 2 (Apr. 1996).

On women artists of the subcontinent, see **G. Sinha** (ed.), *Expressions and Evocations: Contemporary Women Artists of India* (Mumbai, 1996), and **A. Farooqi**, *Indian Women Artists Exhibition* (exhib. cat., Delhi, 1986). On women artists in Pakistan, **S. Hashmi and N. Poobaya-Smith**, *An Intelligent Rebellion: Women Artists of Pakistan* (Bradford, 1994); **N. Farrukh**, *Pioneering Perspectives* (Lahore, 1998); **G. Kapur**, 'Nalini Malani', *Art Heritage Journal*, 2 (1982–3), 72–6. Also on individual artists see **Altaf Mohammedi** (ed.), *Nasreen in Retrospect* (Mumbai, 1995); **P. de Francia**, 'Rekha Rodwittiya', *Art Heritage Journal*, 4 (1984–5), 70–4; **I. Murti**, *Anjolie Ela Menon* (New Delhi, 1995); and **P. Mitter**, 'The Art of Sabah Husain', *Pakistan Music Village* (exhib. cat., London, 1995), 19. For Bangladesh see **N. Khan Majlis**, 'Women Artists of Bangladesh', in *Arts and the Islamic World*, special volume: *Contemporary Art in Bangladesh*.

As expected, the range and variety of collections of Indian art in the subcontinent is wide and only a selection can be made. There are also a number of major private collections in India but they are usually not on public display. I have also included European art collections in the former princely states as they form an important part of the culture of colonial India.

**India:**
**Metropolitan Cities**

**Calcutta**
*Indian Museum*
Founded by the Raj, this is one of the greatest museums in India. Its most famous object is the Bharhut stupa railing.

*Asutosh Museum*
Mainly ancient art and folk art.

*Rabindra Bharati Society*
The finest examples of the Bengal School.

*Academy of Fine Arts*
Major collections of nationalist and modern art.

*Gurusaday Museum*
Unique folk art collection.

*Marble Palace*
Fascinating collection of mostly Victorian paintings, sculptures, and art objects.

*Victoria Memorial Hall*
Mughal painting and works of British artists in India, especially the Daniells.

**Chennai (formerly Madras)**
*Government Museum*
Remarkable Amaravati sculptures that complement the British Museum collection, South Indian bronzes, and Calukya stone sculptures.

**Delhi**
*National Museum*
Fine and comprehensive collection of Buddhist, Hindu, and Jain sculptures and Mughal, Rajput, Pahari, and Deccani miniature paintings, textiles, and decorative art.

*National Gallery of Modern Art*
The most important collection of contemporary art.

*National Handicrafts and Handlooms Museum*
Resource centre for the applied arts to aid their revival and development.

**Mumbai (formerly Bombay)**
*Prince of Wales Museum of Western India*
Represents all periods and includes a fine collection of Mughal and Rajput miniatures, Hindu sculptures, and decorative art.

*Jahangir Art Gallery*
Major venue for temporary modern art exhibitions and a popular cultural centre.

*National Gallery of Modern Art,*
*Sir Cowasji Jahangir Hall*
Set up in 1996 as a showcase for contemporary art.

*Bhau Daji Lad Museum*
Important collection of applied arts, including those produced by the Bombay School.

**India:**
**Provincial Centres**

**Ahmedabad (Gujarat)**
*Calico Museum*
Unique collection of textiles.

*L. D. Institute and Museum*
Miniatures, especially Jain works.

**Aundh (Maharastra)**
*Sri Bhavani Museum*
Designed by an Italian architect in 1938 as a light and spacious villa with a glass ceiling; European art objects and contemporary art and Kangra painting.

**Bangalore (Karnataka)**
*Venkatappa Museum*
Well-displayed and -documented works of a major nationalist painter of the Bengal School.

**Baroda (Gujarat)**
*City Museum*
Organized by the German scholar Hermann Goetz as a major art historical museum; contains some European masterpieces in addition to Hindu and Buddhist sculptures and miniatures.

*Fatesingh Museum*
Includes some of the finest oils of Ravi Varma.

**Bhopal (Madhya Pradesh)**
*State Museum*
Wide and varied, including folk art.

**Gwalior (Madhya Pradesh)**
Central Archaeological Museum
Some fine specimens of ancient sculpture.

**Hyderabad (Andhra Pradesh)**
*State Museum*
Includes some fine specimens of Cola and other South Indian sculptures and Mughal miniatures.

*Salar Jung Museum*
Fascinating assembly of Victorian and Edwardian art objects and bric-a-brac made by a high official of the Nizam (the prince of Hyderabad).

**Jaipur (Rajasthan)**
*Maharaja Sawai Man Singh II City Palace Museum*
Mughal and Rajput miniatures and carpets.

**Mathura (Uttar Pradesh)**
*Government Museum*
Early Buddhist, Hindu, and Jain art.

**Mysore (Karnataka)**
*Sri Jayachamarajendra Art Gallery*
Historically important collection of early colonial and nationalist art, especially oils by Indians, notably Ravi Varma.

**Patna (Bihar)**
*Patna Museum*
Sculpture collection includes the Mauryan *yaksi* from Didarganj.

**Santiniketan (West Bengal)**
*Visva Bharati University*
Collection of several thousands of Rabindranath Tagore's own paintings.

**Sarnath (Uttar Pradesh)**
*Archaeological Museum*
Finest examples of early Buddhist art at the site of the Buddha's preaching.

**Tanjavur (Tamilnadu)**
*Tanjavur Art Gallery*
Finest collection of Cola bronzes.

**Trivandrum (Kerala)**
*Sri Chitra Art Gallery*
Contemporary paintings, including works of Ravi Varma and other leading academic and nationalist painters, in addition to Buddhist and Hindu sculptures.

**Udaipur (Rajasthan)**
*City Palace Museum*
Comprises two parts, sculptures and Rajasthani miniature paintings depicting the history and culture of Mewar.

**Varanasi (Benares)**
*Bharat Kala Bhavan*
Major collections of Indian miniatures and sculptures.

**Pakistan**

**Islamabad**
*Folk Heritage Museum*
Folk arts and crafts.

**Karachi**
*National Museum of Pakistan*
Archaeology, history, and ethnology.

*Archaeological Museum, Karachi University*
Archaeology.

**Lahore**
*Lahore Museum*
Major collection of Buddhist and Hindu sculptures, especially Gandharan; archaeology, history, fine arts, applied arts, ethnology.

*Chughtai Museum*
Works of the nationalist artist at what was his residence.

**Peshawar**
*Peshawar Museum*
Archaeology, fine arts, ethnology.

**Bangladesh**

**Dhaka (Dacca)**
*National Museum*
Contains Buddhist and Hindu art of the Pala and Sena periods and contemporary art, especially the Zainul Abedin Gallery on that artist's work.

There are also 17 active galleries of modern art in Dhaka.

**Mymensingh**
*Zainul Abedin Sangrahashala*
Started by the artist.

**United Kingdom**

**London**

The seat of the former empire holds some of the finest collections of Indian art outside India.

**British Museum**
www.thebritishmuseum.ac.uk
Buddhist and Hindu art, including the Amaravati sculptures, the Stuart-Bridge collection of Pala sculptures and Mughal, Rajput, and Pahari miniatures.

**Victoria and Albert Museum**
www.vam.ac.uk/
Mughal, Rajput, and Pahari paintings and Hindu, Buddhist, and Jain sculptures. Originally set up to train artisans, it is also an important source for the Indian decorative arts.

**India Office Library section of the British Library**
www.bl.uk/collections/oriental/records/
Mughal, Rajput, Pahari, and East India Company art.

**Royal Asiatic Society Library**
www.royalasiaticsociety.co.uk
Small collection of Indian miniatures.

**Oxford**
**Ashmolean Museum**
www.ashmol.ox.ac.uk
Some fine specimens of ancient stone and bronze sculptures, Mughal, Deccani, Rajput, and Company paintings and decorative arts, especially cotton textiles exported from India.

**Bodleian Library**
www.bodley.ox.ac.uk
Major miniature collection, including the earliest examples to arrive in the West.

---

**Other European sites**

**Amsterdam**
**Rijksmuseum**
www.rijksmuseum.nl/asp/start.asp?language=uk
Sculpture collection includes the Cola Nataraja [16] and Nicolaas Witsen's (1641–1717) album of Golconda miniatures.

**Berlin**
**Museum für Indische Kunst**
Major comprehensive collection of stone, terracotta, and bronze sculptures, Rajput miniatures and decorative arts.

**Copenhagen**
**National Museum, Ethnographical Department**
Millennium.arts.kuleuven.ac.be/lhpc/
collections_folder/copenh_nat_mus.html
South Indian bronzes from colonial Tranquebar and sculptures collected by the missionary E. Løventhal, and decorative art.

**Dublin**
**Chester Beatty Library**
www.cbl.ie/home.htm
Major holdings of Mughal and Rajput miniatures.

**Paris**
**Musée Guimet**
ambafrance.org/MUSEES/english/16e.htm
Important collections of Hindu, Buddhist, and Jain sculptures and miniature paintings of all styles.

**Bibliothèque Nationale, Prints Department**
www.bnf.fr/site_bnf_eng/index.html
Late eighteenth-century Indian miniatures.

**St Petersburg**
**The Hermitage**
Mughal miniatures and other objects go back to the late nineteenth century but the actual Indian art collection has been built up since World War II.

**Department for the Peoples of Asia, Academy of Sciences**
orient.thesa.ru/welcome.cgi
Mughal miniatures.

**Vienna**
**Österreiches Museum für Angewande Kunst**
Includes *Hamza Nama* paintings in its rich collection.

**Schloss Schönbrunn**
So-called *millionenzimmer* room wallpaper consists of Indian miniatures, many from Rembrandt's collection.

**Zurich**
**Rietberg Museum**
Eduard von der Heydt collection of Indian sculptures and collections of Mughal, Rajput, and Pahari miniatures.

**United States**

Private collectors in the US created formidable collections in the twentieth century within a short space of time. Among these, John D. Rockefeller's and Samuel Eilenberg's ancient art collections, Paul F. Walter's miniatures and Company paintings, and Chester and Davida Herwitz's modern Indian art (including the largest collection of works of M. F. Husain) are remarkable.

**Baltimore**
*Walters Art Gallery*
www/thewalters.org
Fine Mughal miniatures.

**Boston**
*Museum of Fine Arts*
www.mfa.org/home.htm
Collection formed by the great critic Ananda Coomaraswamy. Boston's well-known masterpieces include a *yaksi* from Sanchi [5], 29 Kangra drawings on the theme of Nala and Damayanti, and *ragamala* paintings from Rajasthan.

**Cambridge, MA (Harvard University)**
*Fogg Art Museum*
www.artmuseums./harvard.edu/fogg
Major Mughal paintings.

**Chicago**
*Art Institute*
www.artic.edu/aic/
Collection includes Mughal and Rajasthani miniatures.

**Cleveland**
*Cleveland Museum of Art*
www.clemusart.com/
Includes Alsdorf collection of sculptures and the Mughal *Tuti Nama* manuscript.

**Los Angeles**
*Los Angeles County Museum of Art (LACMA)*
www.lacma.org
Nasli Heeramaneck collection of Mughal miniatures is among its treasures.

**Norton Simon Museum, Pasadena**
www.nortonsimon.org/
Fine and representative collection of Indian sculptures.

**New York**
*Metropolitan Museum*
www.metmuseum.org/
Comprehensive collection comprising all periods, particularly rich in Mughal art.

**Philadelphia**
*Philadelphia Art Museum*
www.philamuseum.org/
Fine selection, especially ancient sculptures.

**San Francisco**
*Asian Art Museum*
www.asianart.org/

**San Diego**
*San Diego Museum of Art*
www.sdmart.com/
Houses Edwin Binney III's remarkable collection of Indian miniatures.

**Washington, DC**
*Freer Gallery of Art*
www.asia.si.edu
Indian sculpture and Mughal painting.

**A. M. Sackler Gallery, Smithsonian Institute**
www.asia.si.edu
Of recent origin, it contains a wealth of sculptures and paintings.

---

**Japan**

**Himeji-City**
*Art Museum of the Glenbarra food processing factory*
Over 2,000 contemporary Indian paintings have been collected from 1991 onwards under the guidance of its curator, Masanori Fukuyoka; intended as a showcase of Indian culture.

# List of Illustrations

The publisher would like to thank the following individuals and institutions who have kindly given permission to reproduce the illustrations listed below.

1. Dancing girl, Mohenjo Daro, 2300–1750 BCE Bronze. Courtesy National Museum, New Delhi.
2. Asokan lion pillar, Sarnath, third century BCE. Archaeological Museum, Sarnath. Photo: Anil A. Dave/DPA/Images of India Picture Agency.
3. *Vessantara Jataka*, bottom architrave, front and back, north gate, the Great Stupa, Sanchi, first century BCE/CE Courtesy of American Council for Southern Asian Art Color Slide Project © Robert del Bontà.
4. Reconstruction of Sanchi. Reproduced from A. Volwahsen, *Living Architecture: Indian.*
5. *Yaksi*, from a gateway of the Great Stupa, Sanchi, first century BCE/CE Sandstone. Height 72.1 cm. Denman Waldo Ross Collection, Museum of Fine Arts, Boston. (29.999)
6. Buddha's victory over Mara's forces, his final tempters before illumination, the Great Stupa, Sanchi, first century BCE/CE. Courtesy of American Council for Southern Asian Art Color Slide Project.
7. *Caitya*, Bhaja, c.100–70 BCE. Courtesy of Ancient Art and Architecture Picture agency.
8. *Caitya*, interior, Karle, c.50–70 CE. Courtesy of Ancient Art and Architecture Picture agency.
9. *Bodhisattva Maitreya*, Gandhara, c. second century CE. Musée des arts asiatiques-Guimet, Paris. © Photo RMN/Richard Lambert.
10. Standing Buddha dedicated by Friar Bala, Mathura, c.100 CE. Spotted red sandstone. Archaeological Museum, Sarnath. Reproduced from J. Harle, *The Art and Architecture of the Indian Sub-continent*, by permission of Yale University Press.
11. The Great Stupa at Amaravati (reconstruction), second century CE.

Reproduced from R. Knox, *The Amaravati Sculptures at the British Museum.*
12. *Mandhata Jataka*, inner face of outer railing, the Great Stupa, Amaravati, second century CE. © Copyright The British Museum.
13. Seated Buddha, fifth century CE. Archaeological Museum, Sarnath. Photo: Joan Pollock/Global Scenes.
14. Cave I, Ajanta, interior, fifth century CE. Photo: Singh Madanjit.
15. *Bodhisattva Padmapani*, Cave I, Ajanta, fifth century CE. Photo: Douglas Dickins, FRPS.
16. Siva Natajara, Cola period, tenth century CE. Bronze. Courtesy of Rijksmuseum, Amsterdam. (AK-MAK-187)
17. Devi as Kali, Bengal, late nineteenth century. © Copyright The British Museum.
18. Five-Headed Ganesa with his Sakti, Orissa. Bridge Collection, British Museum. © Copyright The British Museum.
20. Nagara or North Indian temple type. Reproduced from A. Volwahsen, *Living Architecture: Indian.*
21. Dravida or South Indian temple type. Reproduced from A. Volwahsen, *Living Architecture: Indian.*
22. The *vastu-purusa-mandala* and temple. Reproduced from A. Volwahsen, Living Architecture: Indian.
23. Visva Brahma temple, Alampur, seventh century CE. Reproduced from Anada K. Coomaraswamy, *Essays in Early Indian Architecture,* by permission of Indira Gandhi National Centre for the Arts, New Delhi.
24. The *sikhara* of Kandariya Mahadeva (Siva) temple, Khajuraho, eleventh century CE. Photo: Joan Pollock/Global Scenes.
25. Vishnu's Boar incarnation, Udaigiri, fifth century CE. Photo: Robert Skelton.
26. Vishnu Anantasayana panel, south side, Dasavatara temple, Deogarh, sixth century CE. Photo: Robert Skelton.
27. Durga temple, Aiholi, eighth century CE. Photo: Douglas Dickins, FRPS.
28. Virupaksha (Siva) temple, Pattadakal,

eighth century CE. Courtesy of American Council for Southern Asian Art Color Slide Project © Stephen Markel.

29. Plan of Siva temple at Elephanta, sixth century CE. Courtesy Georg Michell. Reproduced by permission from Princeton University Press.

30. The Mahesamurti, Elephanta, sixth century CE. Courtesy of Ann and Bury Peerless Picture Library.

31. Siva, slayer of the demon Andhaka, Elephanta, sixth century CE. Courtesy of Ann and Bury Peerless Picture Library.

32. Kailasanatha (Siva) temple, Ellora, eighth century CE. Photo: Douglas Dickins, FRPS.

33. Durga, slayer of Mahisa, Kailasanatha temple, Ellora, eighth century CE. American Council for Southern Asian Art Color Slide Project. Photo: Ann Arbor.

34. The Shore Temple, Mamallapuram, c.700 CE. Courtesy of Ann and Bury Peerless Picture Library.

35. Rajasimhesvara/Kailasanatha (Siva) temple, Kanchipuram, eighth century CE. Photo: Douglas Dickins, FRPS.

36. Rajarajesvara/Brhadisvara (Siva) temple, Tanjavur, eleventh century CE. Photo: Douglas Dickins, FRPS.

37. Rajarajesvara temple, Tanjavur, isometric drawing showing section. Reproduced by permission of Indira Gandhi National Centre for the Arts, New Delhi.

38. Parvati, bronze, Cola period, c. eleventh century CE. Courtesy of the Freer Gallery of Art, Smithsonian Institution, Washington, DC. (F1929.84)

39. Plan of Srirangam, thirteen to seventeenth centuries. Reproduced from J. and S. Huntington, *Art of Ancient India.*

40. *Gopura*, Minaksi-Sundaresvara (Siva-Sakti) temple, Madurai, seventeenth century CE. Photo: Douglas Dickins, FRPS.

41. Rajarani Temple, Bhubaneswar, eleventh century CE. Photo: Anil A. Dave/DPA/Images of India Picture Library.

42. Detail of tower, Lingaraja (Siva) temple, Bhubaneswar, twelfth century CE. Reproduced from N. Wu, *Chinese and Indian Architecture,* Cassell Plc.

43. Temple to the Sun (Surya), Konarak, thirteenth century CE.

44. Laksmana (Vishnu) temple, Khajuraho, tenth century CE. Courtesy of Asian Art Archives, University of Michigan. Photo: Ann Arbor.

45. Kandariya Mahadeva (Siva) temple, Khajuraho, eleventh century CE. Photo: Douglas Dickins, FRPS.

46. Kesava (Vishnu) temple, Somnathpur, thirteenth century CE. Courtesy of J. Alan Cash Picture Library.

47. Temple to the Sun, Martand, Kashmir, eighth century CE. Courtesy of American Institute of Indian Studies.

48. Vishnu's Vaikuntha image, Kashmir, eighth century CE. Photo from the 1960 exhibition, Trésors d'Art de l'Inde, at the Petit Palais, Paris, and published by Publications filmées d'art et d'histoire en accord avec la Commission Française pour l'UNESCO.

49. Vatakkunnathan temple to Hari-Hara (Vishnu-Siva), Trichur, eleventh century CE. Photo: William A. Noble, reproduced from J. and S. Huntington, *The Ancient Art of India.*

50. Vishnu, wall painting, Mattancheri Palace, Cochin, sixteenth/seventeenth century CE. Photo: Douglas Dickins, FRPS.

51. Luna Vasahi temple, Mount Abu, c. thirteenth century CE. © The Board of the Trustees of the Victoria and Albert Museum, London.

52. *Vriksaka* (tree goddess), sandstone, Gyaraspur, twelfth century CE. Central Arch Museum, Gwalior. Photo from the 1960 exhibition, Trésors d'Art de l'Inde, at the Petit Palais, Paris, and published by Publications filmées d'art et d'histoire en accord avec la Commission Française pour l'UNESCO.

53. Siva Ardhanarisvara, Vikrampur, c. twelfth century CE. Asutosh Museum, Calcutta.

54. The Kiss, Kailasa temple, Ellora, eighth century CE. Reproduced from H. Zimmer, *The Art of Indian Asia.*

55. Quwwat ul-Islam mosque, Delhi, ground plan from 1206. Reproduced from A. Volwahsen, *Islamic India.*

56. Sultanate buildings, Delhi, thirteenth century. Reproduced from A. Volwahsen, *Islamic India.*

57. Ghiyas ud-Din Tughlaq's mausoleum, Delhi, fourteenth century. Courtesy of Ancient Art and Architecture Picture Agency.

58. Sher Shah's pavilion tomb, Sasaram, Bihar, 1530–40. Courtesy of Ann and Bury Peerless Picture Library.

59a. *Jami masjid*, roof of the mosque looking west towards Mecca, Gulbarga, 1367. Reproduced from A. Volwahsen, *Islamic India.*

59b. *Jami masjid*, plan and axonometric view, Gulbarga, 1367. Reproduced from A. Volwahsen, *Islamic India.*

60. Fortress at Gulbarga, fourteenth/fifteenth century. Courtesy of Ann and Bury Peerless Picture Library.

61. Man Singh's palace fortress, Gwalior, sixteenth century. Courtesy of Ann and Bury

Peerless Picture Library.

62. Multi-storeyed platform with bathing tank in front, Vijayanagara, sixteenth century. Photo: Georg Michell.

63. Krishna Chandra temple, Kalna, c.1751. Photo: Georg Michell.

64. Detail from palm leaf MS, *Pancaraksa*, Bengal, c.1057. University Library, Cambridge. (Add. 1688 f.127r.)

65. A page from *Ni'mat Nama*, Mandu, fifteenth/sixteenth century. Opaque paint on paper. India and Oriental Office, The British Library. (10 Islamic 149, Ethe 2775)

66. A page from *Kalakacarya Katha*, opaque paint on paper, 1414. P. C. Jain Collection. Photo: Robert Skelton.

67. Siyavash with his bride Farangish, *Shah Nama*, opaque paint on paper, fifteenth century. Museum Rietberg, Zurich. Photo: Wettstein & Kauf.

68. Campavati standing next to a lotus pond, *Caurapancasika*, opaque paint on paper, Mewar, c.1500. No. 76. N. C. Mehta Collection, Ahmedabad.

69. Canda in a garden by the river, *Candayana*, opaque paint on paper, probably Jaunpur, sixteenth century. Courtesy of Prince of Wales Museum, Mumbai.

70a. Humayun's mausoleum, Delhi, 1565. Photo: Ancient Art and Architecture Picture Library.

70b. Plan of Humayan's mausoleum, Delhi, 1565. Reproduced from A. Volwahsen, *Islamic India*.

71. Plan of Akbar's palace enclosure, Fatehpur Sikri, 1569–74. Reproduced from A. Volwahsen, *Islamic India*.

72. Buland Darwaza, Fatehpur Sikri, sixteenth century. Photo: Douglas Dickins, FRPS.

73. Daulat, Self-portrait with Abd al-Rahim the scribe, Mughal, c.1610. Opaque paint on paper. Oriental and India Office, The British Library, London. ((OR12208 f.325v)

74. Khurshidshehr frees Hamid, *Hamza Nama*, Mughal, c.1562–77. Opaque watercolour and gold on fabric. 67.5 × 51 cm. Courtesy of the Arthur M. Sackler Museum, Harvard University Art Museums. © President and Fellows of Harvard College, Harvard University. (0608.1983)

75. Daswanth, A night assault on the Pandava camp, *Razm Nama*, Mughal, c.1582–6. Opaque paint on paper. Maharaja Sawai Man Singh II City Palace Museum, Jaipur (after T. Holbein Hendley, Memoirs of Jeypore Exhibition 1883, Jaipur, 1884, vol. 4, pl. lxix).

76. Basawan and Chatar, Akbar brings the elephant Hawai under control as courtiers anxiously watch him, *Akbar Nama*, Mughal, c.1590. Opaque paint on paper. © The Board of the Trustees of the Victoria and Albert Museum, London. (58994)

77. *Deposition from the Cross*, Mughal, 1598. Opaque paint on paper. Clive Album, Victoria and Albert Museum, London. (CT 52707)

78. Abu'l Hasan, detail from *Squirrels in a Chenar Tree*, Mughal, c.1610. Opaque paint on paper. Oriental and India Office, The British Library, London. (J.1.30)

79. Abu'l Hasan, *Prince Khurram* (Shah Jahan), Mughal, c.1618. Opaque paint on paper. © The Board of the Trustees of the Victoria and Albert Museum, London.

80. Govardhan, A rustic concert, opaque paint on paper, Mughal, c.1625. Reproduced by kind permission of the Trustees of the Chester Beatty Library and Gallery of Oriental Art, Dublin.

81. Abd ur-Rahim, Khan i-Khanan, detail from *Jahangir Receiving Prince Parviz*, Mughal, 1610. Opaque paint on paper. © The Board of the Trustees of the Victoria and Albert Museum, London. (S.1279)

82. Sahifa Banu, *Shah Tamasp*, Mughal, early seventeenth century. Opaque paint on paper. © The Board of the Trustees of the Victoria and Albert Museum, London. (5737)

83. Bichitr, *Jahangir Preferring a Sufi Shaikh to Kings*, page from the St Petersburg album c.1660–70. Mughal. Opaque watercolour, gold and ink on paper. 25.3 × 18.1 cm. Courtesy of the Freer Gallery of Art, Smithsonian Institution, Washington, DC. (F42.15)

84. Mansur, *Chameleon*, Mughal, seventeenth century. Drawing, ink and light colours on paper. 9.5 × 13.3 cm. Courtesy of Her Majesty Queen Elizabeth II. Not to be reproduced without permission of Royal Collection Enterprises Ltd.

85. Hashim(?), *Dying Inayat Khan*, preparatory drawing, Mughal, c.1618–19. Francis Bartlett Donation of 1912 and Picture Fund, courtesy Museum of Fine Arts, Boston, Mass. ©1998, Museum of Fine Arts, Boston. All rights reserved.

86. Shah Jahan's nephrite wine cup, dated in the thirty-first year of his reign (1657). © The Board of the Trustees of the Victoria and Albert Museum, London. (ff938)

87. Taj Mahal, Agra, seventeenth century. Photo: Douglas Dickins, FRPS.

88. Throne *jharoka* in the *diwan-i-amm-khass*, Red Fort, Delhi, completed 1648. Photo: Dr Ebba Koch.

89. *Jami masjid*, Delhi, seventeenth century. Photo: Roderick Johnson/Images of India Agency.

90. Govardhan, *Shah Jahan and Dara Sikoh on Horseback*, Mughal, *c.*1632. Opaque paint on paper. © The Board of the Trustees of the Victoria and Albert Museum, London. (GE2620)

91. The capture of Port Hoogly, *Padshah Nama*, Mughal, *c.*1634. Opaque paint on paper. Courtesy of Her Majesty Queen Elizabeth II. Not to be reproduced without permission of Royal Collection Enterprises Ltd.

92. Farrukh Husain (Farrukh Beg), *Ibrahim Ail Shah II as a Young Man Hawking*, Deccan, *c.*1590–1600. Opaque paint on paper. Academy of Sciences, Institute of the Peoples of Asia, Leningrad. Photo: Robert Skelton.

93. City Palace, east front, Udaipur, Mewar, eighteenth century. Photo: American Council for Southern Asian Art Color Slide Project © Stephen Markel.

94. Samrat Yantra, Jaipur, Rajasthan, eighteenth century. Reproduced from A. Volwahsen, *Islamic India*.

95. Plan of Jaipur, eighteenth century. Reproduced from A. Volwahsen, *Living Architecture: Indian.*

96. *Maharana Jawan Singh of Mewar*, opaque paint on paper, Udaipur, *c.*1835. © The Board of the Trustees of the Victoria and Albert Museum, London. (FD213)

97. *Raja Ajmat Dev*, Mankot, 1730. Opaque paint on paper. © The Board of the Trustees of the Victoria and Albert Museum, London. (CT 17889)

98. *Brijnathji and Durjan Sal Sight a Pride of Lions*, Kotah, eighteenth century. Opaque paint on paper. Collection of H. H. Brjraj Singh of Kishangarh.

99. Nihal Chand, *Radha and Krsna in a Jungle Lotus Bower*, Kishangarh, *c.*1745. Opaque watercolour and gold on paper. 23.7 cm x 32.8 cm. Edwin Binney III collection, San Diego Museum. (1990:756)

100. 'Disguising her real intent; the *gupta parakiya* heroine', *Rasamanjari*, *c.*1660–70. Basohli. Opaque paint on paper. © The Board of the Trustees of the Victoria and Albert Museum, London. (IS 20-1958)

101. Nainsukh, *A Leisurely Ride: Mian Mukund Dev with Companions,* Jasrota (?), *c.*1740. Opaque paint and gold on paper. © The Board of the Trustees of the Victoria and Albert Museum, London.

102. *Radha Goes at Night to Krsna's House*, Purkhu, Panjab Hills, Kangra, *c.*1790. Opaque paint on paper. 29.2 x 23.8 cm. Edwin Binney III collection, San Diego Museum, California.

103. Votive image, goddess on winged bull, Karnataka, nineteenth century. Folklore Museum, Institute of Kannada Studies, Mysore University.

104. A *kohbar* painted on the mud wall of a hut, Madhubani region. Reproduced from Y. Vequaud, *The Art of Mithila, Ceremonial Paintings from an Ancient Kingdom.*

105. Manadasundari Dasi, *sujni kantha*, inscribed by the artist, Khulna, early twentieth century. Reproduced by permission of Seagull books, Calcutta.

106. *Caksudana pata*, a *jadupat*, Santhal Parganas, Bihar, *c.* twentieth century. Natural pigments on paper. Collection of the author.

107. Mango necklace, Tamilnadu, *c.* nineteenth century. Pearls, rubies, gold, and semi-precious stones. Courtesy of National Handcrafts and Handlooms Museum, New Delhi, Ahmedabad. Collection and Photo Crafts Museum, New Delhi.

108. Chintz hanging, painted and dyed cotton made for the European market, Coromandel coast, mid-eighteenth century. Courtesy of Royal Ontario Museum © ROM, gift of Mrs Harry Wearne. (934.4.10)

109. Rickshaw art, Bangladesh, twentieth century. Courtesy of Museum of Mankind, London.

110. Sheikh Zayn al-Din, *Stork*, 1782. Watercolour on paper. Collection of William Ehrenfeld.

111. *Courtesan Playing a Violin,* colour lithograph based on Kalighat painting, nineteenth century. © The Board of the Trustees of the Victoria and Albert Museum, London. (GJ 4161)

112. J. P. Gangooly, *Evening*, exhibited at the Bombay Art Society, 1910. Courtesy of Department of Archaeology and Museums, Maharastra State and Bombay Art Society.

113. Raja Ravi Varma, *Sita Vanavasa*, *c.*1890s. Oleograph. Collection of the Trustees of the Wellcome Trust, London.

114. Abanindranath Tagore, *Bharat Mata*, *c.*1905. Courtesy of Rabindra Bharati Society, Calcutta.

115. Abdur Rehman Chughtai, *The Resting Place*, *c.*1927. Watercolour and bodycolour, heightened with gold, laid down on card. 39 x 55.5 cm. Reproduced courtesy of Bonhams, London.

116. Church of the Holy Spirit, Goa, seventeenth century. Photo: Christopher Tadgell.

117. R. Chisholm and C. Mant, Laxmi Vilas

Palace, Baroda, nineteenth century. Photo: Dinodia/Images of India Picture Agency.
118. The Victoria Terminus, Mumbai (Bombay), nineteenth century. Photo: J. Alan Cash Picture Agency.
119. Plan of New Delhi. Reproduced from C. Tadgell, *The History of Architecture in India*.
120. Edwin Lutyens, Viceroy's residence, New Delhi, *c*.1933. Photo: Douglas Dickins, FRPS.
121. Gaganendranath Tagore, *Dhanyeswari, c*.1918. Lithograph. Private collection.
122. Gaganendranath Tagore, *Poet Rabindranath on the Island of Birds*, 1920s. Wash and tempera on paper. National Gallery of Modern Art, New Delhi.
123. Rabindranath Tagore, *Bird*, *c*.1930. Reproduced by permission of Indar Pasricha Fine Arts Ltd.
124. Amrita Sher-Gil, *The Child Bride*, 1936. Oils. Private collection.
125. Jamini Roy, *A Woman*. Tempera on paper. National Gallery of Modern Art, New Delhi.
126. Ramkinkar Baij, *Santhal Family*, 1938. Pebble cast sculpture. Visva Bharati University, Santiniketan.
127. Charles Correa, dome and inlaid floor, Inter-University Centre for Astronomy and Astrophysics, Pune University. Courtesy of the architect. Photo: Mahendra Sinh.
128. Krishen Khanna, *Emmaus*, 1979. Acrylic on canvas. Courtesy of the artist.
129. Maqbool Fida Husain, *Mother Teresa II*, 1980s. Oil on canvas. Tata Iron and Steel Co Ltd, Mumbai.
130. Francis Newton Souza, *Half-nude Girl in a Chair*, 1960. Oil on board. Collection: Harold Kovner.
131. Sayed Haider Raza, *Jala Bindu*, 1990. Acrylic on canvas Painting missing in transport. Photograph permission of the artist.
132. Nirode Mazumder, *Chandani Holding Gurudas's feathers*, *c*.1968. Jahangir Nicholson Museum, NCPA, Mumbai. Photo courtesy Neville Tuli.
133. K. G. Ramanujam, *Untitled*, 1972. Reproduced from catalogue, The Phillips Collection, *Indian Art Today, Four Artists from the Chester and Davida Herwitz Family Collection*.
134. Sadequain (Naqvi), *Composition from Ghalib*, 1968. Oil on canvas. Reproduced from Naqvi, *Image and Identity*, by permission of Oxford University Press, Karachi.
135. Shahid Sajjad, *Hostage I*, 1992-4. Reproduced from Naqvi, *Image and Identity*, by permission of Oxford University Press, Karachi.

136. Zainul Abedin, *Famine*, 1943. Black ink on paper. Reproduced from Ijaz ul Hassan, *Painting in Pakistan*.
137. Shahabuddin, *Freedom Fighter*, 1997. Reproduced by permission of the artist.
138. Ganesh Pyne, *The Sage*, 1979. Tempera on canvas. Collection: Jane and Kito de Boer. Reproduced by permission of the artist. Photo courtesy Neville Tuli.
139. Jogen Chowdhury, *Man and Woman*, 1987. Black ink and watercolour, heightened with bodycolour on paper. Private collection, New York.
140. Gulammohammed Sheikh, *City for Sale*, 1981-4. Oil on canvas. © The Board of the Trustees of the Victoria and Albert Museum, London, and the artist.
141. Bhupen Khakhar, *Celebration of Guru Jayanti*, 1980. Oil on canvas. Collection of the artist.
142. Meera Mukherjee, *Sitting Woman*, *c*.1990. Bronze. Collection of Dr Georg Lechner. Reproduced courtesy of Marg.
143. Anjolie Ela Menon, *Midday*, 1987. Oil on masonite. 120 x 70 cm. Reproduced courtesy of the artist.
144. Nalini Malani, *Balancing Act*, 1983-4. Reproduced from Helene Barbier, *Coups de Coeur*.
145. Rekha Rodwittiya, *Within Ivory Towers*, London, 1984. Watercolour on paper. Courtesy of the artist.
146. Nilima Sheikh, *When Champa Grew Up No. 7, Tensions in the Household and Prosecution of the New Bride*, 1991. Gum tempura paint on handmade paper. Courtesy of Leicester Art Galleries and Museum, UK. © Leicester City Museums Service.
147. Mrinalini Mukherjee, *Woman on Peacock*, 1991. Hemp. 214 x 130 x 75 cm. Collection of the artist.
148. Zubeida Agha, *New York*, 1970. Oil on board. Reproduced from Naqvi, *Image and Identity*, by permission of Oxford University Press, Karachi.
149. Sabah Husain, *Forest of Yellowing Leaves*, 1993. Mixed media on handmade paper. Courtesy of Bradford Art Galleries and Museums, UK.
150. Rokeya Sultana, *Mother and Child (Madonna series)*, *c*.1995. Collection: Amiya and Aloka Gooptu. Reproduced by permission of the artist.

The publisher and author apologize for any errors or omissions in the above list. If contacted they will be pleased to rectify these at the earliest opportunity.

# Index